Crafts and Craftsmen of the Middle East

The Islamic Mediterranean

Programme Chair Robert Ilbert
Series Editor Randi Deguilhem

Published and forthcoming

1. Writing the Feminine: Women in Arab Sources
 Edited by Manuela Marín and Randi Deguilhem

2. Money, Land and Trade: An Economic History of the
 Muslim Mediterranean
 Edited by Nelly Hanna

3. Outside In: On the Margins of the Modern Middle East
 Edited by Eugene Rogan

4. Crafts and Craftsmen of the Middle East: Fashioning the
 Individual in the Muslim Mediterranean
 Edited by Suraiya Faroqhi and Randi Deguilhem

5. Constituting Modernity: Private Property in the East
 and West
 Edited by Huri İslamoğlu

6. Standing Trial: Law and Person in the Modern Middle East
 Edited by Baudouin Dupret

7. Subversity and the Individual in Arab Literature
 Edited by Robin Ostle

8. Shattering Tradition: Custom, Law and the Individual
 in the Muslim Mediterranean
 Edited by Walter Dostal and Wolfgang Kraus

CRAFTS AND CRAFTSMEN OF THE MIDDLE EAST

Fashioning the Individual in the Muslim Mediterranean

Edited by

Suraiya Faroqhi and
Randi Deguilhem

I.B. TAURIS
LONDON · NEW YORK

Published in 2005 by I.B.Tauris & Co Ltd
6 Salem Road, London W2 4BU
175 Fifth Avenue, New York NY 10010
www.ibtauris.com
in association with The European Science Foundation, Strasbourg, France

In the United States and Canada distributed by Palgrave Macmillan, a division of
St. Martin's Press, 175 Fifth Avenue, New York NY 10010

Copyright © 2005 I.B.Tauris and Co Ltd, European Science Foundation and
Suraiya Faroqhi and Randi Deguilhem

ISBN 1 86064 700 6
EAN 978 1 86064 700 0

A full CIP record for this book is available from the British Library
A full CIP record for this book is available from the Library of Congress
Library of Congress catalog card: available

Typeset in Baskerville by Dexter Haven Associates Ltd, London
Printed and bound in Great Britain by
TJ International Ltd, Padstow, Cornwall

Contents

Preface and Acknowledgements

Suraiya Faroqhi, Randi Deguilhem

The people who work and the forms of organisation that they
devise in so doing are the focus of this volume, which strives to
present a balanced view of the long-lived and multiform society
that supported the Ottoman Empire. In order to do this, it is
necessary to take a hard look at the manner in which the inhab-
itants of Istanbul, Cairo and Damascus, as well as those in the
smaller provincial towns, managed to produce a variety of goods,
market the products of their labour and keep body and soul
together.

In the Ottoman world, but even in the first decades of Turkish
Republican history, the 'typical' urban worker was not as yet
employed in a factory, but either operated as an independent
artisan or turned over his/her product to a merchant for mar-
keting. Throughout the nineteenth century, as Donald Quataert
has shown us, Ottoman craftspeople managed to adapt, albeit
often at the price of declining real wages, to a market into which
imported goods entered in increasing quantities.[1] A degree of
adaptation was possible within the established craft organisations.
Quataert's observations concerning the flexibility of Ottoman
artisans have encouraged us historians to revise our view of their
guilds, which an earlier generation had seen mainly as an im-
pediment to the maximisation of production and as a generator
of more or less insignificant but very time-wasting disputes.
Obviously, adaptation to mid-nineteenth century world markets
did not immediately lead to the demise of older crafts and thus to
the dissolution of the relevant associations. Yet, as John Chalcraft's
study in the present volume has shown, putting-out systems and
the removal of many activities from the traditional workshops in
the urban core did make these guilds increasingly irrelevant to
producers and, as a result, many of them disappeared.

In a sense, the dissolution of Ottoman guilds forms the centre-
piece of our volume. Several studies, (in chronological order
of the cases discussed, Procházka-Eisl, Yi, Gara, Rozen, Faroqhi,
Aynural and Deguilhem) concentrate on the functioning and
relative fluidity of craft guilds in the sixteenth to the nineteenth

centuries but also on their increasing elaboration in the 1700s and 1800s. Here, the editors have tried to strike a balance between studies focusing on the initiatives of the guildsmen themselves (Yi, Rozen) and others in which the role of the Ottoman state has been highlighted (Procházka-Eisl, Gara, Aynural). On the other side of the 'great divide' represented by Chalcraft's contribution stand two monographs of relatively 'traditional' crafts as they could be observed several decades after the dissolution of the guilds (Doğanalp-Votzi, Kickinger). If there are many more studies on Ottoman artisans than on their post-Ottoman successors, this reflects the state of our field: up until now craftsmen both independent and enmeshed within putting-out systems have interested historians much more than sociologists or ethnologists.

In brief, the present collection can be read as the story of craft producers as they functioned in the Ottoman context and then as they negotiated first the shoals of the late eighteenth century economic crisis and then the nineteenth century world market, an early instance of globalisation. As to the grandchildren of these craft producers, they coped as best they could with the processes of limited and often state-sponsored industrialisation both in Turkey and in Egypt.

Acknowledgements

The genesis of this book began with a workshop organised by Suraiya Faroqhi which took place in Munich in October 1997. We would like to thank Robert Ilbert for having established the *Individual and Society in the Mediterranean Muslim World* (ISMM) research programme within the framework of the Humanities Section of the European Science Foundation (ESF) under whose aegis the Munich workshop was organised. We would also like to thank Janie Freshwater, Carole Mabrouk and Madelise Blumenroeder for their invaluable administrative assistance, as well as Gérard Darmon, Marianne Yagoubi and Elizabeth Vestergaard, who directed the Humanities Section of the ESF throughout the duration of the ISSM programme. We would also like to sincerely thank Françoise Gillespie for having drawn up the index for this volume and for most of the preceding ones in *The Islamic Mediterranean* series of I.B. Tauris.

Parts of some studies published here (Eleni Gara, Randi Deguilhem) were first presented in a workshop organised by Randi Deguilhem at AFEMAM (Association Française d'Etudes sur le Monde Arabe et Musulman) in Aix-en-Provence in July 1996, others (Suraiya Faroqhi, Claudia Kickinger, Gisela Procházka-Eisl) were presented at the Munich workshop and the general meeting in Istanbul in July 1998.

Suraiya Faroqhi is grateful to the Wissenschaftskolleg zu Berlin, where much of the work that went into the production of the present volume was done under optimum conditions; special thanks to Mitchell Cohen for his editorial assistance beyond the call of duty. Randi Deguilhem expresses her gratitude to the Institut de Recherches et d'Etudes sur le Monde Arabe et Musulman (IREMAM) and the Maison Méditerranéenne des Sciences de l'Homme, Aix-en-Provence, where significant portions of her time were devoted not only to the preparation of the present volume and the others in *The Islamic Mediterranean* series but also to the ISMM programme as a whole.

Notes

1 Donald Quataert, *Ottoman Manufacturing in the Age of the Industrial Revolution*, Cambridge, Cambridge University Press, 1993.

Transcriptions

Those who have worked with primary sources in different languages know the difficulties of choosing a coherent transliteration system, especially in the case of a collective work. Moreover, since the present volume is not only intended for specialists of the Ottoman Empire and its successor states, but also for scholars and more general readers interested in the lives of artisans in the modern and contemporary Mediterranean world, we have simplified the process by using modern Turkish transliteration for terms and proper names given in Ottoman Turkish while the transliteration of Arabic terms and proper names is done using just a representation of the ayn and hamza and the Western keyboard; Turkish accenting is used for Turkish. As to the details the two editors of this volume have left individual authors to make their own choices and there are thus slight variations between texts.

Part One
PRINCIPLES OF GUILDS

CHAPTER 1

Understanding Ottoman Guilds

Suraiya Faroqhi

Research on Ottoman guilds has appeared, on and off, during the last seventy-five years or so. Ottoman guilds first appeared on the scholarly agenda in the 1920s when Osman Nuri Ergin discussed them in his pioneering study of Istanbul urban affairs.[1] Yet, we are still very far from a full understanding of the Anatolian guilds' late medieval origins, their manner of operation – apart from the well-documented regulation of product quality – and their dissemination into areas where guilds probably had not existed in the past.[2] Most annoyingly, we are still unable to say whether the organisation of craftsmen in guilds formed part and parcel of the Ottoman manner of governing and, as such, was introduced to the Arab world after the conquest of the Mamluk state in 1516–1517.

This ignorance is due to a lack of primary sources, especially where the period before the 1570s is concerned. The major source, namely, the Ottoman kadi (magistrates') registers which cover, albeit with many gaps, both Istanbul and quite a few provincial towns in the Balkans, Anatolia and the Arab provinces, rarely go back much beyond that fatidic date. Bursa, Tekirdağ, Jerusalem and, to some extent, Cairo form the exceptions which prove this particular rule. For the present, nobody knows why it is in the later 1500s and not at some slightly earlier or later date that we observe the growing presence of the Ottoman kadis along with their scribes on the urban scene.[3]

Religion and the economic mentality of craftsmen

At an early stage of scholarly research on Ottoman guilds, quite a few historians tended to concentrate on what might be called the 'ideological' elaborations of craft activity. Only Osman Nuri Ergin, with his background in practical city administration, largely focused on socio-political questions instead. Interest in the spiritual concerns of guildsmen was perhaps due to the fact that, once again with the exception of the resolutely modernist Ergin, studies of Ottoman guilds were first undertaken by scholars whose major focus was on the period before 1500 or 1550. After all, the literary texts – in the broader sense of the term – which largely constitute the sources for the medievalist, emphasise morals and the ceremonial rather than the mundane problems of artisan production. These matters, for instance, were the main interests of Franz Taeschner, who studied early Anatolian hagiographies and their reception while showing that certain features of late medieval associations of urban males continued to be relevant in guild life as late as the eighteenth century.[4]

At about the same time, Abdülbaki Gölpınarlı, best known for his many works on the dervish order of the Mevlevis, published and commented upon several so-called *fütüvvetnames*. These texts describe the qualities expected of a perfect member of a certain type of male brotherhood, the *ahis*, who were supposed to follow the rules of modesty, abnegation and self-control known as *fütüvvet*. The writings in question also describe the rituals which the *ahis* regarded as central to their associations.[5] *Fütüvvetnames* were copied out in artisan circles, which indicates that they were considered important long after the *ahis* as an organisation had faded away. Probably, the hierarchy of 'reputable' and 'disreputable' trades which was described in some of these texts counted for something in everyday social relations. However, there is no indication that the Ottoman government authorities considered this contempt of some guilds for others as juridically or administratively relevant.[6] Moreover, certain *fütüvvetnames* were considered to be significant by religious historians because they made it clear that there existed a widespread popular veneration for the descendants of 'Alî, the nephew and son-in-law of the Prophet Muhammad.[7] According to an important study by Irène Mélikoff, one of these texts recounted the story of an

4

artisan who was supposed to have saved a descendant of the Prophet from his persecutors at the price of sacrificing his own baby boy. Among Anatolian artisans, the memory of this deed was evoked as a model of piety and abnegation, and commemorated in the communal preparation and consumption of helva.

Students of Anatolian religiosity such as Gölpınarlı or Mélikoff became interested in artisan organisation because the guildsmen, in some aspects of their associational lives, strongly focused upon religious values and the ceremonial. On the other hand, the economic historian Sabri Ülgener who himself came from a family of dervishes saw the Ottoman craft guilds in quite a different light. Ülgener was one of the first Turkish social scientists to interest himself in the theories of Max Weber. The link which this latter scholar assumed to have existed in the early modern period between Calvinism and capitalism prompted Ülgener to ask himself in which ways the religious views of Ottoman artisans had affected their economic behaviour. If this concern with Weber ties Ülgener to the social sciences of the early twentieth century, Ülgener himself was a pioneer if seen from another perspective for, in the Ottoman context, his work was one of the first attempts to study what came to be called 'the history of mentalities' in the 1970s and 1980s.[8] Similar to people working in the tradition developed by Michel Vovelle, Ülgener concerned himself with the views of people who wrote little if at all and whose manner of thinking must thus be 'teased out' of sources which refer to the topic only in an indirect fashion.

More specifically, Ülgener asked himself why Ottoman craft producers had failed to make the transition to capitalism. His answer was that due to the shift of international trade routes away from the Mediterranean from the sixteenth century onwards, the Ottoman economy increasingly found itself in a backwater with access to international markets severely limited. To this lack of opportunity on the 'macro' level, craftsmen responded with an ideology which made a virtue out of necessity by emphasising the values of modesty and also of a certain egalitarianism within a culture of poverty. For Ülgener, these values, however, were less important than the concomitant denigration of worldly activity, ambition and drive and he was acutely sensitive to the pettifogging jealousies which, in the narrow confines of a small-town market, all too often flourished behind the façade of otherworldliness.

After all, as an economist, this author was confronted with the problems of the twentieth century and, in Ülgener's perspective, quite a few of these difficulties could be derived from the fact that Ottoman craftsmen and traders had so thoroughly rejected the idea not only of foreign, but also of home-grown capitalism.

In discussing the problem of why a well-developed market economy such as the Ottoman had not made the transition to capitalism, Ülgener's emphasis on endogenous factors and 'ideological' considerations limiting economic expansion did not sit well with the concerns of scholarship during the 1960s and 1970s. After all, this was the time when some Ottomanist historians became involved with 'world economy' studies in the Wallersteinian mode.[9] According to this model, the reasons for economic stagnation and even 'de-industrialisation' were located squarely in developments taking place outside the confines of the Ottoman Empire, namely, in northwestern Europe. Certainly, Ülgener also had viewed the final reason for the 'involution' of Ottoman crafts in their isolation from the lifelines of international trade, but this was not, in the conjuncture of the 1960s and 1970s, taken into serious consideration. That the author had never worked with the 'hard' data derived from the Ottoman archives which even today form the basis of most work on the economic history of the pre-nineteenth century sultanic realm must also have counted against him. It must not be forgotten that in those years, archival work was seen as the *conditio sine qua non* of 'scientific' history. After a long period of neglect, it was only around 1980 that a new interest in Ülgener's work became visible in Turkey.[10]

Towards an examination of social structures

Yet, in Ottoman guild studies as they evolved between 1960 and 1980, it was not the link with religious history, but rather the severely practical approach taken by Ergin which became dominant.[11] To understand this predilection, it is useful to remember that in the 1920s and early 1930s, when Ergin published his pioneering works, Ottoman guilds did not yet constitute the purely historical issue which they have become in our day. After all, Kara Kemal, a former member of the Committee for Union

and Progress who had thrown in his lot with the Kemalists and was, for a brief moment, appointed governor of Istanbul, ordered the compilation of eighteenth and nineteenth century sultanic rescripts relevant to the guilds of Istanbul. Presumably, he had intended this collection as a practical guide for dealing with artisans and their current problems.[12] For as Donald Quataert's work has shown, at least in one specific case, namely, the port of Istanbul, guilds were politically potent even in the years immediately preceding the First World War.[13]

After the guilds were no longer of much practical concern, the emphasis on the 'secular' as opposed to the religious aspects of artisan activity continued. Apart from the secularist commitments of many historians, this may well have been due to the fact that new document finds, in the as yet undeveloped state of the field, constituted *the* indispensable precondition for historiographical progress and these official records were almost never relevant to the religious aspects of craft activity. While Ottoman officials always assumed that Muslims were devoted to their religion and non-Muslims to their own particular *ayin-i batile* (invalid religious rites), this was not a matter on which the authorities had much to say. Of course, there were exceptions: for instance, it once happened that a craftsman from Amasya claimed to be a Mahdi, thus indicating that the end of the world was close by, a claim which found some support among his fellows.[14] But such exceptions were few indeed. Certainly, the repression of beliefs considered heretical by Sunni Muslims was viewed as an important task by the sixteenth century Ottoman administration whenever these ideas became politically relevant. But under 'ordinary' conditions, the convictions and rituals of artisans are almost never mentioned in official sources.

Normally, the archival documents which, from the 1940s onwards, increasingly came to the attention of Ottomanist historians, dealt with the artisans' place in the urban economy and also with the services that the latter were expected to render to the Ottoman state.[15] This meant that historians mainly found evidence on the craft rules which artisans were to follow, both in order to protect the public and to keep down competition among masters operating in one and the same urban marketplace. And as such matters were only documented when a complaint was made to members of the state apparatus, a historiographical

concern with the social structures in which craftsmen earned their daily bread always involved an interest in the functioning of the Ottoman state itself. With but a moderate degree of exaggeration, one might say that state and guild came to be seen as the two sides of one and the same coin.

How historians made the state usurp the place of Ottoman craftsmen

If, however, Ottoman history, as written in the period between the late 1930s and late 1970s, was so strongly informed by the viewpoint of the sultans' officeholders, this was only in part due to the state-centredness of the available documentation. During this period, historians of conservative but also, from the 1960s onwards, left-wing backgrounds saw good reasons for the fore-grounding of the Ottoman state. A 'radical' stage of Republican historiography, in which anything Ottoman was abhorred, had intervened, but it only lasted for about fifteen years. Due to, among other matters, the disorganisation of the archives, this epoch did not produce much major research into the dynamics of Ottoman craft production.[16] From the second half of the 1930s onwards, the Depression and the state policies devised to relieve it, followed by the condition of military mobilisation in which Turkey was obliged to live during World War Two, focused attention on the role of the state in economic life. In the perspective of Ömer Lütfi Barkan, to whom we owe an important publication of early sixteenth century lists of administered prices (*narh*), it was the proper role of the state to direct artisan production toward the aims of conquest or, in times of peace, towards city-building through the medium of officially sponsored pious foundations.[17] From this point of view, Ottoman craftsmen appeared almost as a variety of soldiers.

Nor was this way of regarding matters limited to the Turkish historical community, quite to the contrary. In 1970, the Israeli historian Gabriel Baer published three articles in which he tried to prove that Ottoman guilds were not 'guilds' in the sense in which the term is used by Europeanist historians, in other words, these organisations were not meant to defend the interests of the master artisans.[18] Rather, they were a means of transmission,

established by the state, in order to remedy the lack of urban institutions through which officialdom (which, after all, in the sixteenth and seventeenth centuries formed but a small body of men), attempted to control urban society. Like the state-organised trade unions which existed in many states of that period, Ottoman guilds were supposed to relay the demands of the central government to urban craft producers. It is possible that by stressing this aspect so strongly, Baer also wanted to make a statement in a major debate current at that time: the 1960s and 1970s saw a lively international discussion of the question whether the Ottoman state and society should be viewed as in some way 'feudal' or else as a variant of the 'Asiatic mode of production'. Moreover, in the Turkish academic milieu, it was widely assumed that the Ottoman social formation constituted a phenomenon *sui generis* which had no place in any of the broader categories devised so far. To return to the context of Baer's argument, while 'guilds' operating merely as a means of state control would have fitted into both the 'Asiatic mode of pro-duction' and the social formation *sui generis*, it is difficult to imagine them in the less centralised mode of government associated with one or another variant of feudalism.

Be that as it may, the notion of the Ottoman state's centrality was also of interest to those authors who, in the Turkish political environment, felt attracted to the concept of the 'Asiatic mode of production'. As elsewhere, this positive reaction was, in part, due to the fact that postulating a mode of production not present in Europe allowed a person of Marxian persuasion to avoid the stultifying notion of an obligatory sequence of 'stages' that every society in the world would have to pass through before it could attain socialism. Moreover, if there was no such unavoidable passage through a fixed number of intermediate stages, there was also no reason to assume that the aberrations and crimes of Stalinism would of necessity be repeated in other socialist societies.

But it is also possible that, for Turkish historians of Marxian inclinations, part of the attraction of the 'Asiatic mode of pro-duction' concept lay in the fact that it vindicated the centrality of the state, which, as people of some historical education had long known, was indeed a constitutive feature of the Ottoman social formation. If the 'Asiatic mode of production' was accepted

as a valid model for the study of Ottoman history, the Ottoman Empire was no longer an unclassifiable moloch, but a 'respectable' social formation whose road to socialism might not lead through capitalism. The distrust of Ottoman guildsmen vis-à-vis the market could equally be justified in this context, although Marx had assumed that in the 'Asiatic mode of production', artisans were, to a large extent, members of village communities remunerated by non-market mechanisms. Such a perspective clearly did not make much sense to Ottomanists.[19]

Admittedly, the 'Asiatic mode of production' lost favour among social theoreticians not for its empirical inappropriateness to Ottoman society, but for reasons which had to do with developments in European and North American historiography during the 1980s. But for the historiography of Ottoman guilds, the real paradigm change in those years was due to very different factors. After 1980, the 'mixed economy' model which had formed part of Turkish official policy during the 1960s and 1970s was given up under the pressure of the World Bank and other powers external to Turkey in favour of a neo-liberal policy which emphasised the profit motive. In the historical field, this led to a revitalisation of the history of commerce, with studies falling into the field of business history appearing for the first time in Ottomanist historiography.

In this perspective, at least, certain Ottoman artisans were viewed as a kind of proto-entrepreneurs. As a result, the emphasis was now not so much on the manner in which the guilds hampered competition among individual masters, but rather on the ways which some of their members invented in order to survive – even in the notoriously difficult times of the nineteenth century.[20] In addition, the literature on proto-industry in early modern Europe was finding readers among Ottomanists and, in consequence, there was a search for evidence on practices which could be described as the 'putting out' of raw materials to be made up by rural and urban non-guild producers.[21] Certainly, the evidence was never thick enough on the ground to justify the claim that, in certain regions of the Ottoman Empire, industrial conjunctures replaced good and bad harvests as determinants of demographic behaviour; in any case, due to the absence of population registration, the latter is difficult to describe before the late nineteenth century.

But, despite this, we have learned that, for instance, in the villages surrounding Bursa or Ankara, rural industry co-ordinated by urban merchants was significant even in the sixteenth century.[22] This finding is of considerable importance for guild historians because it demonstrates that not all craft workers were necessarily guild members.[23] Yet, Ottoman 'putting out' seems to have been different from what has been observed in many European regions. Quite a few of the rural part-time artisans of the Ottoman world seem to have owned their tools and possibly their raw materials as well so that their dependence on urban traders was mainly caused by a need for loans and a lack of access to the distribution sector; these deficiencies on the craftsmen's side are not, however, to be underestimated.

Variations between Ottoman regions

Rural non-guild craft production is documented only for certain regions which are, moreover, of limited size. On the other hand, one of the major gains in our understanding of the guild problematic has been an enhanced consciousness of the variability of artisan organisation from one region to the next.[24] Istanbul and Cairo, the two largest cities in the Empire, are also those whose guilds have been most intensively studied. But in addition, we now possess evidence on a sizeable number of Ottoman provincial towns, many of them Arabic-speaking. Some of the fullest evidence concerns Jerusalem which, in spite of its religious role as a centre of pilgrimage for the three Abrahamic religions, was, in the sixteenth century, rather small and insignificant. For reasons which have not been fully elucidated, Jerusalem guilds are much more fully documented than those of most other Ottoman towns of moderate size.[25] In consequence, we have learned a good deal about the ways in which a prosperous Jerusalem butcher might establish links with the local scholarly elite and thus increase his social capital.[26] It is also possible to write a kind of encyclopaedia of Jerusalem guilds, an undertaking which otherwise is possible only where the very largest cities of the Empire are involved.[27] Very significant work also has been done on the cotton town of Nablus, where the 'social embeddedness' of textile production and consumption has been analysed with

particular sensitivity.[28] Damascus, with its active textile industries, has also come in for its share of attention.[29]

Where the Balkan peninsula is concerned, some of our most incisive studies come from Bulgaria, where the surviving kadi registers of Sofia, Rusçuk/Ruse, Vidin and Filibe/Plovdiv have been examined.[30] The studies of Nikolai Todorov have shown that guilds were flexible enough to accommodate themselves to the proto-industrial production of rough woollen cloth which, in the early nineteenth century, acquired an additional outlet as it was used to make the uniforms for the new-style army of Sultan Mahmud II. This observation is important far beyond the Bulgarian or even the Ottoman context for, while the rapid dissolution of English guilds had led many researchers to think that this was a 'normal' development in the early stages of industrialisation, Todorov's work has shown that, quite to the contrary, prosperous manufacturers of woollen cloth might attempt to control their guilds, for instance by getting themselves appointed to the key offices, rather than leaving these craft organisations or trying to subvert their functioning.[31] Presumably, it was the need to negotiate with well-capitalised tax farmers and later with the Ottoman central state itself which made it seem practical to producers to negotiate as groups. Even the most successful masters may well have been wary of tackling the massed power of the Ottoman state on their own.

In other European provinces of the Empire such as Hungary, the evidence on Ottoman-style guilds seems to be largely negative. From the work of Lajos Fekete and other Hungarian scholars, it has become apparent that Ottoman artisans did settle in Hungary, mainly to produce typically 'Ottoman' goods which the governing elite demanded, but which were not part of the repertoire of local craftsmen.[32] However, in the secondary literature accessible to me, I have not found any evidence on the guilds that these artisans may have formed. On the other hand, some of the local craft producers also continued to operate, especially for modestly situated customers in small market towns. Of course, the clientele for European-style luxury crafts such as goldsmithry for which Hungary had been famous in the fifteenth century must have rapidly declined. But in the literature on Hungarian towns, I have not encountered any evidence of interacting Ottoman and Hungarian guilds. Nor do the sources record artisans' associations

encompassing both Muslim and Christians, even though this was not at all a rare phenomenon in the 'central provinces' of the Ottoman Empire nor in the Arab provinces. In Hungary, Muslim and non-Muslim craftsmen seem to have largely kept to themselves.

It is especially intriguing that we know so little about the reactions of Hungarian craftsmen who had been familiar with guilds on the central European model to the Ottoman style of organising artisan production. In certain small towns of Hungary during the post-conquest period, some guilds are attested, although I am not sure whether they functioned according to the medieval Hungarian model or, rather, emulated the Ottoman one – if, indeed, the men concerned were clearly aware of the difference.[33] Many problems of this type, particularly those connected with guild origins, will probably remain unsolved unless we find some absolutely novel sources from the late fifteenth and early sixteenth centuries. While not totally impossible, such a find, unfortunately, does not seem very likely.

Anatolian guilds present yet other problems. In the former Ottoman capital and major manufacturing centre of Bursa, experienced artisans whose opinions provided guidelines for the actions of their fellows are on record for the late fifteenth and early sixteenth centuries. Yet, while this probably means that guilds of some kind were active even in this early period, it is quite possible that they were more loosely structured than their homologues of later years. Moreover, in Bursa, the situation was further complicated by the numerous slaves working for textile manufacturers, a phenomenon not documented for other Ottoman towns.[34] This feature must have subverted the egalitarian tendency inherent in the guilds: while it was easy for the dominant masters to limit the working hours of their colleagues or that of the apprentices whom they could employ, it should have been much more difficult to prevent any artisan from acquiring as many slaves as he was able to afford, a right which was inherent in Islamic law.

Yet, Bursa did not become a town of large workshops operated by a servile labour force. Rather, in many instances, industrial slavery was temporary, as quite a few owners liberated their slaves after they had served satisfactorily for a number of years. Probably, in the late fifteenth and early sixteenth centuries, the

13

free workforce was too small to supply the textiles demanded both
by the Ottoman court and by exporting merchants so that the
rather uneconomical employment of slaves formed a viable
solution. Profits must have been high enough to pay for the
upkeep and training of slaves, not all of whom possessed the
aptitude to learn the complicated techniques that an accom-
plished weaver of brocade needed to know. When, by the later
sixteenth century, these profits declined and poor but free weavers
became available, manufacturers readily gave up slave production
and Bursa became an artisan town similar to others in the
Ottoman Empire.[35]

Guilds in the course of time

Older studies on the whole tended to pay little attention to the
development of Ottoman guilds in the course of the centuries.
While the issue was rarely discussed explicitly, scholars seem to
have assumed that once the guilds had come into being, they
continued to operate in the accustomed fashion until their
demise in the nineteenth or early twentieth century. Minimising
the importance of institutional change was common enough
among Ottomanists of the 1940s and even the 1950s and was in no
way limited to guild historians. Thus, İsmail Hakkı Uzunçarşılı,
in his widely used reference works on the various branches of the
Ottoman administration, was also concerned with an 'eternal
present' which lasted from the late fifteenth to the late eighteenth
century.[36]

A decisive change in this attitude was first signalled by
an article which, due to its appearance in a yearbook almost
inaccessible outside of Berlin, has circulated mainly in the form
of photocopies.[37] In this text, Engin Akarlı has discussed the
eighteenth and nineteenth century practice of limiting the right
to open a shop to masters who had first acquired an 'opening'
(*gedik*) and pointed out that such rules had been rarely applied
before 1750. In the author's view, the *gedik* or, expressed dif-
ferently, the right to open a shop in a given place, was invented
by Ottoman artisans in order to defend their rights to their
workplaces, which were often the property of pious foundations.
When, in the crisis years after about 1760, the state began to dip

into the revenues of these institutions, the latter attempted to make up the shortfall by increasing rents. This placed the artisans in an impossible situation as they themselves were hard hit by the crisis. By claiming that the right to open a shop formed a special kind of property which only could be alienated among fellow guildsmen, the artisans attempted to limit the competition for shops and, thereby, the concomitant bidding up of rents. This argument is remarkable because it implies that guilds of the sixteenth and seventeenth centuries, a time when *gediks* were relatively rare, differed fundamentally from their late Ottoman counterparts in which, by contrast, this limitation of artisan enterprise was widespread.

Other changes concern the relationship of Muslim and non-Muslim artisans. As Mantran has already observed, seventeenth century guilds could be organised on a religious or even denominational basis, But, in many instances, Muslims and non-Muslims shared the same guild. This is apparent from numerous court protocols which contain the names of artisans appearing before the kadis in some dispute or other; the Muslims are listed first and then come the non-Muslims. The warden (*kethüda*) in mixed guilds was always chosen from among the Muslims and it might happen that a guild consisting entirely of Greeks – as far as can be discerned – had a Muslim *kethüda*. However, the latter could not count on the automatic support of the kadi when his fellow guildsmen were dissatisfied with him and, at least in eighteenth century Bursa, the opposite was often true.[38]

Yet, in the nineteenth century, the number of guilds in which a single religion or denomination predominated seems to have grown. No comprehensive lists of nineteenth century guilds in any major city of the Empire appear to have surfaced, so it is difficult to make specific claims on this score.[39] However, there is some information about the religious mixity of guild personnel in nineteenth century Damascus as attested by the document on which Randi Deguilhem has worked for her chapter in this volume. But the impression of growing guild segregation remains nonetheless. In the historiography of the last few decades, it has often been assumed that this growing segregation on religious/denominational grounds was due to the fact that non-Muslim craftsmen could adjust more easily to the capitalist market dominated by European traders. Moreover, wealthy non-Muslims

were now less willing to defer to Muslims and this change in attitudes exacerbated bad feelings. A recent study has pointed out that even in the eighteenth century, tensions between guild masters expressed in terms of religious/denominational antagonisms were not unknown, at least, not in occupations strongly oriented towards an inter-regional market.[40] On the other hand, segregation of guilds by religion or denomination also occurred in crafts which lost ground due to the technical developments of the nineteenth century and not merely in those directly exposed to the capitalist market. The problem definitely needs further investigation.

Links between Ottomanist and Europeanist historiographies

For a long time, the focus of most researchers was either on religious practice or else on the Ottoman state and its demands, while the operation of individual workshops was largely neglected. As long as this situation continued, there was little contact between Ottomanist and European guild historiographies. After all, for a long time, Europeanist historians had considered the guilds as a form of more or less autonomous artisan organisation. They might demand and, under fortunate circumstances, even achieve participation in urban self-government, as happened in certain towns of Flanders and northern or central Italy. On the other hand, English craft guilds had already lost much of their significance in the sixteenth century and, as is well known, England formed the vanguard of the industrialisation process from the eighteenth century onwards. In consequence, it was assumed that the advance of the absolutist state, on the one hand, and the spread of capitalism, on the other, reduced early modern guilds to insignificance. In this view, the persistence of guilds in central Europe, for instance, appeared simply as a sign of political and economic backwardness, not worth a detailed investigation.

However, during the last decade or two, perspectives have changed. As a result of the research of Jan Lucassen and his colleagues, we know that during the 'golden age' of Holland's expansion in the late sixteenth to late seventeenth centuries, a large number of new guilds was established.[41] And while Flanders

16

during the seventeenth century was no longer one of the power-houses of European economic growth as it had been in the fifteenth and sixteenth centuries, it was still a wealthy and active region – yet, its guilds were flourishing.[42] Moreover, in the absolutist kingdom of France of the mid-eighteenth century, which experienced considerable economic expansion, craft organisations, although gradually losing ground, were still far from being a *quantité négligeable*.[43] All this means that guilds and economic growth were more easily compatible than had been assumed by earlier generations of scholars. Moreover, from the 1980s onwards, we observe widespread scepticism vis-à-vis those phenomena which had been regarded as 'economically progressive' in the optimistic atmosphere of the 1960s. In this context, even the growth-inhibiting role of some guilds came in for less condemnation than had been true in the past.

Even more significant for Ottomanists were other features of the changing historiographical scene. By the sixteenth or seventeenth century, city states and largely autonomous towns in most parts of Europe were in full retreat in the face of the expanding absolutist state so that the political function of the guilds had largely become obsolete. This fact had long been known but, while in the first half of the twentieth century the political powerlessness of artisan guilds had been one of the reasons for their neglect by scholars, the establishment of social history as an independent field changed this perspective significantly. After all, loss of political power did not necessarily involve a loss of function. Certainly, European absolutist regimes before the second half of the eighteenth century did not attempt to do away with the guilds: to the contrary, they were inclined to use them for their own purposes. In the eyes of *ancien régime* bureaucrats, guilds were useful because they supervised the quality of the goods produced by their members, a major concern, especially, in France. In addition, these organisations ensured the training of apprentices and aided in the collection of urban taxes.

These aims were not unknown to the Ottoman state either. As we have seen, quality control was a central concern of the sultans' administration even though its officials, differently from those of Colbertian France, were not concerned with exportation, but had the home market and, above all, the needs of army,

navy and sultanic palace in mind. In addition, the sultans in person and, of course, their administrations closely monitored the weight and purity of bread sold in Istanbul.[44] Given this strong interest in quality control, Ottoman authorities also did not contradict local master artisans when the latter demanded that their prospective successors serve lengthy apprenticeships. Thus, the rhetoric of protecting the customers from the shoddy work of *hamdest* (clumsy artisans) never fell on deaf ears in Istanbul. To the present day, I have not found any official warnings to masters who used their already well-trained apprentices as a source of unpaid labour even though such cases surely were not lacking. As to the guilds' role in supplying soldiers on campaign with goods and services, it is so well documented that, as has been noted in a different context, scholars such as Gabriel Baer could regard service to the Ottoman state as the principal function of the guilds without arousing a great deal of protest.[45]

Thus, at least where the crafts sector is concerned, specialists today do not believe that Ottoman and European modes of social organisation were as fundamentally different as had been assumed earlier. It must, however, be admitted that this view has not always been well received, particularly by non-specialists to whom the incommensurability of the Ottoman and European political regimes continues to hold significant appeal. An important factor in this change of perspective is the lengthening of the period under investigation, the study of which, following Fernand Braudel, has come to be known as the *longue durée*.[46] While quite a few older Europeanist historians lost interest in the guilds once previously autonomous cities were incorporated into territorial states, at present the eighteenth century history of artisan organisation has gained acceptance as a legitimate field of study in and of itself. And it is in the *longue durée* of the entire early modern period, down to about 1800, that the common features of Ottoman and European guilds become most clearly visible.

Contributors and contributions

It is against this background that, at least in my view, the studies which have come together in the present volume should be read. They cover the Balkans, Anatolia and the Arab provinces of

the Ottoman Empire, while, where the post-1918 period is concerned, the states of Turkey and Egypt also enter into the picture. Istanbul clearly takes pride of place: where the years before 1800 are concerned, Gisela Procházka-Eisl, Eunjong Yi and Salih Aynural all focus on the Ottoman capital, while Minna Rozen deals with the same city during the eighteenth and nineteenth centuries. Though, for the most part, the authors are interested in guilds regardless of the religious beliefs of the members, the differences particularly between Muslims and Jews are also brought into focus. Most or maybe even all of the producers of woollen fabrics discussed by Eleni Gara were Jewish, and Minna Rozen, in her turn, investigates a purely Jewish guild. Christian bakers figure in Salih Aynural's contribution. But, given the prevalence of Islam in the Ottoman Empire, most of the artisans treated here undoubtedly were Muslims. In terms of craft specialisation, the picture is also quite diverse: weavers, bakers, millers, slaughterers, tanners, masons and coppersmiths all being represented. As to the time span discussed, the studies in the present volume cover the period from the late sixteenth to the twentieth century with, as so often happens, coverage becoming somewhat denser as we approach the present day.

Gisela Procházka-Eisl is the only contributor to deal with the (late) sixteenth century; she has studied the guilds of Istanbul as they appear in the famous 'sultanic festival book' (*sûrnâme-i hümâyûn*) of 1582. The same author had already edited one of the different versions in which this famous festival book has been preserved, namely, the text located in the Austrian National Library in Vienna. The richness of the material that it contains already had impressed Joseph von Hammer-Purgstall in the early nineteenth century.[47] The importance of Ottoman festival accounts for the history of guilds is due to the fact that a procession of guildsmen parading in front of the sultan formed part of quite a few such festivals. From the later sixteenth century onwards, it became customary to list the guilds taking part in these events, thus providing an overview of contemporary artisan specialisation. As the list of 1582 constitutes the oldest version known to date, it can be used as a kind of baseline. Thus, we can compare it with the later list relayed by Evliya Çelebi, which refers to an event which took place in the time of Murad IV, and the even later one recorded in the festival book of 1720.[48]

Apart from this mundane question of who was doing what in Istanbul in the1580s, the list discussed by Procházka-Eisl is also valuable because it contains brief descriptions of the floats which many guilds had prepared for the occasion. We also find a list of the craft products which many artisans carried through the streets of Istanbul in order to demonstrate their skills, thus projecting a public image of competence and reliability. Of course, it is hard to tell to what degree the craftsmen themselves were involved in the planning of the parades and to what extent the images that they presented were imposed on them by the officials in charge of festival planning. Yet, even if the latter were the case and the designs of the floats owed nothing to the guildsmen's initiatives – which in my opinion, is not very probable – the picture seen by the population of Istanbul was that which is reflected in the festival books. And as Carlo Ginzburg has taught us, people will often end up accepting the image which political and religious elites impose upon them, even if, at the outset, the view which they had had of themselves was totally different.[49]

While festival accounts and lists of craftsmen survive only for the Empire's largest cities, in her study of seventeenth century Istanbul guilds, Eunjeong Yi has used the documentation which, as we have seen, forms the 'staple food' of the guild historian, namely, the kadi registers. Unfortunately, for reasons unknown, no material of this type has survived for sixteenth century Istanbul *intra muros*.[50] While older guild historians had usually focused on the institutional framework and, thus, on the relative stability that the guilds imparted to urban life, Eunjeong Yi takes a rather different view. Perhaps it is not entirely due to chance that she has elected to work on documents recorded in the kadis' courts and, thus, in most cases, the by-product of serious conflicts of interest which could not be mediated by informal action. As a result, the records of court cases will contain at least the traces, be they ever so faint, of two or even more conflicting points of view.

By contrast, Robert Mantran, for instance, had relied largely upon sultanic commands, which, by their very nature, are unilateral. Even if experience shows that to enjoin does not necessarily mean being obeyed, any ruler emitting orders has to pretend that his commands will be followed to the letter.

Working in the 1950s when only a small selection of documents was accessible to researchers, Mantran, of course, had little choice; willy-nilly, his book gives an impression of stability and order imposed from above.

By contrast, in the perspective adopted by Eunjeong Yi, the guilds constitute merely a framework within which artisans negotiate among themselves vital matters such as taxation, deliveries demanded by the Ottoman army or, on a less official level, the delivery of raw materials or semi-finished goods from one guild to the next. Thus, in her account, the seemingly firm borders between guild and guild or else between guilds and state apparatus are constantly being challenged, both by artisans and by officials. Craftsmen and members of the state apparatus, moreover, may act both individually and in groups. If the guild manages to function on a day-to-day level, this is due not to any in-built automatism, but to the repeated initiatives of some of its members and the forced or voluntary acquiescence of others.

As to the present author's contribution, it attempts to broaden the scope of our investigations by introducing a broad selection of primary sources with possible relevance to the history of guilds, thus, highlighting the *historical* character of artisan organisation. Admittedly, it appears as a truism that guilds changed over time, for such change, whether slow or rapid, forms a basic characteristic of all human societies. Yet, as we have seen, Ottomanists studying guilds for a long time have tended to largely ignore this particular feature. In my view, it is possible to overcome such ahistorical tendencies by using as many different sources as possible. Eunjeong Yi's work has demonstrated that kadi registers, with their in-built emphasis on contestation, will allow us to grasp something of the 'fuzziness' which so often prevails in daily life. By contrast, the orders issued by the central administration will reflect the ideas – and also the illusions – which Ottoman officials used as guidelines in their attempts to control local society. It is by contrasting these different perspectives that we can obtain a less mechanistic picture of the guilds than has been drawn in the older secondary literature.

But, of course, no source will automatically produce a change of perspective; it is always the questions asked by historians that

bring out the potential inherent in a given type of primary source. In this spirit, my contribution takes up the discussion concerning the emergence of the *gedik*, the well-known 'slot' into which an Ottoman craftsman of the eighteenth and nineteenth centuries had to fit himself before he could open a workshop. Akarlı has assumed that the initiative came from the artisans themselves who attempted to restrain competition for shops and workshops and whose demands received support from the kadis' courts.[51] But this acquiescence on the kadis' part has not been fully demonstrated and some serious doubts are possible. This is especially so since the judges of Istanbul were high-ranking personages close to the court and it is difficult to imagine that they should have sabotaged the efforts of the administrators of sultanic foundations to increase revenues by raising shop rents.[52] After all, kadis and foundation administrators were part of the same socio-political milieu. At least, before the mid-nineteenth century, high-level religious functionaries were major beneficiaries of pious foundations which they or their relatives might even administer. Thus, it seems probable that, on the whole, the kadis of major cities supported policies which secured their own incomes.

Other scenarios are surely possible: the one which comes to the mind of the present author most readily is linked to the fact that, in the eighteenth century, the Ottoman administration attempted to increase its control over those territories which had not as yet fallen into the hands of diverse power magnates. Supervision of Istanbul or Bursa artisans, incidentally, often with the active consent of the craftsmen concerned, formed but one facet of this policy. It may well be that the *gedik* was originally invented by guild members anxious to limit competition. But I think that official support for this arrangement went far beyond the circle of high-level judges and encompassed a significant section of the Ottoman ruling group. While supporting the *gedik* was probably detrimental to foundation incomes, this sacrifice may have seemed well worth undertaking. After all, it served to secure the consensus between rulers and ruled that must have appeared as a political necessity given the challenge of domestic power magnates and aggressive European neighbours.

So far, all authors have emphasised developments taking place in Istanbul. By contrast, Eleni Gara's work takes us into the totally different environment of the small town of Kara

Ferye (Verroia, Veria), a market for agricultural goods and a low-level administrative centre. While, in the Istanbul case, it is possible to control information by comparing different types of sources, this is much less feasible in the case of Kara Ferye. While a few rabbinical *responsa* refer to the place, no local author seems to have produced a chronicle comparable to that of the priest Papasynadinos, active in the town of Serres not many kilometres away.[53] Nor does the town, given its lack of importance, occur very often in collections of sultanic edicts or tax-farming documents. Yet, Kara Ferye is located only at a moderate distance from Salonica, which, at least in the first half of the seventeenth century, was still an important centre for the production of woollens. Kara Ferye itself also formed the site of some textile manufacture, its artisans concentrating on a shaggy woollen cloth used largely for blankets and known as *velençe*. The Jewish artisans who were engaged in its production form the central figures of Gara's story.[54]

From what has by now become a multitude of studies, we know that the Jews of Salonica were obliged to provide the woollen fabrics needed for the uniforms of the Janissaries. By the beginning of the seventeenth century, this had become a serious problem: with the growth of the Janissary corps, military demand soared while the prices of raw wool increased in response to both domestic and foreign demand. On the other hand, the craftsmen could not recoup their losses by increasing prices as, by the 1630s, the influx of affordably priced English woollens of good quality had become appreciable. Fires, plagues and administrative abuse combined to make the weavers' position yet more desperate.

Quite a few Salonica artisans responded by emigrating to other towns which were not obliged to service the Janissaries. However, the authorities, acting in accordance with well-established principles of Ottoman statecraft, attempted to force the fugitives to return to their place of origin. Competition for raw material and labour between the crisis-ridden industry of Salonica and those more prosperous branches of textile production emerging in nearby towns resulted in a long drawn-out dispute concerning the Kara Ferye weavers of *velençe*. Had their community originally emigrated from Salonica and should thus be sent back to its place of origin or had the Jewish *velençe*-weavers been settled in Kara Ferye 'ever since the imperial

conquest' and thus could claim sultanic protection from outside interference? In the contest between the weavers of Salonica and Kara Ferye, Gara shows that the local judge and the Janissary commander in Istanbul did not necessarily see eye to eye. At one point, the Kara Ferye court ruled that the Jews from Salonica should not be sold any milk or wool when they came to town, which amounted to a protection of local supplies against what was regarded as outside encroachment. The commander of the Janissaries must have regarded this as downright obstruction.

In Istanbul, however, artisans had a much harder time whenever they attempted 'to play both ends against the middle' for the central administration was close by and the kadi of Istanbul, differently from his provincial colleague, formed part of the governing elite. In addition, while uniform cloth was certainly needed for the proper functioning of the military establishment, bread was yet more vital. It thus comes as no surprise that the most dramatic examples of administrative control over artisans concern the milling and baking sectors of the Ottoman capital. Covering the second half of the eighteenth and the beginning of the nineteenth century, Salih Aynural's study is based on the numerous rescripts by which the central administration attempted to control the activities of bakers and millers. Copies of these sultanic orders have survived in the Istanbul Ahkâm registers and a selection of them has been published, a project in which Aynural himself has been closely involved.[55] His work may thus be viewed as a continuation of Lütfi Güçer's and Robert Mantran's treatments of these crucial issues.[56] As in the case of his predecessors, Aynural's sources are mainly prescriptive, and if the reactions of the artisans to this torrent of regulations become visible at all, it is in the protocols of occasional court cases and, especially, in the introductions to the sultanic edicts that were issued with such remarkable frequency. As had also been customary in documents of the sixteenth and seventeenth centuries, edicts promulgated around 1800 make some mention, in their beginning sections, of the circumstances under which they were issued and this includes the complaints to which the administration attempted to respond.

From these introductions, it becomes clear that while Istanbul bakers and millers were, of course, as much concerned about

their private profits as anyone else, the mechanisms of mutual supervision worked quite effectively and transgressions were frequently reported by the offending artisans' fellows. This should mean that as we have seen in a different context, Istanbul guildsmen did not particularly object to regulation from above, quite to the contrary. As for the central administration, it would appear that while conditions in the provinces had often, by this time, more or less escaped from its control, there was a will to compensate for this loss by the closest possible supervision of the inhabitants of Istanbul. A kind of consensus, therefore, seems to have existed between rulers and ruled, the extent and limits of which will have to be explored in future studies. Aynural's work thus shows how the examination of a specific case can have general implications for the relationship of the Ottoman state and its subjects.

Minna Rozen's study of the Jewish butchers, porgers and other varieties of meat dealers active in Istanbul is concerned with the *longue durée*, spanning the eighteenth and nineteenth centuries.[57] Her primary sources are largely the records of the rabbinical court, which, apart from their relevance to Jewish studies, are of special interest to historians of the Ottoman Empire. While we often hear that many disputes among Ottoman non-Muslims never reached the kadi's office but were instead decided in church or rabbinical courts, few records documenting the activity of these institutions have hitherto been made accessible. It is thus a real revelation to see which matters came before such courts and how they were decided.

In the Jewish context, the meat trades were subject to numerous rabbinical commands because of the elaborate rules and rituals which needed to be followed if meat was to be fit for consumption by observant members of the community. Partly to ensure that these rules were actually enforced, a variety of artisans and dealers involved in the process of slaughtering and dressing the meat were expected to check up on one another. Butchers who did not follow the rules might be barred from exercising their craft, a penalty also known in non-Jewish guilds. But in the Jewish milieu discussed in Rozen's chapter, excluding an artisan from the meat business took on a somewhat special character. Butchers were typically penalised for selling ritually unacceptable meat; in other words, the culprits had broken not merely the

rules of the craft, but also the commands of the Jewish religion. This association between religious and professional morality led to a very close subordination of the butchers to the religious establishment. Presumably, Jewish artisans whose work was not so intimately involved in the exercise of religion were not so intensely supervised by the rabbinical authorities, but this latter question seems to be as yet unresolved.

In addition, Rozen's chapter shows us that the subordination of butchers and slaughterers to the well-to-do members of the community who also controlled the rabbis came up against its limits in the middle of the nineteenth century. In the course of time, the tax levied on ritually slaughtered meat, the so-called *gabela* which, just as other indirect taxes, fell more heavily on the poor than on the rich, had come to form one of the principal resources of the Jewish community. Increasingly, the wealthy opted out of paying direct contributions. After a number of influential Jewish bankers had been killed upon the orders of Sultan Mahmud II, the community was left for several years without strong leadership and, in this uncertain situation, the butchers, backed by their largely very poor customers, refused to collect the *gabela*. Throughout the nineteenth century, revenues from this source proved difficult to collect as the poor made do with meat that was not approved by the rabbinate. Thus, from an unexpected angle, Rozen's paper focuses on the struggle between rich and poor, a major theme without which no discussion of social history will make any sense.

Minna Rozen's work concerns the tensions and disputes involving craftsmen as members of the Jewish community, while the butchers' and porgers' guilds themselves made but very fleeting appearances. By contrast, Pascale Ghazaleh's study of Cairo artisans is focused on the guilds themselves. Her central concern is with the considerations that may have prompted early nineteenth century craftsmen to form organisations. This is a problem notoriously difficult to solve because the primary sources at our disposal are – once again – not at all geared to the interests of an early twenty-first century social historian. What we have at our disposal is limited to the imagery provided in the volumes through which Napoleon's savants attempted to document the arts and crafts of Cairo during the last years of the eighteenth century, a number of complaints by craftsmen of this city against

their guild elders and the often less than complimentary comments on the public appearances of artisans by an elite chronicler. Last but not least, there survives the list of guildsmen compiled for purposes of taxation by the finance officials of Muhammad 'Alî Paşa, the first khedive of Egypt.

Given the limits of the available documentation, Ghazaleh's results are bound to be largely negative in character. In other words, she shows conclusively that Cairo's guilds in the early 1800s were not formed on the basis of local, religious or ethnic solidarities nor were they clearly structured due to the places which their members occupied in the relevant production processes. More surprisingly, neither were the guilds of this time clearly bounded entities of the kind that the bureaucrats of Muhammad 'Alî Paşa would have found most useful for tax collection. Rather, the borders of Cairo's guilds seem to have been quite fuzzy and, at least in the minds of the recording public officials, the distinction between a religious group such as the Jews and the craft organisations of which Jewish artisans were also members seems to have been rather less than clear-cut. Moreover, if the tax assessments of the time are at all indicative, disparities in average member incomes between the different guilds of Cairo seem to have been enormous. In addition, the guilds differed vastly in terms of size. Thus, at least in this city, there cannot have been a great deal of inter-guild solidarity based on a common ethic of poverty or, at the very least, mediocrity of the type that had been postulated for the artisans of Anatolian towns.

Thirty or even twenty years ago, results of this type would probably have made both authors and readers quite unhappy, as findings of this kind make it almost impossible to fit Ottoman guilds into any kind of 'grand theory'. However, in one respect, Ghazaleh's findings are consonant with, if not a theory, then at least with a problematic, since the absence of clear-cut distinctions made it possible for craftsmen who, at first glance, had little in common to interact with one another. Christians and Jews met their Muslim colleagues and customers in the khans, covered markets and streets of the city and argued in the kadi's court, while the reverse was also true. In a different vein, these artisans' perspective on the street-side amusements that certain elite writers found so distasteful may well have been rather more

positive. Shared poverty may have forged solidarities at times, while, at others, inter-communal rivalries may have made it comparatively simple for this or that wealthy merchant to play off one dependent artisan against another. It was such contradictions that, as we have recently learned, formed the social tissue of great Ottoman cities.

And what about Syrian artisans? Randi Deguilhem has studied a Damascus construction site of the mid-nineteenth century. Her source, which comes from the 1844 Minutes of the High Advisory Council of Damascus (Majlis Shûrâ al-Shâm al-'Âlî), is an account of work days and materials expended on the repair of an official building, written in an odd mixture of Ottoman and Arabic, but otherwise of the type that Ottoman bureaucrats had been accustomed to produce ever since the sixteenth century. Deguilhem's work is concerned with what seems to have been an average building project and, in such a context, administrative routine prevailed. In 1860, Damascus was to be shaken by a riot in which many Christians lost their lives. But, in 1844 whatever potential for conflict surely must have existed did not as yet manifest itself in everyday life.

Or, in any event, the Ottoman state of the Tanzimat period in whose service the artisans were employed was firmly committed to inter-denominational workplaces in order to further its own legitimacy. After all, this was the period in which the Ottoman ruling group attempted to counteract the nascent nationalisms among its subjects by fostering a common loyalty towards the sultan; providing employment to artisans of different religions and denominations would have fitted well into this policy. Thus, on the construction site, Muslims, Christians and Jews all worked together, and even though certain craft specialisations were favoured by this or that religious group, it appears that in the building sector, religiously and denominationally mixed artisan organisations were quite common. Nor does this document reflect any attempts on the part of Muslim artisans to deprive their non-Muslim colleagues of access to the more prestigious guilds. Had that been the case, it is likely that there would not have been so many Christians in the builders' craft organisation, which, according to a late nineteenth century Damascene author, was very prestigious even though its members did not make a great deal of money.

Guilds thus provided social status and self-confidence if nothing else. But what happened to craftsmen who continued in handicraft industries after the demise of the guilds? Claudia Kickinger's study of the coppersmiths and their workshop organisation deals with a location in downtown Cairo where this craft has been practised for centuries. While some of the craftsmen have switched to the cheaper aluminium kitchenware used by today's poor, it is remarkable that quite a few copper vessels are still being produced for actual use by better-off customers.[58] This includes the trays which, in present-day Turkey, are regarded either as *objets d'art* or as items suitable for the tourist trade. Even ornaments demanding considerable manual skill such as wire inlays made of metals other than copper continue to form part of the coppersmiths' repertoire. Kickinger has provided us with detailed descriptions of copper-working techniques which are all the more valuable as no one can tell for how long Cairene artisans will continue to employ them.

In quite a few cases, these men have had training beyond 'traditional' apprenticeship procedures: some members of the younger generation have, in fact, obtained formal technical schooling of one kind or another. These people either work part-time in the family shop or as a stopgap measure until a better-paying job can be found. From the interviews conducted and discussed by Kickinger, it is obvious that family solidarities, rather than contacts between master craftsmen who are otherwise strangers to one another, are decisive for the operation and survival of a workshop. People come to work in the enterprise of a relative and sons take over from their fathers. But given the limited demand for the coppersmiths' products and the poor working conditions in the shops, it is not surprising that many place their hopes in other kinds of employment.

In this particular case, the production of 'traditional' goods continues even though the relevant guild has disappeared without leaving a trace. By contrast, Heidemarie Doğanalp-Votzi discusses a craft of which only vestiges survive today, even though it was significant one hundred years ago. The scene is set in the shop district of Safranbolu, a small urban centre that today serves as a residential area where some of the people working in the nearby iron and steel town of Karabük prefer to live. Not too long ago, the town's handsome wooden houses earned it

a place on the World Heritage list and, since the 1980s, tourism has become a subsidiary source of the inhabitants' livelihoods. In the first section of her chapter, Doğanalp-Votzi attempts to reconstruct the history of the town, about which little is known before the nineteenth century. The buildings of Safranbolu themselves constitute an important source, partly due to the oral traditions connected with them which, in the relatively stable environment of a small town, have perpetuated themselves reasonably well.[59] Moreover, one may hope that in the near future, dendro-chronological investigations on the timber used in many monumental buildings will help date some of them. This applies especially to the tanners' workshops which, though in poor condition, form such a prominent feature of Safranbolu's urban core.[60]

In the second part of her study, Doğanalp-Votzi discusses the fate of tanning and the leather industries, especially the saddler's craft, vestiges of which survived into the 1980s. In the description of production techniques, her study links up with that of Kickinger. However, Doğanalp-Votzi records a phenomenon to which Kickinger makes little reference, namely, the remarkable lack of co-operation between masters even when such co-ordination would have been to their obvious advantage, for instance, when bargaining with outsiders for the prices of raw materials. This phenomenon is all the more remarkable as, even in the 1940s, memories of the guilds were still vivid in the workshops of Safranbolu. Doğanalp-Votzi concludes that we are confronted here with the 'competitive individualism' or 'amoral familism' which has been observed among petty commodity producers in many different regions of the world, many of them without any links to Ottoman political or artisan culture. And thus we may conclude that in western Anatolia following 1950, but not as yet during the early Republic, all vestiges of the Ottoman order in the crafts sector have well and truly disappeared.[61]

We have thus discussed the condition of artisans with and without guilds. Yet, we still need to cover one major issue, namely, the ultimate disappearance of old-style craft associations. Although guilds rapidly declined in the late nineteenth and early twentieth centuries, that is, in a period with relatively ample documentation, very little research on this question has as yet

been undertaken. Thus, John Chalcraft, who has studied this momentous development with respect to the Egyptian case, must be regarded as a real pioneer. Chalcraft takes issue with the notion, invoked by the few authors who have reflected on the guilds' demise, that it was the collapse of Ottoman handicraft production, due to the importation of European factory-made goods, which led to the dissolution of craft organisations. According to the existing secondary literature on Egypt, the matter is quite simple: artisans disappeared and guilds disappeared with them.

By contrast, Chalcraft proposes a more sophisticated model. Basing himself on Donald Quataert's study of the survival strategies of nineteenth century Ottoman craftsmen, he points out that it was exactly those strategies that made the guilds appear increasingly irrelevant.[62] In an attempt to escape ruinous taxation, handicraft production moved from the urban centres, particularly from Cairo, to the countryside, where guilds had never existed.[63] In addition, at least in the textile sector, women, who also had not been guild members in the past, were employed in their homes at derisory wages. Rural textile production, undertaken by a labour force in which wretchedly poor females formed a significant share, could, of course, function only because of the capital investment of merchants who operated a putting-out system. And, as is well known from studies of putting-out systems in other cultures, the survival of guilds in such an environment is difficult if not impossible. In late nineteenth or early twentieth century Egypt, textile production thus largely came to be in the hands of a labour force deprived of guild protection and Quataert's observation that Ottoman handicrafts survived at the price of declining worker incomes is thoroughly vindicated.[64]

Notes

1 Ergin, 1995.
2 Since the work of Ira Lapidus on medieval Cairo and Damascus, it has been generally accepted that there were no guilds on Mamluk territory: Lapidus, 1984. If true, this means that guilds must have been introduced some time in the sixteenth or

seventeenth century, presumably, by the Ottoman administration since they were flourishing in Cairo at the time of Evliya Çelebi's visit in the 1670s. Compare Evliya Çelebi, 1896–1938, v. 10, pp. 358–377.

3 For an overview over the kadi registers (*sicils*) in the National Library in Ankara, see Akgündüz *et al.*, 1988–1989. As to the inventories which record registers outside Turkey, see Faroqhi, 1999, pp. 76–80.

4 Taeschner, 1979. This volume contains articles written in earlier decades.

5 Gölpınarlı, 1949–1950.

6 As one of the very few possible exceptions that I know of, the keepers of wine-shops in Istanbul were obliged to furnish rowers for the Ottoman galleys, perhaps because their lowly status made them seem fit company for the criminals and prisoners of war who otherwise did the rowing; see Bostan, 1992, pp. 199ff. But certain other guilds, such as the boatmen, had to provide the same service as well, presumably for purely practical reasons. Thus, it seems doubtful that even these 'non-respectable' persons really counted as outcasts in the Ottoman socio-political system.

7 Mélikoff, 1964.

8 Vovelle, 1982.

9 Wallerstein, Decdeli and Kasaba, 1987.

10 In 1981, shortly before his death, Ülgener was able to issue new versions of his two major works, both first published in the 1950s: Ülgener, 1981a; *ibid.*, 1981b. On the problems encountered when historians limit themselves to what they consider 'hard' evidence, see Kafadar, 1989.

11 Thus, the account of guild activity in Mantran, 1962, pp. 349–424, which is still one of the most comprehensive accounts of guild life in a major Ottoman city, has affinities with Ergin's study.

12 Kara Kemal, however, committed suicide during the Izmir trials of 1926. On his compilation of Ottoman rescripts, compare Akarlı, 1985–1986.

13 Quataert, 1983.

14 Başbakanlık Arşivi, Osmanlı Arşivi, Mühimme Defteri n° 29, p. 96.

15 The pioneer in this field was Ahmed Refik Altınay, who published the first sampling of such documents already in 1917 and continued with this activity during the early Republican period. A reprint of all the relevant volumes appeared in 1988: as an example, compare Altınay, 1988.

16 For a relatively optimistic view of this 'Jacobin' period of Turkish Republican historiography, compare Berktay, 1991. For a much more pessimistic evaluation, see Ersanlı, 2002.

17 Barkan, 1942, 1963, 1972 and 1979. The latter study, in spite of its late publication date, was actually written before 1963.

18 Baer, 1970.

19 However, certain rural communities of Egypt form an exception: a paper given by Nicolas Michel (Cairo, April–May 2002) and due to be published soon in a volume edited by Rachida Chih and others on Ottoman rural history, records the existence of pieces of land which did not pay taxes in quite a few villages of the Ottoman period. With the assent of the provincial administration, they had been set aside to provide incomes for certain artisans such as blacksmiths who were indispensable for the functioning of the village economy.

20 On business history, see Çizakça, 1996; Gedikli, 2000. On the survival strategies of Ottoman craftsmen, compare Quataert, 1993.

21 Faroqhi, 1995a.

22 Ergenç, 1975.

23 This is important because a widespread view of Ottoman craft production insisted that there was no such activity outside the guilds. However, researchers interested in women's history have shown that while women do not seem to have formed any guilds, in some places, their contribution to the textile sector was not inconsiderable: see Dalsar, 1960. In addition, the work of Halil Sahillioğlu has shown that, at least, in Bursa during the late fifteenth and early sixteenth centuries, slaves, who also were not guild members, were active as weavers: see Sahillioğlu, 1985.

24 Given my linguistic limitations, I have not been able to discuss studies in languages other than English, French, German and Turkish.

25 As a result, it has been possible to write brief monographs concerning individual Jerusalem guilds, an impossible undertaking where most other medium-sized Ottoman towns are concerned: see Cohen, 2001.

26 Cohen, 1989, p. 18.

27 Cohen, 2001.

28 Doumani, 1995.

29 Establet et Pascual, 1998, pp. 112–116.

30 Compare the articles in Todorov, 1977, as well as the monograph published in French: Todorov, 1980.

31 Todorov, 1967–1968.
32 Fekete, 1976.
33 Dávid and Fodor, 2002, p. 330.
34 Inalcik, 1960; Sahillioğlu, 1985.
35 Gerber, 1988, pp. 27, 63, see also Faroqhi, 1995b.
36 Uzunçarşılı, 1943–1944; *ibid.*, 1945; *ibid.*, 1948: *ibid.*, 1965.
37 Akarlı, 1985–1986.
38 On the complicated appointment process of a guild warden, compare Inalcik, 1986; Faroqhi, 2002 contains information on the disputes between *kethüda* and guildsmen arising in such a situation.
39 Raymond, 1973–1974, v. 2, pp. 458–459, concludes that throughout the seventeenth and eighteenth centuries, the Copts of Cairo do not seem to have possessed guilds of their own.
40 Yıldırım, 2002.
41 Lis, Lucassen and Soly, 1995.
42 Lis and Soly, 1994.
43 For a recent comparative perspective on European guild studies, compare Epstein and Nuñez, *et al.*, ed., 1998.
44 Compare the contribution of Salih Aynural in the present volume.
45 Baer, 1970. For a study on the actual functioning of artisans in a military context, see Veinstein, 1988.
46 Braudel, 1966, *passim.*
47 Procházka-Eisl, 1995. For a study of the illustrated version in the Topkapı Palace library, see Atasoy, 1997 and also Hammer-Purgstall, 1834.
48 Evliya's list has recently been republished: compare Evliya Çelebi; ed. Gökyay, 1996, pp. 220–317. For comments, compare Mantran, 1962, pp. 349–424, who, however, had to work with the truncated edition available at the time. For the guild list of 1720, see Atıl, 1999.
49 Ginzburg, 1983.
50 While the kadi registers of Üsküdar do go back to the 1520s, the work of Yvonne Seng makes it obvious that at that time, this settlement was very small and not an appropriate venue for guild activity: see Seng, 1994 and 1996.
51 Akarlı, 1985–1986.
52 On the privileged position of high-level judges cum scholars in the eighteenth century, compare Zilfi, 1988.
53 Papasynadinos, ed. by Odorico *et al.*, 1996.
54 For a discussion of surviving samples, see Tezcan, 1992.
55 Kal'a *et al.*, 1997–present.
56 Güçer, 1950–1951 and 1964; Mantran, 1962, pp. 185–193. For a much fuller discussion, compare Aynural, 2001.

57 Porgers are responsible for removing certain fats and sinews which cannot be consumed by practising Jews from the meat before it is offered for sale. They need to be familiar with the relevant aspects of Jewish law.

58 This is all the more remarkable as, in middle-class Turkish homes, aluminium and often enamelled iron pots have replaced copperware.

59 Doğanalp-Votzi's fieldwork dates from 1982 and thus her observations are themselves on the way towards becoming historical. For her book on tanners and tanning, see Doğanalp-Votzi, 1997.

60 For the use of dendro-chronological studies for the social and economic history of Anatolia, see Kuniholm, 1990.

61 For an opinion that certain late Ottoman structures survived in Turkey down to the 1950s, compare Keyder, 1987.

62 Quataert, 1993, *passim.*

63 In this respect, Egyptian artisans seem to have succeeded better than their colleagues in late eighteenth century Tokat, who also fled to rural sites in order to avoid the taxman: Duman, 1998.

64 Quataert, 1993, pp. 98, 176.

Bibliography

Akarlı, Engin, 'Gedik: Implements, Mastership, Shop Usufruct and Monopoly among Istanbul Artisans, 1750–1850', *Wissenschaftskolleg-Jahrbuch,* 1985–1986, pp. 223–232.

Akgündüz, Ahmet *et al.*, ed., *Şeriye Sicilleri,* 2 v., Istanbul, Türk Dünyası Araştırmaları Vakfı, 1988–1989.

Altınay, Ahmed Refik, *Onuncu Asr-ı hicrîde Istanbul Hayatı (1495–1591),* Istanbul, Enderun Kitabevi, reprint, 1988.

Atasoy, Nurhan, 1582, *Surname-i Hümayun, An Imperial Celebration,* Istanbul, Koçbank, 1997.

Atıl, Esin, *Levni and the Surname, The Story of an Eighteenth-Century Ottoman Festival,* Istanbul, Koçbank, 1999.

Aynural, Salih, *İstanbul Değirmenleri ve Fırınları, Zahire Ticareti (1740–1840),* Istanbul, Tarih Vakfı Yurt Yayınları, 2001.

Baer, Gabriel, 'The Administrative, Economic and Social Functions of Turkish Guilds', *International Journal of Middle East Studies* 1, 1970, pp. 28–50.

Barkan, Ömer Lütfi, 'Bazı Büyük Şehirlerde Eşya ve Yiyecek Fiyatlarının Tesbit ve Teftişi Hususlarını Tanzim Eden Kanunlar', *Tarih Vesikaları* I, 5, 1942, pp. 326–340; II, 7, 1942, pp. 15–40; II, 9, 1942, pp. 168–177.

Barkan, Ömer Lütfi, 'Şehirlerin Teşekkül ve İnkişafı Tarihi Bakımından: Osmanlı İmparatorluğunda İmaret Sitelerinin Kuruluş ve İşleyiş Tarzına ait Araştırmalar', *İstanbul Üniversitesi İktisat Fakültesi Mecmuası*, 23, 1–2, 1963, pp. 239–296.

Barkan, Ömer Lütfi, *Süleymaniye Cami ve İmareti İnşaatı*, 2 v., Ankara, Türk Tarih Kurumu, 1972, 1979.

Berktay, Halil, 'Der Aufstieg und die gegenwärtige Krise der nationalistischen Geschichtsschreibung in der Türkei', *Periplus* 1, 1991, pp. 102–125.

Bostan, İdris, *Osmanlı Bahriye Teşkilâtı: XVII. Yüzyılda Tersane-i amire*, Ankara, Türk Tarih Kurumu, 1992.

Braudel, Fernand, *La Méditerranée et le monde méditerranéen à l'époque de Philippe II*, 2nd ed., 2 v., Paris, Armand Colin, 1966.

Çizakça, Murat, *A Comparative Evolution of Business Partnerships, The Islamic World and Europe, with Specific Reference to the Ottoman Archives*, Leiden/New York, E. J. Brill, 1996.

Cohen, Amnon, *Economic Life in Ottoman Jerusalem*, Cambridge, Cambridge University Press, 1989.

Cohen, Amnon, *The Guilds of Ottoman Jerusalem*, Leiden, E.J. Brill, 2001.

Dalsar, Fahri, *Türk Sanayi ve Ticaret Tarihinde Bursa'da İpekçilik*, Istanbul, İstanbul Üniversitesi İktisat Fakültesi, 1960.

Dávid, Géza and Pál Fodor, 'Hungarian Studies in Ottoman History', in Fikret Adanır and Suraiya Faroqhi, ed., *The Ottomans and the Balkans, A Discussion of Historiography*, Leiden, E. J. Brill, 2002, pp. 305–350.

Doğanalp-Votzi, Heidemarie, *Der Gerber, der Kulturbringer: Politik, Ökonomie, Politik, Zivilisation im osmanischen Vorderasien*, Frankfurt/Main, Peter Lang, 1997.

Doumani, Beshara, *Rediscovering Palestine, Merchants and Peasants in Jabal Nablus, 1700–1900*, Berkeley/Los Angeles/London, University of California Press, 1995.

Duman, Yüksel, 'Local Notables, Textile and Copper Manufacturing in Tokat', 1750–1840, PhD dissertation, State University at New York (SUNY), Binghamton, 1998.

Epstein, Stephen, Clara Eugenia Nuñez *et al.*, ed., *Guilds, Economy and Society, Proceedings of the Twelfth International Economic History Congress*, B1, Seville, Fundación Fomento de la Historia Económica, 1998.

Ergenç, Özer, '1600–1615 Yılları Arasında Ankara İktisadi Tarihine Ait Araştırmalar', in Osman Okyar and Ünal Nalbantoğlu, ed., *Türkiye İktisat Tarihi Semineri, Metinler-Tartışmalar, 8–10 Haziran 1973*, Ankara, Hacettepe University, 1975.

Ergin, Osman Nuri, *Mecelle-i Umûr-ı Belediyye*, Istanbul, İstanbul Büyükşehir Belediyesi, reprint 1995.

Ersanlı, Büşra, 'The Ottoman Empire in the Historiography of the Kemalist Era: A Theory of Fatal Decline', in Fikret Adanır and Suraiya Faroqhi, ed., *The Ottomans and the Balkans, A Discussion of Historiography*, Leiden, E. J. Brill, 2002, pp. 115–154.

Establet, Colette and Jean-Paul Pascual, *Ultime Voyage pour la Mecque. Les inventaires après décès de pèlerins morts à Damas vers 1700*, Damascus, French Institute of Arab Studies in Damascus (IFEAD), 1998.

Evliya Çelebi, *Seyahatnamesi*, 10 v., Istanbul, Ankara, İkdam and others, 1314/1896/1897–1938.

Evliya Çelebi b. Derviş Mehemmed Zilli, *Evliya Çelebi Seyahatnâmesi, Topkapı Sarayı Bagdat 304 Yazmasının Transkripsyonu–Dizini*, v. 1, Orhan Şaik Gökyay and Yücel Dağlı, ed., Istanbul, Yapı Kredi Yayınları, 1996.

Faroqhi, Suraiya, 'Merchant Networks and Ottoman Craft Production (16–17th Centuries)', *The Proceedings of International Conference on Urbanism in Islam (ICUIT)*, 3 v., Tokyo, 1989, v. 1, 1989, pp. 85–132, reprinted in Suraiya Faroqhi, ed., *Making a Living in the Ottoman Lands, 1480–1820*, Istanbul, Isis Publications, 1995a, pp. 169–192.

Faroqhi, Suraiya, 'Bursa at the Crossroads: Iranian Silk, European Competition and the Local Economy 1470–1700', in Suraiya Faroqhi, ed., *Making a Living in the Ottoman Lands, 1480–1820*, Istanbul, Isis Publications, 1995b, pp. 113–148.

Faroqhi, Suraiya, *Approaching Ottoman History: An Introduction to the Sources*, Cambridge, Cambridge University Press, 1999.

Faroqhi, Suraiya, 'Between Collective Workshops and Private Homes: Places of Work in Eighteenth-century Bursa', in Suraiya Faroqhi, ed., *Stories of Ottoman Men and Women: Establishing Status, Establishing Control*, Istanbul, Eren, 2002, pp. 235–244.

Fekete, Lajos, *Buda and Pest under Turkish Rule*, Budapest, n.publ., 1976.

Gedikli, Fehmi, *Osmanlı Şirket Kültürü*, Istanbul, İz Yayıncılık, 2000.

Gerber, Haim, *Economy and Society in an Ottoman City: Bursa, 1600–1700*, Jerusalem, The Hebrew University, 1988.

Ginzburg, Carlo, *The Night Battles, Witchcraft and Agrarian Cults in the 16th and 17th Centuries*, Baltimore (Maryland), Johns Hopkins University, 1983.

Gölpınarlı, Abdülbaki, 'İslâm ve Türk İllerinde Fütüvvet Teşkilâtı ve Kaynakları', *İstanbul Üniversitesi İktisat Fakültesi Mecmuası* 11, 1–4, 1949–1950, pp. 3–354.

Güçer, Lütfi, 'Osmanlı İmparatorluğu dahilinde Hububat Ticaretinin Tabi Olduğu Kayıtlar', *İstanbul Üniversitesi İktisat Fakültesi Mecmuası* 13, 1–4, 1951–1952, pp. 79–98.

Güçer, Lütfi, *XVI–XVII. Asırlarda Osmanlı İmparatorluğunda Hububat Meselesi ve Hububattan Alınan Vergiler*, Istanbul, İstanbul. Üniversitesi İktisat Fakültesi, 1964.

Hammer, Joseph von, *Geschichte des Osmanischen Reiches, größtenteils aus bisher unbenützten Handschriften und Archiven*, 4 v., Pesth, C.A. Hartleben, 1834.

Inalcik, Halil, 'Bursa and the Commerce of the Levant', *Journal of the Economic and Social History of the Orient* 3, 1960, pp. 131–147.

Inalcık, Halil, 'The Appointment Procedure of a Guild Warden (Kethudâ)', *Festschrift für Andreas Tietze, Wiener Zeitschrift für die Kunde des Morgenlandes* 76, 1986, pp. 135–142.

Kafadar, Cemal, 'Self and Others: The Diary of a Dervish in Seventeenth-Century Istanbul and First-Person Narratives in Ottoman Literature', *Studia Islamica* LXIX, 1989, pp. 121–150.

Kal'a, Ahmet *et al.*, ed., *İstanbul Külliyatı I, İstanbul Ahkâm Defterleri*, Istanbul, İstanbul Büyükşehir Belediyesi, 1997–present.

Keyder, Çağlar, *State and Class in Turkey, a Study in Capitalist Development*, London, New York, Verso, 1987.

Kuniholm, Peter I, 'Archaeological Evidence and Non-Evidence for Climatic Change', *Philosophical Transactions of the Royal Society* A330, 1990, pp. 645–655.

Lapidus, Ira, *Muslim Cities in the Later Middle Ages*, Cambridge, Cambridge University Press, 1984.

Lis, Catharina and Hugo Soly, ed., *Werken volgens de regels, Ambachten in Brabant en Vlaanderen*, Brussels, VUB Press, 1994.

Lis, Catharina, Jan Lucassen and Hugo Soly, ed., *Before the Unions, Wage Earners and Collective Action in Europe 1300–1850*, Cambridge, Cambridge University Press, 1995.

Mantran, Robert, *Istanbul dans la seconde moitié du dix-septième siècle. Essai d'histoire institutionelle, économique et sociale*, Istanbul, French Institute for Anatolian Studies (IFEA), 1962.

Mélikoff, Irène, 'Le rituel du helva', *Der Islam* 39, 1964, pp. 180–191.

Odorico, Paolo with S. Asdrachas, T. Karanastassis, K. Kostis and S. Petmézas, *Conseils et mémoires de Synadinos prêtre de Serrès en Macédoine* (XVIIe siècle), Paris, Association 'Pierre Belon', 1996.

Procházka-Eisl, Gisela, *Das Surname-i hümayun, die Wiener Handschrift in Transkription, mit Kommentar und Indices versehen*, Istanbul, Isis, 1995.

Quataert, Donald, *Social Disintegration and Popular Resistance in the Ottoman Empire, 1881–1908*, New York, New York University Press, 1983.

Quataert, Donald, *Ottoman Manufacturing in the Age of the Industrial Revolution*, Cambridge, Cambridge University Press, 1993.

Raymond, André, *Artisans et commerçants au Caire au XVIIIe siècle*, 2 v, Damascus, French Institute of Damascus, 1973–1974.

Sahillioğlu, Halil, 'Slaves in the Social and Economic Life of Bursa in the late 15th and early 16th Centuries', *Turcica* XVII, 1985, pp. 43–112.

Seng, Yvonne, 'Standing at the Gates of Justice: Women in the Law Courts of early Sixteenth-century Üsküdar, Istanbul', in Susan Hirsch and Mindy Lazarus-Black, ed., *Contested States: Law, Hegemony and Resistance*, New York, Routledge, 1994, pp. 184–206.

Seng, Yvonne, 'Fugitives and Factotums: Slaves in Early Sixteenth-Century Istanbul', *Journal of the Economic and Social History of the Orient* 39, 2, 1996, pp. 139–169.

Taeschner, Franz, *Zünfte und Bruderschaften im Islam, Studien zur Geschichte der Futuwwa*, Munich/Zurich, Artemis Winkler, 1979.

Tezcan, Hülya, 'Topkapı Sarayında Velense ve benzeri Dokumalar', *Topkapı Sarayı Yıllığı* 5, 1992, pp. 223–240.

Todorov, Nikolai, '19.cu Yüzyılın İlk Yarısında Bulgaristan Esnaf Teşkilatında Bazı Karakter Değişmeleri', *İstanbul Üniversitesi İktisat Fakültesi Mecmuası* 27, 1–2, 1967–1968, pp. 1–36.

Todorov, Nikolai, *La ville balkanique sous les Ottomans*, London, Variorum, 1977.

Todorov, Nikolai, *La ville balkanique aux XVe–XIXe siècles. Développement socio-économique et démographique*, Bucharest, AIESEE, 1980.

Ülgener, Sabri, *İktisadi Çözülmenin Ahlak ve Zihniyet Dünyası*, Istanbul, DER Yayınları, 1981a.

Ülgener, Sabri, *Dünü ve Bugünü ile Zihniyet ve Din, İslâm, Tasavvuf ve Çözülme Devrinin İktisat Ahlâkı*, Istanbul, DER Yayınları, 1981b.

Uzunçarşılı, İsmail Hakkı, *Osmanlı Devleti Teşkilâtından Kapukulu Ocakları*, 2 v., Ankara, Türk Tarih Kurumu, 1943, 1944.

Uzunçarşılı, İsmail Hakkı, *Osmanlı Devletinin Saray Teşkilâtı*, Ankara, Türk Tarih Kurumu, 1945.

Uzunçarşılı, İsmail Hakkı, *Osmanlı Devletinin Merkez ve Bahriye Teşkilâtı*, Ankara, Türk Tarih Kurumu, 1948.

Uzunçarşılı, İsmail Hakkı, *Osmanlı Devletinin İlmiye Teşkilâtı*, Ankara, Türk Tarih Kurumu, 1965.

Veinstein, Gilles, 'Du marché urbain au marché du camp : l'institution ottomane des *orducu*', in Abdeljelil Temimi, ed., *Mélanges Professeur Robert Mantran*, Zaghouan, Centre d'Etudes et Recherches Ottomanes, Morisques, de Documentation et d'Information (CEROMDI), 1988, pp. 299–327.

Vovelle, Michel, *Idéologies et mentalités*, Paris, François Maspéro, 1982.

Wallerstein, Immanuel, Hale Decdeli and Reşat Kasaba, 'The Incorporation of the Ottoman Empire into the World Economy',

in Huri Islamoglu-Inan, ed., *The Ottoman Empire and the World Economy*, Cambridge/Paris, Cambridge University Press and Maison des Sciences de l'Homme, 1987, pp. 88–100.

Yıldırım, Onur, 'Ottoman Guilds as a Setting for Ethno-Religious Conflict: The Case of the Silk-Thread Spinners' Guild in Istanbul', *International Review of Social History* 47, part 3, December 2002, pp. 407–419.

Zilfi, Madeline, *The Politics of Piety: The Ottoman Ulema in the Post-classical Age (1600–1800)*, Minneapolis, Bibliotheca Islamica, 1988.

CHAPTER 2

Guild Parades in Ottoman Literature: The *Sûrnâme* of 1582

Gisela Procházka-Eisl

In Ottoman cities, public procession-like parades of artisans were regularly held on various occasions.[1] Such an occasion could be the departure of the army for a military campaign, the reception of a foreign ambassador, a victory celebration or a public court festivity (*şenlik*), such as the circumcision of a prince or the wedding of a princess. Besides their aspect as a time for amusement and change in the daily life of the masses, these parades were a good opportunity for the government to obtain a general view of its economic reserves[2] and also to demonstrate economic power and wealth to representatives of foreign, mostly European, states.[3]

It is not known how often and how regularly the artisans met for such processions; about forty-eight sultan's festivities are known in the course of Ottoman history[4] and one may suppose that the guilds were more or less involved. Up to the eighteenth century, they enjoyed especially great popularity in the *şenlik* programmes, later, from the Tulip Age onwards, the focal point was on other kinds of amusement. In addition to the forty-eight festivals mentioned, one must assume that there were an uncertain number of processions on various other occasions. There are some indications that guilds even met regularly once a year for parades.[5]

This chapter intends to show how guild parades are presented in literary sources. It will treat in particular the guild parade of 1582 at the hippodrome (Atmeydanı) in Istanbul on the occasion

of the longest and most splendid circumcision festivity in Ottoman history, organised by Murad III for his son Mehmed, which lasted for fifty-two days.

From the middle of the sixteenth century onwards, literary accounts of wedding or circumcision festivities broke away from the chronicles, forming the literary genre of the *sûrnâme* – the festival book. The way in which these *sûrnâmes* inform us about the subject depends completely on their authors. Rhymed and prose *sûrnâmes* are found as well as concise lists of presents and guests, in addition to detailed flowery praises of the sultan, the guests and the participants in the ceremonies. Astonishingly enough, the guild processions are generally mentioned only incidentally, although they used to take up most of the time of the festival programme. 'Abdî's *sûrnâme*, for example, which describes the circumcision festivity in Edirne in 1675, deals mainly with amusing artistic acts. The artisans are not important at all to 'Abdî and they are mentioned with just a few words, e.g. 'after the craftsmen parade had finished...'.[6] Likewise, in the numerous accounts by European spectators, one scarcely finds more details concerning the guilds.[7]

But in the case of the 1582 *şenlik*, the situation is different: there are two very detailed accounts of the guilds' parade, one written by an Ottoman author, one by a European spectator.

The main source is the *Sûrnâme-i Hümâyûn*, written by an author of Bosnian origin with the pen-name of İntizâmî.[8] The account is written in Ottoman-Turkish *süslü nesir* in the form of a strictly chronological diary-like description of the whole festivity, focusing on artisans. There are various manuscripts of this *sûrnâme*, the most famous being the one in Topkapı Sarayı (hereafter TS). This TS manuscript, which, unfortunately, is not complete, is famous for being wonderfully illustrated with more than 400 miniatures, which, together with the text, are a very valuable source. There are manuscripts in Leiden, in the Süleymaniye Library in Istanbul and also in Vienna (hereafter VI). The VI manuscript is the source upon which this chapter mainly relies.[9] Over the course of 140 pages, this text presents the festivity programme with its many events, written down neatly and tidily, structured by headings for each new day and for the arrival of each group of artisans. The artisans are the

absolute centre of this work; in no other *sûrnâme* to date are they described in such great detail.

When reading a literary account like this, which is not intended to be a dry chronicle but rather a pleasure to read, some questions arise:
– How does the author present the artisans?
– Are there differences in his language and style when treating different guilds?
– Is the account complete or are there groups of artisans which are left out and, if so, why?
– Does the author take sides or is he neutral?
– Which kind of information does one get?

İntizâmî is not the only author who described the circumcision festivity of 1582 and one is able to draw a relatively complete picture of this event with the help of some other sources. Therefore, the *Particularverzeichnuß* by Nicolaus Haunolth and the *Khitânnâme* of Mustafâ 'Âlî will also be referred to.

Concerning the chronological order of the festival programme, one can say that the sources are more or less in agreement, especially Haunolth and the Vienna manuscript, which show that the authors were good observers and took notes with great zeal. If one tries to find the principle for a systematic order for this guild procession, there are only a few indicators: in the first two weeks of the festival, there is a certain accumulation of guilds which produce clothes, hats and shoes and others which present extravagant items.[10] The reason for this may be that Murad III was renowned for his predilection for beautiful, luxurious clothes and furs. From the third week of the festival, there is a certain emphasis on guilds of the building trade. Near the end of the procession, one can see guilds which are traditionally despised in many cultures, such as blacksmiths, tanners and butchers, but they are mentioned along with the *mü'ezzins* and *imâms*.

This leads one to the question of whether there may have been general order criteria common to every guild procession. For this reason, three famous parades are examined, with the conclusion that it is not possible to detect more than a few vague tendencies and there is certainly not any sign of a common structural order.[11] Not even the expectation that highly esteemed guilds were followed by less respected ones could be confirmed.

Common to all the parades was only the position of the wine-shop keepers at the end or almost at the end.[12]

For the 1582 *şenlik*, it is not possible to find out how many groups really did take part since varying total numbers are found in the various sources:

Source	Number
Vienna *sûrnâme*	177
Topkapı *sûrnâme*	163
Nicolaus Haunolth	172
Mustafâ 'Âlî	46

The VI manuscript presents 177 groups which is the highest number of all. The TS manuscript mentions only 163 guilds, 148 of which are to be found in both manuscripts. Haunolth, who notes 172 groups, describes 30 which are neither mentioned in the VI nor in the TS *sûrnâmes*. Mustafâ 'Âlî, who does not focus on the artisans, reports 46 artisan guilds.

Adding up these numbers, one reaches an approximate total[13] of 225 different groups which presented themselves at the Atmeydanı; the Vienna manuscript is the source closest to this number. It is interesting that, in each of these sources, there are groups which are mentioned only in that particular source. Even in Mustafâ 'Âlî's small number of guilds, one finds three groups mentioned only by him: the artists (*naqqâş*), the carpet-sellers (*qalîçe-fürûş*) and the slave-traders (*esîr-fürûş*). This means that for one reason or another, the eye-witnesses must have excluded certain guilds.

Haunolth, being a Christian, does not list the different religious guilds such as the *imâms*, *khatîbs* or *qâdîs* nor guilds which did not produce goods to be presented, for example, the public criers (*dellâl*) and the market controllers (*mühtesîb*). This is understandable from his point of view – he simply may not have understood the professions of these groups.

When taking a look at the guilds not mentioned in the Vienna manuscript, one notes that there is a clear tendency towards ignoring guilds that do not command much respect. Groups exclusively consisting of non-Muslims also tend to be left out.[14] Therefore, one does not find wine-sellers, blind beggars, stable boys, buffalo herders, chimney sweepers, Arab street-lamp lighters and gypsy blacksmiths. Although blacksmiths sent

two delegations on two different days, they are not mentioned, nor does one find Greek fishermen, Jewish gunpowder makers, Jewish mirror makers and Greek fruit-sellers.

Furthermore, the copyist of the VI *sûrnâme* does not seem to have found it worthwhile to mention groups which produced small miscellaneous items and were, therefore, possibly not able to present themselves in a spectacular manner. So, for example, he ignored (in contradistinction to the copyist of the TS *sûrnâme*) ironers (*ütücü*), saw-makers (*dest-erre-kârân*), nailsmiths (*çelengîrân*), brush-makers (*kefe-kârân*), net-makers (*şerekciyân*) and box-makers (*qutu-kârân*). Nevertheless, as mentioned above, it is the Vienna *sûrnâme* which has the widest range of guilds.

The descriptions of the arrivals of artisan groups are rather stereotyped. First of all, there is a Persian title in the simplest form, e.g. *âmeden-i cemâ'at-i delv-fürûşân* (the arrival of the group of the bucket-sellers: VI f.53r); the profession mostly gets an attribute according to the *sec'*, for example: *nîze-kârân-i istiqâmet-'unvân* (javelin-makers, entitled with straightness: VI f.37v), *câme-şûyân-i pâk-bünyân* (cloth-washers on a clean basis: VI f.53r), *cündîyân-i çâpik-süvârân* (*cündis* swiftly riding: VI f.65r). Nearly always, the Persian title is translated into Turkish, e.g. Persian: *âmeden-i cemâ'at-i delv-fürûşân be-seyr-i sûr-i hümâyûn* and, then, continuing in very simple Turkish: *andan soñra qova isler üstâdlar geldiler*: VI f.53 r.

İntizâmî mostly uses the word *cemâ'at* (134x) to signify the word guild. He sometimes uses *üstâdân*, *zümre* or *fırqa*; in one case, he uses *tâ'ife* and, in a few instances, only the profession without a group specification (e.g. *âmeden-i bostâniyân*). The author chooses these terms without distinction, regardless of whether the concerned groups were really organised in guilds or not.

After such a heading, the proper description of the guild begins, varying in detail and intensity. When one takes a look at the narrative density – this is the relation between real information and the amount of text used for it – one notices that it varies extremely. There are groups which are only accorded one line, such as the bucket-sellers mentioned above. With other groups, one finds step-by-step descriptions of working procedures in clear and short words, thus obtaining important information in a few lines. On the other hand, there are guilds

for which the author or copyist allows a space of more than a page but, in spite of this, one learns almost nothing about them. They seem only to fulfil the aim of providing an appropriate setting for flowery descriptions of beautiful boys or expensive, soft, sparkling materials.[15]

Although the TS manuscript is much longer than the VI manuscript (432pp. versus 140pp.), it does not really present more information; this can be explained by the excessive use of poems in the text (ca. 450:100) and an exaggerated love of metaphoric language. The following chart shows the differences in length of the description of guilds – one must be aware that the information is not necessarily proportional to the length!

There are 64 guilds whose description takes only one or two lines and about which one knows nothing except for the fact that they took part in the parade. These are mostly guilds which did not bring a carriage with workshops on it and which did not offer noteworthy presents to the sultan. For example, the members of the *ulama,* who naturally did not display workshops but only prayed in the Atmeydanı, are described in a few lines. The same is true for many groups dealing with agriculture (such as shepherds, hay-sellers and cattle-traders), guilds that repair things (clothes or shoes), tradesmen who sell goods for daily use (nuts, pickles, needles, brooms, towels) and guilds of the

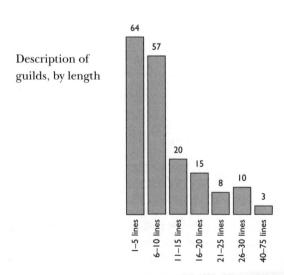

Description of guilds, by length

building trade (brick-makers or lime-kilners). The following is an example of such a very short form of description:

> The coming of the tailors living in Galata: Then the tailors from Galata came again. They said a prayer for the *pâdişâh* and left.[16]

An example of descriptions that are a little more detailed:

> The coming of the group of the *imâms*, entitled with salvation: Then the *imâms* came; in their hands, they had the *tesbîh*, on their lips the name of God, (on their shoulders) the *ridâ* and the *taylesân*.[17]

Guilds which are described with great relish for detail encompass mostly tradesmen. This is especially true of weavers, in particular, cloth-traders from the *bedestân-i cedîd*, fruit-sellers, furriers, caftan tailors, *taqîye*-makers and coffeehouse keepers.

But it would be wrong to conclude that a short description means a low reputation and a long one, a highly honoured guild. Our author, İntizâmî, clearly was an epicure who became inspired to write rhetoric cascades when observing shining, brightly coloured clothes and jewels, spectacular performances and, especially, beautiful boys. For example, he writes one and a half pages about the *helvâ*-makers, not because of their fascinating profession but because of the fact that they tried to blow up a living rabbit with fireworks: VI f.21r.

The more or less detailed descriptions, together with the miniatures, allow us to reconstruct the standard type of a presentation: normally, two or four men pulled a high, narrow carriage to the square with the help of a kind of yoke[18] which was meant to symbolise a shop or workshop; horses or oxen were used only with very heavy constructions.[19] These carriages were decorated with typical goods that the guild produced or sold; craftsmen often sat on the carriage and worked, showing the different steps involved in producing their goods.[20] It was also a common practice to present to the padishah an outsized product as, for example, giant shoes, paper tulips as tall as a tree or cakes which had to be carried by four men.[21] Some groups tried to show extraordinary skill or speed, for instance, the craftsman who sewed 120 pairs of shoes in a very short time or the barber who shaved his customers standing on his head.[22] Guilds which did not bring a carriage often had a kind of stretcher where they arranged their products, while other guilds hung them on poles. Poorer, smaller groups walked along, carrying their goods in their

hands. According to the occasion, clothes were splendid, often uniform-like, and sometimes made of the raw material typical of the guild. Therefore, mirror-makers wore clothes made out of small mirror pieces, paper-makers of course wore paper clothes, furriers – although it was August – came dressed in furs.[23]

They lined up front of the sultan's seat, said prayers and congratulations and delivered their presents, which were normally especially beautiful or typical examples of their skill. In return, the sultan threw coins among the apprentices. Some guilds used this audience as an opportunity to depose petitions with the sultan.

But let us come back to the *sûrnâme* and the description of all these things. Frequently, one gains the impression that guilds which are suitable from the point of view of vocabulary and possible word play attract more attention than the others. When one takes a look at the metaphors and similes, one recognises the typical metaphors of the popular descriptions of craftsmen which are also found in *dîvân* poetry[24] – we know that İntizâmî was familiar with this genre since he mentions in the TS manuscript that he has written a *şehrengîz*.[25]

Of course, there are groups whose profession is not very suitable for a play on words or only for a very banal one – such as the broom-makers who 'sweep along' or lime-kilners who 'have white faces' (with the double meaning of *ak yüzlü*). These are standard plays on words and one frequently finds them in relation to these professions.[26]

Below are found a few short examples to give an impression of the language of the text:

The straw mat weavers greet the sultan with the sweet sounding *ney* (meaning 'straw' and 'flute') and when leaving the square, they rub their faces on the ground looking like straw in the wind: VI f. 34r.

The water-carriers line up in front of the sultan like beautiful glasses from Dimetoka, rub their faces in the dust like water, flow aside and seep away: VI f. 46r.

The apprentices of the spice-dealers look like nutmeg, are refined with ginger, their birthmarks are saffron-coloured and are sprinkled about their faces like peppercorn: VI f. 68v.

Of course, guilds such as fruit- or flower-sellers are also ideal for word play as, especially in this case, *dîvân* poetry provides a

great wealth of vocabulary and metaphors. Word play seems to be the main motivation of our author when dwelling on a guild; good performances especially stimulate him, as in the case of the fishermen's arrival:

> Then, the seamen of the sea of skill and the masters of the ocean of merriment, that is, the fishermen, dressed in clothes according to their group, pushed a ship along on the dry in front of the *pâdişâh*. They stood upright, raising their heads like sail-masts; their arms were stretched out like sails, then, they fell to the ground, heavy like anchors and presented their presents.[27]

Be it a long or short description, flowery or concise, İntizâmî always tries to stay polite and impartial; he never expresses disgust or contempt, not even indirectly – this is no simple matter, of course! Concerning Faqîrî, an author of the sixteenth century who wrote poems about various professional groups, E. Ambros has found out that, in his case, there was a direct connection between language level and the image of the guild. One finds absolutely nothing like this in İntizâmî's *sûrnâme.*[28]

İntizâmî does not even mention less than delightful scenes. When he finds a guild worth noting, he describes it politely by observing the proprieties. İntizâmî crosses off his list guilds with which he is not fascinated, using stereotyped remarks such as the one- or two-lined minimal variants cited above. From Nicolaus Haunolth, one knows that not all the presentations were a feast for the eyes. He openly comments that some groups were paltry, even shabby looking, that a group presented low-quality gifts which were not accepted by the court, or that some guilds were even chased away ignominiously.[29]

İntizâmî remarks only in a very few cases that a presentation was not perfect, but he never descends into vulgarity or obscenity as occasionally happens in the *şehrengîz* literature. He even sometimes tries to find mild words and understanding for poor guilds. For example, the junk-dealers are criticised indirectly: they are almost hidden by İntizâmî giving them the attribute, in the title, of being *qanâ'at-'unvân*: 'entitled with modesty'.[30] As for the riddle (sieve) makers (*ghırbâl-kârân*) who must really have been very shabby and dressed in ragged clothes, the two poor men who tried hard to push an old carriage to the square are criticised only by minor suggestions that they may not have been very successful in presenting themselves:

Then the riddle makers hanged their riddles, which looked like heavenly spheres, inside and outside their craft-shop and, in this way, showed the riddle-holes which were as many as there are stars in the sky. They decorated their group according to their possibilities and so their assembly had an opportunity to gather fame. Modestly and with some small imperfections, they came to the port of happiness, prayed and praised and went away.[31]

The occasional critical remarks in the text do not sound as if İntizâmî meant them seriously, but they are, rather, amusing quips or simply plays on words designed to rhyme. When the snake-charmers (*yılancı*) are called liars (*yalancı*) it is not meant as an insult: it has to be like this because the reader expects it. It is a sort of stylistic obligation which is as normal as, for example, the epithet *ak yüzlü* for the lime-kilnworkers. The only group which really comes off badly are the public criers (*dellâl*); it is a well-known fact that the *dellâl* were a most unpopular group who did not even have the right to participate in *fütüvvet*. İntizâmî calls them greedy for money, blindly seeking profit, auctioning off even their personal property before their death and not opening their mouths without demanding payment (VI f.42 v).

Conclusion

Summing up, one must again reflect upon the kind of knowledge that this chapter provides concerning Ottoman guilds. One has to take into consideration the fact that the *sûrnâme* was exclusively written for edification and not as a chronicle. In this case, to the Ottoman reader, it could have seemed rather like a miniature painted in words – one has to 'watch' the text with relish, observing the guilds coming and going in all their beauty and carefully register details mentioned in passing. Consequently, the kind of information that can be filtered out is not to be compared with facts provided by archival documents or by price and product lists. There are, of course, some detailed step-by-step descriptions of the production of goods. These yield the appropriate vocabulary, i.e. *termini technici* for working tools and different kinds of materials such as cloth, leather, food, spices, etc. But the importance of the *sûrnâme* is to be found more in its function

as a document showing fashions and tastes in popular entertainment at the end of the sixteenth century.

Abbreviations

TS Topkapı Sarayı
VI Vienna
SÜL Süleymaniye

Notes

1 Such craftsmen's parades were also organised in Europe (Hammer-Purgstall, 1967, p. 393) and Iran (Floor, 1984, p. 114).

2 For this reason, guild processions were often held at the beginning of military campaigns: Hammer-Purgstall, 1967, p. 393.

3 Taeschner, 1979, p. 418.

4 Nutku, 1972, preface (no pagination).

5 Lewis, 1957, p. 32

6 Göksel, 1983, p. 74: '*esnaf alay gösterdikten soñra...*', '*esnaf alay nümayan eylediklerinden ghayrı*....'.

7 Faroqhi, 1995, p. 191.

8 Until recently, its author was considered to be unknown but, thanks to his own hints in the *sûrnâme*, a few things about him are known: his above-mentioned pen-name, İntizâmî, his approximate year of birth which is 1540 and his immigration from Foça/Bosnia to Istanbul, where he worked as a *dîvân kâtibi*: cf. *sûrnâme* VI, f. 2r, 2v, 70v and TS p. 429: Procházka-Eisl, 1995, pp. 31f.

9 The Süleymaniye and the VI manuscripts are almost identical; the latter was published in 1995: cf. Procházka-Eisl, 1995.

10 As, for example, the shoemaker who brought a giant shoe with a little boy sitting in it.

11 These are the two splendid circumcision festivals of 1582 and 1675 (in Edirne) and the parade of 1638, documented in Evliya Çelebi's famous account: cf. Hammer-Purgstall, 1967, v. II., pp. 399–522.

12 For details: Procházka-Eisl, 1995, pp. 37ff.

13 The number can only be an approximate one because it is not possible to reconstruct all the guilds in Haunolth's translation (1959). Descriptions such as 'die da so Brötel machen' could refer to any guild baking any kind of bread or cake.

14 By contrast, Haunolth describes precisely how many Muslims, Christians, Jews and gypsies came along.

15 The author uses a conception which is very similar to *şehrengîz* literature. In the *şehrengîz*, a city functions as a frame for detailed description of beautiful boys; in the present case, it is the festival that provides this frame. With some guilds, one hardly understands what they produce because evidently it is more important to sing the boys' praise.

16 f. 67v: *ameden-i khayyâtân-i sâkinân-i Ghalata ve yinede Ghalatada işler derziler geldiler anlar dakhı du'â'-i pâdişahî edüb revâne oldılar.*

17 f. 66r (resp. SÜL.133a): *âmeden-i cemâ'at-i imâmân-i salâhiyet-'unvân andan soñra imâmlar geldiler zikr ü tesbîh ellerinde ve dillerinde ve ridâ vu taylesân (omuzlarında ve boyunlarında).*

18 e.g. miniature 65A. Some miniatures also show carriages which are pushed to the square by two or three men: e.g. miniature 49A.

19 For example, the stove of the blacksmiths (miniature 337A) or the Turkish bath at original size (miniature 307A).

20 Therefore, farmers showed all the steps of their work, from sowing the corn to the milled flour (VI f. 51r).

21 VI f. 14r, 17r, 42r, 26r and 33v.

22 VI f. 65v, 48r and 12r-v.

23 Mirror-makers: see, for example, Haunolth, 1959, p. 490; paper-makers cf. VI f. 35r; furriers cf. VI f. 40v.

24 In addition to the *şehrengîz* poems, we find descriptions of artisans' boys in *qıt'as* found in various *divans* from the sixteenth century.

25 Which is unfortunately lost: cf. Boyraz, 1995, p. 231.

26 e.g. the *letâyif* of Zati, ed. Çavuşoğlu.

27 VI f.40r: *ba'dehû mellâhan-i qolzum-i mehâret ve üstâdân-i yemm-i şetâret a'nî sayyâdân-i mâhî muqâbele-i pâdişâhîde semtlerince geyinüb ve 'âdetlerince donanub quruda gemiyi yürütdiler ve dik durub sütûn-i keştî-veş sorudub cenâhân-i keştî-mânend ellerin küşâde ve lenger-vârî aghır düşüb du'â vü senâ tuhfelerin âmâde eylediler...*

28 Ambros, 1998, pp. 27f.

29 Haunolth, 1959, p. 499: 'So sind auch ein 10. Mohren / mit einem schwarzen Fahnen auffgezogen / ohne andere Musica / als daß sie gebettet uñ gesungen / haben dem Sultano auff einem Platt oder Schüssel / Zibeben / Mandeln / Feigen und dergleichen schlechte Sachen verehren / man hats aber nicht annehmen wollen.'

30 VI f.61r: *âmeden-i cemâ'at-i khurde-fürûşân-i qanâ'at-'unvân ba'dehû khurde-fürûşân gelüb.*

31 VI f. 52r: *âmeden-i cemâ'at-i ghirbâl-kârân ba'dehû ghirbâl düzer khurde-karlâr dâyire-i sipihr-âsâ ghirbâlleri kârkhânelerinüñ derûn u bîrûnında*

âvîkhte ve nücûm-kerdâr sûrâkhların amîkhte edüb hâllerine göre cem'îyetlerine zînet ve bu deñlü fürce bulub encümenlerine şöhret verüb eksük gedük haqîrâne der-i devlet-nisâba qarşu du'â vü – sena edüb 'avdet eylediler.

Bibliography

Primary Sources

Vienna
Österreichische Nationalbibliothek:
İntizâmî : *Sûrnâme-i Hümâyûn*, Cod. HO. 70, Flügel 1019.
Istanbul
Topkapı Sarayı:
İntizâmî : *Sûrnâme-i Hümâyûn*, TS H. 1344.
Mustafâ 'Âlî, *Cevâmî'ü l-khubûr der mecâlis-i sûr*, TS HO. 203.

Secondary Sources

Ambros, Edith, 'The Image in the 16th Century of Representatives of Science and Technology: Cameos by the Ottoman Poet Fakîrî', *Essays on Ottoman Civilization, Archív Orientální*, Suppl. VIII, 1998, pp. 17–28.

And, Metin, *Kırk Gün Kırk Gece*, Istanbul, 1959.

Arslan, Mehmet, *Surnameler* (Osmanlı Saray Düğünleri ve Şenlikleri), Ankara, Türk Tarih Kurumu, 1999.

Atasoy, Nurhan, *1582 Surname-i Hümayun. An Imperial Celebration*, Istanbul, Koçbank, 1997.

Aynur, Hatice, 'Sultan II. Mahmud'un Kızı Saliha Sultan ile Tophane Müşiri Rif'at Paşa'nın Düğün Törenini Anlatan Sûrnâmeler', unpublished MA thesis, Istanbul, 1988.

Boyraz, Şeref, 'İlk Mensûr Sûrnâme Müellifi: İntizâmî', *Türklük Bilimi Araştırmaları* 1, 1995, pp. 227–231.

Çağman, Filiz, 'Türkische Miniaturmalerei', in Ekrem Akurgal, ed., *Kunst in der Türkei*, Würzburg, 1980, pp. 229–254.

Çavuşoğlu, Mehmed, 'Zâtî'nin Letâyifi', *İstanbul Üniversitesi Edebiyat Fakültesi Türk Dili ve Edebiyat Dergisi*, cilt XVIII, 1970, pp. 1–51.

Evliya Çelebi b. Derviş Mehemmed Zıllî, *Evliya Çelebi Seyahatnâmesi, Topkapı Sarayı Bağdat 304 Yazmasının Transkripsiyonu-Dizini*, v. 1, ed. Orhan Şaik Gökyay and Yücel Dağlı, Istanbul, Yapı Kredi Yayınları, 1995, pp. 220–319.

Faroqhi, Suraiya, *Kultur und Alltag im Osmanischen Reich, Vom Mittelalter bis zum Anfang des 20. Jahrhunderts*, Munich, C.H. Beck Verlag, 1995.

Floor, Willem, 'Guilds and Futuvvat in Iran', *Zeitschrift der Deutschen Morgenlaendischen Gesellschaft* 134, 1984, pp. 107–114.

Gerlach, Stephan, *Tage-Buch*, Frankfurt, 1674.

Glunz, Michael, 'Şâfîs şahrangîz ein persisches Matnawî über die schönen berufsleute von Istanbul', *Asiatische Studien – Études Asiatiques* XL/2,1986, pp. 133–145.

Göksel, Aslı, 'The Surname of 'Abdî as a Sample of Old Turkish Prose', unpublished MA thesis, Bogaziçi University, Istanbul, 1983.

Hammer-Purgstall, Joseph von, *Constantinopolis und der Bosporus*, v. 2, reprint of 1822, Osnabrück, 1967.

Haunolth, Nicolas, 'Particular Verzeichnuß/ mit was Ceremonien/ Gepräng und Pracht das Fest der Beschneidung deß jetzt regierenden Türckischen Keysers Sultan Murath/ diß Namens deß dritten/ u. Sohns/Sultan Mehemet genannt/ welches vom andern Junij biß auff den 12.Julij deß 1582. Jars gewehret und continuiert hat/ zu Constantinopol celebriert und gehalten worden', in Hansen von Amelbeurn Lewenklaw, *Neuwe Chronika Türckischer Nation*, Frankfurt, 1959, pp. 468–514.

Lewis, Bernard, 'The Islamic Guilds', *The Economic History Review* 7, 1936–1937, reprint New York, 1957, pp. 20–37.

Nutku, Özdemir, *IV.Mehmet'in Edirne Şenliği*, 1675, Ankara, Türk Tarih Kurumu, 1972.

Öztekin, Ali, ed., *Gelibolulu Mustafa Âli, Câmi'u'l-Buhur der Mecâlis-i Sur, Edisyon Kritik ve Tahlil*, Ankara, Türk Tarih Kurumu, 1996.

Procházka-Eisl, Gisela, *Das Sûrnâme-i Hümâyûn. Die Wiener Handschrift in Transkription, mit Kommentar und Indices versehen*, Istanbul, The Isis Press, 1995.

Stout, Robert, 'The Sur-i Humayun of Murad III: A Study of Ottoman Pageantry and Entertainment', unpublished PhD dissertation, Ohio State University, 1996.

Taeschner, *Franz, Zünfte und Bruderschaften im Islam – Texte zur Geschichte der Futuwwa*, Zurich/Munich, Artemis Verlag, 1979.

Uran, Hilmi, *Üçüncü Sultan Mehmed'in Sünnet Düğünü*, Istanbul, 1942.

CHAPTER 3

Guild Membership in Seventeenth Century Istanbul: Fluidity in Organisation

Eunjeong Yi

Membership is a crucial issue that characterises the nature of a guild organisation. The way in which the membership of an organisation is constituted and controlled gives us an idea of its overall character. There have been general assumptions on membership issues in Ottoman guilds, but not much is actually known about the membership of earlier guilds. This study concentrates on examining the structure and management of guild membership in seventeenth century Istanbul, in which one observes an unexpected degree of fluidity despite the conventional wisdom which says otherwise.

Former perceptions

In previous scholarship, strict control of membership by the guild or the state was taken for granted as an integral part of the monopoly and regulation in the guild system.[1] Such an analysis has been salient because Osman Nuri's vast study of municipal affairs has been repeatedly used.[2] According to Nuri, the restrictions in the guild system (*inhisar*, often translated as monopoly) not only included those that directly contributed to monopolies of specific goods and services (limiting the number of members in a guild and preventing intruders from practising a trade), but they involved other regulations as well, such as control of the allocation of required materials among the members and even a dress code.

In other words, guild monopolies were underpinned and guaranteed by tight control of guild members. Meanwhile, restrictions were useful and necessary for administering such things as the determination and application of fixed prices (*narh*). Therefore, the government supported and sanctioned regulations related to the control of guild membership. Osman Nuri's portrait of the guilds leaves the impression that guild membership was under a dual control by guild authorities and the government. This characterisation greatly influenced the understanding of guild membership by a later generation of scholars. Robert Mantran, for example, viewed the guilds as a controlling mechanism and assumed that guild and government authorities were involved in authorising those who became new masters.[3] Furthermore, Gabriel Baer emphasised the government's intention to control the guilds when discussing almost all restrictions inherent in the guild system. Under the assumption that ethno-religious separation would have served the interest of the government, he even speculated that, in most cases, each guild or its sub-branches exclusively consisted of people belonging to a specific community.[4]

The conventional wisdom on Ottoman guilds has been largely based on the perceptions of Istanbul guilds and their practices in the eighteenth and nineteenth centuries without considering whether these perceptions were well-founded or balanced. Therefore, one may justifiably assume that these perceptions best apply to Istanbul guilds.[5] The tendency to place restrictions on becoming a member of a guild and on opening a new shop was, indeed, an important aspect of the guilds and the guilds had good reason to restrict this when there was outside competition. In fact, however, the established concept of a rigidly controlled guild system may not guarantee a satisfactory understanding of the Istanbul guilds over time, especially where those functioning in the seventeenth century and before are at issue. It is doubtful that 'control' of urban society was always so important and, even if that were true, the degree of thoroughness is in question. In other words, the tight control that the guilds and the government were supposed to have exercised may have been the result of certain historical conjunctures. Scholars have only recently begun to consider restrictions on guild membership in a specific time frame. Engin Akarlı's work on the development of *gedik*

(certification of mastership/shop usufruct) and the reinforcement of guild monopolies in the eighteenth and nineteenth centuries are noteworthy in this respect.[6] Istanbul guilds in the seventeenth century have not yet been made a separate issue; simply, not much is known about them. Nevertheless, there has been a dominant assumption that seventeenth century guild membership in Istanbul was always intensely controlled, just as was true in later centuries.

Primary sources

The examination of the Istanbul court records (*siciller*) is needed in order to understand the nature of guild membership in the seventeenth century. The utility of the court records for social history has been pointed out many times.[7] The first six available court registers from the main court in Istanbul were compiled in the second decade of the seventeenth century, while the next four date from the early 1660s. Unfortunately, the hiatus between them is quite long, but the existence of two distinct blocs of data lends itself to a comparison between the two periods. Supplementing these, some documents from the Galata court records and some *divan* documents (e.g., Mühimme Defterleri and Şikâyet Defterleri) have also been used for the present research.[8]

Boundaries of a guild

There is little precise information regarding the number of guilds in seventeenth century Istanbul nor do we know very much about their exact place in the urban economy. Evliya Çelebi's account of the 1638 guild procession enumerates more than a thousand groups, including government officials, men of religion, entertainers and criminals. Evliya's description is the most expansive and detailed one, incorporating several hundred crafts and services. On the other hand, there are shorter lists of trades which date from before and after Evliya's depiction of Istanbul guilds: these lists give various totals. An anonymous *sûrnâme* (festival book) about the 1582 guild procession as part

of the circumcision festival of a prince enumerated 148 trade groups.[9] In 1669, Hezârfen Hüseyin reported that there were 139 guilds that held shops in Istanbul.[10] A law code (*kanunnâme*) or a price register (*narh defteri*) gave an even smaller number of guilds that were presumably crucial for provisioning and price control.[11] These lists of guilds, which are apparently incomplete and made for different purposes, do not provide consistent information about contemporary guilds. Even the price registers from 1600 and 1640 each give a rather different set of guilds. Allowing that there may have been a creation of new guilds and a dissolution of old ones, this fluctuation in the number and kinds of guilds that were enumerated suggests that contemporary observers, including government authorities, did not know – or were not even interested in knowing – the exact number of guilds. Moreover, there was not an official standard register of existing guilds.

To begin with, the guilds in the seventeenth century Ottoman capital do not seem to have been clearly defined organisations, although those who were then in the guild system probably had a clearer understanding of the principles governing each respective guild than we do today. In addition to the lack of definitive information about the guilds of this period, which blurs the whole picture, guild activities, as described in court records, rarely provide a clear understanding about the boundaries of these organisations. For example, there is no detailed account as to the guildsmen's definition of membership in a guild, the rights and duties of a member or the exact procedure by which a total outsider could become a member. Besides, even when one does have some information about certain guilds, there is no guarantee that the information was true of all Istanbul guilds since the latter had different interests and apparently varied in organisation.

Terms conventionally applied to guilds also reflect the amorphousness of guild organisation. These terms include *ta'ife*, which simply means a social category of any kind, *hirfet* or *san'at*, which means a trade or a craft, and *esnaf* (a term whose original meaning is classes/kinds). The latter refers, in general, to artisans and menial workers who often doubled as shopkeepers.[12] Among the above-mentioned terms, the most commonly used to designate a guild in the Istanbul court records is *ta'ife*, meaning any kind of real or imaginary group. The term was applied to any

ethno-religious, professional or general social group, regardless of its degree of organisation. Its application was so broad that one even comes across such examples as 'women in general' (*nisvan ta'ifesi*)[13] or the social stratum of 'officers' (*ağa ta'ifesi*).[14] This imprecision of the term *ta'ife* has attracted the attention of many scholars.[15] On the other hand, *hirfet*, the second-most used term, clearly designates a commercial trade and never any other types. One may assume, however, that from an insider's point of view, *ta'ife* had multiple usages to designate generic guild-like or government groupings, the exact meaning depending on context. The word *ta'ife* itself does not signify the qualities of a given group. Therefore, one cannot know the characteristics of a given guild until one sees how it acted and how it was constituted. One cannot even be sure that an occupational *ta'ife* mentioned in a seventeenth century document was organised like a guild unless it acted as a group under the leadership of certain guild officials.[16]

Even among occupational *ta'ifes*, there must have been substantial differences corresponding to the nature of the occupation. For example, some special social and occupational groups were under closer government surveillance than others because the authorities viewed them with suspicion.[17] Therefore, guilds such as those of the brokers and slave-dealers might be more tightly knit due to the government's demand that the members guarantee one another's good behaviour. Meanwhile, groups of social outcasts such as beggars[18] and pickpockets[19] or those which did not have a fixed station such as peddlars (*koltukçular*) might not have had a regular guild structure[20] even when they were called *ta'ifes*, since they were almost never seen in court claiming their rights. In this study, the groups discussed will be limited to those consisting of a tangible organisation of artisans or service workers, which can sometimes be a structure as simple as a group of craftsmen acting collectively in court.

In addition to the unclear qualities and structures of Istanbul's professional organisations, the groupings of these organisations did not necessarily stay fixed. In other words, a professional group may appear alone at a particular time but, at another time, it may be joined with a slightly different but related group. The cooks (*aşçılar*) of Istanbul provide a good example. According to a version of Evliya Çelebi's account (1638), it

seems that the cooks were a major guild which had many assistant guilds (*yamaklar*), including the *kebab*-makers (grouped together with the *köfte*-makers), stew (*yahni*) makers and so on. Each organisation had separate shops and members.[21] The cooks appeared alone in the price register of 1600,[22] but were grouped together with the *kebab*-makers in a contract in the early 1660s[23] and were designated in an *ihtisâb* register in the early 1680s as cooks and stew-makers (*aşçılar ve yahniciyan*).[24] Likewise, the boot-makers (*çizmeciyan*), who were listed alone in Hezârfen Hüseyin's account (1669),[25] were joined by the makers of heavy army shoes (*postalcıyân*) in the same *ihtisâb* register.[26] It is possible that only the names changed while the real organisations varied but little,[27] yet it is hard to imagine that the change of the designation did not reflect any reorganisation at all. Guilds also divided over time along geographical or ethno-religious lines.[28] Most probably, the fluctuation resulted from the internal dynamics of a given trade and not from administrative orders.[29] The government does not even seem to have cared about monitoring all the trade associations that existed.[30] All in all, the inconsistent delineation of guilds in this period makes it more difficult to think of their membership as unchanging or constantly controlled.

Given the diversity, ambiguity and fluctuating boundaries of seventeenth century Istanbul guilds, it is certainly a difficult task to identify general patterns in their organisational structure based on a limited number of cases. Nonetheless, a general understanding of guild membership in Istanbul in this period is not impossible. The listings of guild members as litigants in the court records would suggest that many guilds shared similar organisational features such as officials with the same titles (e.g., *kethüdâ* and *yiğitbaşi*), elders (*ihtiyarlar*)[31] and regular members without titles. Moreover, some indirectly related matters such as shop sales, sublets and business partnerships involving tradesmen also shed light on the question of membership. Totally un-related guilds in these matters showed similar features of organisation and behaviour. After all, it is quite plausible that many Istanbul guilds shared some common features since they were mostly in the same physical and social arena and apparently learned keenly from one another.[32]

Membership structures

It is difficult to fathom the exact delineation of guild membership in seventeenth century Istanbul, given that craftsmen themselves did not leave their own documents behind and that government sources are vague about guild delineation. Seventeenth century documents frequently refer to an artisan only as affiliated with such and such a guild (... *ta'ifesinden*) and do not always give his rank within the latter, which is hardly satisfactory for understanding guild membership. Some court cases, however, shed light, if only in passing, on how membership was acquired and relinquished, in addition to the kinds of rights and duties entailed by guild membership.

Above all, guilds seem to have controlled membership matters themselves and in the early to mid-seventeenth century, government authorities were content to let guilds oversee their own membership. The government only registered and watched members of trades that might engage in criminal practices. It required guarantors (*kefil*)[33] for the members of such trades, presumably to prevent them from doing any harm to society,[34] but not for others. The government's insistence that all guildsmen have guarantors and that those who lacked them should be expelled from the city seems to have started much later, in the eighteenth century, when population pressures were severely felt.[35] The government, therefore, seems to have been unwilling to intervene deeply in guild membership issues, but guildsmen saw these organisations as vital to their own interests. Naturally, individual guilds shaped and established regulations regarding their own membership.

The huge diversity in size and characteristics among Istanbul guilds may have resulted in diverse membership structures. A cursory glance at Evliya Çelebi's account of various guilds in 1638 discourages us from expecting that each and every craft or service trade in Istanbul would have had an identical structure. The size of what he lists as guilds – in his term, *esnaf* – ranges from only a few people to several thousand, depending on the trade. Although we should discount his numbers to some extent, given his tendency toward hyperbole, his account remains a good indication of the disparate sizes of the guilds. For example, whereas there were major guilds of considerable

size such as bakers (10,000 people with 999 shops), tanners (3,000 men with 700 shops) and saddle-makers (5,000 men with 1,084 shops), there were also very small groupings such as sellers of leather pieces (*parçacı*: 15 men with 10 shops) and oven-builders (10 men with no mention of the number of shops).[36] Such diversity in size seems to suggest that there were different degrees of organisation among the craft and service guilds. One might assume that the larger guilds providing daily necessities with many shops dispersed throughout the Istanbul area would have been divided into regional divisions headed by *bölükbaşıs* (division chiefs)[37] and, therefore, have had less cohesion as a whole. In that case, regional subgroups may have had relatively more cohesion than the encompassing organisation.

In addition, other unique features of each guild, such as the level of required skills, the degree of religious homogeneity, an independent attitude to state authorities and geographical concentration, must have also affected the nature of its membership. Important provisioning guilds such as bakers and butchers were most closely supervised by the state. Some service trades that did not require complicated skills or substantial investment such as water-carriers and porters might well have been particularly alert to the encroachment of outsiders and stringent about taking them as new members. There were apparently many guilds with religiously homogeneous membership, which may have resulted from the religious orientation of specific groups or simply from the easiness of networking among co-religionists.[38] On the basis of the *futuwwa/ahi* moral code, some Muslim guilds probably displayed a communal and egalitarian mentality more than others.[39] The tanners' guild, with its reputation for independence and its strong attachment to the cult of its patron saint, Ahi Evren, is likely to have had inter-city networks through dervish lodges of the cult.[40] At least according to Evliya Çelebi, this guild even accepted criminals pursued by state authorities into its realm to protect and discipline them with hard work, eventually incorporating them as members.[41] One may also assume that guilds with a high degree of cohesion and geographical concentration must have found it easier to control their membership.[42]

On the other hand, although different guilds were likely to have different conceptions of membership and different policies, they seem to have shared common ground. Most guilds had a

tiered membership structure. One can easily trace the distinctive appearances of masters (*usta*, Turkish form of the Persian word *ustâd*, meaning master/teacher) back to the sixteenth century, if not earlier, which definitely indicates that there also were lower rank(s) in a guild.[43] Scholars of Ottoman guilds have often presumed that guilds in general had a three-tiered structure comprising masters (*usta*), senior apprentices (*kalfa*, Turkish from the Arabic word *khalifa*, originally meaning deputy/successor) and regular apprentices (*şagird* = *çırak*) regardless of the time period, but one may have to avoid generalising for the early period up to the seventeenth century. What is clear for this time is only that there was a general differentiation between masters and apprentices. Suraiya Faroqhi has expressed doubt about the existence of *kalfa* before the eighteenth century, pointing out that, in earlier times, the word was rarely used.[44] Indeed, the rank of *kalfa* was rarely mentioned in the seventeenth century.

It was used, for example, only among the ranks of government scribes[45] and, in Bursa, outside the regular guild hierarchy.[46] The documents examined for this study did not refer to it. In addition, the much better documentation of the court workshops reveals that palace artisans were only either masters or apprentices (*şagird*).[47] Also, among the few documents that touch upon apprenticeship, there is a case from 1072/1662 in which a gunstock-maker's (*kundakçı*) apprentice (*şagird*) was approved when he asked to open an independent shop after having worked for a master, information which shows that this guild did not have the rank of *kalfa*.[48] In fact, even Osman Nuri does not say that it was always the rank of *kalfa* from which one was promoted to a mastership, the term that he uses for the promotion ceremony being *çırak çıkarma*.[49] Therefore, even if there were some *kalfas* in some guilds, the rank was not necessarily widespread. Of course, the absence of a senior apprenticeship does not necessarily indicate that all apprentices were equal under the masters; there may well have been a line of seniority among the apprentices working in the same shop.[50]

Because there are only very few documents from this period which even cursorily mention apprenticeship, it is difficult to know any details about the varieties of apprenticeship from guild to guild. This is because guildsmen did not have to address

issues of apprenticeship in court except when there was a problem, which may have happened rarely due to the obviously unequal power relations between masters and apprentices. When the above-mentioned gunstock-maker became independent, he sued his former master for having exacted more money than the latter legitimately could claim, but such a case is exceptional. In a case involving the hard biscuit-makers, one issue which they wanted their newly selected *kethüdâ* to settle was that concerning the scouting of other masters' apprentices. The masters collectively made an agreement not to take someone else's apprentices (...*birbirimizin şagirdini âharın yanına almayup...*).[51] This shows that skilled apprentices were obviously an important human resource and masters resented losing those whom they had trained.

Wage labour in the guild is even more rarely mentioned in the court records. We have no information on how important wage labourers were in each guild or why they were needed. In addition, the relationship between apprentices and wage labourers – if the latter existed in the guild in question – is yet another question without an obvious answer. There are only a couple of examples in the seventeenth century court registers that I have used. One case involves Armenian coal-dealers. An Armenian in the coal-dealers' guild sued two others of the same guild who were also Armenians. The reason for the lawsuit was that the latter two had failed to pay 35 *riyal kuruş* (approximately 3,080 *akçes*)[52] to the guild member for his year's work. The plaintiff claimed that he had a contract by which he 'rented himself out' (*kafamı icar*) to the two guild members for this amount. When the defendants denied his claim, arbitrators intervened and helped the two parties settle the suit for *11 riyal kuruş*. This case provides little information about guild structure or about whether those involved were contracted in a master–apprentice relationship. However, the plaintiff does seem to have been employed at a higher level than that of an apprentice, given that he was initially promised 35 *riyal kuruş* which was more than a token amount likely to be given to an apprentice.[53] In another case, a non-Muslim shoemaker, Yani, hired a Muslim (a certain Ibn Abdullah) on a contract whereby he would give 4,000 *akçes* a year to the latter, a sum that is also more than a token amount.[54] However, these cases are too random to

formulate a general idea on wage labour in the guild and the situation could have varied greatly from guild to guild.

In any case, apparently only the masters counted as full-fledged guild members with membership rights and duties. They were the heads of individual business units within a guild and apprentices were probably affiliated mainly through their masters. Mastership/full membership evidently entailed various obligations such as paying a due share of the taxes imposed on the guild by the state, following rules set by internal agreements, government directives or a combination of these two (for example, fixed prices and production standards) and participating in all other collective economic and communal activities. In return for fulfilling these duties, members had the right to benefits provided by the guild such as wholesale purchase of raw materials. Above all, guild membership gave legitimacy to those in the relevant trade in the eyes of both the guild and the state authorities. Members could and often did complain about the intrusion of outsiders and they often succeeded in having illicit businesses banned, at least officially, although, in reality, this may not have guaranteed their monopolies.[55] A master in a craft guild seems to have had the right to procure his due share (*hisse*) of any raw material supply which the guild had acquired[56] and, within a service guild, presumably to secure a certain level of opportunities for work. The rights and duties accompanying membership are not stipulated by a legally prescriptive document prepared by the guild, but are corroborated repeatedly through guild operation during disputes that were played out in court. This can be considered in terms of give-and-take since, for example, a cook specialising in sheep trotters demanded his share of raw materials on the grounds that he had paid taxes along with other guild members.[57]

Ways to join a guild

It has been argued above that masters were full members with certain rights and duties. How, then, did one become a master, a person who ran a shop in affiliation with a guild?

The standard way to become an independent master with one's own shop was to be approved by guild authorities after

having completed an apprenticeship under a master. If thoroughly applied, this would have ensured the guilds' total control over those who were admitted to membership. Clearly, the guilds seem to have considered this path to be the only legitimate way to enter a guild on the grounds that anyone who worked in a trade should be sufficiently trained and have worked for a long enough period of time under a qualified master. Therefore, *ham-dest* (unskilled) and *na-ehl* (unqualified) were terms that guildsmen could use to accuse intruders.[58] Since the period of the Celali rebellions, the early seventeenth century disorder in the countryside, a situation was created where large numbers of rural immigrants looked for jobs in urban trades. There is no need to mention that guilds did not want outside competition. When a certain Ömer, who was not connected to the sherbet-makers' guild, opened a sherbet shop, the guild appealed to the court claiming that no one without permission from the guild authorities could do this. They even claimed that they had an imperial order to the effect that nobody who had not gone through an apprenticeship under a master could open a shop.[59]

A large percentage of the apprentices must have been the sons of masters. Most probably, in the first place, masters' sons were not considered to be outsiders to the guild. Even before the gradual consolidation of membership through *gedik*, which normally guaranteed a son's inheritance of mastership from his father, shop leases acquired from pious foundations (*waqf*) gave a deceased tenant's sons the right to continue the lease.[60] In these cases, if the son had come of age and had been trained in the trade in question, it was natural for him to inherit the mastership and continue his father's business in the same shop.

Even though practising an apprenticeship and, thereafter, being approved by the guild authorities was the normal pre-condition for acquiring full membership, one might question whether there were other ways of joining a guild. In other words, were there ways of practising a certain trade without officially joining a guild, while indirectly benefiting from it? The greatest difficulty in addressing this question concerns the ambiguity around an individual's membership status in court documents. It is doubtful that the court confirmed the identity of the petitioners and litigants beyond recording what they said that they were. Nonetheless, with some degree of caution, one may assume that

being affiliated with such and such an artisan group (... *ta'ifesinden*) meant that a person was a member (i.e. a master) of a guild and not just that he practised the trade, especially when other documents confirm that such a guild existed and had clearly recognisable guild officials.

In the early decades of the seventeenth century, most guilds apparently did not attempt a strict regulation of people coming into their trade or leaving it, particularly if the matter was handled through existing guildsmen or established shop-owners. Shop sale and rental documents corroborate this. Shops changed hands freely and with few signs of involvement on the part of guild authorities. Probably guildsmen were upset only when an outsider opened a business in their trade while having no connection to the existing shops and networks and thereby disrupted the established order. Even then, some guilds were rather tolerant toward intruders. For example, when outsiders started setting up saddle stores, the saddle-makers' guild in Üsküdar simply wanted the government to tax them as well.[61]

Therefore, sometimes outsiders could enter the domains of guilds without disrupting the existing order. First, one could sublet the shop, the commodities and the tools of the trade from a guildsman. Nothing is specified about the qualifications required to do so, although one cannot eliminate the possibility that the guild screened the sub-lessees' qualifications without recording them. There are examples of sublets from perfumers' (*'attar*), brass-founders' (*dökmeci*) and bakers' (*habbaz*) guilds.[62] In these documents, whereas the lessors are mentioned as members of a *ta'ife*, the tenants are not described in this way. It seems that a non-guild member could take up a trade through subletting from a guildsman.

A second possibility was by renting or purchasing a shop from the owner or the *waqf* administrator. Many shops were pre-designated for a particular trade[63] and the way in which shops changed hands through the landlord at least partly explains this: it was convenient for a landlord to receive reimbursement from a tenant and then offer the shop to a new tenant with commodities and tools already in place. When a guildsman could no longer pay the rent for his shop and therefore went out of business, the owner or administrator of the shop could buy the existing commodities and tools from the insolvent guildsman and simply

provide a new tenant with a fully equipped shop. For example, in one case, a non-Muslim master dyer named Dimo rented a shop that was privately owned by a certain Mustafa Subaşı. When the contract ended and Dimo could not pay the full rent, he sold the goods in the shop to Mustafa. In turn, Mustafa cancelled Dimo's remaining debt.[64] The new tenant could also be a member of the same guild, but the landlord seems to have been able to rent out his shop to a non-guild member as well. When a Muslim woman, Safiye Hatun, rented out her grocery shop, there was no indication that her non-Muslim tenant was already a qualified guild member.[65] We only rarely come across an example in which a guild warden was involved in the transfer of a shop.[66] The fact that guilds and guild officials were not usually mentioned in the transaction documents for shops and commodities shows that these transactions were deemed to be a matter between the concerned individuals and not primarily a guild issue.

A third possibility apparently involved taking up a trade by becoming a business partner (şerik) of a guild member. Sometimes, guildsmen could have a business partner from outside their guild whether the relevant guild liked it or not. In this case, the outsider partner might indirectly benefit from the privilege of being affiliated with a guild. Some documents suggest that guildsmen could form partnerships with outsiders,[67] although whether the partnerships concerned the trades that they were supposed to engage in as guild members is not clear. According to André Raymond's research,[68] Cairene Janissaries often entered a variety of trades as they threatened tradesmen into forced şirkets. The same must have been possible in seventeenth century Istanbul. Although guild authorities may not have willingly approved şirkets between their members and outsiders,[69] there is no evidence in court records that the guilds opposed such partnerships.

In tangential relation to guild membership, we should not neglect the involvement of investors although they were not considered proper members of craft/service ta'ifes. Some landlords invested in esnaf shops. The aforementioned Safiye Hatun, who rented her grocery shop for 7,000 akçes per year, also lent 20,000 akçes to her non-Muslim tenant.[70] Even those who did not own or administer the real estate where business was taking place could rent a shop and sublet it. A certain Muharrem Ağa and

Öküz Reis rented a bakery and then sublet it to two Greeks who were members of the bakers' guild.[71] A *kapıcı başı* (officer, palace doorkeepers) also rented a few *başhanes* (sheep-head restaurants) under a state-owned waqf in Galata and secured shares (*hisse*) of sheep heads from slaughterhouses for the shops.[72] There is only limited information about investors' influence on guilds, but we can safely say that non-guild investors such as military officers and wealthy women do not seem to have had any visible friction with the guilds. One may assume that investors were another element that might have indirectly affected a guild's control of its membership through its involvement in the selection of sub-lessees and financial relationships with them. The court records indicate that leaving a trade was not a difficult process. In relation to the two non-Muslim members of the bakers' guild who sublet a bakery from Muharrem Ağa and Öküz Reis, one of them, Anastas, simply decided to leave for another town. He ended the business partnership and cancelled all mutual debts with his partner. From then on, his partner was to pay the shop rent on his own. Interestingly, Anastas did not have to settle anything with the guild when he left.[73] His partner kept the same business and it seems that the bakers' guild did not interfere with the personnel in a member shop as long as there was continuity. This is interesting since the bakers controlled their members more strictly than other guilds. It seems that guild membership was taken more casually in leaving a trade than in entering it.

Intruders and membership

One may safely assert that, in seventeenth century Istanbul, the boundary of guild membership was not clearly defined and that there was a grey area between the realms of guild and non-guild. This may well have meant that it was not difficult for an outsider to penetrate the Istanbul guilds, at least in the early years of the century. One can demonstrate the relative ease of penetration by showing new, 'foreign' elements in guilds. There are many cases of Anatolian and Rumelian immigrant members in different guilds[74] and one also sees many more Janissary elements in the 1660s than in the 1610s.[75] Given such an encroachment, the idea of 'guild monopoly' may have to be rethought, at least in

the context of the early seventeenth century. Even if there was a principle of guild monopoly, it could not be thoroughly applied if membership was not strictly delineated or limited.

However, the boundary of a guild did not always remain ambiguous and porous throughout the seventeenth century. First of all, guilds may have had a clear conceptual boundary between their members and outsiders, given that there was talk of 'expulsion' from a guild as a future option to punish a violator of guild rules.[76] Although the present research has not uncovered actual cases of expulsion, cases are reported from other towns.[77] Expulsion is an important indicator not only of clear boundaries (at least to the members of the guild in question), but also of the guild's will to keep troublemakers outside the boundary, even as it could not or did not prevent all newcomers from getting into the trade.

Secondly, *gedik* (literally, a 'slot', which can be roughly translated as a licence) is mentioned for several guilds over the middle decades of the seventeenth century, which seems to show that there was at least some effort to make the guild less permeable. Apparently, this institutional device was only being introduced into the guild system in the seventeenth century. Those guilds which had *gedik* in the mid-seventeenth century include water-carriers (*sakkalar*),[78] butchers of Etmeydanı (The Janissary Square),[79] brokers of the Inner Bedestan,[80] porters (*hammallar*) under the Un Kapanı Emini,[81] coffee-grinders,[82] shoe tip-makers (*na'lçacılar*) and glass-makers (*camcıyan*).[83] Water-carriers especially seem to have instituted *gedik* early on, the earliest evidence coming from 1630. Their guild was the only one mentioned as having *gedik* in the 1640 price register.[84] Although the exact meaning of *gedik* in this period is not clearly explained in the documents, it was often mentioned in the context of limiting the number of masters and businesses in one guild or restricting the location of shops.[85] It should be acknowledged that there may have been other factors that facilitated its formation, aside from the guild's need for membership control.[86] But, even when *gedik* was widespread and formalised after the mid-eighteenth century, it did not completely prevent outsiders from encroaching upon the guilds.[87] However, it must at least have made casual encroachment much more difficult. The introduction and spread of this institution may well have partly

resulted from the extensive intrusion of outsiders into the open-ended guilds.[88]

Conclusion

In seventeenth century Istanbul, neither the government nor the guild attempted to control guild membership for control's sake. The government did not get involved in the management of guild membership except when it needed to register the members of dubious groups or to muster those who might be useful in emergencies (e.g., water-carriers for fire fighting). Although guilds sometimes brought intruders to Istanbul courts saying that only those who were sufficiently trained under a master of the guild and approved by guild authorities were qualified to open a shop in the relevant trade, guild membership was, in reality, a more complex matter than guild officials would have outsiders believe. Whereas a guild had to basically determine and manage its membership structure, there were other factors that could compromise the official rules. The guild, while being a collective organism constituted basically of shops, probably did not exercise full command over the latter. Individual guild members could bring in outsiders by contracting partnerships and sublets. Shop owners, waqf administrators and renter-investors also seem to have had a say in determining who the new practitioner would be since they could select the tenants for their shops from pre-designated trades. Although it is unclear how readily guilds recognised those who came into the trade with these connections, the barriers do not seem to have been insurmountable. As long as such room for encroachment did not create new competition or disorder beyond the level that the established guild masters could tolerate, it seems to not have worried them much. For example, when the numbers and locations of shops involved remained the same, as in the case of sublet or transfer of a shop lease that kept the facilities in place, the established masters did not have reason to be concerned about heightened competition. In addition, a guild could be relaxed and not object to intruders engaging in their members' trade as long as the newcomers paid a fair share of taxes.

The multitude of soldiers and immigrants found in many trades by the mid-seventeenth century is evidence for the

flexibility and unintentional 'openness' of the guilds. However, in the seventeenth century, the relaxed attitudes of guildsmen started to change, beginning with the service trades that were vulnerable to outside competition. Membership control seems to have gradually strengthened over the next century with the spread of *gedik*, but probably not to the extent that it stifled any new development.[89] In any event, the fluidity and flexibility of the seventeenth century guild membership unequivocally show that these groups were not yet the heavily institutionalised guilds of the late eighteenth and nineteenth centuries, even if they engaged in many similar activities.

Abbreviations

AŞ 'Atik Şikâyet Defterleri
AK MC Atatürk Kitaplığı, Muallim Cevdet
GK Galata Court Registers
IK Istanbul Court Registers
MD Mühimme Defterleri

Notes

1 The term 'guild system' has implied that the main purpose of the Ottoman/Istanbul guilds was to cater to the needs of the state. I do not agree with this viewpoint, but I use the term with a different definition, namely, as a guild arena comparable to an eco-system in which disparate guilds coexisted, formed and died out over time; they learned from one another and evolved institutionally.
2 Nuri, 1995, v. 1, pp. 644–651, v. 2, pp. 627–633. He asserts that guild monopoly before the Tanzimat reforms was based on two elements: one was the *gedik* (certification of mastership/shop usufruct), the other was a guild's control of its particular commodity by preventing the intrusion of outsiders and the free opening of shops by artisans.
3 Mantran, 1962, pp. 358, 369–370. He regards being affiliated with a guild as an obligation that no one could evade unless he was enrolled in the military: 'There, one comes across the traditional Ottoman system in which control occupied a major place': Mantran, 1962, p. 357. In this context, Mantran supposes that acquisition of mastership had to be authorised by the guild and that perhaps the

administration – i.e., the kadi and the *muhtesib* – also had a say in the process.

4 Baer, 1970a, pp. 145, 155–159, 163. He modified some of his extreme statements later (in Baer, 1976). Baer might have been inspired by Osman Nuri's comments on ethnic preference in some trades. Nuri, for example, maintains that about 90 percent of the food provisioning business [in Istanbul] was in the hands of Muslims because of [the government's] mistrust of non-Muslims: Nuri, 1995, v. 2, p. 628.

5 Eldem, 1999, pp. 160–161: '...if this [guild] system ever did reach a point of maturation resembling its idealised version as expressed by the state and "classical" historians alike, it most probably did so in the capital city of the Empire'.

6 See Engin Akarlı's articles: Akarlı, 1985–1986; Akarlı, 1988.

7 Seng, 1991; Akgündüz *et al.*, 1988. Also, more specifically, Haim Gerber's chapter on the guilds in Gerber, 1988, convincingly shows the benefits of using court records in studying the guilds.

8 Hereafter, Istanbul court registers will be abbreviated as IK, Galata court registers as GK, Mühimme Defterleri as MD and 'Atik Şikâyet Defterleri as AŞ. The time periods covered by these registers are as follows, although some documents exceptionally bear different dates.
 IK: 1 (1021–22/1612–14); 2 (1024–25/1615–16); 3 (1027/1618) 4; (1028/1618–19); 5 (1028–29/1618–20); 6 (1028–29/1618–20); 7 (1069–70/1658–60); 8 (1071/1660–61); 9 (1071–72/1660–62); 10 (1072–73/1661–63)
 GK: 73 (1060–62/1650–52); 80 (1067/1656–57)
 AŞ: 1 (1059–/1649–); 2 (1062–63/1651–53)
 MD: 81 (1024–25/1615–16); 85 (1040–42/1628–32); 88 (1046–48/1636–38)

9 Hammer-Purgstall, 1837, 7: 163, n° 6, pp. 402–405, as cited in Nuri, 1995, v. 2, pp. 578–579. Being a description of a festive parade, it includes some non-trade groups as well.

10 Hüseyin, 1998, pp. 53–54.

11 See Kütükoğlu, 1978, pp. 11–13; Kütükoğlu, 1983, pp. 91–338; Akgündüz, 1990–1999, pp. 524–533. The 1600 price register lists approximately 60 guilds, the 1640 register lists 79 and Ahmed I's *ihtisâb* law code lists 76. These numbers may vary depending on what one counts as guilds among the inconsistent entries of trade groups and commodities.

12 Evliya Çelebi used the term *esnâf* but probably not in the narrow sense of tradesmen or trade groups. In his time, it may have only meant groups or kinds as it does in the original Arabic. Nuri, 1995,

v. 1, pp. 476–479 summarily shows the amazing range of groups covered in Evliya's account.

13 IK 7: 31a.

14 Abdurrahman Paşa's 'Kanunnâme', (1087/1676–1677), *Milli Tetebbu' Mecmuası* 3, p. 544.

15 Baer, 1964, p. 17; Gerber, 1988, p. 34; Goffman, 1994; Raymond, 1995.

16 It may be careless to assume that a *tâ'ife* with no mention of guild officials was not an organised group since, even without officials, a crafts/service group could take legal action together. Without guild officials, such a group must certainly have been less organised than those with guild officials, but it could have been in the process of establishing stricter organisation. Members of such groups could choose later on to have guild officials (GK 73: 123a for biscuit-makers, GK 80: 38a and 93b for bottle-makers).

17 There were some guilds that the government authorities must have been closely interested in controlling so that officials tried to organise these trades under state supervision. For example, brokers (*dellâlân*) and slave-dealers (*esirciyân*) seem to have been mistrusted by the government so much that individuals in these trades were registered in the *defter* of fixed prices: Kütükoğlu, 1983, pp. 255, 287.

18 Ahmed I's law code (*Osmanlı Kanunnâmeleri*, 9: 533) orders that beggars (*dilenci tâ'ifesi*) and lepers (*cüzzamlılar*) should be driven away.

19 Evliya Çelebi describes groups such as pickpockets, thieves and panders: Gökyay, 1996, p. 223; Hammer-Purgstall, 1834, 1, pt. 2, p. 109.

20 'Regular' guild structure in a broad sense should encompass some minor variations in leadership structure, degree of internal control and so on, but I would define it for the purpose of this study as consisting of masters and apprentices and having the usual guild officials such as a *kethüdâ* and a *yiğitbaşı*.

21 Gökyay, 1996, pp. 248–249.

22 Kütükoğlu, 1978, p. 11.

23 IK 10: 93a, 94b.

24 Atatürk Kitaplığı, Muallim Cevdet (hereafter AK MC) B 2 (1092/1681–82). İhtisâb Defteri, 19a.

25 *Telhîsü'l-Beyân*, pp. 53–54.

26 AK MC B 2. İhtisâb Defteri, 19b.

27 For example, the kadi's court could have acknowledged whoever came to court pleading together as a group, not distinguishing the major and assistant guilds unless the dispute at issue made the division clear.

28 AK MC B 2, 19a–b lists some ethnic or regional groups which had not been identified before, such as Greek silk-dealers, the grocers of Tahtakale, the porters of Topkapı, the yogurt-makers of Kanlıca, etc. The separation of subgroups may be corroborated by the establishment of *kethüdâ*-ship in them, as in the candle-makers' case (MD 81: 178/394, in the year 1017/1608).

29 For example, the bakers' guild and its assistant guilds agreed on uniting all the assistant guilds under the same guild officials because they had had problems in tax collection before (IK 9:52b).

30 *Osmanlı Kanunnâmeleri*, 9: 533. Ahmed I's *ihtisâb* code, after listing regulations for scores of guilds, states, 'God the Blessed and Exalted created all the others that are not listed here. It is ordered that the *muhtesib* should supervise all of them as well.' Although the government did not relinquish supervision over all trades, it does not seem to have had a firm grasp on those not listed. Meanwhile, the government acknowledged the legitimacy of any trades that existed – i.e. also including newly formed ones – as 'God's creation'.

31 It is very difficult to determine the precise functions of the elders since, in most cases, they are mentioned only cursorily in the court records as part of the guild delegation along with the guild leaders. However, it is likely that they were selected from the most powerful masters who had a say in guild affairs.

32 For example, a guild wanted to have the office of *yiğitbaşı* on the grounds that '[many] other guilds had *yiğitbaşı*'. See IK 5: 52b/370 (horse-cart drivers).

33 The sources concerning government-required mutual guarantees (*kefalet*) among guildsmen do not specify the nature of the guarantee. Legally, a guarantor could either be responsible for paying the amount owed by the person for whom he stood surety or for finding and presenting the latter in person: Bilmen, 1967–1969, 6, pp. 247–248, 251–252. I surmise that for the guilds of dubious morality, the guarantee may have been of the latter type.

34 The case of slave-dealers, some of whom illegally sold freeborn Muslims: MD 88: 20/48.

35 AK, MC, B10: 26a (1176/1763) includes the register of guildsmen from the Galata and Kasımpaşa areas, which comprised 41 guilds with a total of 5,156 masters, as well as senior and regular apprentices. Of these, 497 people who had been working without guarantors were expelled to their places of origin by imperial order. This measure seems to have been intended to control immigration from the countryside. For another example, see Orhonlu, 1984, pp. 87–88. Also, Aktepe, 1958, pp. 24–25 gives examples of voluntary

adoption of *kefalet* within guilds such as *kafesçi* (cage-makers/ wooden lattice workers) and *örücü* (menders/darners).

36 Evliya Çelebi even mentions a trade which comprised only one person (screw-vise maker [*burma işkenceci*]: Gökyay, 1996, p. 300, Hammer-Purgstall, 1834, 1, pt. 2, p. 231, as cited in Baer, 1970b, p. 32 [although Baer translates it, after Hammer, as torture-instrument maker, this is not likely]). Obviously, this one person could not constitute a guild by himself, but it could have been a sub-specialisation within the trade of carpentry. In any case, the numbers that Evliya gives are often apparently exaggerated. For example, he estimates the number of boatmen as 7,000 in the mid-seventeenth century. But a more realistic figure given by Cengiz Orhonlu as based on the study of a government register of 1751 (Başbakanlık Osmanlı Arşivi, Kamil Kepeci 7438, p. 15) refers to only 1,274 boatmen: Orhonlu, 1984, p. 85.

37 IK10: 74a. The grocers' guild, for example, had division chiefs besides the *bazarbaşı* who headed the whole guild.

38 Out of 54 guilds that came to the Istanbul court as registered in IK 1–10, 36 had exclusively Muslim names. Six consisted of *zimmis* (probably Greek), three were Jews and two were Armenians. There were three non-Muslim guilds whose leaders were Muslims and four guilds definitely with mixed membership, containing both Muslim and non-Muslim men. However, one should take this data with a grain of salt because it is known that some major guilds which were seemingly all-Muslim according to the court records did in reality include some non-Muslim practitioners (e.g. bakers and grocers). Court record entries do not enumerate the guild members down to the last person and religiously homogeneous subgroups of a guild might have acted independently in court in a way which makes it difficult to distinguish them from their larger organisations.

In addition, there were many cases of inter-religious partnerships between individual tradesmen.

39 Beside the tanners, the barbers' guild seems to have been a group that had a definite religious/communal leaning, given that they referred to themselves as 'all of us brothers' (*cümlemiz ihvân*). However, whether such communal identity applied to a wide range of guilds is unclear, much less whether it led the guilds to develop economic egalitarianism.

40 Taeschner, 1960.

41 Gökyay, 1996; p. 283, Hammer-Purgstall, 1834, 1, pt. 1, p. 206.

42 Faroqhi, 2002, referring to the example of the Sarraçhane, the Istanbul saddlers' workshop.

43 According to Barkan, the construction trades in the mid-sixteenth century had only masters and apprentices: Barkan, 1979, 1, pp. 185–329, 2, pp. 173–189.

44 Faroqhi, 1998.

45 For example, Katib Çelebi, a well-known man of letters in the mid-seventeenth century, was also known as Hacı Halife in reference to his scribal rank.

46 Gerber, 1988, pp. 41–42. Haim Gerber found some cases in which *kalfas* were mentioned by guildsmen, but it was in the sense of mere wage-earners and not as a fully established rank in a guild.

47 According to the salary (*mevâcib*) register in the Topkapı archives, D 2993 (1033/1623–24), D 1072 (1037/1627–28) and D 3410 (1060/1650), palace artisans in the early seventeenth century were divided only into masters and apprentices.

48 IK 10: 36b.

49 Nuri, 1995, v. 2, p. 568.

50 Some of the palace artisans (*simitçiler* and *fodlacılar*, certain kinds of bakers), however, seem to have formed clear hierarchies (*merâtib silsilesî*) among the subordinates under a single master: Refik, 1988, pp. 7–8. By the same token, one may suppose that masters within a guild had different degrees of power and authority, depending upon their economic resources, expertise and age. Some masters who counted as elders were probably deemed more important.

51 GK 73: 123a.

52 Pamuk, 1994, p. 964. A *riyal kuruş* (a large Spanish silver coin) was worth about 88 *akçes* in 1659. The exchange rate between the *riyal kuruş* and the *akçe* fluctuated greatly in the seventeenth century.

53 We do not have any indication about the level of remuneration received by guild apprentices. It is likely, however, that they did not receive anything or merely a token amount, given the nature of their work as 'on-the-job training'. As in the case of the aforementioned gunstock-makers, the master could even demand money from the apprentice (IK 9: 28a).

54 IK 7: 17b.

55 IK 3: 473 (tinsmiths), IK 5: 75a (water-carriers without horses), IK 6: 2b/10 (fruit-sellers), IK 6: 25b (chicken-sellers), AŞ 1: 88/419 (grocers, vegetable-sellers and shopkeepers), IK 9: 190b (sherbet-makers), IK 10: 54b (sellers of imported mirrors).

56 IK 10: 52a. The cooks of sheep feet (*paçacılar*) collectively decided to ensure fair and equitable distribution of raw materials to each of the members.

57 IK 9: 70a.

58 AŞ 2:17/66 as cited in Kütükoğlu, 1986, p. 62. By these terms, the
 mühürger (seal-makers) guild described intruders who opened
 businesses without having served a master or being approved by
 the guild authorities.
59 IK 9: 190b.
60 Sıtkı, 1325 /1909–1910, pp. 5–8. Under the terms of both *icâre-i
 vâhide* and *icâreteyn* (which were the prevalent types of leases for
 waqf shops), sons of shop tenants could inherit the lease.
61 AŞ 2: 221/853. Also, some guilds might put up with their rivals
 despite other offences if the latter shared their tax load. See IK 3:
 56a/473 (tinsmiths) and IK 6: 2a/10 (fruit-sellers). This is rather
 similar to what Haim Gerber has observed with respect to
 seventeenth century Bursa guilds, namely, that some guilds were
 relaxed about newcomers as the latter fulfilled their obligations. On
 the other hand, other guilds showed exclusionary tendencies early
 on; the saddle-makers of the Sarraçhane wanted to have non-
 members' shops closed as early as in 1015/1607: Uluçay, 1951–
 1952, pp. 5–6, 151–154. It seems that a claim to a monopoly was in
 direct relation to the seniority of a guild and more often occurred if
 the premises were situated in a locale belonging to a prestigious waqf.
62 IK 1: 15a/88 (perfumers), IK 7: 34b (brass-founders), IK 8: 16a
 (bakers).
63 For example, a woman in the early 1610s complained that her ex-
 husband had sold a '*kebab*-maker's shop' that she had inherited
 from her father (IK 1: 10a/58). For similar assignment of shops to
 certain trades, see IK 3: 70b/588, which is about a grocer's shop
 owned by a woman.
64 IK 4: 21a/145,146. In contrast, there was a case in which the trade
 of a shop was not designated at first, but it was made into a
 butcher's shop by the tenant. The tenant was a *beğ*, which means
 that he was of military origin and probably had set up shop without
 having a connection to the butchers' guild (IK 2: 6b/58).
65 IK 3: 70b/588.
66 IK 10: 47b.
67 Halabi, 1290/1873, p. 363 mentions a partnership between a tailor
 and a dyer as legitimate. There are also examples of partnerships that
 may have included a guild member and an outsider. See IK 10: 38b
 (between a Janissary and a candle-maker in the firewood business)
 and IK 8, p.17 (between a sailor and another person whose previous
 occupation is not specified – the latter might have been a member of
 the grocers' guild since they started a partnership in a grocery
 business).

68 Raymond, 1991, p. 18.

69 For example, the *Plovdiv abacı* (weavers of coarse wool textile) guild in 1805 laid down its rules, including a stipulation that a master should form a partnership only with another master in the same guild: Todorov, 1983, p. 224.

70 IK 3: 70b/588.

71 IK 5:90a.

72 AŞ 2:74/301. Given that he could not have personally managed the *başhanes* that he rented, he must have sublet them to *başçıs* of Galata. He petitioned against a kadi's newly established *başhane*, which was taking away his shops' share of sheep heads.

73 IK 5: 90a.

74 For example, see IK 9: 53a. An Armenian immigrant who had migrated from Anatolia and had become a member of the bakers' guild entrusted his land back home to another Armenian. There are many cases where Istanbul tradesmen were involved in the transfer of real estate in the provinces, which seems to indicate that they were recent immigrants who still kept ties with their native regions. Also see IK 1: 8b/50, IK 3: 59b/502, IK 5: 102a, IK 7: 25b, IK 8: 26a and 41b, IK 9: 59b, 85b, 110b, 211a, 273a and IK 10: 113a, GK 73: 56a and GK 80: 73a as cited in Yi, 2000, pp. 209–212.

75 While there were only five groups that had military members among the 27 guilds that came to court in the 1610s (about 15 percent), in the 1660s there were 18 that included military elements out of a total of 37 (about 49 percent). Those guilds in which the *kethüdâ* was the only military element are not counted.

76 There is only one court case from this period where the possibility of expulsion was discussed. A tanner who had violated his guild's rule concerning raw material purchase swore that he would willingly face expulsion if he committed the same violation again (IK 9: 145b). Although slave-dealers and brokers were also supposed to expel wrongdoers from their trades (1640 *Tarihli Narh Defteri*, pp. 257, 287), in their case the expulsion may not have been institutionalised not on the initiative of the guilds but on that of the government, which was concerned about possible criminal activities.

77 Haim Gerber gives three examples of expulsions from guilds: Gerber, 1988, p. 57.

78 Both regular (MD 85: 226/518 dated 1040/1630 as cited in Mantran, 1962, p. 369) and water-carriers without animals (IK 8: 20a, 1071/1660).

79 Gökyay, 1996, p. 244; Hammer-Purgstall, 1834, 1, pt. 2, p. 144. 'At Meydanı' in both editions should actually be read 'Et Meydanı'.

80 Gökyay, 1996, p. 294; Hammer-Purgstall, 1834, 1, pt. 2, p. 222.

81 Gökyay, 1996, p. 255; Hammer-Purgstall, 1834, 1, pt. 2, p. 162.

82 Gökyay, 1996, p. 256; Hammer-Purgstall, 1834, 1, pt. 2, p. 162. Actually this group is only described by its facilities, *gedikli dibekler* (large mortars) for coffee-grinding.

83 Istanbul Ahkâm Defteri 3: 354/1282 (dated 1168/1755) published in Kal'a, 1997, pp. 98–99. This eighteenth century document testifies that the glass-makers' guild came to have *gedik* in the middle of the seventeenth century.

84 Kütükoğlu, 1983, pp. 249–250.

85 Water-carriers without animals who adopted *gedik* relatively early, also started to control their members on the basis of a register that listed the names and designated fountains of all the legitimate practitioners for the purpose of fire fighting in the event of a large fire (IK 5: 75a). Also, for the shoe tip-makers, *gediks* were associated with shops in a specific location (IK 9:189a).

86 For example, *gedik* in the guilds may have been inspired by *gedik* in the government sector, including the military. In addition, Akarlı's studies (1985–1986, 1988) clearly show that *gedik* in the eighteenth and nineteenth centuries evolved in the guilds' complex relationship with waqfs, merchants and the state.

87 Akarlı, 1988, p. 5. In the eighteenth century, outsiders could acquire a *gedik* through sale, leasing, mortgaging and pledging, donation or inheritance, something about which many guildsmen complained. Mantran had also suspected that the sale of mastership/*gedik* might have allowed outsiders to join seventeenth century guilds. (Mantran, 1962, pp. 369–70).

88 For more details, see Yi, 2000, pp. 216–233.

89 Quataert, 1994, pp. 888–934. He shows that the Ottoman manufacturing sector, even in the nineteenth century, adapted resiliently to the Industrial Age both within and outside the guild system, even though some large guilds visibly declined. The practice of *gedik* continued even after the official abolition of monopolies in 1839 and it was compatible even with the expansion of certain manufactures.

Bibliography

Primary Sources

Istanbul
İstanbul Müftülüğü Arşivi:
İK: 1 (1021–1022/1612–1614); 2 (1024–1025/1615–1616);
 3 (1027/1618); 4 (1028/1618–1619); 5 (1028–1029/1618–1620);
 6 (1028–1029/1618–1620); 7 (1069–1070/1658–1660); 8 (1071/
 1660–1661); 9 (1071–1072/1660–1662); 10 (1072–1073/1661–1663)
GK: 73 (1060–1062/1650–1652); 80 (1067/1656–1657)

Başbakanlık Osmanlı Arşivi:
AŞ: 1 (1059–/1649–); 2 (1062–1063/1651–1653)
MD: 81 (1024–1025/1615–1616), 85 (1040–1042/1628–1632), 88
 (1046–1048/1636–1638)

Atatürk Kitaplığı:
MC: B 2 (1092/1681–1682); B 10 (1176/1763)

Secondary Sources

Akarlı, Engin, 'Gedik: Implements, Mastership, Shop Usufruct and Monopoly among Istanbul Artisans, 1750–1850', *Wissenschaftskolleg-Jahrbuch*, 1985–1986, pp. 223–232.

Akarlı, Engin, 'The Uses of Law among Istanbul Artisans and Tradesmen: The Story of Gedik as Implements, Mastership, Shop Usufruct and Monopoly, 1750–1850', *International Symposium on Legalism and Political Legitimation in the Ottoman Empire and in the Early Turkish Republic: ca. 1500 to 1940*, Universität Bochum, Ruhr, 1988, unpublished conference paper.

Akgündüz, Ahmet *et al.*, *Şer'iye Sicilleri*, 2 v., Istanbul, Türk Dünyası Araştırmaları, 1988.

Akgündüz, Ahmet, *Osmanlı Kanunnâmeleri ve Hukûki Tahlîlleri*, 9 v., Istanbul, FEY Vakfi, 1990–1999.

Aktepe, Münir, *Patrona İsyanı*, Istanbul, Istanbul Üniversitesi Edebiyat Fakültesi Basımevi, 1958.

Baer, Gabriel, *Egyptian Guilds in Modern Times*, Jerusalem, Israel Oriental Society, 1964.

Baer, Gabriel, 'Monopolies and Restrictive Practices of Turkish Guilds', *Journal of the Economic and Social History of the Orient* 13, 1970a, pp. 145–165.

Baer, Gabriel, 'The Administrative, Economic, and Social Functions of Turkish Guilds', *International Journal of Middle East Studies* 1, 1970b, pp. 28–50.

Baer, Gabriel, 'Ottoman Guilds – A Reassessment', *VIII. Türk Tarih Kongresi: Kongreye Sunulan Bildiriler*, 1976, 2, pp. 95–101.

Barkan, Ömer Lüfti, *Süleymaniye Cami ve İmareti İnşaatı (1550–1557)*, 2 v., Ankara, TTK, 1979.

Bilmen, Ömer Nasuhi, *Hukuki İslamiyye ve İstilahatı Fikhiyye Kamusu*, Istanbul, Bilmen Yayınevi, 1967–1969.

Eldem, Edhem, 'Istanbul: from Imperial to Peripheralized Capital', in Edhem Eldem *et al.*, *The Ottoman City between East and West: Aleppo, Izmir, and Istanbul*, Cambridge, Cambridge University Press, 1999, pp. 135–206.

Faroqhi, Suraiya, 'Between Conflict and Accommodation: Guildsmen in Bursa and Istanbul during the 18th Century', in Stephen Epstein, Clara Eugenia Nuñez *et al.*, ed., *Guilds, Economy and Society. Proceedings of the Twelfth International Economic History Congress*, Sevilla, Fundación Fomento de la Historia Económica, 1998, pp. 143–152.

Faroqhi, Suraiya, 'Urban Space as Disputed Grounds: Territorial Aspects to Artisan Conflict in Sixteenth to Eighteenth-Century Istanbul', in Suraiya Faroqhi, ed., *Stories of Ottoman Men and Women: Establishing Status, Establishing Control*, Istanbul, Eren, 2002, pp. 219–234.

Gerber, Haim, *Economy and Society in an Ottoman city: Bursa, 1600–1700*, Jerusalem, Hebrew University, 1988.

Goffman, Daniel, 'Ottoman Millets in the Early Seventeenth Century', *New Perspectives on Turkey* 11, 1994, pp. 135–158.

Gökyay, Orhan Şaik, ed., *Evliya Çelebi Seyahatnâmesi*, Istanbul, Yapı Kredi Yayınları, 1996.

Halabi, İbrahim ibn Muhammad, Mülteka ü'l-Abhur, trans. Mehmet Mevkufati, Istanbul, Dâru't-Tıbaati'l-'Amire, 1290/1873.

Hammer-Purgstall, Joseph, trans., *Narrative of Travels in Europe, Asia, and Africa in the Seventeenth Century by Evliya Efendi*, 2 v., London, William H. Allen & Co., 1834.

Hammer-Purgstall, Joseph, *Histoire de l'Empire Ottoman*, 18 v., Paris, Bellizard, Barthès, Dufour et Lowell, 1837.

Hüseyin, Hezârfen, *Telhîsü'l-Beyân*, ed. Sevim İlgürel, Ankara, TTK, 1998.

Kal'a, Ahmed, ed., *Istanbul Esnaf Tarihi* 1, Istanbul, İstanbul Araştırma Merkezi, 1997.

Kütükoğlu, Mübahat, '1009 (1600) Tarihli Narh Defterine Göre İstanbul'da Çeşidli Eşya ve Hizmet Fiatları', *İstanbul Üniversitesi Edebiyat Fakültesi Tarih Enstitüsü Dergisi* 9, 1978, pp. 1–83.

Kütükoğlu, Mübahat, *Osmanlılarda Narh Müessesesi ve 1640 Tarihli Narh Defteri*, Istanbul, Enderun Kitabevi, 1983.

Kütükoğlu, Mübahat, 'Osmanlı Esnafında Oto-Kontrol Müessesesi', *Ahilik ve Esnaf*, Istanbul, Yaylacık Matbaası, 1986.

Mantran Robert, *Istanbul dans la seconde moitié de XVIIe siècle*, Paris, Libraire Adrien Maisonneuve, 1962.

Nuri, Osman, *Mecelle-i Umur-ı Belediye*, 5 v., Istanbul, 1914–1922, transcribed in 9 v. Istanbul, İstanbul Büyükşehir Belediyesi, 1995.

Orhonlu, Cengiz, 'İstanbul'da Kayıkçılık ve Kayık İşletmeciliği', *Osmanlı İmparatorluğunda Şehircilik ve Ulaşım üzerine Araştırmalar*, Izmir, 1984, pp. 83–103.

Pamuk, Şevket, 'Money in the Ottoman Empire, 1326–1914', in Halil Inalcik and Donald Quataert, ed., *An Economic and Social History of the Ottoman Empire*, Cambridge, Cambridge University Press, 1994, pp. 947–985.

Quataert, Donald, 'The Age of Reforms, 1812–1914', in Halil Inalcik and Donald Quataert, ed., *An Economic and Social History of the Ottoman Empire*, Cambridge, Cambridge University Press, 1994, pp. 761–943.

Raymond, André, 'Soldiers in Trade: The Case of Ottoman Cairo', *British Journal of Middle Eastern Studies* 18-1, 1991, pp. 16–37.

Raymond, André, 'The Role of the Communities (*tawa'if*) in the Administration of Cairo in the Ottoman Period', in Nelly Hanna, ed., *The State and Its Servants: Administration in Egypt from Ottoman Times to the Present*, Cairo, The American University in Cairo Press, 1995, pp. 32–43.

Refik, Ahmed, *Onuncu Asr-ı Hicrî'de İstanbul Hayatı (1495–1591)*, Istanbul, Enderun Kitabevi, 1988, first published 1333/1914–1915.

Seng, Yvonne J., 'The Şer'iye Sicilleri of İstanbul Müftülüğü as a Source for the Study of Everyday Life', *Turkish Studies Association Bulletin* 15-2, 1991, pp. 307–325.

Sıtkı, Mehmet, *Gedikler*, Istanbul, 1325 /1909–1910.

Taeschner, Franz, 'Akhî Ewrân', *Encyclopaedia of Islam* (2nd ed.), 1960, pp. 324–325.

Todorov, Nikolai, *The Balkan City: 1400–1900*, Seattle, University of Washington Press, 1983.

Uluçay, Çagatay, 'Istanbul Saraçhanesi ve Saraçları', *Tarih Dergisi* III, 1951–1952, pp. 147–164.

Yi, Eunjeong, 'The Istanbul Guilds in the Seventeenth-Century: Leverage in Changing Times', unpublished PhD dissertation, Harvard University, 2000.

CHAPTER 4

Ottoman Craftsmen: Problematic and Sources with Special Emphasis on the Eighteenth Century

Suraiya Faroqhi

What can be learned from familiar sources

At first glance, it may appear that 'new' sources on Ottoman craftsmen are no longer to be expected. For the last forty years or so, we have known that wherever they exist, registers compiled by the scribes of the local kadi courts (*kadı sicilleri*) constitute the principal documentation on artisan life. After all, other archives originating 'at grassroots level' in Ottoman towns or cities have survived only in exceptional cases. Thus, the documents manufactured by the kadi's scribes will continue to form our principal resources, particularly since here we find quantities of estate inventories concerning, among others, deceased craftsmen.

If we are lucky, these texts will list not only the contents of dwellings, but also those of shops and workshops. Disputes between guildsmen, another topic frequently covered by the kadi registers, may involve non-adherence to standards supposedly valid from time immemorial or they may concern the sharing out of taxes levied as lump sums upon the inhabitants of this or that town as a totality. If serious enough, such disagreements might be adjudicated not by mere guild elders and market supervisors, but by the kadi himself.[1]

This, our principal source of information, which flows more abundantly for some towns than for others, to some extent can be supplemented by sultanic commands attempting to regulate artisan behaviour.[2]

Both the Registers of Important Affairs (*Mühimme Defterleri*) and the Registers of Complaints (*Şikâyet Defterleri*) contain many examples, mainly involving the sixteenth and seventeenth centuries. Again, disputes constituted the main occasion for issuing such commands. Rival claimants might address themselves to the Sultan's Council (*Divan-ı Hümayun*) either from the very beginning of their suit or else at a later stage, namely, if they were dissatisfied with the kadi's judgement.[3] Moreover, the lists of administratively fixed prices (*narh*), particularly, the 1050/1640 list superbly edited by Mübahat Kütükoğlu, tell us a good deal about the kinds of goods available in the Istanbul market.[4] But again, the existence of these documents has been known since the 1940s when Ömer Lütfi Barkan edited the first examples.[5] Other price lists will turn up again and again in kadi registers, but rarely long or elaborate enough to warrant a separate edition, so this is not really a 'new' source for the historian of Ottoman artisans.

Archival documents have been supplemented by more or less narrative material. As far back as the 1950s, Abdülbaki Gölpınarlı had pointed out that *fütuvvetnames*, dealing with ceremonial originating with medieval *ahis* but frequently copied out by sixteenth century craftsmen, could shed some light on the customs and values of early Ottoman guildsmen.[6]

Last but not least, there are the festival books (*sûrnâme*), which describe, among other things, the artisan parades which often accompanied circumcision festivities in the ruling family or the departure of an army on campaign. This material has been known for over a hundred and fifty years; Joseph von Hammer referred to it in his multi-volume history of the Ottoman Empire.[7] Apart from the textual evidence, two *sûrnâmes*, namely those of 990/1582 and 1133/1720, have been lavishly illustrated with contemporary miniatures.[8] Moreover, there exists some archival material pertaining to craftsmen's parades. One such list of participants was consulted by Evliya Çelebi when, in the mid-seventeenth century, he described Istanbul; it is probable that his account of Cairo craftsmen depends on similar evidence.[9] But as well-stocked markets and local speciality products in Evliya's view constituted noteworthy features of any town, his travelogue also provides information on craft production in other Ottoman towns and

cities. Yet, unfortunately for us, he is generally concerned with the product, rather than with the producers.[10]

New kinds of problematic

However, it must be admitted that the sources used up until now allow us to ask many questions, but to answer only a small number of them. One of the most perplexing will be mentioned very briefly as it concerns the pre-eighteenth century period. To put it in a nutshell, how did Ottoman craftsmen's guilds come into being, not only in the 'core provinces' of Rumelia and Anatolia, but also in the Arab lands? As for the latter, modern researchers assume that guilds did not exist in the pre-Ottoman period.[11] Yet, since they were active and lively by the middle of the seventeenth century, they must have formed during the first one hundred years or so of Ottoman rule. No evidence has been located until now which would shed any light on this matter. Thus, historians have not found any sultanic command ordering the institution of craft guilds in Mosul, Cairo or Jerusalem, even though these towns/cities have been well studied.[12] Nor do we have the slightest idea why craft guilds were so rapidly adopted by the artisans of regions which, supposedly, had fared well enough without them during the past centuries.[13] It would be an illusion to assume that an order of the ruler would have been sufficient; plenty of sultanic commands were issued which were mostly honoured in the breach.

Moreover, we would be deceiving ourselves if we assumed that we really understand the process by which the earlier Anatolian craftsmen's organisations emerged, probably during the little-documented fifteenth and sixteenth centuries. Fourteenth century sources indicate the existence of *ahis*, apparently Anatolian counterparts to the better-known *fityan* of Syria. These young men seem to have formed factions and, in towns such as Ankara where, at times, no sultan was recognised, prominent *ahis* apparently functioned as city governors.[14] Texts composed in this milieu, the so-called *fütuvvetnames*, were popular among guildsmen, as we have seen. In copying these older texts, Ottoman artisans attested to their continuing relevance; many guilds probably arranged their own rituals accordingly. Remarkable is the posthumous fame of Ahi Evran of Kırşehir, who, though

by no means a tanner according to his legendary *vita*, was soon 'adopted' by the tanners' guild. Even in the eighteenth and nineteenth centuries, Istanbul tanners continued to turn to the shaykhs of Ahi Evran's remote central Anatolian lodge.[15] But these and other links between *ahis* and guilds do not explain why and how the *ahis* who did not constitute guilds, even though many of their members must have been artisans, faded away in the fifteenth century, while the *ahis'* descendants formed guilds. It is not very likely that we will locate further sources relevant to these matters and the available texts have been mined for all the information that they contain. Probably, the genesis of Ottoman guilds will remain something of an enigma.

Tracing the *gedik*

However, even where later guild history is concerned, enough problems remain to keep the historian busy. A sizeable documentation shows that during the late eighteenth and early nineteenth centuries, Ottoman guilds became much more structured. At least in Bursa and Istanbul, many of the more important guilds instituted foundations of their own whose revenues financed the guildsmen's ceremonial gatherings. Cohesion was thus reinforced, but another factor was even more significant in drawing the guildsmen together. Seventeenth and even early eighteenth century records do not often mention the right of a given craftsman to do business in a certain place, the so-called *gedik*. But this institution is mentioned much more often and, presumably, became more widespread in the later eighteenth and early nineteenth centuries.[16]

Gediks could only be transferred from one member of the relevant guild to another. If the artisan in question did not leave behind a son capable of succeeding him, the right to open a shop passed to the senior journeyman. If the artisan left a son too young to take over his father's shop, a journeyman might be allowed temporary tenure with a sum of money changing hands when the young master took up his inheritance. Whether *gediks* were freehold property in the conventional *şer'î* sense is, however, less clear; down to the present date, I have not seen estate inventories of artisans in which *gedik* figured as a separate item. But all these

uncertainties apart, clearly a guild with many *gediks* needed a more formalised structure than one from which *gediks* were largely absent.

Moreover, the researcher's life is complicated by the 'double meaning' of the term *gedik*. In addition to being used in the sense outlined above, the term is also employed for the implements and raw materials in a given shop. Apparently, Ottoman officials of the time thought that this latter usage might give trouble to the readers of the documents that they composed.[17] While they did not usually consider it necessary to explain the term *gedik* when used as 'the right to do business in a certain place', they often defined *gedik* when they intended 'implements and materials'. Why these two rather different concepts were expressed by the same term, at the present stage of our research, must remain unexplained.

That *gediks* transformed the existence of guildsmen is not open to doubt. In the case of seventeenth century Bursa, where *gediks* were still rare, it has been established that entrance into and exit from a guild were not too difficult: the individual artisan's payment of market taxes with a given guild constituted the crucial factor.[18] As a result, some artisans might, in the course of their lives, become members of more than one guild. But once *gediks* had become widespread, the acquisition of this crucial prerequisite for exercising a given craft had to be inherited, acquired by a long waiting period or purchased from a fellow guildsman. Migration from one city to another became more difficult once the entry of outsiders into a given guild only was possible under exceptional circumstances. It is unlikely that the artisans concerned considered this development as a major drawback, for 'outsiders' to many organisations had long been considered, both by bureaucrats and by artisans themselves, as less skilled than the original members. Describing someone as a stranger (*ecanib*) for a long time had been tantamount to demanding his expulsion.[19]

But apparently, at least in Bursa with its craft industries working partly for the Istanbul market, there had existed, down to the seventeenth century, a grudging *de facto* flexibility which disappeared with the diffusion of the *gedik*. However, it must be admitted that things were quite different, for instance, in nineteenth century Damascus, where *gediks* were routinely rented out along with shops and it was in no way necessary to inherit or purchase them. As in many other matters, we must conclude that

while many institutions showed a family resemblance throughout the far-flung Ottoman territories, the amount of regional variation remained considerable.[20]

At the roots of gedik: crisis or prosperity?

The question is what motivated Ottoman artisans to invent *gediks*, kadis to accept their existence and the central administration to at least tolerate them. It has been suggested that *gediks* were intended as a response to adversity.[21] In the second half of the eighteenth century, the Ottoman government involved itself in a series of ruinous wars leading to financial crisis, and to partly compensate for the deficit, attempts were made to collect money from pious foundations. Legally speaking, this was a highly dubious undertaking, for according to the *şeri'at*, foundations should have spent their funds entirely on the purposes determined by the donor (*şart-ı vâkıf*). In response to these official demands, legal or not, foundation administrators tried to increase revenues by demanding more rent, while artisans concerned about retaining their accustomed locales limited competition for shops and workshops by devising the *gedik*. If a given shop could only be passed on within a small circle of masters, it was less likely that rents would be bidden up to dizzying heights.

As a counter-proposition, it has been suggested that *gedik* was not so much a result of late eighteenth century adversity as of early eighteenth century prosperity.[22] After 1699 and especially after the losses of the Ottoman-Habsburg war had, to some extent, been compensated for by the Peace of Belgrade (1739), the Ottoman central state made a concerted effort to get trade going once again. Caravan security was a major item on the agenda. Khans were restored or newly built and the old custom of making villagers responsible for the guarding of passes was revived.[23] In the latter case, this involved the institution of clear lines of command and also a careful redefinition of the guardsmen's responsibilities.

Apart from increased security resulting from these political measures, it has been suggested that economic revival also benefited from the international conjuncture of the time.

European merchants of this period were only moderately interested in the eastern Mediterranean. Thus, their demand was no longer causing raw material scarcities for local craftsmen, as had been true in many sectors of the Ottoman economy during the later sixteenth and early seventeenth centuries.[24] Bengali and Chinese silks were in higher demand than their Ottoman (or, for that matter, Iranian) counterparts, while cotton was now grown in such large quantities that domestic and foreign markets could be satisfied at the same time. In some regions, Ottoman craftsmen even succeeded in imitating Indian fabrics, a major import both into the Ottoman Empire and Western Europe during the seventeenth century. Printed cottons from Aleppo and Ayntab (Gaziantep) became popular not only among Ottoman consumers, but were even exported to Marseille.[25] Indicators of economic revival have been observed in many parts of the far-flung Ottoman Empire from Cairo to Tokat and from Ambelakia or Filibe (Plovdiv) to Ayntab. Specialised studies record economic growth, particularly in textiles, even though this expansion did not exclude serious difficulties in other localities.[26]

Apart from merchants and tax takers of various kinds, at least some craft masters must have benefited from this prosperity. It is not unthinkable that they should have been unwilling to share their recent gains with journeymen or part-time peasant manufacturers and that they developed *gedik* as a means of keeping out unwelcome competitors. But as adverse conjunctures are usually more conducive to restrictive behaviour than times of expansion, a link with the economic crisis of the later eighteenth and early nineteenth centuries somehow seems more probable.[27]

State pressure and mutual supervision

Another possible factor causing the increasing rigidity of guild structures was the growing demand for mutual guarantees (*kefalet*). This institution had been typical of Ottoman towns even in the sixteenth century and probably had its source in the legal system. As is well known, Ottoman sultanic law demands that blood money for killings whose perpetrators cannot be traced should be paid by the village or town quarter on whose territory the crimes in question had taken place. Therefore, in crisis

situations, townsmen were required to furnish guarantees, for instance, that they would not open the citadel gates to rebels. Those unable to produce the appropriate guarantors would be ordered to leave town. In some cases, this practice might lead up to a more formal organisation of the townsmen concerned. Thus, in early seventeenth century Ankara, when the town was threatened by rebellious mercenaries, town quarters even appointed *yiğitbaşıs*, just as if they had been guilds.[28]

But it would seem that in the eighteenth century, this customary demand for mutual guarantees was remodelled and amplified by the authorities, possibly to cope with something that the Ottoman administration viewed as a kind of authority crisis. Thus, the state impinged upon rural society by adapting the religious vow (*nezir*) to the purpose of political control. For instance, villagers were required to post important sums of money as bond that they would hand over a person whom the state authorities deemed to be a robber or rebel, even if the man in question happened to be a close relative of one of the village community members. If the man was not turned over, the village as a whole paid a crippling fine. In the same way, nomads were required to post bond that they would not visit a particular summer pasture or refrain from using a route passing through a village from which there had been complaints. These practices required an increasing control on the part of the community over the constituent households and individuals. As one dissident might bring disaster upon the whole group, the latter presumably took good care to get rid of troublesome people long before a major conflict ensued.[29]

Until now, I have not encountered guildsmen required to post bond in the same way as was sometimes demanded of villagers and nomads. But that was not really necessary as guilds were probably more amenable to state pressure than most villages or groups of nomads. Increasing authority of guild officials over their fellow guildsmen may well, at least in part, have been the consequence of state pressure. Thus, in 1133/1720, the Ottoman administration made a determined effort to weed out bakers selling underweight loaves. Those deemed guilty had their assets confiscated and, with the co-operation of guild officials, stores and implements were sold at auction with the proceeds accruing to the state treasury.[30] It is not hard to imagine how, in such a

situation, established guildsmen might be denounced by journey-men and others hoping to take their places, and guild officials attempted to arbitrate such disputes. It may equally have been to the advantage of the established masters to have as small a number of fraud cases proven as humanly possible and this concern may have involved removing the 'black sheep' from the guild before formal procedures were begun.

Artisans in conflict with tax farmers

This brings us to the conflicts in which artisans might be involved. Recent research has shown that craftsmen were more often in conflict with tax farmers and their subcontractors than with the administrators of pious foundations.[31]

After all, many craftsmen possessed permanent leases (*icareteyn*) and thus were not immediately threatened by increased rents.[32] Foundation administrators' demands could be very troublesome in specific circumstances which we have yet to discuss. But other opponents posed a more permanent and probably also a more formidable threat.[33]

The system of life-time tax farms (*malikâne*), instituted in 1106/1695, particularly affected not only the revenues of the central treasury, but also the well-being of artisans. This was contrary to the intentions of the Ottoman government. When life-time tax farms were first instituted, the idea had been to protect taxpayers from the exactions of rapidly changing tax farmers. Appointed for a few years or months, these men typically had been unwilling to invest in mines, dye houses or bridges, but were only interested in collecting a maximum of revenue during their brief tenures. Life-time tax farmers, who paid a fixed rate every year for the tax farm, were expected to think of long-term perspectives and therefore to avoid killing the goose that laid the golden eggs.[34] Moreover, life-time tax farms had the political side effect of stabilising Ottoman control in an age of major challenges. Local elites were made into 'shareholders' of the Ottoman political enterprise and were thus discouraged from attempting to set up states of their own.[35]

However, where taxpayers were concerned, protective effects of the life-time tax farm were soon counteracted. Tax farms of

this type were only awarded to members of the Ottoman political class (*askerî*) who, for the most part, did not reside in the localities where their tax farms were located. They, therefore, employed subcontractors who, usually lacking the guarantees accorded to the principal tax farmers, exploited the taxpayers just as badly as the earlier short-term appointees had done. Moreover, where investment was needed, responsibility presumably often devolved upon the subcontractors, whose motivation to put money into someone else's enterprise cannot have been very high.

Artisans attempted to cope with this situation by taking flight. A recent study has shown how, in the late eighteenth and early nineteenth centuries, Tokat artisans sought refuge in the small towns of the area such as Ezinepazarı or Turhal in order to escape the attention of the tax collector.[36] Tokat textile manufacturers also became quite expert in faking official stamps and thus evading the stamp tax. As a secondary consideration, artisans may also have been establishing themselves in places where living costs were lower. Auxiliary labour, such as spinners, also must have demanded lower wages in small towns than in a major commercial centre such as Tokat. In consequence, artisan mobility was high and migration often took place in fairly large groups of families. Tax farmers attempted to maintain the profitability of their tax farms by impeding artisan mobility wherever possible. But by so doing, they also prevented craftsmen from seeking out locations where production could be carried out in the most efficient manner.

In a sense, this behaviour constitutes the 'civilian' peacetime counterpart to the Ottoman state's penalising of more efficient producers during wartime.[37] When eighteenth century Ottoman armies needed to be supplied, the more prosperous producers were often made to ruin themselves by forced deliveries to the state at less than cost, so that the aftermath of war came to be synonymous with severe economic depression. In both war and peace time, artisans were obliged by administrative pressure to produce under conditions that were less than optimal and which, in certain cases, may have even approached disaster. As Ottoman bureaucrats before the Tanzimat were not much given to defending their policies in writing, we do not know to what extent this connection between state finance and declining artisan production was understood by the responsible officials. But it is likely that in

the view of Ottoman policy-makers, the short-term needs of the state had absolute priority.[38] Moreover, officials may have accepted the notion so prevalent among craftsmen themselves that rough equality should prevail among guildsmen and, therefore, wealthy artisans constituted a danger to the harmonious functioning of the guild.[39] However, these are mere hypotheses to be checked when and if the relevant sources become available.

Disputes between artisans, on the one hand, and foundation administrators and especially tax farmers, on the other, may be interpreted as an Ottoman variant of the age-old struggle between the poor and the powerful. While anything smacking of class struggle is out of fashion these days, it is worth noting that historians totally innocent of Marxian *problématiques* have pointed to the role of the Ottoman 'political class' in limiting the expansion of craft production.[40] One might even say that the integration of provincial elites into the Ottoman system, which the grants of life-time tax farms seem to have quite effectively secured, was achieved at the expense of artisans and artisan production.

This line of reasoning may also link up with the argument, much discussed in the 1960s and 1970s, that the crisis in Ottoman craft production was the effect of European demand for raw materials. As producers were unable to pass on increased costs to their customers, this demand led not to an expansion of raw material production, but merely to 'profit squeezes'.[41] When examining the reasons why costs could not be passed on and the reasons why, in spite of Naima's injunctions, the Ottoman bureaucracy avoided protectionism, we are concerned with a political issue, namely, the functioning of the Ottoman state apparatus.[42] We can thus reformulate the 'profit squeeze' hypothesis by stating that Ottoman artisans were especially vulnerable to pressures originating from the European world economy. This vulnerability was due to the manner in which the Ottoman state operated and to the peculiar manner in which artisans and the Ottoman political class related to one another.

Craftsmen and merchants

As far as the eighteenth century is concerned, the relationship between artisan producers and merchant distributors constitutes

one of the least known aspects of urban life. For the sixteenth and seventeenth centuries, some evidence on putting-out merchants giving work to rural artisans has been brought to light.[43] But things are much less clear for the later period. In eighteenth century Izmir and Ankara, local non-Muslim merchants competed sharply with French traders where the procurement of cotton or mohair wool was concerned.[44] Orders for carpets could be placed with manufacturers through merchant intermediaries, but evidence on carpets in this period is few and far between.[45] On the whole, the activity of merchants in organising manufactures has aroused but little comment in the available primary sources. Such enterprises were of marginal interest to the tax farmers who directly or indirectly generated so much of the Ottoman documentation relevant to this period. On the other hand, European traders were not usually concerned with Ottoman manufactured goods. Hopefully, a closer investigation of the economies of large cities such as Bursa and Istanbul, provided due attention is given to their hinterlands, will help us clarify the issue.

Craftsmen confronting one another

However, it is not at all clear whether, in the consciousness of Ottoman artisans themselves, these struggles had priority over disputes between guilds or even over disagreements between masters within a single guild. Here, the problem of deciding who controls what territory, a situation which we have already encountered in conflicts between artisans and tax farmers, appears again in a new guise. This issue took on particular importance in the eighteenth century when we encounter a large and probably increasing number of craftsmen plying their trades not in individual shops, but in collective workshops. Here, upwards of twenty and, in some instances, several hundred artisans in the same trade used common vats or other costly implements and defended the territory of their khan or other workshops against all other comers.[46]

As a hypothesis to be tested, I would submit that craftsmen in such locations were comparatively powerless against the administrators of the highly prestigious foundations that often owned the collective workshops in which they laboured. But where

95

'outsiders' were concerned, in other words, guild members deviating in one way or another from accepted rules as well as members of other guilds trying to establish a foothold in this particular location, the power of the established guild might be great indeed. Perhaps we can develop this argument by claiming that the administrators of pious foundations affected the work conditions of artisans not so much by raising rents, but by building new khans and collective workshops.[47] Once such buildings had been constructed, foundation administrators might use their political power in order to oblige reticent craftsmen to accept these new locations. Foundation revenues might be increased by demanding higher rents in a new location or by assembling a larger number of artisans on a single site.

If our hypothesis is at all reasonable, then this tendency to bring artisans together on a single site affected guild cohesion. Not only did guildsmen attempt to establish exclusive control over the collective workshops in which they spent most of their waking hours but working together with implements which were common property encouraged dyers or saddlers to supervise their fellow guildsmen more closely than had been the custom when they worked in individual shops. Moreover, it is probable that, in many cases, prosperous (though not overly wealthy) artisans had a better chance of obtaining guild offices than their poorer colleagues.

This tendency would explain why, at least, in the case of the Istanbul saddlers' workshop (the Saraçhane), the better-off guildsmen wanted the complex restored after a major fire while the poorer ones were apparently quite happy to move somewhere else.[48] Thus, the growing number of collective workshops which resulted from the need for extra revenue was presumably felt by many eighteenth century pious foundations. As, on the other hand, the strengthening of guild ties was presumably connected with the concentration of artisans in collective workshops, we may postulate an indirect link between the initiatives of foundation administrators and growing guild rigidity.[49]

Beyond hypotheses?

Up to this point, we have relayed a set of hypotheses concerning eighteenth century guild history developed by a small number

of scholars on the basis of, in every case, a limited number of observations. Our real difficulty is now to move beyond such more or less ingenious constructs, assuming, of course, that our sources are unambiguous enough to permit verifiable statements. I cannot claim that I am ready for this step at the present juncture. However, in this contribution, I propose to do part of the preparatory spade work by discussing some of the little-known sources which present-day Ottoman archivists have placed at the disposal of researchers. This proceeding should help us come up with some projects of feasible research.

It is not easy to decide whether an investigation of artisans and their guilds should limit itself to a single town or a few localities, or else focus on a sizeable region such as Rumelia, Anatolia or the Arab provinces. Once again, conditions differed enough from one Ottoman region to the next that observations valid for Egypt do not necessarily apply to Mosul, to say nothing of Istanbul or Athens. Monographs concerning an individual city recommend themselves because they allow us to reproduce some of the flavour of artisan life in that particular place, a feature which particularly distinguishes recent monographs on Aleppo.[50] However, at the present time, monographs even of high-quality have proved difficult to 'sell' as publishers respond to diminishing library funds by moving toward books which hopefully will tempt the general reader. This development is a potential source of trouble as, by a bit of bad luck, facile generalisations usually avoided in scholarly monographs are often deemed appropriate for the non-specialist public. Yet, by now, the Balkan and Arab provinces in particular have been well enough covered that we can try to place observations gained for Istanbul or Aleppo in a broader context. Viable compromises between the demands of scholars and publishers can sometimes, with some good fortune, be negotiated.

By concentrating upon the eighteenth century, the present author hopes to avoid the somewhat non-temporal accounts of Ottoman artisans found in much of the literature. For if we amalgamate data from the seventeenth, eighteenth and nineteenth centuries, admittedly we arrive at a picture that is more complete than an image of a more limited time period could ever be. But, in the process, we make it impossible to see changes over time, a concern which has gained in urgency now that most of

us have become allergic to notions of 'the timeless East'. And since this research is based on the assumption that the consolidation of Ottoman guilds was, to a significant extent, a later eighteenth and early nineteenth century phenomenon, the question of historical change occupies centre stage.

A gem: Bursa foundation accounts

A set of documents with considerable significance for guild history is connected with the Ottoman central government's attempts, constantly renewed, to monitor the administration of pious foundations. In eighteenth century Bursa, persons responsible for pious foundations frequently needed to present accounts which the auditors copied into registers forming part of the local court archives. Today, these account books are catalogued among the Bursa kadi registers. Many of the pious foundations existing in Bursa at that time consisted of sums of money which the donors had entrusted either to the *imam* of the local mosque or to an administrator of their choice. This money was lent out at interest at a moderate rate (10–15 percent) and the income served to finance whatever religious or charitable activity that the donor considered appropriate.[51]

While we do not encounter guilds as pious donors in the foundation registers of the sixteenth century, by the end of the eighteenth many craft guilds had acquired foundations of this kind. In any case, foundations established by guilds financed religious ceremonies at which some food was often distributed. Auditors wanted to know the identities of the donors contributing to every pious foundation, what the latter's resources amounted to and whether revenues were being used in accordance with the wishes of the donor. Thus the auditors' registers tell us which Bursa guilds had acquired pious foundations of their own and how much money was in the possession of these institutions. At any given time, most of this money was in the hands of the borrowers and the administrators thus needed to list the names of the latter. Not only guild members, but also significant numbers of outsiders benefited from the resources of guild foundations. These formed one of the many integrative devices securing a degree of urban cohesion, although formal

institutions organising Ottoman cities as a whole were weakly developed.[52]

Scholars are beginning to work with this material, but we have by no means exhausted its potentialities. Thus, we may compare lists of pious foundations established by guilds and compiled in different years so that the emergence of the guild foundation can be charted. We may be able to determine in which guilds the custom of establishing pious foundations originated, which ones took up the idea with alacrity, which ones remained reticent and how the whole arrangement ultimately disappeared – even though, in order to answer the last question, we will have to study nineteenth and even twentieth century materials. However, until now, such registers have only been located for Bursa, but the existence of guild foundations themselves is known for Istanbul as well. It is, moreover, likely that other Rumelian and Anatolian towns also possessed them. Yet, since the present catalogues of kadi registers do not record the contents of individual volumes, we will learn about listings of guild foundations only when a scholar working on the relevant time and place happens to locate such documents.

A special register of pious foundations

Due to the pioneering work of Halil Inalcık and Halil Sahillioğlu, we think of the Bursa kadi registers mainly as a treasure trove for the late fifteenth and early sixteenth centuries.[53] By contrast, the eighteenth century appears to the non-aficionado mainly as a period of *ancien régime* involution and the sources pertaining to this later period have been very much neglected. Thus, we have tended to ignore the fact that considerable administrative re-organisation took place during the eighteenth century and that, if nothing else, the new bureaus produced large amounts of doc-umentation.[54] This rule also applies to the administration of Bursa pious foundations, many of which had been established by members of the sultan's family in the early centuries of the Ottoman Empire. Sultanic foundations were administered by the Darüsse'ade Ağası, the Chief Black Eunuch.[55]

The series of Bursa kadi registers contains a volume dating from the late eighteenth century, totally dedicated to the affairs

of local sultanic foundations. But, this time, it was not the accounts which were at issue, but ordinary court cases such as we would expect in any kadi register.[56] Presumably, the responsible officials assumed that they needed to explain why they had removed these cases from the general register. They thus declared that for a long time now (*öteden beri*), the affairs of people residing on land belonging to the foundations in aid of the Holy Cities of Mecca and Medina had been judged by an official known as the Haremeyn-i Şerifeyn Vekili and not by the local kadi and his aides.[57] However, since a special sultanic command had recently been issued in this affair, it is likely that the arrangement was not, in fact, as ancient as it was made out to be. It may have been instituted in the context of an attempted reform of sultanic foundation administration undertaken by Sultan Abdülhamid I (r. 1774–1789).[58]

For the historian of artisans, this register is important because the number of people bringing their disputes to the Haremeyn-i Şerifeyn Vekili was, after all, limited and a good deal of energy could therefore be devoted to individual cases. There must have been a good deal of overlap between sultanic foundations and those benefiting the Holy Cities. Certainly, the early Ottoman sultans had built elaborate complexes of mosques, theological schools and soup kitchens which needed to be financed out of endowment funds. But often some minor donation to the populations of the Holy Cities was included in a large sultanic foundation and, with Egyptian supplies to the Holy Cities failing from the late seventeenth century onward, such sources of support gained in importance. From our study's point of view, it is fortunate that the foundation supporting the library of Sultan Ahmed III within the Palace grounds (established in 1131/ 1719) was covered by our register. This foundation possessed a large dyers' workshop, first located in Istanbul and later in Bursa, which had been endowed with substantial privileges. As a result, craftsmen working for this foundation seem to have spent a good deal of time and energy defending their rights in front of the Haremeyn Vekili.[59] Only further detailed work with the Bursa registers will show whether this particular document was unique or not.

An old topic in a novel brand of register: confirming the commands of previous sultans

It is well known that from early Ottoman times onward, a sultan was not bound by the grants of privilege or appointment made out by his predecessor(s). Thus, after a new ruler had ascended the throne, the holders of such documents applied to the relevant chanceries for confirmation.[60] But, while for earlier periods, we encounter, for instance, these renewed sultanic commands scattered throughout the Registers of Important Affairs, for the eighteenth century special volumes documenting just this one procedure have survived.[61] Of course, these formidable collections of several hundred pages each do not contain especially large numbers of texts relating to guild affairs. Religious communities, foreign consuls and ambassadors, dervishes and administrators of pious foundations have all figured among the numerous personages applying for confirmation from the newly enthroned ruler. Many of these applicants, both Muslim and non-Muslim, must have been more powerful than our modest craftsmen, who may have spent a good bit of time waiting for their turn.

But, even so, the number of commands concerning artisans is quite remarkable and often so is their intrinsic interest. A certain depth in time is also achieved as these texts routinely enumerate the documents which the guildsmen in question submitted to the Ottoman chanceries. In most cases, this was merely a command from the recently deceased ruler. After all, older texts, while bolstering the craftsmen's claim to ancient rights, were not immediately relevant from a legal point of view. But in some instances, such older material can also be located in the archives.

These registers of confirmed documents are tempting to the historian because, in principle at least, they should be exhaustive. As the privileges issued by a deceased ruler were not valid unless confirmed, all persons, families or organisations had an immediate interest in applying to the authorities as fast as feasible. However, distance, the condition of the roads or the activities of robber bands must have made it impossible for certain beneficiaries to secure confirmation, especially if the new sultan remained on the throne for only a limited period of time. Moreover, nobody has yet tried to locate and list, for the benefit

of his/her colleagues, all the registers made up uniquely of commands confirming earlier orders.[62] Nor has there been any study of the bureaucratic confirmation process itself. As a result, we do not know how many registers were compiled at the accession of any given sultan and whether the number of volumes was fixed by convention or else varied from case to case. Exhaustiveness thus remains a mirage. Present researchers will often limit themselves to a search for sultanic commands relevant to this or that topic, while the information which might be gained from studying series of registers in their entirety usually continues to elude us.[63]

Registers concerning campaign preparations

Such registers must have been needed as far back as the fifteenth century, if not earlier. However, even for the late sixteenth and early seventeenth centuries, they have survived only occasionally.[64] Sometimes collections of campaign-related orders were integrated into the Registers of Important Affairs, but this was not always true and, since so many registers of this period have been lost, it is hard to judge which bureaucratic procedures were followed when putting together campaign records. However, in the late eighteenth century, Ottoman commanders may have gained fewer victories, but their record-keeping was more systematic. Thus, in this late period, we do encounter voluminous registers concerned with the supplies of uniforms, sailcloth and other war materiel needed for a single campaign.

A good example of this type is a register dated 1215/1800–1801 concerning the campaign against the Napoleonic occupation of Egypt.[65] Given the naval component of this undertaking, quite a few commands relate to the Arsenal. This is a fortunate circumstance for the historian of Ottoman craftsmen for many more manufactured items are needed for naval than for land wars. Arms, clothing and shelter are necessary in both instances but, technologically speaking, ships pose more sophisticated challenges than carts, horses or camels. As a result, the services of numerous artisans were required. Some of them were occupied permanently in the Arsenal, while the services of others were commandeered for the occasion.[66]

Thus, to cite a random example, when the copper sheaths which, in the eighteenth century, often protected ships' hulks were to be put in place, kettle-makers (*kazgancı*) were called up for service with the co-operation of their guild elders.[67] An experiment was undertaken to determine costs. But whoever was responsible seems to have entered figures which did not please the authorities, both where the losses of copper during smelting and the wages paid to the craftsmen were concerned. Permissible smelting losses were thus reduced from 5 percent to 3 percent while costs including wages, presumably for the production of sheaths weighing 100 *vukiyye* (128.28 kg) were reduced from 79 to 73 *akçe*. Once again, the elders of the kettle-makers' guild were summoned and, in one way or another, made to consent to the reduced wages and material costs.

Whether any of the figures cited were realistic is, of course, a different matter. In wartime, as is now well known, the Ottoman state was notorious for bankrupting producers due to the low prices paid for grain and war materiel.[68] A monographic treatment of this or some other naval campaign will probably provide further information about the role of craftsmen in campaign provisioning and help us determine whether there were any major changes in the eighteenth century when compared to earlier periods. What we know about this issue at present concerns mainly the sixteenth and seventeenth centuries.[69]

The Vilayet Ahkâm Defterleri: newly explored source

For a long time, printed catalogues of the Ottoman archives have indicated the existence of a collection known simply as 'provincial command registers' (*Vilayet Ahkâm Defterleri*). These were instituted in the mid-eighteenth century to cope with what must have been a vastly increased amount of correspondence. For even though sultanic commands were now to be divided up among 16 different provincial registers, the long-established Registers of Important Affairs and Complaint Registers continued to exist as well. The latter contain particularly worthwhile information on eighteenth century artisans, as earlier volumes of the same series had done about the latter's seventeenth century predecessors. For the time being, I do not know which

considerations prompted the scribes to enter a given command into the provincial command registers rather than into those concerned with general complaints (şikâyet). Responses to complainants are certainly frequent in both collections.

The chances of finding sultanic commands pertaining to craft affairs are obviously greater when dealing with provincial registers than when 'looking for a needle in a haystack' in the overall Registers of Important Affairs. But even so, it is still an arduous business where any place except the Ottoman capital is involved. Disputes among the grantees of military tax assignments (sipahi) and administrators of pious foundations take up major amounts of space and so do complaints from heirs who felt that they had not received their due. Moreover, the size and structure of the province in question has a considerable impact on the amount of material on artisans that we find in the registers.

Thus, in the province of Karaman, there is much more evidence on the two towns of Konya and Kayseri than on smaller places such as Akşehir or Beyşehir. Moreover, as bad luck would have it, some of the most important cities of eighteenth century Ottoman Anatolia, namely Izmir, Ankara and Bursa, were all located in the same enormously large province of Anadolu. In the absence of indices to the Ahkâm registers, this means that historians working on any one of these cities are bound to waste a good deal of time. Only in the case of Istanbul, a series commenced some years ago by the local City Administration promises to make much material contained in the Ahkâm Defterleri more easily accessible in the future.[70]

Sultanic commands copied into kadi registers

It has been known for a long time that kadis were supposed to record the sultanic commands addressed to themselves and to provincial governors into their registers. For the most part, the kadis' scribes would begin entering these texts on what to them was the last page of their notebook and which to us is the first, gradually proceeding toward the middle. When the register was full, entries beginning on the back page, which concern ordinary affairs of the tribunal, and the entries concerning sultanic commands would therefore meet more or less halfway.

Only in certain large cities, such as Aleppo and Damascus, were there separate registers just for sultanic commands. If records had been systematic and both the registers prepared by the central administration (*Mühimme*, *Şikâyet* and *Vilayet Ahkâm Defterleri*) and those produced by the kadis' courts had been preserved without major losses, we would expect to possess two copies of all commands sent out to provincial kadis and governors. In actual fact, this almost never occurs and we are fortunate if a single copy has been preserved. As to the selection of commands copied into the kadis' registers, no special attention was paid to artisans, even though they are referred to time and again. So we find ourselves once more searching for the proverbial needle in the haystack.

A multitude of single commands: originals, not copies

Individual sultanic commands addressed to Ottoman subjects, along with the supplementary evidence which so often accompanied them, have rarely survived for the sixteenth and seventeenth centuries, but they are abundant for the eighteenth and nineteenth. However, locating them is quite a problem as most of the relevant catalogues do not feature indices. We must assume that documents of this kind surviving in the central archives were submitted to the authorities by the addressees or their descendants when seeking confirmation. When the new command had been issued, the previous one was presumably retained in the central archives.[71] Wars and migrations apart, such a practice would account for the paucity of such documents surviving in private hands.[72]

An important category among the extant individual commands concerns guild officials.[73] Procedures followed when appointing a guild warden (*kethüda*) involved an informal canvassing of the master craftsmen concerned. Though this must have been done orally, it was important.[74] As we do occasionally encounter cases of *kethüdas* deposed for failing to gain the approval of their fellow guildsmen, we can be sure that, in most instances, the consent of the masters was sought before the procedure was even begun.[75] As the first official step, the name of the candidate was proposed to the kadi or adjunct kadi (*naip*), who, if he endorsed the candidacy,

sent a petition to the office of the Grand Vizier. This official ordered investigations to be made by the responsible bureaus. Unfortunately, we have no very clear idea as to the people asked for their opinions. If no problem ensued, the Grand Vizier issued a *buyuruldu*, upon the reception of which first a sultanic command (*ferman*) and then a formal appointment document were issued.[76] When such documents had been confirmed by a later sultan and before being placed in the archives, they were sometimes attached to one another so as to form a file.

Many appointment documents are not very informative as they will only tell us that X resigned his post and asked for Y to be appointed in his place, or else that Y had died and Z was a suitable person to succeed him. More informative are the records of disputes which might be settled by the kadi (in which case, as we already know, they found their way into the kadi registers) or by the central government.[77] To mention just one example, in 1181/1767–1768, a dispute pitted Istanbul hoof-smiths against the makers of large nails, which the former needed for the conduct of their trade. At issue were the prices for different varieties of nails which had been agreed upon in 1176/ 1762–1763 in the presence of the Chief Architect. However, the nail-makers claimed that their expenses were so high that they could not abide by the agreement, a claim which the central administration found unacceptable. An order was thus issued to the nail-makers to deliver nails to the hoof-smiths at the price agreed upon a few years previously.[78]

Last but not least: a few exotic tidbits

At first glance, it would appear as if sources on Ottoman craft production are not to be expected outside the Ottoman archives. After all, European merchants of the time were concerned largely with the sale of craft products from their own countries, especially fabrics, and from the Ottoman Empire they imported raw materials such as cotton or silk, or foodstuffs such as olive oil or grain. As a result, consular officials of France, England or the Netherlands only in exceptional cases had any occasion to concern themselves with Ottoman artisans whom, in any case, they would have not encountered very often.

However, some of the information on raw material trade is of value for the history of Ottoman craftsmen as well. Thus the Archives of the Chamber of Commerce in Marseilles contain some valuable information about the mohair trade, a speciality of Ankara ever since the fifteenth century. Seventeenth century Dutch merchants bought mohair for use in the Leiden manufacture of camelots which, however, was in decline by the 1730s.[79] Mohair was also employed in the manufacture of buttons, but these went out of fashion after 1700. Thus, by the mid-eighteenth century, the major European employment for mohair was the camelot industry of Amiens in northern France.[80]

All goods imported into France from the eastern Mediterranean and not passing through Marseilles paid a punitive surtax of 20 percent until the French Revolution. However, during the Seven Years' War (1756–1763), French merchantmen were unable to reach Izmir due to attacks both by the English fleet and those of numerous privateers, many of them Greeks, who were happy to eliminate a major competitor for the carrying trade in Ottoman waters. In order to prevent the collapse of the Amiens industry for lack of raw material, Louis XV therefore suspended the surtax for the duration of the war. Until 1763, Amiens merchants were authorised to import mohair from Holland without any penalties.

However, the Marseilles merchants, who, it must be admitted, during this period often reacted more like petty shopkeepers than like wholesale merchants, saw this exemption with much concern. Their worry increased when, toward the end of the period of grace, the Amiens manufacturers indicated that they wanted to continue importing by way of Holland. Presumably, this demand was linked, at least in part, to lower transportation costs, for the multiple unloading, loading and transit dues on French roads and rivers must have constituted a significant expense. But, possibly, in order not to alienate the royal officials in charge of deciding their case – for the latter were quite as fiscalist as their Ottoman counterparts – the Amiens merchants and industrialists dwelt instead on the higher quality of the material purchased from the Dutch. A veritable war of pamphlets ensued, which is notable, given the limited significance of mohair imports not only to the French economy as a whole, but even to the trade of Marseilles.[81]

In this context, both sides to the dispute have furnished detailed information on the commerce in angora wool, which is, as far as I can tell, not available in Ottoman sources. First of all, we learn that the rule which gave monopoly access to local artisans for the best qualities of mohair, documented in Ottoman sources for the early nineteenth century, was actually being applied by the mid-1700s as well.[82] Exporters were only concerned with the lower qualities and did not show any interest in the more expensive ones. However, care was taken in the sorting of raw angora wool to be exported and, here, the Dutch apparently had an edge over their French competitors. We do not know whether Ankara artisans were at all interested in these lower qualities of mohair but, if they were, the information relayed about sorting procedures and arrangements for storage would have some validity for Ottoman craftsmen as well.

Moreover, the French buyers of angora wool sent home invoices detailing the extra expenses incurred from the moment of purchase to the time that the merchandise was safely stowed on board ship. Again, the conditions under which Ottoman artisans transported their raw material probably were vastly different. But it is still of value to know how many people expected tips along the way and what real weighing dues (as opposed to those recorded in the contract of a tax farmer) may have amounted to. Therefore, linking this French evidence to the documents recorded in the eighteenth century Ankara kadi registers promises some interesting results.

What to do next: a provisional conclusion

Given the limitations of time and money, I have not been able to make a systematic survey of all the available documents in any category discussed here, even though I have made tentative forays into virtually all of them. At present, the most promising avenues of research seem to be the following: to begin with, we will want to concentrate upon the putative spread of the 'collective workshop' in the eighteenth century. To put it differently, we need to determine whether such workshops did, in fact, become more widespread after 1700 than they had been in earlier periods. A second approach will involve a closer analysis of the conflicts

between artisans and tax farmers, foundation administrators and rival guilds. After the results obtained with respect to Tokat, I would surmise that conflicts between craftsmen and tax farmers are by far the most significant of all, but that is a hypothesis which needs to be verified. In any case, all conflicts are helpful to the historian because the parties to the dispute often 'spilled the beans' concerning issues on which they normally kept silent.

One of the problems to be solved when following this research agenda is the constitution of a corpus of texts. As has become apparent from the survey attempted here, our documentation is 'open-ended'. An unknown but rather large number of sultanic commands survive, preserved either in the original or as official copies. If one were to study, for example, all documents of this type to be found in a particular section of the Ottoman central archives, this would not guarantee that relevant source materials will not also crop up in other totally unexpected places. To the contrary, previously unknown clusters of documents relevant to our chosen topic may be located at any time. Therefore, it is not very helpful to randomly select documents for detailed study among those we already happen to know, however useful this procedure would be for statistical purposes. Yet it may be helpful to study administrative procedures documented in a limited quantity of registers, such as preparations for a given campaign or the confirmation of guild privileges by a sultan newly acceding to the throne. In some instances of this latter kind, a random selection of documents to be examined in detail may well turn out to be worthwhile.

But on the whole, I think that we have little choice but to investigate case histories on an inductive level and follow up the leads that they give us. This means that we have little hope of giving a complete picture of guild dynamics where an entire large region is concerned. Only if and when a couple of monographs on eighteenth century Ottoman guilds or on large manufacturing centres such as Istanbul or Bursa have been completed will we be ready to draw a reasonably encompassing picture on the regional level. At present, when we think of Ottoman craftsmen as a totality, all we can do is generate hypotheses. I think that we should continue to do that even while, on the other hand, we stay rather close to the nitty-gritty of our documents. Rather than deducing the history of Ottoman guilds from some more or less

imaginary 'grand narrative', I would advocate a constant back-and-forth between primary sources and working hypotheses.

Notes

1 The pioneering study is Inalcik, 1953. For a discussion of guild affairs in seventeenth century Bursa, see Gerber, 1988, pp. 33–80.
2 For an early anthology of such materials, compare Refik, 1988.
3 For Istanbul, see Mantran, 1962, pp. 641–667 who gives a listing of the relevant documents. For Anatolia: Faroqhi, 1984.
4 Kütükoğlu, 1983.
5 Barkan, 1942.
6 Gölpınarlı, 1949–1950, pp. 92–93.
7 von Hammer, 1829, v. IV, pp. 118–133.
8 On the 1720 *sûrnâme*, see Atıl, 1999. On the *sûrnâme* of 1582, compare Proházka-Eisl, 1995; Atasoy, 1997. I thank Sevgi Gönül for providing me with a copy of this latter, extremely sumptuous book and Michael Rogers for informing me of its existence.
9 Mantran, 1962, pp. 355–356; for the full text see Evliya Çelebi, 1995, pp. 220–320. On Cairo, compare Raymond, 1973–1974, v. I, pp. 203–204.
10 This problem exists in much other Ottoman documentation as well, especially where the pre-eighteenth century period is concerned. As a result, monographs on the decorative arts such as book-binding or faience generally contain a great deal of information on the artefacts, but very little on the artists/artisans; see, for example, Raby and Tanındı, 1993, pp. 222–223.
11 Lapidus, 1984, p. 96.
12 Cohen, 1989, p. 2 mentions the existence of a Jerusalem black-smiths' guild in the 1540s. But, although this constitutes one of the oldest references to guilds in an archival document, the author has not followed up this issue. Behrens-Abouseif, 1994, p. 76 refers to guilds existing in Egypt in the early seventeenth century. Khoury, 1997, p. 36 assumes that there was no 'effective and functioning guild structure in sixteenth-century Mosul'.
13 However, the early seventeenth century source mentioned by Behrens-Abouseif on the basis of Baer, 1964, pp. 11, 14f. does assume that guilds existed in Egypt before the Ottoman conquest.
14 Cahen, 1988, pp. 152ff.
15 Taeschner, 1956.

16 Akarlı, 1985–1986.
17 Faroqhi, 1995a, p. 99.
18 Gerber, 1988, pp. 34–35.
19 Another term used for such persons was *haricden*, which also means 'outsiders'. Compare Dalsar, 1960, p. 338.
20 See Deguilhem, 1995, pp. 213–215, 217–221, where the author discusses the *kadak* along with the *kadak wa-khulû*.
21 Akarlı, 1985–1986.
22 Mehmet Genç made this suggestion orally in a public discussion: lecture at the American Research Institute of Turkey, Istanbul, spring of 1998.
23 Orhonlu (1967) has studied the sultanic commands (*padişah fermanları*) concerning the reorganisation of eighteenth century pass-guards.
24 Çizakça, 1985; Kredian, 2002.
25 Fukasawa, 1987.
26 Still valuable, even though by now over forty years old, is the article by Stoianovich, 1960; also see Raymond, 1973–1974. Genç (1987) discusses the evidence that life-time tax-farming data provide on Ottoman commercial and industrial growth down to the 1760s. On Tokat's prosperity and decline, we now have the dissertation by Duman, 1998.
27 This is also the position taken by Akarlı, 1985–1986.
28 Ergenç, 1995, p. 91.
29 Faroqhi, 1993.
30 Istanbul Bab Mahkemesi, n° 124, fol. 159b., 1133/1720 and elsewhere.
31 This is one of the major points made by Duman, 1998. I am grateful to Dr. Duman for providing me with this information just when I was completing the present research.
32 On the secure and inheritable tenures provided by 'double rent' arrangements, see Kreiser, 1986.
33 Faroqhi, 2002.
34 Genç, 1975.
35 Salzmann, 1995.
36 Duman, 1998.
37 Genç, 1995.
38 This is the fiscalism which, along with a concern for provisioning and the maintenance of tradition, constituted a central concern for Ottoman bureaucrats. See Genç, 1994, p. 60.
39 Inalcik, 1969, especially p. 107.
40 Inalcik, 1969, pp. 135–140.

41 Çizakça, 1980.
42 Inalcik, 1970, on Naima, see p. 215.
43 Inalcik, 1969, also see Faroqhi, 1995b.
44 Frangakis-Syrett, 1992.
45 Archives de la Chambre de Commerce de Marseille, LIX/1254 (fonds Roux) constitutes one of the few exceptions proving the rule.
46 Faroqhi, 2002.
47 For one example, compare Faroqhi, n.d.
48 Uluçay, 1951–1952. On the Saraçhane, also compare the recent, as yet unpublished, thesis by Özkoçak, 1997.
49 This is a revised version of the hypothesis originally formulated by Akarlı, 1984–1985.
50 See among others: Masters, 1988; Marcus, 1989.
51 Çizakça, 1995, pp. 313–354.
52 Faroqhi, 1995a.
53 Inalcik, 1960; Sahillioğlu, 1985.
54 Uzunçarşılı, 1948, pp. 353–393.
55 This explains why so many documents concerning pious foundations have wound up in the archives of the Topkapı Sarayı.
56 Bursa Kadı Sicilleri B89 (Milli Kütüphane, Ankara), dated 1207/ 1792–1793. The explanation for the peculiar contents of the register is found on fol. 41a.
57 I have not located any direct references to the Haremeyn-i Şerifeyn Vekilleri in the secondary literature. Presumably, this personage had been trained as an *alim*. In all likelihood, he was identical with the official called Haremeyn Müfettişi by Pakalın, 1971, v. 1, p. 745 (article Haremeyn Nezareti), since the Haremeyn Müfettişi was, in fact, under the supervision of the Darüsse'ade Ağası concerned with the *şer'î* aspects of the administration of sultanic foundations.
58 Pakalın, 1971, v. 1, p. 745.
59 Faroqhi, 1996.
60 In the tax registers (*tahrir*) of the sixteenth century, it was often noted which rulers had confirmed the rights of a given beneficiary. In the eighteenth century, whenever these rights needed yet further confirmation, it was common practice to copy out these series of long-dead rulers once again, sometimes rather to the frustration of the modern historian.
61 Compare Başbakanlık Arşivi-Osmanlı Arşivi, Maliyeden Müdevver (MAD) 9983, which encompasses commands confirmed after the accession of Sultan Mustafa III in 1171/1757 and MAD 7940, with commands confirmed after the accession of Sultan Mahmud II in 1222/1808.

62 A sizeable number of these registers has been catalogued as part of the MAD section, but it is quite possible that they are to be found in other sections as well.

63 A pioneering reconstitution of one such series, the Kuyud-i Mühimmat, can be found in an article by Bostan, 1995.

64 Finkel, 1988, v. 1, p. 331 states that she found a considerable number of sultanic commands relevant to a Hungarian campaign in a single volume of the Registers of Important Affairs (*Mühimme Defterleri*, n° 77).

65 MAD 10073.

66 Bostan (1992) is a mine of information on the Arsenal at the time when galleys were being phased out in favour of sailing ships. Many procedures recounted by Bostan were doubtlessly in use during the eighteenth century as well. On a collection of documents concerning the preparation of a naval campaign in the mid-sixteenth century, compare Veinstein, 1985.

67 MAD 10073, p. 21.

68 Genç, 1995.

69 For a short analysis of the Istanbul situation between 1703 and 1730, compare Aktepe, 1958; Mantran, 1962, pp. 389–394; Veinstein, 1988.

70 Kal'a, 1997.

71 However, this explanation does not account for the fact that, before the 1690s or thereabouts, so few sultanic commands survive as individual items outside of registers in the central archives. Possibly, they had been regarded as irrelevant in earlier times.

72 Thus, the archive of the dervish convent of Emirci Sultan, published by Ahmet Yaşar Ocak, contains *buyuruldus* and *tezkeres*, but few if any sultanic commands. See Ocak, 1978.

73 Inalcik, 1986.

74 Too little is known about the appointment of guild officials farming their offices to discuss this matter here.

75 Faroqhi, 1996.

76 Inalcik, 1986, pp. 136–137.

77 Many documents of this kind can be found in the sections Başbakanlık Arşivi-Osmanlı Arşivi, Cevdet Belediye and Cevdet İktisat, but other locations are also possible.

78 Başbakanlık Arşivi-Osmanlı Arşivi, Istanbul, Cevdet Belediye 471.

79 Israel, 1989, pp. 262–263 and elsewhere.

80 Paris, 1957, pp. 521–522.

81 Compare the Archives of the Chamber of Commerce in Marseilles, files B 181R, H 200, H 201, J 92, LIX 1206. For the relevant figures, see Frangakis-Syrett, 1992, pp. 218–223.

82 Faroqhi, 1982–1983, p. 231.

Bibliography

Primary Sources

Istanbul
Başbakanlık Arşivi:
Cevdet Belediye 471
İstanbul Bab Mahkemesi n° 124, 1133/1720
Maliyeden Müdevver (MAD) 7940; 9983; 10073.
Ankara
Bursa Kadı Sicilleri B89: Milli Kütüphane, Ankara, 1207/1792–1793
Marseilles
Archives of the Chamber of Commerce:
Files B 181R, H 200, H 201, J 92, LIX 1206.
Fonds Roux: LIX/1254.

Secondary Sources

Abdel Nour, Antoine, *Introduction à 1'histoire urbaine de la Syrie ottomane* (*XVIe–XVIIIe siècle*), Beirut, Université Libanaise, 1982.

Akarlı, Engin, 'Gedik: Implements, Mastership, Shop Usufruct and Monopoly among Istanbul Artisans, 1750–1850', *Wissenschaftskolleg-Jahrbuch*, 1985–1986, pp. 223–232.

Aktepe, Münir, *Patrona İsyanı (1730)*, Istanbul, İstanbul Üniversitesi Edebiyat Fakültesi, 1958, pp. 97–101.

Atasoy, Nurhan, *1582, Surname-i Humayun, An Imperial Celebration*, Istanbul, Koçbank, 1997.

Atıl, Esin, *Levni and the Surname. The Story of an Eighteenth-Century Ottoman Festival*, Istanbul, Koçbank, 1999.

Baer, Gabriel, *Egyptian Guilds in Modern Times*, Jerusalem, Israel Oriental Society, 1964.

Barkan, Ömer Lütfi, 'XV. Asrın Sonunda Bazı Büyük Şehirlerde Eşya ve Yiyecek Fiyatlarının Tespit ve Teftişi Hususlarını Tanzim eden Kanunlar', *Tarih Vesikaları*, I, 5, 1942, pp. 326–340; II, 7, pp. 15–40; II, 9, pp. 168–177.

Behrens-Abouseif, Doris, *Egypt's Adjustment to Ottoman Rule, Institutions, Waqf and Architecture in Cairo (16th and 17th Centuries)*, Leiden, E.J. Brill, 1994.

Bostan, İdris, *Osmanlı Bahriye Teşkilâtı: XVII. Yüzyılda Tersâne-i Amire*, Ankara, Atatürk Kültür, Dil ve Tarih Yüksek Kurumu, 1992.

Bostan, İdris, 'Kuyud-i Mühimmat Defterlerinin Osmanlı Teşkilât Tarihi Bakımından Önemi', *Osmanlı-Türk Diplomatiği Semineri, 30–31*

Mayıs 1991, Istanbul: İstanbul Üniversitesi Edebiyat Fakültesi, 1995, pp. 143–163.

Cahen, Claude, *La Turquie pré-ottomane*, Istanbul, Isis, 1988.

Çizakça, Murat, 'Price History and the Bursa Silk Industry: A Study in Ottoman Industrial Decline, 1550–1650', *The Journal of Economic History* XL, 3, 1980, pp. 533–550.

Çizakça, Murat, 'Incorporation of the Middle East into the European World-Economy', *Review* VIII, 3, 1985, pp. 353–378.

Çizakça, Murat, 'Cash Waqfs of Bursa, 1550–1823', *Journal of the Economic and Social History of the Orient* 38/3, 1995, pp. 313–354.

Cohen, Amnon, *Economic Life in Ottoman Jerusalem*, Cambridge, Cambridge University Press, 1989.

Dalsar, Fahri, *Türk Sanayi ve Ticaret Tarihinde Bursa'da İpekçilik*, Istanbul, İstanbul Üniversitesi İktisat Fakültesi, 1960.

Deguilhem, Randi, 'La naissance et la mort du waqf damascain de Hafîza Hânim al-Mûrahlî: 1880–1950', in *Le waqf dans l'espace islamique. Outil de pouvoir socio-politique*, ed. Randi Deguilhem, preface by André Raymond, Damascus and Paris, Institut Français d'Études Arabes de Damas and Éditions Adrien Maisonneuve, 1995, pp. 203–225.

Duman, Yüksel, 'Local Notables, Textile and Copper Manufacturing in Tokat, 1750–1840', PhD dissertation, State University of New York (SUNY) Binghamton, 1998.

Ergenç, Özer, *Osmanlı Klasik Dönemi Kent Tarihçiliğine Katkı: XVI. Yüzyılda Ankara ve Konya*, Ankara, Ankara Enstitüsü Vakfı, 1995.

Evliya Çelebi, *Evliya Çelebi Seyahatnamesi*, ed. by Orhan Faik Gökyay, Istanbul, Yapı ve Kredi Yayınları, 1995.

Faroqhi, Suraiya, 'Mohair Manufacture and Mohair Workshops in Seventeenth-Century Ankara', *Ord. Prof. Ömer Lütfi Barkan'a Armağan, İstanbul Üniversitesi İktisat Fakültesi Mecmuası* (henceforth *İFM*). 41, 1–4, 1982–1983.

Faroqhi, Suraiya, *Towns and Townsmen of Ottoman Anatolia, Trade, Crafts and Food Production in an Urban Settinq, 1520–1650*, Cambridge, Cambridge University Press, 1984.

Faroqhi, Suraiya, 'Räuber, Rebellen und Obrigkeit im osmanischen Anatolien', *Periplus* 3, 1993, pp. 31–46.

Faroqhi, Suraiya, 'Ottoman Guilds in the Eighteenth Century: the Bursa Case', in Suraiya Faroqhi, *Making a Living in the Ottoman Lands, 1480–1820*, Istanbul, Isis, 1995a, pp. 93–112.

Faroqhi, Suraiya, 'Merchant Networks and Ottoman Craft Production (16th to 17th Centuries)', in Suraiya Faroqhi, *Making a Living in the Ottoman Lands, 1480–1820*, Istanbul, Isis, 1995b, pp. 169–192.

Faroqhi, Suraiya, 'Ortak İşliklerle özel Evler Arasında XVIII. Yüzyıl Bursa'sında İşyerleri', in Engin Yenal, ed., *Bir Masaldı Bursa*, İstanbul, Yapı ve Kredi Bankası, 1996, pp. 97–104.

Faroqhi, Suraiya, 'Between Conflict and Accommodation: Guildsmen in Bursa and Istanbul during the 18th Century', in Stephen Epstein, Clara Eugenia Nuñez *et al.*, ed., *Guilds, Economy and Society. Proceedings of the Twelfth International Economic History Congress*, Sevilla, Fundación Fomento de la Historia Económica, 1998, pp. 143–152.

Faroqhi, Suraiya, 'The Centre of Urfa in the mid-18th Century', in Yıldız Sey *et al.*, ed., *Tarihten Günümüze Anadolu'da Konut ve Yerleşme, Housing and Settlement in Anatolia, a Historical Perspective*, Istanbul, T.C. Başbakanlığı and Tarih Vakfı, n.d., pp. 278–283.

Faroqhi, Suraiya, 'Urban Space as Disputed Grounds: Territorial Aspects to Artisan Conflict in Sixteenth to Eighteenth-Century Istanbul', in Suraiya Faroqhi, ed., *Stories of Ottoman Men and Women: Establishing Status, Establishing Control*, Istanbul, Eren, 2002, pp. 219–234.

Finkel, Caroline, *The Administration of Warfare: the Ottoman Military Campaigns in Hungary, 1593–1606*, Vienna, VWGO, 1988.

Frangakis-Syrett, Elena, *The Commerce of Smyrna in the Eighteenth Century (1700–1820)*, Athens, Centre for Asia Minor Studies, 1992.

Fukasawa, Katsumi, *Toilerie et commerce du Levant, d'Alep Marseille*, Marseille, Editions du CNRS, 1987.

Genç, Mehmet, 'Osmanlı Maliyesinde Malikâne Sistemi', in Osman Okyar and Ünal Nalbantoğlu, ed., *Türkive İktisat Tarihi Semineri, Metinler, Tartişmalar 8–10 Haziran 1973*, Ankara, Hacettepe University, 1975, pp. 231–296.

Genç, Mehmet, 'A Study of the Feasibility of Using Eighteenth-Century Ottoman Financial Records as an Indicator of Economic Activity', in Huri Islamoglu-Inan, ed., *The Ottoman Empire and the World Economy*, Cambridge (UK)/Paris, Cambridge University Press and Maison des Sciences de l'Homme, 1987, pp. 345–373.

Genç, Mehmet, 'Ottoman Industry in the Eighteenth Century: General Framework, Characteristics and Main Trends', in Donald Quataert, ed., *Manufacturing in the Ottoman Empire and Turkey, 1500–1950*, Albany (NY), State University of New York (SUNY) Press, Binghamton, 1994, pp. 59–86.

Genç, Mehmet, 'L'économie ottomane et la guerre au XVIIIe siècle', *Turcica* XVII, 1995, pp. 177–196.

Gerber, Haim, *Economy and Society in an Ottoman City: Bursa, 1600–1700*, Jerusalem, The Hebrew University, 1988.

Gölpınarlı, Abdülbaki, 'İslam ve Türk İllerinde Fütüvvet Teşkilâtı ve Kaynakları', *İFM*, XI, 1–4, 1949–1950, pp. 3–354.

Hammer, Joseph von, *Geschichte des Osmanischen Reiches* grossentheils aus bisher unbenützten Handschriften und Archiven, 9 v., Budapest, C.A. Hartleben, 1827–1833.

Inalcık, Halil, '15. Asır Türkiye İktisadî ve İçtimai Tarihi Kaynakları', *İFM*, XV, 1953, pp. 51–57.

Inalcik, Halil, 'Bursa and the Commerce of the Levant', *Journal of the Social and Economic History of the Middle East* 111, 2, 1960, pp. 131–147.

Inalcik, Halil, 'Capital Formation in the Ottoman Empire', *The Journal of Economic History* XIX, 1969, pp. 97–140.

Inalcik, Halil, 'The Ottoman Economic Mind and Aspects of the Ottoman Economy', in M.A. Cook, ed., *Studies of the Economic History of the Middle East*, London, Oxford University Press, 1970, pp. 207–218.

Inalcik, Halil, 'The Appointment Procedure of a Guild Warden (Kethuda)', *Festschrift Andreas Tietze zum 70. Geburtstag Wiener Zeitschrift für die Kunde des Morgenlandes* 76, 1986, pp. 135–142.

Israel, Jonathan, *Dutch Primacy in World Trade, 1585–1740*, Oxford, Clarendon, 1989.

Kal'a, Ahmet, *et al.*, eds., *İstanbul Külliyatı I, İstanbul Ahkâm Defterleri*, Istanbul, İstanbul Büyükşehir Belediyesi, 1997–present.

Khoury, Dina Rizk, *State and Provincial Society in the Ottoman Empire, Mosul 1540–1834*, Cambridge, Cambridge University Press, 1997.

Kredian, Armin, 'The Private Papers of an Armenian Merchant Family in the Ottoman Empire, 1912–1914', in Nelly Hanna, ed., *Money, Land and Trade. An Economic History of the Muslim Mediterranean*, London, I.B. Tauris, 2002, pp. 139–156.

Kreiser, Klaus, 'Icareteyn: Zur "Doppelten Miete" im osmanischen Stiftungswesen', in *Raiyyet Rüsûmu, Essays Presented to Halil Inalcık*, ed. Bernard Lewis *et al.*, 1986, also printed in *Journal of Turkish Studies* 10, 1986, pp. 219–226.

Kütükoğlu, Mübahat, *Osmanlılarda Narh Müessesesi ve 1640 Tarihli Narh Defteri*, Istanbul, Enderun Kitabevi, 1983.

Lapidus, Ira, *Muslim Cities in the Later Middle Ages*, Cambridge, Cambridge University Press, 1984.

Mantran, Robert, *Istanbul dans la seconde moitié du dix-septième siècle, histoire administrative, économique et sociale*, Paris/Istanbul, Adrien Maisonneuve and Institut Français d'Archéologie d'Istanbul, 1962.

Marcus, Abraham, *The Middle East on the Eve of Modernity, Aleppo in the Eighteenth Century*, New York, Columbia University Press, 1989.

Masters, Bruce, *The Origins of Western Economic Dominance in the Middle East. Mercantilism and the Islamic Economy in Aleppo 1600–1750*, New York, New York University Press, 1988.

Ocak, Ahmet Yaşar, 'Emirci Sultan ve Zaviyesi', *Tarih Enstitüsü Dergisi* 9, 1978, pp. 129–208.

Orhonlu, Cengiz, *Osmanlı İmparatorluğunda Derbent Teşkilâtı*, Istanbul, İstanbul Üniversitesi Edebiyat Fakültesi, 1967.

Özkoçak, Selma, 'The Urban Development of Ottoman Istanbul in the Sixteenth Century', unpublished PhD dissertation, University of London, 1997.

Pakalın, Mehmet Zeki, *Osmanlı Tarih Deyimleri ve Terimleri Sözlüğü*, Istanbul, Milli Eğitim Bakanlığı, 1971.

Paris, Robert, *Histoire du commerce de Marseille de 1660 à 1789, Le Levant*, Paris, Plon, 1957.

Proházka-Eisl, Gisela, *Das Surname-i Humayun, die Wiener Handschrift in Transkription, mit Kommentar und Indices versehen*, Istanbul, Isis, 1995.

Raby, Julian and Zeren Tanındı, *Turkish Bookbinding in the 15th Century, the Foundation of an Ottoman Court Style*, London, Azimuth Editions, 1993.

Raymond, André, *Artisans et commerçants au Caire au XVIIIe siècle*, Damascus, Institut Français de Damas, 1973–1974.

Refik, Ahmet, *Onuncu Asr-ı Hicrî'de İstanbul Hayatı (1495–1591)*, reprint Istanbul, Enderun Kitabevi, 1988.

Sahillioğlu, Halil, 'Slaves in the Social and Economic Life of Bursa in the late 15th and early 16th Centuries', *Turcica* XVII, 1985, pp. 43–112.

Salzmann, Ariel, 'Measures of Empire: Tax Farmers and the Ottoman Ancien Régime, 1695–1807', PhD dissertation, New York University, 1995.

Stoianovich, Traian, 'The Conquering Balkan Orthodox Merchant', *The Journal of Economic History* XX, 1960, pp. 234–313.

Taeschner, Franz, 'Eine Urkunde für den Stiftungsinhaber der Zaviye des Ahi Evran in Kirşehir', *Vakıflar Dergisi*, III, 1956, pp. 309–314.

Uluçay, Çağatay, 'İstanbul Saraçhanesi ve İstanbul Saraçlarına dair bir Araştırma', *Tarih Dergisi* 111, 1951–1952, pp. 147–164.

Uzunçarşılı Ismail Hakkı, *Osmanlı Devletinin Merkez ve Bahrive Teşkilâtı*, Ankara, 1948.

Veinstein, Gilles, 'Les préparatifs de la campagne navale franco-turque de 1552 à travers des ordres du Divan ottoman', *Revue de l'Occident musulman et de la Méditerranée* 39, 1, 1985, pp. 35–67.

Veinstein, Gilles, 'Du marché urbain au marché du camp: l'institution ottomane des orducu', in Abdeljelil Temimi, ed., *Mélanges Professeur Robert Mantran*, Zaghouan, CEROMDI, 1988, pp. 299–327.

Part Two

SOCIAL LIFE, POLITICS
AND GUILDS

CHAPTER 5

Çuha for the Janissaries –
Velençe for the Poor: Competition for
Raw Material and Workforce between
Salonica and Veria, 1600–1650

Eleni Gara

During the first half of the seventeenth century, Salonica manufacturers of the woollen fabric *çuha* repeatedly tried to inhibit the growing manufacture of rival woollen *velençe* cloth in the town of Veria by appealing to the local and central authorities of the Ottoman Empire. In their numerous petitions, the Salonica masters adduced a most appealing argument: that the state's very interests were at stake. According to their allegations, the craftsmen from Veria were competing with them for the purchase of raw wool and were attracting a workforce indispensable for the manufacture of *çuha* for the Janissaries.

The conflict between the manufacturers of *çuha* and those of *velençe* was related to a state affair of major importance, namely, the supply of the Janissary corps with woollen cloth. Conflicts among Ottoman guilds or rival groups of craftsmen were not a rare occurrence and were regularly brought before the state authorities for judgement. The outcome of such routine cases may have been influenced by the status or wealth of the respective litigants, but there is no reason to suspect that the Ottoman judicial authorities systematically favoured any particular group of craftsmen over any other. The question is what happened when the state itself had a direct interest in the issue, as was the case in this particular conflict? Did an obscure group of provincial craftsmen stand a fair chance of defending their cause or even prevailing over a rival which enjoyed the support of the sultan's own Janissaries?

Establishment of *velençe* manufacture in Veria

The early history of woollen manufacture in Veria in Ottoman times is not well documented. Available information – dating back to the early 1600s and deriving mainly from the town's *şeriat* court records[1] – associates the manufacture, especially the processing of wool and weaving, with the local Jewish population. Although one of the oldest Jewish communities in Macedonia had once existed in Veria, its seventeenth century successor consisted of 'newcomers' as a result of the old Romaniot community's relocation in Istanbul soon after the latter's conquest.[2] According to Ottoman survey registers from the sixteenth century, Jews settled once again in Veria between 1526 and 1543. The community, which comprised only six households in 1568, increased in the first decades of the seventeenth century, but it does not seem to have become very numerous.[3]

There is no information concerning the occupations of the Jewish inhabitants of Veria in the mid-sixteenth century.[4] Nevertheless, it is safe to assume from ensuing evidence that the new settlers had originated from Salonica and, from the beginning, were involved in the manufacture of woollens.[5] The cattle-breeding district of Veria was well known to Salonica Jews and the town offered many advantages for the establishment of a woollen manufacture: proximity to raw materials, abundance of water – indispensable for the processing of wool – and a fairly good commercial infrastructure. Presumably, woollen cloth of some sort had always been manufactured in the town; all available evidence shows, however, that only woollen fabrics introduced and manufactured by the new settlers acquired any commercial importance. The Jews of Veria also manufactured other woollens including felts (*keçe*),[6] but they specialised very early on in the production of *velençe*, a broad, longhaired kind of cloth mainly used for raincoats, blankets, bedspreads and rugs.[7] By 1600, the new manufacture was well established and its products were sold not only in the local market and the Balkan fairs, but also in Istanbul, where, according to the official price list, they were priced between 200 and 500 *akçes*.[8]

Velençe required the same raw materials as *çuha*, the strong felted fabric in which the woollen manufacture of Salonica specialised. The processing and craftsmanship were also similar

and manufacturers of both *velençe* and *çuha* relied on the wool produced in the district of Veria.[9] These circumstances thus had the potential to result in a competition for resources between the two manufactures. In the mid-sixteenth century, however, people may not have been aware of this; *velençe* was, after all, a different fabric, which, presumably, would not endanger the commerce of *çuha*. As long as raw materials and workforce were abundant, the small manufacture of Veria seemingly posed no threat to its mighty counterpart in Salonica. The competition which was to come and the ensuing conflict between the two communities were, in all probability, unforeseen by contemporaries.

A conflict emerges

The conflict arose within the conjuncture apostrophised in historiography as 'the decline of the woollen manufacture of Salonica'. Established by Jewish immigrants in the late fifteenth century, the manufacture of woollens soon became the most important domain of production in Salonica.[10] According to a contemporary account, by 1540 the woollen manufacture was the sole support for most of the Jewish population.[11] At that time, Salonica was one of the bigger textile producers of the Mediterranean, with an estimated maximum production capacity of about 40,000 pieces of cloth per annum.[12] This was largely due to the fact that its manufacture exclusively supplied the Janissary corps with *çuha*.[13]

According to Jewish tradition adopted by later historiography, cloth deliveries to the Janissaries, designated in contemporary Jewish sources as the 'king's cloth', were introduced as a sort of payment in kind in exchange for the community's extensive tax exemption.[14] This, however, is not corroborated by either Ottoman documentation or Jewish sources from the sixteenth century. Recent research has shown that there had been no fiscalisation of cloth delivery and that the Jewish tradition represents a misapprehension of the facts.[15] This notwithstanding, *çuha* deliveries, the payment of the poll-tax and exemption from extraordinary taxes and corvées were inextricably linked. The fabrics were paid for in cash and not delivered in exchange for the payment either of the poll-tax or other taxes; the community's

poll-tax was simply one of the various sources earmarked by the Ottoman authorities for the financing of *çuha* supplies. The manufacture of *çuha* was connected with another obligation of the community toward the Ottoman state, namely, to finance the operation of the Sidrekapsa/Sidre Kapısı mines in Chalcidice. Because of this double obligation, the Jews of Salonica were exempted from extraordinary taxes and corvées.

Although it is now certain that *çuha* deliveries to the Janissaries did not function as a tax payment in kind, there is disagreement concerning the grounds upon which the Jewish community's extensive tax exemption was based. Gilles Veinstein has argued, on the basis of Ottoman archival evidence, that soon after 1536, Salonica Jews acquired an imperial decree according to which they were granted the privilege to furnish *çuha* to the Janissaries in exchange for assuming the responsibility of financing the mining operations in Sidrekapsa. It was this particular service to the state that brought as recompense the community's exemption from extraordinary taxes and corvées. This settlement was reconfirmed in 1568.[16]

Minna Rozen, however, favours a different interpretation on the basis of Jewish sources. According to her, the manufacture of *çuha* was a corvée imposed upon the Jewish community of Salonica. The community was first granted exemption from other corvées in 1537, exactly because it was already at the service of the Ottoman state. This, however, did not prevent the authorities from imposing corvées upon individual members of the community, including the funding of the Sidrekapsa mines operation.[17] Thirty years after the initial settlement, Salonica Jews renegotiated their taxation status with the Ottoman authorities. In 1568, they managed to acquire a new imperial decree granting the community and its individual members exemption from corvées, but only after accepting the obligation to collectively finance the operation of the Sidrekapsa mines.[18]

It is beyond the scope of the present study to discuss the Jewish community's taxation in detail; for our purpose, it is sufficient to point out the one thing of which we can be sure: that, at least since the second half of the sixteenth century, both the community and the Ottoman authorities construed the cloth deliveries to the Janissaries as a compulsory service (*hizmet*).[19] It was a service owed to the state, not by a particular group of craftsmen but by the

community as a whole. Although relevant Ottoman documentation is rather vague on the matter,[20] contemporary Jewish sources make it quite clear that the 'king's cloth' was a collective obligation, incumbent upon all current and future members of the community, i.e. upon all persons registered in the tax records of Salonica.[21]

As a consequence, *çuha* manufacture of the late sixteenth and early seventeenth century can hardly be regarded as an independent commercial enterprise.[22] The craftsmen, without actually being employed by the state, were nevertheless obliged to deliver a precisely defined quantity and quality of cloth at a prescribed time according to the current needs of the Janissary corps.[23] In exchange, local and central state authorities, especially the *ağa* of the Salonica Janissaries and the superintendent of woollen cloth, the *çuha emini* (the official responsible for *çuha* supplies), were expected to assist the manufacturers in securing the necessary raw materials, in particular, wool.

The attachment of the woollen manufacture of Salonica to the Ottoman military supply system resulted in a great production boost but, in the long run, it proved an impediment to its growth. The monetary crisis of the Empire in the 1580s, in addition to the constant rise in demand for wool,[24] drove prices to dizzying heights.[25] But the state was unwilling to adequately recompense the craftsmen and it kept cloth prices low.[26] In addition, contrary to the hopes of the community, the financing of the Sidrekapsa mining operations did not make Salonica Jews immune to tax demands,[27] while their obligations to the Janissaries proved, at the end, to be ruinous to production for the free market.[28] The state expected them to meet its constantly rising need for cloth without taking into consideration the craftsmen's power to produce. Even when the town was hit by disasters such as severe plague epidemics and extensive fires, the authorities were reluctant to lower their demands and allow for a temporary suspension of the *çuha* workshops' operation.[29] As a result, by the early seventeenth century, Salonica manufacturers of woollens found themselves working for the state on a far larger scale and under tighter control than they had anticipated. The Jewish community was obliged to keep up this costly and unprofitable production in order not to fail in supplying the military with its cloth, and its members had no possibility of avoiding deliveries to the Janissaries and shifting to other markets or fabrics.

The first decades of the seventeenth century brought new hardships for *çuha* manufacture. The turn of the century had witnessed a steep rise in the price of wool[30] which was not followed by an equal rise in cloth prices as paid by the state. The price of woollens remained low in the free market as well. According to Benjamin Braude, Ottoman woollen manufactures 'were caught in the middle' between high wool prices caused by the demand of Italian, Dutch and, later on, by French merchants, as well as by low cloth prices induced by the offer of cheap, good-quality English cloth in the Ottoman markets.[31] Within this conjuncture, the owners of workshops tried to keep costs low at the expense of hired labour, craftsmen started looking for other occupations and work opportunities outside Salonica[32] and the wealthy tried to avoid their obligations toward the community and started migrating to other towns.[33]

Jewish sources from the first half of the seventeenth century frequently lament the misfortunes of the community and bear testimony to two major crises, one in 1620 and another one in 1637, the latter being the more serious. The year 1620 proved particularly disastrous for the Jewish community of Salonica. While the plague was raging and people were either dying or fleeing the town,[34] a great fire destroyed a large part of the Jewish quarter.[35] In addition to that, state demands for cloth delivery were excessive.[36] The crisis of 1637 was directly associated with the output of *çuha* manufacture. Because of irregularities in cloth deliveries in previous years, the central authorities demanded that the Jewish community send a delegation to Istanbul. Pieces of cloth presented to the *defterdar* (treasurer) on that occasion were judged to be of poor quality and the community's representatives were imprisoned. After unsuccessful negotiations, the incident ended in September 1637 with the execution of the head of the delegation, Rabbi Juda Covo, for 'adulterating cloth'.[37]

It is not surprising that, under these circumstances, the manufacturers of Salonica strongly reacted to anyone or anything that could endanger the fulfilling of their obligations to the Janissaries, all the more since organised actions were neither beyond the community's ability nor were they a novelty. Regulation of the purchase and distribution of raw wool as well as of the conditions of cloth production and sale had been a major concern of the Jewish leadership since at least the 1540s.

For that purpose, the rabbis of Salonica had repeatedly issued the so-called 'regulations of wool', a series of prohibitions and restrictions aimed at solving competition problems and keeping social peace and the unity of the local community.[38] Additionally, mass migration of workers, especially after 1620, was a new challenge. The Jewish leadership managed, however, to respond with significant success. The community could not afford to lose any of its members and its authorities did everything in their power – including recourse to the state's judicial and executive apparatus – to prevent workers from fleeing the town and to bring back fugitives.

The orders of 1617 and 1620

The first entry in the *şeriat* court records testifying to an effort to suppress the production of *velençe* in Veria in favour of Salonica's woollen manufacture has been traced to 1617. It is an official communication to the *yasakçıs* of Veria announcing that Beşir Beşe, the bearer of the document, had arrived with orders to seal all the looms in town. The *yasakçıs* were ordered not to allow anyone to buy raw wool in the district before the needs of *çuha* manufacture were fully covered and not to permit the breaking of the seals under any circumstances.[39] *Velençe* workshops had to stay closed for an indefinite period of time and available raw wool was to be reserved so that *çuha* production could be completed on schedule.

Despite being the earliest extant record on this conflict in Veria, the style and language of this document suggest that 1617 was not the first time that similar orders were issued: the text sounds too routine-like and probably did not discuss something entirely unfamiliar either to the author or the recipients. This assumption is admittedly speculative but, up to a point, it is supported by further evidence, namely that part of the document forbidding common merchants and craftsmen from purchasing raw wool, a prohibition which has a long history. Orders ensuring *çuha* manufacturers' precedence are attested to since the 1560s; those that I have been able to trace (listed in the bibliography) as far as we know only prohibited the export of wool to Europe.[40] In any case, the order of 1617 is the first of its kind located up until now, addressed to the kadi of Veria.

There is no information about the extent to which these orders were executed. It is certain that the manufacture of *velençe*, though not abandoned, was disrupted for a time and suffered extensive damage: documentation pertaining to the 1619 tax farm of stamp duties payable on locally manufactured *velençe* shows a decrease in production of about 40 percent compared with 1613.[41] Nevertheless, the craftsmen of Veria were still not to be left in peace to pursue their trade. An official communication dating from 16 April 1620, addressed to the kadi of Veria, demanded once again that the looms should be sealed 'as usual' until the manufacture of 'state *çuha*' was completed.[42] In lieu of introduction – by way of explaining the necessity of the orders in question – it was stated that *velençe* manufacturers, apart from working in their own quarters, had also put up looms in other people's houses, thus delaying the progress of *çuha* manufacture. In a display of pure *raison d'état*, a whole branch of production in another town was once again forced to interrupt its operation so that the required quantity of *çuha* could be delivered on time. In the meanwhile, the interests of the Janissaries were accorded such a high degree of priority that little thought was given to the survival of the local craftsmen; even the tax farmer who had been incautious enough to contract for stamp duties was left to fend for himself as well as he could.

Jewish manufacturers of *velençe* did not live or work in a social vacuum. The exact meaning of sealing the looms in the town of Veria can only be a matter of speculation. Nevertheless, information from the *şeriat* court records enables one to get a glimpse of everyday life and to form an opinion about the complications that were due to arise. First of all, weavers were not the only craftsmen involved in *velençe* manufacture. Fullers and dyers, suppliers of wool and merchants of finished fabrics also stood to lose much from the interruption of *velençe* production. In addition to these persons, one should also not forget grocers and other petty traders in the town market, as well as creditors and landlords of the Jews, in short, the whole micro-cosmos of local people whose livelihood depended, to a smaller or greater extent, on *velençe* manufacture.

Such persons were to be found among all groups making up the local society, Christians and Muslims, *askeri* and *reaya*, notables and common people. They were local merchants

such as Kostandin ibn Mehmed Ağa[43] and Mustafa ibn Hızır.[44] They were merchants from Istanbul such as Topal Yorgi, a grocer in the market Balık Bazarı of Galata.[45] They were local money-lenders such as the Muslim military men Racil Ali[46] and Gulam-i Şahi Mustafa Beg[47] or the notable Mahmud Efendi ibn Arnavud Mustafa.[48] They were suppliers of raw wool such as Yazıcı Mustafa Beg ibn Mehmed,[49] Christian fullers such as Pulyo veled-i Kiro[50] or Yorgo Komno and his partners Kosta Pulyo and Istamad Pulyo,[51] Muslim owners of fulling mills such as Kadı Abdurrahim Efendi and his brother İbrahim Çelebi,[52] Yakub Çelebi ibn El-Hacc Mahmud[53] or the pious foundation of Niksarizade.[54] They were landlords such as the local Muslim notable Helvayizade Mustafa Çelebi[55] or the princess Güverhan Sultan, daughter of Ahmed I, who owned the *yahudi hane* of Veria, the place where the Jewish manufacturers of *velençe* lived and worked.[56]

In 1620, the population of Veria did not passively submit to the orders from Salonica. On 28 April, twelve days after the issuing of the document discussed above, the notables and common people of the town launched a complaint before the *şeriat* court. They stated that the Salonica Jews constructed sheepfolds in the country, took dairy products to Salonica and paid high advances for raw wool, the consequence being that 'the townsfolk and the poor could not find any cheese, *velençe* or butter'. They asked the court to order the population and the governor of the district not to allow any Jews from Salonica to construct sheepfolds or buy dairy products and raw wool in the district of Veria.[57] The court granted the demand.

The Jewish manufacturers of Veria and their problems are not mentioned in the document. Nevertheless, the townspeople's pressing for such a prohibition, at that particular time, cannot be a pure coincidence, all the more because the complaints refer explicitly to raw wool and *velençe* as well as to the Jews of Salonica. It is highly unlikely that the exports of dairy products had increased so much that the inhabitants of Veria would have feared for the supply of the local market. By contrast, raw wool was indeed a major commodity for which craftsmen of both towns competed.

This local initiative to prevent Salonica Jews from buying raw wool in the district of Veria was an act of defiance directed at the orders and interests of the Janissary corps. Here was an outright

challenge to *çuha* manufacturers' customary privileges concerning the purchase of raw wool, which had been explicitly sanctioned by the central state. It is doubtful whether the townsmen of Veria really aimed at preventing all wool exports to Salonica, an endeavour which hardly had any chance of success. A regulation issued by the local court, without an imperial decree to back it up, would never have sufficed to counteract joint pressure exerted by *çuha* manufacturers and the Janissaries. The decision taken by the court could, at most, temporarily offer an excuse to local raw wool suppliers for not selling, provided that they were not satisfied with the – presumably low – prices that *çuha* manufacturers were willing to pay.

I am inclined to interpret this action as an attempt to force *çuha* manufacturers and their Janissary supporters to work out a compromise agreement with local craftsmen. This assumption is backed up by another event. Soon afterward, the kadi of Veria – most probably acting at the townspeople's instigation – decreed the removal of the *yasakçıs* of the town,[58] the very persons responsible for implementing the orders that demanded the closing of *velençe* workshops and the reservation of all available raw wool.

If the purpose of the townspeople was indeed to force the opponents of *velençe* manufacture into a compromise, it was obviously achieved. Two months later, at the end of June, not only were the looms in Veria still in operation, but individual craftsmen also continued to abandon Salonica in order to join *velençe* manufactures in Veria. The Janissaries were, of course, not willing to allow this situation to continue. However, the official communication sent at that time to the kadi of Veria shows a radical change in their attitude: This time, the *ağa* of the Janissaries did not demand the interruption of *velençe* manufacture, but only asked that the *yasakçıs* be permitted to take up their duties again and that migrant workers be sent back.[59]

The crisis of 1643–1646

For the next twenty-three years, our sources remain silent about relations between the craftsmen of Veria and those of Salonica. The old conflict entered a new phase in 1643 when representatives

of *çuha* manufacturers reported damages to the kadi of Salonica caused by the competition of *velençe* manufacture. Dire consequences were predicted for the Janissaries' supply of cloth if their rivals were not forced to join the manufacture of 'state *çuha*' immediately:

> Though, in past times, the Jewish community near Selanik possessed [only] four looms, now they have put up many and, because of that, a great number of Jews manufacturing state *çuha* have been fleeing [Selanik] and going to Kara Ferye, [where] they establish looms and manufacture *velençe*. In addition, they take the best [quality] of raw wool and, thus, cause [us] severe shortage of both workers and raw wool. If the masters who went to Kara Ferye, establishing looms [there] and making *velençe*, do not return to Selanik afterwards and do not attach themselves to the affairs of state *çuha* like in old times, we shall be in great difficulties in manufacturing the necessary [quantity of] *çuha*.[60]

On the initiative of the kadi of Salonica, the matter was brought to the attention of the central authorities. As a result, an imperial decree was issued, directing that there should remain only as many looms in Veria as had existed in the town 'in old times' and that all superfluous craftsmen should go back to Salonica and join the *çuha* manufacture there.[61]

The vague formulation, 'as many looms as existed in old times', was the key to the turn that matters would take. Its interpretation, which was to be decided at the local level, defined how serious the blow would be for *velençe* manufacture. The formulation could be construed as referring to the number of looms that had existed in the 1600s or to those that had remained in operation after the orders of 1617 and 1620; it could even refer to the number of looms that had been established at the very beginning of the manufacture about a century ago, which was obviously the *çuha* manufacturers' objective. If their allegation that only four looms used to exist in Veria were confirmed by the court, the implementation of the imperial decree would practically mean the demise of *velençe* manufacture. Since the operation of a loom required one to two weavers,[62] the radical reduction of their number to only four would leave Veria with four to eight adult craftsmen and a negligible production output. In the end, the authorities did not opt for this interpretation although they did not hesitate in implementing the imperial

decree. The consequences for *velençe* manufacture were grave. In the aftermath of this event, fifteen to twenty looms remained in town,[63] while the community suffered extensive demographic loss and economic damage.[64]

The extent to which the imperial decree was executed did not, however, satisfy *çuha* manufacturers, as becomes evident from subsequent events. Our sources suggest that the craftsmen of Salonica, after the radical reduction of *velençe* looms had proved impossible, made a further attempt to bind their rivals to *çuha* manufacture. In pursuit of this objective, they applied exactly the same kinds of pressure that they had used twenty years previously, which had provoked the reaction of the Jews of Veria. In the spring or early summer of 1645, the kadi of Veria forwarded a petition to Istanbul about local *velençe* manufacturers making complaints against their opponents. According to this petition, Salonica craftsmen were continuing to harass the Jews of Veria with demands for assistance in *çuha* manufacture and were inciting the Janissaries to close down their workshops and confiscate part of their production:

> Though the Jewish community dwelling in Kara Ferye has no connection at all with the [Jews] working in the service of state *çuha* in the town of Selanik and though there do not remain many Jews in Kara Ferye – there are only fifteen to twenty looms in operation where *velençe* is woven – in recent times, the Jewish community in the service of state *çuha* dwelling in the town of Selanik [has been harassing them] contrary to usage. They say: 'You do not help out with state *çuha* service' and cause the *çorbacıs* of Selanik to pester us. They incite [the *çorbacıs*] to seal our looms and take one hundred and sixty to two hundred *vukkiye* every year from our *velençe* without paying anything. There is no end to their oppressing and harassing us.' Though [these people] have been living in Kara Ferye since [the time of] the imperial conquest, although there are no Jews among them from Selanik and they have no connection at all with state *çuha*, the *çorbacıs* of Selanik oppress and wrong them.[65]

It is worthwhile looking closely at the *velençe* manufacturers' and the kadi's arguments since they reveal the core of the matter and help explain the persistence of Salonica craftsmen in pursuing the conflict even after their victory of 1643. Furthermore, the arguments also throw light on the background of the orders of

1617 and 1620 to temporarily seal *velençe* looms, which had, at first, looked arbitrary.

The Jews of Veria tried to prove that they were subject to illegal oppression (*zulm*) by using three arguments: first, that they offered no competition to Salonica manufacturers since there remained only a few craftsmen in town operating about twenty looms; second, that not one of the current *velençe* manufacturers originated from Salonica, but all were locals and, finally, that the Jewish population of Veria had been living in the town since the Ottoman conquest, thus implying that, since they did not originate from Salonica, there could not exist a legal claim on them for any obligation relating to *çuha* manufacture.

The structure of the reasoning plainly shows that the conflict concerned the question of whether the Jewish community of Veria was part of that of Salonica. As the *velençe* manufacturers found it necessary to give assurances that they were indigenous to Veria, one may assume that their adversaries claimed that they were not originally from that town. The matter was of great consequence since the Ottoman legal framework stipulated that no subject of the sultan could avoid his tax obligations – including services owed to the state – in his community of origin by going away and working in another place. Although this principle was not applied with consistency, it could be successfully adduced if necessity arose. Orders, which were based on exactly this principle and which had met with success, demanded that migrant workers return to Salonica.

This also allows one to see the orders of 1617 and 1620 demanding the sealing of *velençe* looms in another perspective and not to easily dismiss them as a major abuse of authority. If the Jewish craftsmen of Veria were part of the Salonica community, then they were also bound to *çuha* service. In that case, the prohibition to manufacture other fabrics until the necessary quantity of *çuha* was completed should be regarded as a harsh, but thoroughly legal, measure for which there was actually precedent.[66] To the contrary, such a prohibition would be out of place if *velençe* manufacturers were not connected with the community of Salonica. In any case, no matter how exaggerated the Salonica Jews' claims may have been – which they were if indeed they concerned persons whose families had been living in Veria for generations[67] – that particular argument would not

leave the Ottoman authorities unmoved. As long as the Jews and the Janissaries of Salonica regarded all Jewish inhabitants of Veria as former community members trying to disengage themselves from their obligations to *çuha* manufacture, *velençe* craftsmen could not expect to be left in peace.

The central authorities responded to the petition by checking up on the tax status of the Jewish community of Veria, but did not dwell upon the question of whether these persons originated from Salonica. Instead, they carried out a thorough examination of records kept at the imperial treasury which pertained to the poll-tax (*cizye*) and tax farms (*mukataa*). After the examination had proved that the community's taxes were not included in the sources earmarked for the financing of *çuha* for the Janissaries, the Jews of Veria were provided with an imperial decree declaring them free of any obligation related to *çuha* manufacture and ordering the Janissary officers to let them pursue their trade in peace:

> Until now, according to the register, the poll-tax of the Jews from Selanik, Manastır, İsküb, İstib, Sidre Kapısı, Siroz, Tırhala, Yenişehir and Kesriye has been earmarked for the affairs of *çuha* for the Janissaries of my sublime court as well as the tax farm revenue from goats, wine, spirit and *boza* which only derives from Selanik. [Therefore] they do not have any connection [with the matter].[68]

As can be seen, the central authorities' handling of the case implies a different approach to the issue. The excerpt cited above seems to suggest that, for the central state, the allotment of the Veria Jews' poll-tax towards the financing of *çuha* supplies would have sufficed in order to establish this group's obligation to manufacture *çuha*. This, however, does not agree with either Ottoman tax practices or available documentation as regards the supply of woollen cloth for the Janissaries. As is well known, only the Jewish community of Salonica was involved in the actual manufacture of the cloth; the other communities mentioned in this particular document as having their poll-tax earmarked for '*çuha* affairs' did not contribute any woollen fabrics towards deliveries. How then would an obligation of that sort arise for the Jews of Veria?

One must dismiss the possibility that the other communities enumerated in the imperial decree contributed fabrics towards *çuha* deliveries. Such an event would have left traces in both

Ottoman and Jewish sources and would not have passed unnoticed by the numerous scholars who have treated the subject.[69] This, however, does not provide any conclusive evidence with respect to the issue dealt with here. On the other hand, if the authorities had no intention to involve the Jews outside Salonica in *çuha* manufacture for the Janissaries, how is the phrasing of the imperial decree to be explained? First and foremost, why did the authorities proceed in the investigations in such a way? How could the *cizye* and *mukataa* records help them decide whether the Jews of Veria were obliged to manufacture *çuha* for the Janissaries or not?

One can consider some alternative explanations for the matter. The complication may simply arise from crediting the Ottoman authorities with more rationality than they actually had; perhaps one should not deduce from the reason given for the community not being involved in *çuha* supply that, in the reverse case, the obligation would have been established. Furthermore, it is possible that, in the authorities' view, the matter to be decided was whether the Jews of Veria had any connection with *çuha* manufacture in general terms and not whether they were specifically obliged to contribute to *çuha* deliveries. This would explain why the authorities checked up on tax records for information about any possible involvement of the Veria Jews – no matter how remote – in the cloth supply, although such an approach to the matter would hardly be relevant to the petition. Although none of these explanations is quite satisfying, there is no point in further pursuing the matter since all that one can do is speculate without any hope of finding proof. It suffices to note that the document raises many problems of interpretation.

The imperial decree of 1645 declaring the Jews of Veria free of any obligation concerning *çuha* manufacture did not put an end to the conflict. The *velençe* manufacturers' opponents did not give up, but pursued their litigation. Towards the end of the same year, both the Jewish community and the *ağa* of the Salonica Janissaries sent separate petitions to the sultan,[70] requesting that *velençe* looms not be allowed to operate as long as manufacture of *çuha* was in progress:

> Although [the manufacture of] state *çuha* has begun, [the Jews of Kara Ferye] establish looms, manufacture *velençe* and take the best

[quality of] raw wool. Thus, we get into difficulties with the raw wool [necessary] for the [quantity of] *çuha* that we are obliged to manufacture. Furthermore, they incite our workers to leave us, with the consequence that there is a shortage of workers.[71]

This reaction of the Janissaries and the Jewish community of Salonica put the central authorities in an awkward position. The Jews of Veria were in possession of a perfectly genuine imperial decree issued only some months earlier which corroborated that they had no obligation towards *çuha* manufacture. On the other hand, the message from Salonica was clear: if the operation of *velençe* looms continued undisturbed, the necessary quantity of cloth for the Janissaries would not be ready on time. The Sublime Porte tried to find a compromise solution. The imperial decree in answer to the *çuha* manufacturers' petition made it quite plain that there could be no delay for *çuha* production while, at the same time, it instructed the kadi of Veria to take care that the Jews of the town were not unjustly treated:

> You must let *çuha* be manufactured for the Janissaries of my sublime court under the same conditions under which it was manufactured last year. You must prevent those who revolt against this command [from doing so], but you must not allow that, on this pretext, people become oppressed contrary to the holy law and the state statutes.[72]

It was the kadi's responsibility to perform the feat of successfully fulfilling the two mutually exclusive requirements of the imperial decree.

The case closed in an unexpected way. In July 1646, four months after the issuing of this decree, the litigation was brought before the *şeriat* court of Salonica where the Jews of Veria pleaded their cause.[73] The document recounts that they accused the *çuha* manufacturers of harassing them with demands for assistance and of inciting the Janissaries to close down their workshops and confiscate their fabrics. They presented the imperial decree that declared them free of any obligation to deliver cloth. Then, the *ağa* of the Salonica Janissaries, Deveci Halil Ağa, was questioned about the matter. He did not deny the accusations, but justified his subordinates' actions by referring to the imperial decree that he had recently received which confirmed that no craftsmen should be allowed to abandon *çuha* looms and work elsewhere. Consequently, the court focused on clarifying whether there

were any Jews from Salonica currently working in Veria. As the *velençe* manufacturers declared that they did not employ any workers from Salonica, the *ağa* was asked to prove his allegations, but he was unable to produce evidence in their support. Then, the representatives of the Salonica *çuha* manufacturers were interrogated. Quite astonishingly, they stated that their colleagues in Veria pursued their own trade and caused them no difficulties at all with either raw wool or with their workforce. As a consequence, the court pronounced Deveci Halil Ağa guilty of having illegally ordered the sealing of *velençe* looms and the confiscation of two hundred *vukiyye* of finished fabrics. The court ordered him never to harass *velençe* craftsmen again.

It is not easy to explain why *çuha* manufacturers stated in court that Veria craftsmen did not compete with them and that the operation of *velençe* looms had no consequences for the progress of *çuha* production. There is no doubt that, despite their statement, the Salonica craftsmen had been actively involved in the conflict at least just as much as the Janissaries. It is known that, at that time, the Jewish community's leadership was desperately trying to bring fugitives back to Salonica from all over the Empire and that it would not have hesitated calling in the Ottoman authorities if unofficial efforts had proven futile.[74] As seen, the Salonica craftsmen had, in fact, sent numerous petitions to the Sublime Porte requiring the dismantling of *velençe* looms and the return of migrant workers. Furthermore, craftsmen from Veria had always explicitly referred to *çuha* manufacturers as instigators of the conflict and accused them of having tried to force them to work at the service of 'state *çuha*'.

I am rather inclined to interpret the *çuha* manufacturers' declaration as evidence of a compromise between the two Jewish communities. It is obvious that, after four years of continuous confrontation which brought little but financial distress to both opponents, the problem could not be solved without both of them reaching an agreement. Mutual concessions and co-operation could help avoid competition and diminish friction between the artisans of Veria and Salonica. Any viable solution should not challenge the independence of the former while, at the same time, it should ensure the primacy of the latter. One cannot dismiss the possibility that the Janissaries, for their own reasons, did not consent to a compromise; this would explain why there

was a divergence before the kadi between the declarations of the two former allies. No matter what the reason was, the case closed with the judgement of the kadi of Salonica. Measures taken in 1646 against *velençe* manufacturers were pronounced oppressive and arbitrary and the *ağa* of the Salonica Janissaries was found guilty of having illegally issued the orders.

Conclusion

In the first half of the seventeenth century, *çuha* manufacturers were put under severe strain by the attachment of the woollen manufacture of Salonica to the Ottoman military supply system, together with an increase in the state's tax demands. In addition, manufacturers had to cope with a discrepancy between the high prices of raw wool and the low prices of manufactured woollens, as well as with the calamities that hit the Jewish community during those years. The constantly rising demands of the Janissaries for cloth were exhausting the manufacturers' productive capacity while bringing them no financial gain. Craftsmen moving to other towns with a view to avoiding *çuha* deliveries were regarded as fugitives and forced to return. If manufacturers lowered quality standards in order to retain a certain profit margin or to shorten production time, they ran the risk of being severely punished. Under these circumstances, the only way for *çuha* manufacturers to cope with the situation was to secure inexpensive raw materials and a poorly remunerated workforce. By contrast, the craftsmen of Veria had the great advantage of flexibility. They were producing for the market and were not under rigid control as regards the quality or the quantity of their fabrics. They were in a position to pay more for raw wool and for workers without running the risk of ruining themselves financially.

Because of their close ties, the confrontation between the two Jewish communities was made longer and bitterer. *Velençe* manufacture owed its existence to settlers from Salonica and, for many decades, had been offering an additional income to numerous seasonal workers from that town. As long as *velençe* production flow took the needs of *çuha* manufacturing into consideration and the craftsmen of Veria were able to function within the limits set by the Salonica community's 'regulations of

wool', the rise of *velençe* manufacture did not cause any serious competition with that of *çuha* and, thus, was not perceived as a threat. On the contrary, its relative prosperity worked to the advantage of the much deprived and tightly controlled craftsmen of Salonica. This ceased to be the case when the Salonica community attempted to bind the Jewish community of Veria to 'state *çuha* service' and the latter tried to break loose from these restraints. I believe that the conflict between the two communities was equally due to the decline of the Salonica woollen manufacture as to the Veria community's struggle to gain its independence from the metropolis. The course of the conflict between the two groups of craftsmen shows that the competition for raw wool and a workforce was only part of the problem. The main issue was the *çuha* manufacturers' demand that their colleagues from Veria contribute to *çuha* deliveries. As far as concerns the central authorities, the matter closed with an imperial decree issued in 1645, declaring that the craftsmen of Veria had no obligation to 'state *çuha* service'. This occurred, however, only after most of the *velençe* workshops had closed down and the workers from Salonica had gone back to their hometown.

Throughout their confrontation with the craftsmen of Veria, *çuha* manufacturers enjoyed the support of the Janissaries, who were just as interested in the issue as the craftsmen themselves. The alliance between the Janissary authorities and the leadership of the *çuha* manufacturers was not new, but one which resulted from their long-standing close co-operation in matters concerning cloth production. The Janissaries saw to it that Salonica craftsmen took precedence over other buyers in the purchase of raw wool and that workers fleeing the service of 'state *çuha*' were forced to return. There is no doubt that the influence and intervention of the *ağa* of the Janissaries on behalf of the *çuha* manufacturers gave added weight to the arguments of the latter against *velençe* craftsmen when the matter reached the central authorities. Thanks to their co-ordinated efforts, only some months after its issue, the two allies managed to partly counteract the imperial decree in favour of the Veria community. The active involvement of the Janissaries was also crucial for the effectiveness of the measures taken against *velençe* manufacturers. The Janissaries did not often hesitate to abuse their authority in order to reach their objectives. Even if one allows for a certain degree of

exaggeration on the part of the Veria craftsmen in their complaints to the authorities, it is certain that the Janissaries repeatedly tried to intimidate them by arbitrarily closing down workshops and confiscating fabrics.

While *çuha* manufacturers could rely for support on the Janissaries, Veria craftsmen could aspire only to the solidarity of their fellow countrymen. Efforts to suppress *velençe* manufacture did not leave the local community unmoved. Nevertheless, at least as far as one can judge from the *şeriat* court records, the attempt to prevent Salonica Jews from buying raw wool within the jurisdiction of the Veria district in 1620 was the sole organised reaction of the townspeople throughout the conflict. No similar initiative was taken during the crisis of 1643–1646. There is, however, hardly any doubt that the opinion and attitude of the Muslims and Christians of the town, who were also affected by the heavy blow dealt to *velençe* manufacture by the imperial decree of 1643, succeeded in mitigating the severity of the measures taken against the Jewish craftsmen.

In their petitions to the Sublime Porte, *çuha* manufacturers and the Janissaries argued that the Veria craftsmen's competition made impossible the timely completion of the required quantity of cloth. Since ensuring the military supplies was a priority for the Ottoman state, this particular reasoning left *velençe* manufacturers only narrow margins of manœuvre. Despite this, the course of events shows that the outcome of the confrontation was by no means foregone, but depended on constant negotiation and compromise between the actors. Both sides had access to the administrative apparatus and, up to a certain point, could manipulate it for their own ends. Each group was backed by the kadi of its respective hometown in its petitions and both succeeded in obtaining imperial decrees favourable to their objectives.

The Sublime Porte was sensitive to the Salonica party's invocation of state interests, but at the same time, it was reluctant to damage its image as an impartial authority and a protector of the common people. Therefore, it did not openly favour either opponent, though the Porte made it clear that the manufacture of *çuha* was not to be compromised. True to Ottoman tradition, the imperial decrees did not dictate any solution, but confined themselves to giving instructions in rather vague terms about

how to deal with the problem. Actual decisions were left to local authorities, i.e. to the kadis of Veria and Salonica. The kadis were the persons to decide how many looms had existed 'from old times' and, therefore, were to be spared, as well as which workers were to return to Salonica and which were to stay.

At the moment when the issue was transferred from the level of the central to that of the local authorities, local politics were undoubtedly given free scope. This seems to have worked to the advantage of *velençe* manufacturers, who were thus able to maintain a far greater part of the looms than that petitioned for by their opponents. In this instance, decisions reached were more or less a compromise doomed to leave both sides un-satisfied. *Çuha* manufacturers did not succeed in closing down all but four workshops or in binding Veria craftsmen to *çuha* production, while *velençe* manufacturers were left with only about twenty looms in operation. In the end, the two communities probably came to an agreement of some sort on their own accord since, at the closing act of the conflict which took place before the kadi of Salonica in 1646, local *çuha* manufacturers denied having any problems with their colleagues from Veria, thus leaving the part of the villain to be played by the *ağa* of the Janissaries.

The sultan's orders and the kadi's decisions put an end to this particular crisis, but did not solve the problem since they did not affect its causes. *Çuha* manufacture in mid-seventeenth century Salonica, inasmuch as it was attached to the procurement of military supplies, was not a profitable option for the local population. Craftsmen continued to search for employment in other towns and to flee the service of 'state *çuha*' whenever they could. *Velençe* manufacture still held some attraction: only two years after the end of the confrontation between the two com-munities, new complaints about workers going to Veria reached the Sublime Porte.[75]

The situation changed, in fact, only with the reorganisation of *çuha* manufacture in 1664 and its transformation into a state-controlled enterprise. Henceforth, the craftsmen who were entrusted with the manufacture of woollen cloth for the Janissaries were to work on the premises of one workshop in the district of Agia Sofia and were to live in the Salonica citadel. In addition, they were no longer subject to the civil authorities,

but were put under the jurisdiction of the Janissary corps.[76] In this way, the craftsmen were effectively controlled and could not flee their service. Presumably, at that time, their customary privilege of precedence in the purchase of raw wool, something which was still challenged in the first half of the century, was institutionalised. Ordinary customers, both Ottoman and European, were subsequently expected to buy raw wool only after the needs of *çuha* manufacture were fully satisfied. Thus, it was within an entirely different framework that the *çuha* manufacturers' demands were finally satisfied. Their conflict with the manufacturers of *velençe*, although it was not responsible for the developments of 1664, may have had an indirect part in them since it had shown the organisational weaknesses and impasses of *çuha* manufacture in the first half of the seventeenth century.

Acknowledgements

This work originated in a short paper delivered in 1996 at the Xe réunion de l'AFEMAM – 2nd EURAMES Conference in Aix-en-Provence. Since then, I had the opportunity to do further research and profit from the feedback of several audiences to which I presented my conclusions. Special thanks are due to Eyal Ginio for his useful suggestions and help with the reading of Jewish family names.

Abbreviations

IKB Ierodikastikos Kodikas Beroias (Şeriat Court Record of Veria)
MD Mühimme Defteri (Register of Important Affairs)
MM Maliyeden Müdevver ([collection of documents] transferred from the Finance department)
TTD Tapu Tahrir Defteri (Survey Register)

Notes

1 Veria (Kara Ferye in Ottoman) is situated about 60 km southwest of Salonica, Greece. The local archive (G.A.K. – Archeia Nomou Emathias) houses the main bulk of the surviving *şeriat* court records (*kadı sicilleri*) of the town (129 volumes dating from 1602 to 1882). For further information about the *kadı sicilleri* of Veria, see Günay, 1997; Anastasopoulos, 2001.

2 Compare Yerasimos, 1995, p. 112.

3 TTD 424, probably dating from 1526, records no Jewish inhabitants in Veria. TTD 433, p. 762, probably dating from 1543, records 11 Jewish male individuals. TTD 723, p. 771, from 1568, records six households and two unmarried males. According to the *avarız* tax record of 1620 copied in the *kadı sicilli* of the same year (IKB 9, p. 46 [f. 25v], n° 1), the Jewish community was liable for eight *avarız hane*.

4 With the exception of doctors (two in 1543 and one in 1568), the occupations of the Jewish inhabitants of Veria are not recorded in the survey registers.

5 An undated legal opinion (*responsa*) by Samuel de Medina, rabbi of Salonica from the early sixteenth century until his death in 1589, was requested by 'a part of the congregation of the Vereja synagogue', all of them manufacturers of 'raincoats'. Since the petitioners use the expression, 'in our town', when presenting the case (*[p]redi dosta dalgo vreme zapocnahme v naşija grad da proizvezdame jamurluci*), it is more than probable that the otherwise unknown synagogue named 'Vereja' was, in fact, located in Veria. The *responsa* has been published in a Bulgarian translation in *Evrejski izvori*, 1958, n° 19, p. 61. The first positive information about Jewish involvement in the woollen manufacture of Veria comes from the 1595 census for the poll-tax (MM 14725, p. 64). In that instance, the Jewish inhabitants of Veria did not appear to register and the record was made according to the statement of their neighbours. For that reason, the registration does not follow the usual pattern (first name, father's name), but records first names and occupations. Only six of the estimated 15 household heads are mentioned by name: three *velençe* manufacturers (*velençeci*), a çuha manufacturer (*çuhacı*), a butcher and a painter.

6 Compare IKB 6, p. 197 (f. 56r), n° 5 (16/4/1620).

7 On sixteenth and seventeenth century *velençe*, see Tezcan, 1992.

8 Tezcan, 1992, p. 225.

9 The district of Veria was, of course, not the sole supplier of wool for the manufacture of Salonica. Among other major sources of supply

were spring shearings from the Salonica plain and other Macedonian districts as well as from Thrace, Thessaly and Central Greece. On this matter, compare Uzunçarşılı, 1943–1944, v. 1, pp. 274–276; Sahillioğlu, 1973–1974, pp. 421–422; Braude, 1992, pp. 220–221.

10 On the woollen manufacture of Salonica, see especially Emmanuel, 1935; Uzunçarşılı, 1943–1944, v. 1, pp. 273–277; Braude, 1979; Schwarzfuchs, 1989; Braude, 1992; Veinstein, 1992; Veinstein 1997. For a survey of the bibliography, see especially Schwarzfuchs, 1989; Braude, 1992. For a detailed discussion on the manufacture's origins, see Braude, 1992, pp. 221–228.

11 Braude, 1992, p. 220.

12 Braude, 1992, p. 220.

13 The Janissary corps had procured *çuha* from Salonica since at least 1509. According to the account (*çuha muhasebesi*) of 1510/1511, *çuha* bought for the Janissaries that year consisted of 96,000 cubits (*zira*) of cloth from Salonica and 1,476 cubits from Florence. The account is published in Sahillioğlu, 1973–1974, pp. 436–445.

14 Without having direct access to the Jewish sources, as far as I can judge, the tradition can be traced back to seventeenth century texts such as the memorandum of Hayyim Shabetai, rabbi in Salonica between 1607 and 1647. According to him, 'les draps du roi, ils en ont accepté le principe en échange des nombreux et lourds impôts qu'ils ne pouvaient plus supporter. Ils ont donc demandé à fabriquer ces draps du roi' (Schwarzfuchs, 1989, p. 229). This excerpt, apart from not clarifying whether, at the author's time, the arrangement between the community and the state still held, implies that the deliveries covered only part of the community's taxes, albeit a large one. By the early nineteenth century, the Jews of Salonica believed that their ancestors did not pay any taxes, but instead delivered *çuha*. According to Rabbi Acher Covo, 'jadis les Juifs de notre ville ne payaient pas d'impôts, sinon une grande quantité de draps qu'ils s'étaient engagés à manufacturer pour le roi – que sa gloire augmente – et qu'ils lui vendaient selon leur valeur pour habiller chaque année les soldats de son armée' (Schwarzfuchs, 1989, p. 232).

15 Veinstein, 1992; Rozen, 1997; Veinstein, 1997.

16 Veinstein, 1992, pp. 58–60; Veinstein 1997, pp. 582–585. On the Salonica community's exemption from extraordinary taxes, see also Emecen, 1996, p. 99, note 8.

17 Rozen, 1997, pp. 457–459.

18 Rozen, 1997, pp. 465–469.

19 As concerns the Jewish community, compare the following statement of Rabbi Hayyim Shabetai: 'jusqu'à présent [les Juifs de

Salonique] sont tous asservis, dans leur personne et leur biens, au service du Roi' (Schwarzfuchs, 1989, p. 229). Also compare Veinstein 1992, p. 60. As concerns the Ottoman state, compare the documents discussed in the present study as well as various imperial decrees forbidding the manufacture of other fabrics until the completion of the *çuha* deliveries (for an order dating from 1574, see Sahillioğlu, 1973–1974, pp. 422–423) or demanding the return of migrant workers to Salonica (for an order dating from 1610, see Emecen, 1989, p. 79, note 382).

20 *Çuha* manufacturers are alternatively designated as 'the Jews of Selanik' (Sahillioğlu, 1973–1974, p. 420, note 20), 'the Jews manufacturing *çuha* in Selanik' (Sahillioğlu, 1973–1974, p. 421, note 21; Emecen, 1996, p. 102, doc. n° I; MD 89, p. 68, n° 2), 'the Jews manufacturing the state (*mîrî*) *çuha* in Selanik' (Uzunçarşılı, 1943–1944, v. 1, p. 274, note 3), 'the Jewish workers (*işçi yahudileri*) manufacturing the state *çuha*' (IKB 6, p. 194 [f. 54v], no 1), 'the workers (*rençperler*) manufacturing *çuha*' (IKB 17, p. 138 [f. 69v], n° 1), 'the Jewish community (*taife*) manufacturing the *çuha* of the Janissaries' (Sahillioğlu, 1973–1974, p. 420, note 18), 'the Jewish community at the service of the state *çuha* (*mîrî çuha hizmetinde olan*) dwelling in the town of Selanik' (IKB 17, p. 171 [f. 86r], n° 2, and p. 173 [f. 87r], n° 2), 'the Jewish community dwelling in Selanik charged with (*memur olan*) the manufacture of the *çuha* of the sublime court's Janissaries' (IKB 17, p. 138 [f. 69v], n° 2).

21 Compare the following account by Rabbi Hayyim Shabetai: 'Cet impôt des tissus ne ressemble pas aux impôts sur les habitations ou sur les terrains. Il est collectif, les autres sont individuels. [...] Il n'en est pas de même de l'impôt drapier qui incombe à l'universalité des Juifs de la ville, tenus solidairement responsables, eux et leurs descendants, dans leurs biens propres et dans leurs héritages, jusqu'à la fin des générations. [...] L'ordre impérial est que chacun paye de sa personne, et sans lambiner, vivement, pour que la quantité exigée soit prête en temps dû. Chacun même doit aider son voisin pour accélérer la tâche' (Nehama, 1936–1959, v. 5, p. 88).

22 Braude, 1992, p. 232, with good reason, sees the introduction of the office of the superintendent of the cloth (*çuha emini*), which brought the manufacture under the supervision of the Janissaries, as the turning point for its transformation. Up until 1554, the responsibility for cloth deliveries rested with the kadi of Salonica (Uzunçarşılı, 1943–1944, v. 1, p. 273).

23 Compare the detailed instructions given in an imperial decree dating from 1574 (Sahillioğlu, 1973–1974, pp. 422–423).

24 The reorganisation of the Ottoman army after the mid-sixteenth century, together with the numerous wars, led to a steep rise in numbers of the Janissary corps and, consequently, in the demands for *çuha*: between 1527 and 1574, the number of Janissaries rose by 84.40 percent; between 1574 and 1609, it rose by a further 122.97 percent (estimations based on figures given by Murphey, 1999, table 3.5, p. 45). On the developments in the Ottoman army and warfare in the sixteenth and seventeenth centuries, see İnalcık, 1980 and Murphey, 1999. On the monetary crisis of the late sixteenth and early seventeenth century, see especially Pamuk, 1994, pp. 958–965; Pamuk, 2001.

25 According to Braude, 1979, p. 442, wool prices rose by 244 percent between 1550 and 1600. Also see Braude, 1979, graph I, p. 440.

26 Braude, 1979, p. 447. Also compare the complaint of Aaron Sasson (cited in Schwarzfuchs, 1989, p. 229) dating from the late sixteenth or early seventeenth century: 'En raison de nos pêchés [...] on paie les draps moins que sa valeur'.

27 In 1572, the state demanded the amount of 20,000 *filori* from the Jewish community in order to finance repairs for the fortifications of Salonica. On this matter, see Veinstein, 1992, p. 57.

28 Despite the hardships, *çuha* manufacture in the 1620s was still in a position to adversely affect the sale of English kersies in the Ottoman market. Ten years afterwards, however, it had ceased to have any commercial significance. On this, see Braude, 1992, pp. 233–235.

29 For an example dating from 1568, see Sahillioğlu, 1973–1974, p. 421, note 21.

30 See Braude, 1979, graph I, p. 440.

31 Braude, 1979, p. 445. English cloth was more expensive than Ottoman, but it was quite cheap in relation to its superior quality.

32 Destinations of migrant workers included Veria, Skopje and Rhodes (Emmanuel, 1935, p. 45), Seres, Bitola and Tire (Faroqhi, 1980, p. 69) as well as Manisa (Emecen, 1989) and Izmir (Barnai, 1991).

33 On social tensions within the sixteenth century community of Salonica, see Rozen, 1997.

34 Emmanuel, 1936, p. 264.

35 The fire broke out during the night of 8 August, causing the destruction of '28 synagogues officielles, le grand et le petit Talmud-Thora, un grand nombre d'académies, de riches bibliothèques, des milliers de maisons appartenant à des Juifs, les manuscrits d'un grand nombre de rabbins de l'époque ou du siècle précédent' (Emmanuel, 1936, p. 265).

36 According to Rabbi Salomon Halevi le jeune, the state demanded about 4,000 pieces of cloth that year, which amounted to a value that 'la bouche ne peut exprimer' (Emmanuel, 1935, p. 47).

37 On this issue, see Emmanuel, 1935, pp. 49–50; Nehama, 1936–1959, v. 5, pp. 77–83; Braude, 1979, p. 233.

38 For examples of such regulations from Salonica as well as from other communities, see Schwarzfuchs, 1989.

39 IKB 4, p. 4 (f. 7v), n° 3: 'You must seal all looms that are there and from now on you must not let anyone take raw wool before all raw wool of that place that is needed for the *çuha* of the Janissaries is taken. You must know that, if I learn here that somebody has taken raw wool, afterwards you shall greatly regret it. [...] You must not let [even] one person take raw wool while the raw wool for the *çuha* of the Janissaries [needed] here has not yet been wholly taken. [...] You must not let the seals be destroyed in any way while our letter of permission has not yet arrived.' The entry bears no date, but undoubtedly followed the appointment of the *yasakçıs* İbrahim Beşe and Mehmed (or Mahmud) Beşe to whom it was addressed. It must have been written in the spring of 1617 in time for the shearings (an entry of similar content but dating from 1620 was written on 16 April). According to IKB 4, p. 4 (f. 7v), n° 2 (21–30/12/1616), the two Janissaries were appointed *yasakçıs* of Veria in late December 1616.

40 It is very probable that imperial decrees securing *çuha* manufacturers' precedence in the purchase of raw wool had been issued in previous decades as well; the ones known from the bibliography date, however, from 1566 onward. Compare the decree prohibiting the export of wool to Europe, addressed to the kadis of Filibe, Üsküb and Gümülcine in 1566 (Sahillioğlu, 1973–1974, p. 420, note 18). Similar orders were addressed to the kadis of Filibe and Sofia in 1569 (Sahillioğlu, 1973–1974, note 20) and to the kadis of Sofia, Filibe, Üsküb, Istrumca and Tatarpazarı, in 1575 (Uzunçarşılı, 1943–1944, v. 1, p. 274, note 3). The bibliography offers no example of a sixteenth century decree prohibiting the purchase of raw wool by local craftsmen, although H. Sahillioğlu remarks that *çuha* manufacture was a priority and 'the town's guilds came second' (Sahillioğlu, 1973–1974, p. 420, note 20). For an example from Sofia contemporary to the orders discussed here, see Duda and Galabov, 1960, p. 154, n° 554 (22/5/1619) and n° 555 (26/5–4/6/1619).

41 The stamp-tax (*tamga resmi*) for the year 1613 was farmed out for 5,000 *akçes* while that of 1619 was farmed out for 3,000 *akçes*

(compare IKB 2, p. 14 [f. 8v], n° 1 [2–11/4/1613] and IKB 6, p. 97 [f. 6r], n° 5 [19–28/11/1619] respectively).

42 IKB 6, p. 197 (f. 56r), n° 5 (16/4/1620).

43 IKB 2, p. 11 (f. 47r), n° 1 (27/9/1612). Kostandin had commissioned 22 *velençe* to the manufacturer İsak.

44 IKB 2, p. 66 (f. 34v), n° 1 (23/7/1613). Mustafa had commissioned 39 *velençe* to the manufacturer Yasef veled-i Musa, which were to be delivered in time for the fair of Elassona.

45 IKB 15, p. 28 (f. 14r), n° 2 (16/9/1639). Topal Yorgi had commissioned 1,500 *akçes* worth of *velençe* to the Christian grocer Muşara.

46 IKB 4, p. 766 (f. 21v), n° 1 (8/4/1617). The Jew Biçan owed 8,000 *akçes* to Racil Ali due to be paid at the time of the Elassona fair.

47 IKB 16, p. 278 (f. 30v), n° 3 (10/7/1641). Mustafa Beg had given a loan of 100 *riyali guruş* to the Christian Kiryazi veled-i Nikola for which the Jew Çalıkoğlı Salomo was the guarantor.

48 IKB 17, p. 86 [f. 42v], n° 6 (18/7/1646). The Jews Boğaz veled-i Davi, Yuda veled-i Musa, Nesi veled-i İshak, Baruh Yasef and Dezid ibnet-i Yasef owed 50 *guruş* to Mahmud Efendi from a loan and 25 *vukkiye* of *velençe* as interest.

49 IKB 20, p. 371 (f. 16r), n° 1 (25/7/1651).

50 IKB 2, p. 30 (f. 16v), n° 6 (30/5/1613).

51 IKB 11, p. 46, n° 1 (15/6/1627).

52 IKB 2, p. 30 (f. 16v), n° 6 (30/5/1613).

53 IKB 15, p. 126 (f. 63r), n° 2 (9/8/1640).

54 IKB 14, p. 99, n° 2 (8/11/1638).

55 IKB 15, p. 15 (f. 7v), n° 2 (26/7/1639). Mustafa Çelebi rented a suite of three rooms to Yopno (?) bint Salomo, a woman originating from Salonica.

56 IKB 2, p. 57 (f. 30r), n° 2 (27/6/1613). According to Alderson 1956, n° 1154, table XXXIV, Güvherhan or Gevherhan Sultan was the daughter of Ahmed I (1603–17), niece of Mustafa I (1617–18 and 1622–23) and sister of Osman II (1618–22), Murad IV (1623–1640) and İbrahim I (1640–1648). By 1645, Güvherhan Sultan had passed away, but the *yahudi hane* – in some documents, also called the *velençe kârhanesi* – had been transformed into a pious foundation (*vakıf*). See IKB 17, p. 191 (f. 96r), n° 1 (1/3/1645).

57 IKB 6, p. 152 (f. 33v), n° 2 (28/4/1620): 'We request that the owners of sheep be ordered not to sell any milk and raw wool to the aforementioned Jews and that the villages in which these Jews have constructed sheepfolds every year and have collected cheese and butter be ordered, from now on, not to allow them to construct any sheepfolds in the [aforementioned] villages. Also let the *zabıt* of

the district arrest and punish the Jews in case he finds any of them collecting milk and raw wool in the aforementioned way.'

58 IKB 6, p. 194 (f. 54v), n° 1 (30/6/1620). The craftsmen and merchants of Veria resented the supervision of their affairs by the *yasakçıs* and often brought them to court on accusations of oppression and abuse of authority. For another example, see Gara, 1998, p. 159.

59 IKB 6, p. 194 (f. 54v), n° 1 (30/6/1620).

60 MD 89, p. 68, n° 2 (1643–44).

61 MD 89, p. 68, n° 2 (1643–44).

62 IKB 6, p. 194 (f. 54v), n° 1 (30/6/1620): 'Ten Jews have fled to that direction (i.e., to Veria) with the excuse of working *velençe* and five to ten *çuha* looms have been left empty'.

63 IKB 17, p. 171 (f. 86r), n° 2 (13/9/1645).

64 As concerns this matter, the *velençe* manufacturers' statements are supported by independent evidence as well: in 1643 and 1644, the Jews of Veria were not able to pay the rent to the *vakıf* of Güvherhan Sultan (IKB 17, p. 191 [f. 96r], n° 1 [1/3/1645]). In 1646, a fulling mill with four rooms was let out for only 250 *akçes* per month while, in 1617 and 1627, the rent had amounted to 500 *akçes* (IKB 17, p. 1 [f. 1r], n° 3 [6/2/1646], IKB 10, p. 174 [f. 7v], n° 6 [21/5/1617] and IKB 11, p. 46, n° 1 [15/6/1627] respectively). The stamp-tax of 1645 was farmed out for 3,500 *akçes* while, in 1640, it amounted to 4,000 *akçes* (IKB 17, p. 14 [f. 7v], n° 6 [28/4/1645] and IKB 15, p. 152 (f. 77r), n° 2 [5/8/1640] respectively).

65 IKB 17, p. 171 (f. 86r), n° 2 (13/9/1645).

66 Such an order was included in an imperial decree issued in 1574. See Sahillioğlu, 1973–1974, pp. 422–423.

67 Most probably, the version of the Salonica Jews was closer to reality. As already shown (note 3), the Jewish community of Veria emerged only in the mid-sixteenth century and did not date from 'the time of the imperial conquest', as the kadi of Veria claimed. The fact that, in 1595, no Jews appeared at the poll-tax registration in Veria (see above, note 5) strongly suggests that they had had themselves registered somewhere else, by all evidence, in Salonica. If this is the case, the formation of a separate community in Veria took place only during the first half of the seventeenth century.

68 IKB 17, p. 171 (f. 86r), n° 2 (13/9/1645).

69 Also compare the following excerpt from IKB 19, p. 73 (f. 44v), n° 2 (8/9/1649): 'Since past times, *çuha* has been manufactured nowhere else, but [only] in Selanik.'

70 IKB 17, p. 138 (f. 69v), n° 1 (7-16/2/1646) and n° 2 (21/3/1646) respectively.

71 IKB 17, p. 138 (f. 69v), n° 2 (21/3/1646).
72 IKB 17, p. 138 (f. 69v), n° 2 (21/3/1646).
73 IKB 17, p. 173 (f. 87r), n° 2 (26/7/1646). Present at court were the *velençe* manufacturers Çalıkoğlı Salomo, Yasef Pinton, Bereketoğlı Yom, Yakof Şabatay, İsak Ambani, Yako Pinto, Salomo Saltiel, Şabatay Alhanat (sic), İsak Kvenka and Nesim Alkazil, as well as the *çuha* manufacturers' representatives, Rabbi (*haham*) İsak Pardo, Yakof Menahem, Yom Benbeniste, Yasef Leril and Avram Abuaf.
74 At about this time, Rabbi Hayyim Shabetai, the Salonica community's supreme spiritual authority, sent a lengthy memorandum to Rabbi Salomon ben Mohavar, one of the most influential persons in the community of Istanbul, requesting his help in bringing back fugitives who had settled in the capital. The author laments the situation concerning the Salonica population and begs the leadership of the Istanbul community for help. He also remarks that the community could easily have recourse to state authorities in this matter if it so decided: 'On doit exiger des déserteurs de venir reprendre leur place dans la ville, ou s'il leur est impossible de rentrer, de trouver un moyen d'acquitter leur part d'impôt. On est en droit de les y forcer en ayant recours à l'État, et nul n'aurait à redire contre une telle procédure. Mais on préfère s'en abstenir' (Nehama, 1936–1959, v. 5, p. 88).
75 IKB 19, p. 73 (f. 44v), n° 2 (8/9/1649).
76 On the reorganisation of *çuha* manufacture in 1664, see mainly Uzunçarşılı, 1943–1944, v. 1, p. 276; Faroqhi, 1994, pp. 30–32.

Bibliography

Primary Sources

Greece
G.A.K. – Archeia Nomou Emathias, Veria: IKB 2, 4, 6, 9, 10, 11, 14, 15, 16, 17, 19 and 20.
Turkey
Başbakanlık Arşivi, Istanbul: TTD 424, 433 and 723, MD 89, MM 14725.

Secondary Sources

Alderson, A. D., *The Structure of the Ottoman Dynasty*, Oxford, 1956.

Anastasopoulos, Antonios, 'Oi othomanikoi ierodikastikoi kodikes (sitzil) tes Beroias: Problemata taxinomeses', *Imeros*, 1, 2001, pp. 149–169.

Barnai, Jacob, 'The Congregations in Izmir in the Seventeenth Century', *Peamim* 48, 1991, pp. 66–84 [in Hebrew].

Braude, Benjamin, 'International Competition and Domestic Cloth in the Ottoman Empire, 1500–1650: A Study in Undevelopment', *Review* 2/3, 1979, pp. 437–451.

Braude, Benjamin, 'The Rise and Fall of Salonica Woollens, 1500–1650: Technology Transfer and Western Competition', in Alisa Meyuhas Ginio, ed., *Jews, Christians, and Muslims in the Mediterranean World after 1492*, London/Portland (*Mediterranean Historical Review* 6/2), 1992, pp. 216–236.

Duda, Herbert W. and Galabov, Galab D., ed., *Die Protokollbücher des Kadiamtes Sofia*, Munich, 1960.

Emecen, Feridun M., *XVI. asırda Manisa kazâsı*, Ankara, Türk Tarih Kurumu, 1989.

Emecen, Feridun M., 'From Selanik to Manisa: Some Information about the Immigration of the Jewish Weavers', in Elizabeth Zachariadou, ed., *The Via Egnatia under Ottoman Rule (1380–1699)*, Rethymnon, The University of Crete Press, 1996, pp. 97–112.

Emmanuel, I.-S., *Histoire de l'industrie des tissus des Israélites de Salonique*, Paris, 1935.

Emmanuel, I.-S., *Histoire des Israélites de Salonique, t. I (140 av. J.C. à 1640)*, Paris, 1936.

Evrejski izvori za obstestveno-ikonomiceskoto razvitie na balkanskite zemi prez XVI vek, v. 1, Sofia, Bulgarian Academy of Sciences, 1958.

Faroqhi, Suraiya, 'Textile Production in Rumeli and the Arab Provinces: Geographical Distribution and Internal Trade (1560–1650)', *Osmanlı Araştırmaları* 1, 1980, pp. 61–83.

Faroqhi, Suraiya, 'Labor Recruitment and Control in the Ottoman Empire (Sixteenth and Seventeenth Centuries)', in Donald Quataert, ed., *Manufacturing in the Ottoman Empire and Turkey, 1500–1950*, Albany, SUNY Press, 1994, pp. 13–57.

Gara, Eleni, 'In Search of Communities in Seventeenth Century Ottoman Sources: The Case of the Kara Ferye District', *Turcica* 30, 1998, pp. 135–162.

Günay, Vehbi, 'Balkanlara ait siciller ve Karaferye kazası şer'iye sicilleri kataloğu', *Türk Dünyası İncemeleri Dergisi*, 2, 1997, pp. 103–113.

İnalcık, Halil, 'Military and Fiscal Transformation in the Ottoman Empire, 1600–1700', *Archivum Ottomanicum* 6, 1980, pp. 283–337.

Murphey, Rhoads, *Ottoman Warfare, 1500–1700*, New Brunswick, UCL Press, 1999.

Nehama, Jos., *Histoire des Israélites de Salonique*, Salonica, 5 v., 1936–1959.

Pamuk, Şevket, 'Money in the Ottoman Empire, 1326–1914', in Halil İnalcık and Donald Quataert, ed., *An Economic and Social History of the Ottoman Empire 1300–1914*, Cambridge, Cambridge University Press, 1994, pp. 947–980.

Pamuk, Şevket, 'The Price Revolution in the Ottoman Empire Reconsidered', *International Journal of Middle East Studies* 33/1, 2001, pp. 69–89.

Rozen, Minna, 'The Corvée to Operate the Mines in Siderokapısı and its Effects on the Jewish Community of Thessaloniki in the 16th Century', in I.K. Hassiotis, ed., *The Jewish Communities of Southeastern Europe: From the Fifteenth Century to the End of World War II*, Thessaloniki, 1997, pp. 579–589.

Sahillioğlu, Halil, 'Yeniçeri çuhası ve II. Bayezid'in son yıllarında yeniçeri çuha muhasebesi', *Güney-Doğu Avrupa Araştırmaları Dergisi* 2–3, 1973–1974, pp. 415–466.

Schwarzfuchs, Simon, 'Quand commença le déclin de l'industrie textile des juifs de Salonique?', in A. Toaff and S. Schwarzfuchs, ed., *The Mediterranean and the Jews: Banking, Finance and International Trade (XVI–XVIII centuries)*, Ramat Gan, 1989, pp. 215–235.

Tezcan, Hülya, 'Topkapı Sarayı'ndaki velense ve benzeri dokumalar', *Topkapı Sarayı Müzesi Yıllık*, 5, 1992, pp. 223–240.

Uzunçarşılı, İsmail Hakkı, *Osmanlı devlet teşkilatından kapukulu ocakları*, Ankara, 2 v., Türk Tarih Kurumu, 1943–1944.

Veinstein, Gilles, 'Sur la draperie juive de Salonique (XVe-XIXe s.)', *Revue du Monde Musulman et de la Méditerranée* 66/4, 1992, pp. 55–62.

Veinstein, Gilles, 'La draperie juive de Salonique: une relecture critique de Joseph Nehama', in I.K. Hassiotis, ed., *The Jewish Communities of Southeastern Europe: From the Fifteenth Century to the End of World War II*, Thessaloniki, 1997, pp. 579–589.

Yerasimos, Stéphane, 'La communauté juive d'Istanbul à la fin du XVIe siècle', *Turcica* 27, 1995, pp. 101–130.

CHAPTER 6

The Millers and Bakers of Istanbul (1750–1840)

Salih Aynural[1]

Due to the special importance of Istanbul's food supply, the Ottoman state had developed well-defined policies to ensure its regularity. Within the Ottoman borders, all goods that were not needed for the consumption of the producing areas could not be sold inter-regionally before the needs of the capital had been met. Istanbul was not merely granted the right to buy before other prospective customers were given access. To be more exact, along with the Ottoman army, navy and palace, the great city even enjoyed a monopoly when it came to securing privileged access to primary producers.

Among the supplies earmarked for Istanbul, the place of bread was rather special. When it came to problems connected with the grain supply, particular care was taken by everyone in a position of responsibility, from the sultan down to the lowliest officials. All manner of solicitude was shown in order to ensure that the population of Istanbul did not lack this essential foodstuff. When it came to securing the bread supply, and in fact all other grain products needed in Istanbul, carefully co-ordinated measures began with the purchase of grain in the producing regions and continued with its transfer to the nearest ports and from there to the Ottoman capital. Storage in the official weighing centre for grain (*unkapanı*) or in granaries directly belonging to the state formed the next stage. The process ended with the distribution of the grains to millers and bakers and the sale of flour and baked goods to the urban population.

This system involved close co-operation between the state and the private sector. The ruler and his officials supported the traders and craftsmen who operated as private entrepreneurs, while at the same time closely controlling the latter.

Until the end of the eighteenth century, about 90 percent of all grain consumed in the Ottoman capital was brought in by specialised grain-traders. In 1755–1762 the quantities of grain distributed to the millers and bakers of Istanbul amounted to an annual average of 5.5 million *kiles* (140,800 tons), of which wheat constituted 70 percent. Barley amounted to 24.6 percent, while the remainder was millet.[2] Flour was distributed to the tune of 4,371 sacks.[3] From the grains distributed to millers and bakers, it becomes apparent that the daily bread of the Istanbul population did not, by any means, consist of pure wheat.

In those years 93.2 percent of all the grain arriving in the capital was sold to privately operating millers and bakers, the state's share amounting to a mere 6.8 percent.[4] This confirms the estimate of Lütfi Güçer, who had suggested that in 1757, 91.4 percent of all grain was brought into the city by private traders and 8.6 percent by the state.[5] Throughout the centuries the Ottoman state purchased and stored grain in order to prevent shortages, especially during the winter months. The share of these direct official purchases increased significantly after the Grain Inspectorate (Zahire Nezareti) had been created in 1793 and the Treasury in Charge of Grain (Zahire Hazinesi) in 1795.

The millers of Istanbul

Three types of mills were present on Ottoman territory. In horse-operated enterprises, four horses were needed to drive a single millstone.[6] Watermills were established close to rivers and streams, while windmills would have depended on power supplied by the changeable winds traversing the Bosphorus area. In the period under investigation, practically all mills in Istanbul were horse-driven. While much more expensive than the two other types, horse-operated mills could be located anywhere and function the year round without interruption. The capacity of a mill was measured by the number of millstones that it contained, and according to this capacity, it was officially assigned

greater or lesser quantities of grain. As this was a rule which brooked no exception, it was more or less known in advance how much any given mill could produce and the same principle, incidentally, applied to the city's bakeries. This high degree of predictability in the production sector can be linked to the 'economic mind' of Ottoman craftsmen, who saw themselves as producing according to the perceived needs of their customers rather than for a continuously expanding market.

When the Ottoman army went on campaign, part of the grain needed to feed it was sometimes procured from Istanbul itself. Wheat and barley were often collected from the granaries of the Naval Arsenal, transported to the mills of Istanbul for processing against payment of a fee and then sent on to one of the stopping points on the route along which the army was expected to pass. Thus, in 1214/1799, 33,333 *kiles* of wheat were remitted from the Naval Arsenal to the Istanbul millers, who were to receive 18 *akçes* for each *kile* ground into flour. Of course, there were losses in processing which, in this instance, amounted to about 14 percent of the total delivered: 28,660 *kiles* of flour were actually passed on to the army.[7]

The millstones employed in Istanbul were produced in the western Anatolian town of Foça by the 'taxable unit' (*mukata'a*) concerned with millstones (*seng-i asiyab*).[8] In certain years, demands on the millstone manufacturers might be quite heavy. Thus, after Istanbul's mills had suffered severe damage during a fire in 1793, 449 millstones were brought in from Foça.[9] The capital's operators were not permitted to buy their millstones in any other place as the revenues of the Seng-i Asiyab Mukata'ası were, to a large extent, derived from the sale of these items. Purchasing them from any other source would therefore have hurt the revenues of the Ottoman treasury.[10]

The millstones manufactured in Foça and known in Istanbul under the name of *horos* had a standard width of eight spans and an equally standard eight fingers' thickness. A second type of millstone was called the *çarh*; at a width of twelve spans, it was 50 percent larger than the *horos*, even though the thickness was the same. Accordingly, the two types differed in price. As stated by an undated document, a pair of *horos* cost 22 *kuruş*, while 35 had to be spent for a *çarh*.[11] In 1797 the price of a *horos* had increased to 24 *kuruş*, while 38 were demanded for a *çarh*.[12] By 1806,

inflation had progressed yet further. As the prices of iron, steel, gunpowder, coal, workers' wages and transportation had all increased, we learn of a demand to adjust the price of a pair of *horos* to 30 *kuruş* and that of a pair of *çarh* to 50.[13]

As the *çarh* was so much larger than the *horos*, if a miller was planning to work with the smaller variety, he was permitted to use two pairs of millstones instead of a single one.[14] If the millers were able to show a valid reason, they also could transfer the millstones from one establishment to another: for instance, if a mill burnt down and the owner did not have the means to rebuild it.[15] In this context, if a miller wished to add millstones to his enterprise, according to the rules of his craft, he was required to first re-employ the stones from other mills which were currently not in use. Only if this was not possible did he receive permission to add a new stone.[16]

The number of shares which could be owned by partners operating a mill was determined according to the number of horses used in its operation. This is documented in numerous texts where we find expressions such as the following: 'I own a six-and-a-half horse share in a mill equipped with twenty horses and other necessary tools well known [to the concluding parties]....'.[17] When there were accounting problems among the shareholders of mills or bakeries, they turned to the Grain Inspectorate. The inspector formed a commission consisting of *kethüdas* and 'experienced masters' from among the millers and bakers, which also included merchants cognisant of the situation. This commission would review the accounts and attempt to solve the trouble.[18]

Feeding the horses indispensable for the operation of the mills was a special problem: for this purpose, the millers were obliged to employ stable boys. The straw needed for this purpose usually came from landholdings near Istanbul such as those located in Büyükçekmece and Küçükçekmece.[19] Even the disposal of horse dung, a by-product of any mill, was organised by the state: there were rules as to which mill was to supply which owners of gardens or vineyards. Without such regulation, a lot of difficulties might have ensued.[20]

In every mill, there was a man known as the *kapancı*, who was responsible for fetching the grain from the public weighing scales and the grain distribution centre (*kapan*).[21] In mills operated by

partnerships, the *kapancı* was normally chosen from among the partners.[22] Millers were obliged to keep a stock of grain sufficient for at least six months and, as we have seen, the official weighing centre for grain (*unkapanı*) supplied stores for the winter according to the capacities of each mill. As a result, the entrepreneurs operating the latter were supposed to construct storehouses for the grain that was received as well as for the straw needed by their horses.[23] Some mills and bakeries might be in poor condition and urgently need repairs. As a result their owners were often unable to collect the grain which they needed to store for the winter and this placed the official in charge of the public weighing scales (*kapan naibi*) in a difficult position. In consequence, we find the *kapan naibi* putting pressure on millers and bakers in order to force them to pick up their allotted stores of grain.[24]

In *intra muros* Istanbul and Eyüp, Galata and Üsküdar, most bakeries possessed their own mills, which ground up the grain coming in from the official weighing centre and the state granaries; the flour was then turned into bread on the spot. To put it in a nutshell, mills and bakeries formed part of what we would call today 'integrated enterprises'. This arrangement had the support of the Ottoman state, as is clearly apparent from a sultanic rescript addressed, as early as 1568, to the kadis of Istanbul and the Three Towns (that is, Eyüp, Galata and Üsküdar): 'as you have informed [me] that in the aforementioned well-protected city, it is necessary to construct a mill next to every bakery, I order that when you receive [this missive], you should make every owner of a bakery build a flour mill for each one of his bakeries. If possible [the mill] should be located next to the bakery, if not, in some other suitable place.'[25] Bakers thus secured some of the flour they needed from the mills with which they were associated. The remainder came from enterprises which, though located somewhere else, had been assigned to them for deliveries. Operators of bakeries were forbidden to take 'even the tiniest grain except from the mills which had been assigned and attached to them'.[26]

Those bakeries – and they were very few in number – which did not possess their own mills were allotted by the Başmuhasebe (Chief Accounting Office) to one of the existing mills from which they had to obtain their flour. In conformity with the

rules current in their respective crafts, they could not supply themselves from any other source. Every master was obliged to produce loaves of bread in accordance with the amount of grain which had been assigned to him. In 1197/1783, it was demanded that bakers who had neglected doing this and who sold part of the flour in question should be hanged as a warning to others.[27] Millers and bakers organised in order to regulate these matters.[28]

When a mill or bakery burnt down and the owners wished to put up a new building, as a first step millers and bakers were called to the presence of the kadi in order to testify. Thus, it was determined whether there was anything in the current situation which did not conform to the rules of the two crafts concerned. In consequence, if there were sufficient mills and bakeries in the area and the inhabitants would not be adversely affected by the permanent disappearance of the previously existing establishments, permission was given to put up some other building. But if the opposite was true, the owners were obliged to reconstruct the mill and/or bakery.[29]

If mills had burnt down or had otherwise been destroyed and this caused a deficiency in the provisioning of the city's inhabitants, the owners of the enterprises in question were tracked down and encouraged to repair or rebuild.[30] After major fires, there might be such a need for specialised artisans that additional craftsmen were brought in from outside Istanbul. Thus, in 1786, pavers from Edirne participated in the rebuilding of the capital's mills.[31] Nor were these the only artisans whose services were needed to keep the mills operating regularly by day and by night. Millstones broke and had to be refurbished by specialist repairmen: in 1172/1761, these were not available in sufficient numbers in the town of Eyüp so that there ensued a visible decrease in the quantities of flour produced. In response, the local millers demanded that the requisite number of repairmen be on call when required.[32]

Bakers' mills

From time to time, the Ottoman administration made counts of the mills serving the needs of the capital, partly in order to

establish which mills delivered how much flour to which bakeries and partly to ferret out those millers who had secretly added extra millstones to their enterprises.[33] For the modern historian, these figures are of great value because they allow us to estimate productive capacity. As has become apparent, Istanbul's horse-driven mills fell into one of two different categories, namely, the bakers' mills and the flour-manufacturers' mills. Bakers' mills were known by this term because they were usually located close to bakeries and because the proprietors of the two types of enterprise concerned were usually identical. Within Istanbul and the Three Towns, in 1152/1739, 231 bakers' mills were in operation. By 1176/1763, only two additional mills had been built *intra muros* so that the total was now 233. Furthermore, 116 flour-manufacturers' mills were also in existence in 1763, which gives us a total of 349 enterprises located in Greater Istanbul, operating 1,500 millstones.

In 1739, a total of 991 millstones was recorded. In 1753 there were 1,118, whereas a document dated 1756 gives a total of 1,474.[34] As we have seen, by 1763 there were 1,500 of them so that the number of millstones must have increased by 26 in the intervening seven years. These changes usually resulted from the addition of millstones to existing enterprises. The flour produced by mills not attached to specific bakeries was assigned to those bakers who might be in need of additional supplies and, once again, it was not possible to change this arrangement without special permission.

When grain was distributed to the mills from granaries belonging to the state, two-thirds went to the bakers' mills and one-third to those of the flour-manufacturers.[35] This distribution reflects the greater share of bakers' mills in the total of Istanbul's milling enterprises. For most of the time, millstones operated by mills attached to bakeries were about three times as numerous as those employed in flour-manufacturers' establishments. In 1763, when bakers' mills *intra muros* used 662 stones, the flour manu-facturers possessed only 223 of them.[36] The grain assigned to each mill was determined not only by the number of millstones used, but also by the size of the millstones. A large millstone (*çarh*) was expected to grind 20 *kiles* (512 kg) a day.[37] By contrast, for the smaller *horos*, the owners were to merely process 9 *kiles* (230.4 kg) daily.[38] However, matters were different if a mill worked for a

public soup kitchen since, in that case, a small millstone was supposed to grind 10 *kiles* a day.[39]

For certain dates, these figures permit us to compute the amount of grain processed in Istanbul's mills. Thus, for the early eighteenth century, we possess the information that 42 mills using the large variety of millstone were in operation within the perimeter of the walls; this involved a total of 114 *çarhs*. As each one of these stones ground 20 *kiles* per day, total production must have amounted to 2,280 *kiles* or 58,368 kg of flour. This total did not include the grain that was ground in mills using the smaller type of millstone.[40]

Flour-manufacturers' mills

Apart from providing supplementary flour to bakeries, the flour-manufacturers' mills also delivered their product to the manufacturers of baked goods other than bread. This included workshops making ring-shaped rolls (*simit*), sweetened bread (*çörek*), millefeuille pastry (*börek*), sweet noodles (*kadayif*), fried pastry (*lokma*) and flat bread (*gözleme*), not to mention the shop-keepers who sold flour to those consumers who did their own baking.[41] As the work of these millers differed from that done by the operators of bakers' mills, they had formed a guild of their own. This separation of producers according to the type of customer who was being served applied not only to *intra muros* Istanbul, but to the districts of the Three Towns as well.[42]

Moreover, the flour-manufacturers' mills produced flour of a higher quality and thus they were assigned one *kile* less per millstone than the bakers' mills (8 *kiles* or 204.8 kg).[43] After the production of this more expensive type of flour, known as *has un*, there remained a meal that was strongly mixed with bran (*kepek*). This was sold in the market as well as in three or four shops outside the official grain distribution centre (*unkapanı*) as cameleers and villagers used it to feed their animals. It was prohibited to sell this kind of low-grade flour to bakeries.[44] Emergencies and special assignments apart, flour-manufacturers' mills could not sell to bakeries producing bread, while the mills attached to bakers' establishments could not deliver their flour to the manufacturers of ring-shaped rolls and the like.[45] Millers

who illegally supplied bakeries were severely punished; the 'slots' (*gediks*) essential for the practice of their craft even might be confiscated.[46]

In 1739, Istanbul *intra muros* and the Three Towns, as we have had occasion to note, possessed 116 flour-manufacturers' mills with 360 millstones. By 1763 there had been no change in the number of mills, but the millstones had increased to 382.[47] This means that the average enterprise in this category operated 3.3 millstones and its capacity was thus lower than that of a typical bakers' mill. By the year 1201/1787, the total of all flour-makers' mills had increased to 128. In case of necessity, it was possible to move millstones from flour-makers' to bakers' mills or *vice versa*; of course, permission by the *kethüda, yiğitbaşıs* and 'experienced masters' was needed for such a transaction to be valid.[48] As a next step, the permission of the kadi of Istanbul was obtained and, finally, the new situation was recorded in the registers of the Başmuhasebe.[49]

An artisan operating a baker's mill might purchase millstones from a flour-manufacturer's enterprise and might choose to operate his new acquisitions according to their previous purpose, thus straddling the fence between two different guilds.[50] As a result, in a few enterprises, certain millstones might be producing ordinary flour while others in the same place produced *has un*. This would result in the otherwise anomalous situation of one and the same mill delivering both to the bakers of bread and to the manufacturers of baked non-bread goods.[51]

What did it cost to establish a mill? In relation to this important question, our data furnish at least a partial answer. In the year 1808, a millstone driven by four horses changed hands for 3,000 *kuruş*.[52] This was a very substantial sum since, in 1804 a construction worker earned an average daily wage of 4 *kuruş*. Thus the typical miller must have been a man of some substance, the more so as most mills were operated in conjunction with bakeries.

The bakers and bakeries of Istanbul

In Istanbul, the production of baked goods was highly specialised. Apart from producers of ordinary bread, we encounter manufacturers of fine white bread (*francala*), plus the

variety of baking products listed at the start of the previous section. It was forbidden for masters in any one of these crafts to produce the goods forming the specialities of their competitors.[53] In fact, the makers of the different types of baked goods promised to ferret out those among their colleagues who did not abide by this rule, hand them over to the authorities for punishment and exclude them from the exercise of their crafts.[54] Exceptions were, however, made in extraordinary situations. Thus in 1218/1803 the production of bread in Istanbul was way below what was needed and long queues formed in front of bakeries. To remedy the situation, the Ottoman state permitted the bakers of fine white bread to manufacture the 'standard' variety and ordered the proprietors of bakeries that needed repairs to bring them back into working order without delay.[55]

Another critical situation ensued in 1829 when large quantities of wheat arrived in Istanbul from Russia. However, as this wheat did not keep well and had to be consumed as soon as possible, the bakers of fine white bread received permission to temporarily produce the 'ordinary' kind of bread.[56] Furthermore, in spite of this strict division of labour, some of the guilds producing baked goods shared the same officials. This applied, for instance, to the bakers of ring-shaped rolls and those specialising in sweetened bread.[57] During the Tanzimat period (1839–1878), this rigid order governing the baking crafts became more flexible. Now, 'ordinary' bakers, producers of fine white bread and manufacturers of flour came to be considered as a single grouping of artisans, making movement across previously unpassable craft borders a great deal easier.[58]

In any guild, the most important personage was the *kethüda*, whom we have already encountered in a variety of contexts. A *kethüda* had wide-ranging powers and equally multifarious responsibilities. But when he abused these powers, the artisans of his guild often complained and the *kethüda* could lose his position. If his infractions were serious, he was, moreover, liable to further punishment.[59] In such instances, the complaints were of course first investigated by the authorities in order to establish whether the guildsmen's claims were well founded. Thus in 1819 the *kethüda* of the bakers, who had been causing trouble within his guild, was accused by the masters in his charge and banished to Rhodes.[60] In due course, the bakers would

suggest for the vacant position another candidate in whose rectitude they trusted and who could be expected to apply the rules of the guild in a proper fashion.[61]

But it also happened that the administration regarded an accusation as unfounded. We know of a case in which a complaint to the Sultan's Council (*Divan-ı Hümayun*) concerning a *kethüda* and an 'experienced master' of the bread-bakers' guild was rejected by the kadi of Istanbul as being devoid of reason, the kadi having heard the matter in the presence of all master bakers.[62] Similarly, in 1203/1789, some master bread-bakers handed in an unsigned petition to the Sultan's Council in which they claimed that their *kethüda* kept all the high-quality grain for himself, leaving only the poor varieties for the remaining masters. Upon the Council's orders, the kadi of Istanbul called the *yiğitbaşıs* of the guild, in addition to the officially licensed grain-traders and a number of bakers: in all, there were 150 persons, both Muslim and non-Muslim. In this hearing, all witnesses confirmed that the *kethüda* was an honest person and that the distribution of grain was undertaken not only by this particular warden, but also by the official in charge of the weighing and distribution centre for grain (*kapan naibi*), as well as by the masters themselves.[63]

When a new bakery was to be opened, the master baker in question invariably had to furnish a guarantor and have his name entered into the registers of the Başmuhasebe, where the rules of the craft also were on record.[64] According to these regulations, bakeries without guarantors were shut down.[65] The latter rules also specified that if there was no demand for his products, no baker was permitted to start a new enterprise.[66]

Three kinds of bread were made in both the specialised bakeries producing fine white bread and those baking the ordinary variety. The best quality was known as *hâsü-'lhâs*, the second as *hâs* and the third as *bayağı*. Accordingly, the grain used for these different types was known as that of the 'three bakeries'.[67] Istanbul bakers used salt that was a product of the Ahyolu saltpans, distributed to the bakers after first having been stored in the public salt storehouse.[68] As to the firewood, which was brought to the city from Kocaeli and Karasu in northwestern Anatolia, it came from the beech tree, in this context known as *elleme*.[69] The authorities encouraged the bakers to use *elleme*

rather than less expensive fuels such as brushwood because the latter increased the fire hazard.[70] While it was acknowledged that bakers producing ring-shaped rolls and sweetened bread would use brushwood, they were admonished to keep only what was immediately needed and to take special care in order to prevent fires.[71] For the same reason, bakers were warned to clean their chimneys frequently; after all, fires were a frequent cause of the destruction of bakeries and mills.[72] For example, at 2 o'clock in the morning on 13 Ramazan 1196/12 August 1782, a large number of bakeries producing sweetened bread, ring-shaped rolls, flatbreads and sweet noodles were reduced to ashes in a major conflagration.[73]

Sometimes, bakers of ordinary bread or of ring-shaped rolls and sweetened bread wished to change their field of operations and instead manufacture fine white bread or some other type of baked goods. As a first step, these bakers had to apply for permission to the Sultan's Council. The latter would then investigate whether there was any need for the kind of bakery that the applicant wished to operate. For this purpose, the Council elicited the opinions of the *kethüda* as well as the 'experienced masters' and other persons cognisant of the situation. If these men replied in a positive way, then the change was officially approved; the former entry in the Başmuhasebe registers was deleted and the new speciality was entered instead.

Every bakery had its allotted places for the sale of bread and the owners were not permitted to sell anywhere else.[74] It was also contrary to the rules for bakeries *intra muros* to send bread to be sold outside the city walls by street sellers. Yet, in exceptional instances, permission for such sales could be granted by the authorities.[75] Thus, the inhabitants of the Bosphorus village of Beykoz received a special permit to buy their bread from bakers near the Mevlevihane gate in the Istanbul land walls.[76] However, not only were some of the bakers known to have broken these rules but neither did they respect the regulations which governed the relationships of the master bakers to the official distribution centre for grain.[77]

Bakers' and millers' liaison with
the grain distribution office

As seen above, bakers were only supposed to procure their grain supplies from the grain distribution office. Twelve masters, six from the so-called Rumelian branch and six from its Anatolian counterpart, were to appear at this centre every day in order to discuss matters pertaining to the bakeries. This did not always happen, however, and the delinquent masters had to be issued official warnings.[78] One reason why the administration insisted on such a close liaison between the bakers and the grain distribution office was, as has already been noted in a different context, the requirement that millers and bakers should hold sufficient stocks for six months. From the distribution registers (*tevzi defterleri*) kept by the head of the distribution office, it is possible to establish whether millers and bakers had in fact bought the requisite quantities of wheat and barley. The kadi of Istanbul checked these registers, particularly in the late autumn (*ruz-ı kasım*), and warned those masters who had not as yet made their purchases.[79] Sultanic commands to the kadis of Istanbul are quite specific in this respect: 'as the distribution registers show whether bakers and flour manufacturers have purchased enough grain to last them through the winter, the kadis of Istanbul should never omit checking these registers. Before the advent of the *ruz-ı kasım*, they should personally consult the distribution registers and make those [bakers and millers] who have not formed stocks for six months do so...'[80]

The reason why certain millers and bakers did not comply with these regulations was doubtless a sheer lack of capital. In fact, it was not rare for masters to flee the city because they were unable to pay their debts to the official grain-traders and to the Ottoman state. As a solution, a sultanic rescript was issued to make sure that millers and bakers were well-off and, if that was not possible, it granted those official money-changers (*sarraf*) who were prepared to take over the financing of a bakery permission to do so.[81] In 1256/1840–1841, a new set of regulations was adopted: people who now wished to build a new mill or bakery or to restore and operate an abandoned enterprise of this kind needed to obtain a licence from the Ministry of Trade. For this purpose, mill operators had to pay 350 *kuruş* to the Trade Treasury for

every millstone that they operated while 150 *kuruş* were due from prospective bakers.[82]

When a bakery or mill burnt down or, as happened in the earthquake of 1766, collapsed or was severely damaged, property owners were responsible for the reconstruction of the buildings.[83] Since it was such a major concern not to leave the population of Istanbul without bread, a property owner incapable of making this investment was obliged to sell his mill or bakery, hopefully for a fair price.[84] If a mill or bakery needed repairs and the property owner did not undertake them even though he possessed the means of doing so, his tenant could obtain redress through the intervention of the kadi's court.[85]

While repairs were underway, the bakery's flour assignment would go to other enterprises located close by, which would bake bread to be sold in the outlets which the bakery under re-construction would be expected to possess.[86] As noted previously, while most of these measures favoured the tenants of mills and bakeries, certain privileges were also accorded to the owners of the properties concerned. If the customers complained about a given baker, the owner of the bakery in question could terminate the rent contract.[87] The dominant aim throughout was to prevent a lack of bread in the areas affected by natural or man-made disasters.

In case the grain assigned to bakers by the grain distribution office was insufficient, the *kethüda* of the bakers' guild and the 'experienced masters' applied to the state granaries for supplements.[88] But this necessitated a special sultanic order to the treasurer (*defterdar*).[89] A minor problem with respect to this proceeding resulted from the fact that the measurers, and millers employed in the state granaries mostly came from the small eastern Anatolian town of Eğin and tended to favour their compatriots among the bakers by assigning them larger quantities of grain.[90]

Given the fact that Ottoman craftsmen saw themselves as producing in conformity with the needs of their customers, a miller or baker could not close down his enterprise whenever he felt like doing so.[91] After all, if this happened, the system was no longer in balance and, as a result, there would be a shortage of bread. In addition, bakers and millers, due to their collective responsibility in such an instance, were strongly interested in

the ways in which their colleagues conducted their respective businesses. Accordingly, the relevant craft rules demanded that when a miller or baker planned to return to his province of origin and, therefore, wished to sell or rent his enterprise, the *kethüdas* and 'experienced masters' had to appear in front of the kadi and declare that they were willing to stand surety for the new purchaser or tenant. In this manner, the members of the craft attempted to prevent the entry of unknown and untried persons and to make sure that the departure of this or that individual did not hurt the guildsmen as a whole.[92]

The bakers of 'regular' bread

There were 49 bakers of 'regular' bread who were active in *intra muros* Istanbul in 1124/1712, with 42 mills attached to them.[93] Either this list is incomplete, which is not improbable, or there had been a remarkable increase in these types of bakers by 1182/ 1768. If the latter is true, Istanbul's population should also have grown substantially during the intervening years. At that time, the Ottoman authorities counted no less than 140 bakeries producing 'regular' bread, while there were 55 in Galata, 31 in Üsküdar and 17 in Eyüp, giving a total of 243 such bakeries.[94] By 1201/1787, there had been a slight decline, with 136 establishments recorded in Istanbul proper, 52 in Galata, 28 in Üsküdar and 17 in Eyüp, resulting in a total of 233. Only in Eyüp had the number of bakeries remained constant.

Relatively good documentation is available for the township of Üsküdar. In 1124/1712, there were 17 bakeries on record, with two of them specialising in the manufacture of sweet bread, but which had been accorded permission to bake 'regular' bread as well. These two enterprises had been allotted relatively modest quantities of flour. As to the flour consumption of the Üsküdar bakeries, it amounted to 303 *kiles*, which resulted in a total production of 'regular' bread worth 21,800 *akçes*.[95] Since, at this time, a loaf of bread was priced at one *akçe*, 21,800 loaves must have been produced. Moreover, given the fact that within 56 years the number of bakeries had almost doubled (from 17 to 31), the population of this township must have increased substantially as well.

The majority of Istanbul's bakers were Armenians, while most of the Muslims in this craft were from Albania.[96] In 1195/ 1781, more than sixty operators of bakeries were Albanians, usually members of the Janissary corps and known for their numerous infringements of craft rules. In consequence, local officials used every opportunity to get rid of these people. In times of war, Albanian bakers were sent on campaign by special order of the sultan and their bakeries were turned over to Armenian masters.[97] The bakers' guild was divided into subgroups consisting of three to five practitioners of the craft; each subgroup was under the authority of an 'experienced master'. In the late eighteenth century, there were 61 such groupings recorded in Istanbul. However, in the course of time, the system broke down and could no longer be applied.[98]

Bakers who wished to sell their enterprises had to do this in front of the kadi of Istanbul and receive a judicial affidavit (*hüccet*) from him confirming the transaction.[99] This rule not only applied to the masters of Istanbul *intra muros*, but to those of Galata, Üsküdar and Eyüp as well. The kadis of the Three Towns did not possess the right to confirm such sales.[100]

Baking fine white bread

Francala (fine white bread) was baked out of high-quality (*hâs*) flour and its standardised weight was linked to that of 'regular' bread. Until the year 1790, a loaf of *francala* was supposed to be half as heavy as the 'regular' loaf; in 1213/1798, its weight was fixed at two-thirds of the standard established for cheaper bread.[101] As the weight of this officially sanctioned 'standard' loaf changed according to the abundance or scarcity of grain in Istanbul, the same thing obviously also applied to *francala*. As previously discussed, the relevant bakeries bought most of their *has* flour from specialised mills and only obtained a very small percentage from their own grindstones.[102] They could not secure their flour from any other source except in unusual instances and by special permission.[103]

When a master received permission to open a new *francala* bakery, this fact was entered into the bakers' register which formed part of the Istanbul court records and further entries were

made into the Başmuhasebe registers and also into those pertaining to the Sultan's Council (*Divan-ı Hümayun*).[104] In some cases, permission was granted under the condition that 'this does not become a precedent for others...'.[105] The number of Istanbul's manufacturers of fine white bread did not remain constant. In emergencies, all *francala* bakeries, with the exception of those working for foreign embassies, were even closed down. Thus, in 1769, 25 such bakeries were on record, but there were only 15 in 1789. In 1803, the number had risen once again to 32. In 1808, there were a mere seven *francala* bakeries. By contrast, in 1814, at first there were 69 and then, after a sharp decline, 32 such enterprises were on record.[106]

The unusually high number of *francala* bakers in 1814 gave rise to an investigation on the part of the kadi of Istanbul. On the basis of the latter's report, a sultanic command reduced this number to 37.[107] All bakers of fine white bread were non-Muslims and, in 1204/1790, most of the owners of these enterprises were women.[108] As to the workmen employed in the manufacture of *francala*, they mostly came from the island of Chios. Apparently the number of skilled bakers in Istanbul was limited. From 1803 onwards, whenever the number of bakeries was on the increase, *francala* manufacturers began to employ workers from shops producing other baked goods, whom they attracted by offering high wages. But whenever this happened, the bakers of 'regular' bread had trouble securing the necessary labour.[109]

Normally, when foreign ambassadors asked for bakeries of fine white bread to serve the needs of their households, their petitions were granted.[110] In fact, some bakeries of *francala* were only permitted to work for this or that foreign embassy and it was thus against the rules of the craft for these bakers to sell bread on trays or from baskets in the markets and shopping districts of the city. When opening a bakery assigned to an embassy, the owner had to formally accept this limitation of his activity.[111] Thus, in the Bosphorus village of Büyükdere, until 1821, a bakery served the needs of the French, Austrian and Spanish embassies, which had their summer quarters in this locality. But in this year, the Austrian ambassador asked for this previously common bakery to be assigned solely to his own embassy as in the meantime the Spaniards and Frenchmen had

acquired separate establishments. His petition was granted under the condition that the baker in question would not sell bread to the general public.[112] In addition, in 1230/1815, the Russian embassy's request for a bakery of its own was accepted by the sovereign in person, thus bringing the number of *francala* bakers working exclusively for foreign embassies up to six.[113]

As *francala* was regarded as a luxury, we find that all bakeries producing this bread, with the exception of those working for the embassies, were closed down every now and then. Thus a register of administered prices (*narh*) for the period from 1790–1798 does not contain any prices for *francala*, which should mean that fine white bread was not available in the Istanbul markets at this time.[114] In fact, a document from the year 1204/1790 tells us that the relevant bakeries were being shut down because they did not produce a well-baked pure bread weighing two-thirds of the 'regular' loaf and did not sell at the current officially determined price. A document from the following year explains that 'for a considerable time, *francala* bakers have been buying up the *has* flour of high quality produced from the wheat arriving in Istanbul at elevated prices, using it to bake *francala* and selling the ensuing product with a profit. In consequence, what is left for the "holy and beloved bread" (*nan-ı aziz*) sold to ordinary people is largely bran and waste which constitutes a source of trouble for the people [of the city].'[115]

Francala bakers reacted to this prohibition with the counter-claim that their livelihoods would be adversely affected if their enterprises were closed down and they guaranteed that, henceforward, they would themselves procure their flour outside the city and produce *francala* of the desired quality, which they would sell at the 'current price'. But following a repetition of the reasons outlined above, this petition was rejected.[116] Some *francala* bakers then requested sultanic permission to convert their workshops into bakeries of sweetened bread (*çörek*), subject to the assent of the relevant guild. As a result, the *kethüda*, *yiğitbaşıs* and 'experienced masters' of the *çörekçis* were called into the presence of the kadi in order to hear the request of former *francala* bakers. In the end, the necessary permission was granted under the condition that the applicants limit themselves to the production of so-called Syrian-style bread rings and biscuits and that the flour sellers act as their guarantors.[117]

After an interval of nine years, in 1213/1798, a sultanic command once again permitted 25 *francala* bakers to reopen.[118] These new bakeries were not supposed to possess their own mills and it was administratively determined from which establishments they were to receive their daily assignments of *hâs* flour. It was strictly forbidden to open such bakeries without official permission. If a master was caught in the act, his implements were destroyed and the *kethüda* warned to prevent such occurrences in the future.[119] Given the frequent interruptions suffered by *francala* bakers, it was in these masters' best interests to rent their workshops from the pious foundations established by members of the Ottoman dynasty. Particularly when such bakeries were closed down because the government felt that there were more such establishments than needed by Istanbul's population, foundation administrators often intervened with the argument that shutting down the bakeries in question would hurt the financial interests of the institutions for which they were responsible. Quite frequently, permission was then granted for *francala* bakers to resume activity.[120]

Due to their close links to foreign diplomats, most of the bakeries producing fine white bread were located in Galata, the area where diplomatic personnel normally resided. From this situation, the *francala* bakers of Galata drew the (illegitimate) conclusion that the production of their particular speciality was forbidden outside the limits of their own township, a claim which they used in order to hinder the operation of competitors outside the Galata walls. In response to complaints from the affected craftsmen, the central government tried to prevent this kind of interference.[121]

With the approval of the state and the wardens of the guilds involved, bakeries producing 'regular' bread, ring-shaped rolls and sweetened bread were converted into *francala* shops when there was need. Once again, this change of activity had to be entered into the registers of the Başmuhasebe. In some cases, such conversions were not well received by the poorer customers, who complained that they could not afford fine white bread and thus would be adversely affected by the change.[122]

From 1218/1803 onwards, the bakers who, up to this point, had produced a single type of *francala*, began to come up with three different varieties known as *has* (high-quality), *bayağı*

(ordinary) and *okkalık*, that is, loaves weighing an *okka* (1.28 kg). High-quality bread was made entirely from the best flour and weighed half of what a normal loaf was supposed to weigh, while the lower-grade variety contained 66.7 percent *hâs* flour.[123] As for the *okkalık*, at first it was not regulated so that manufacturers could set their own prices. But this resulted in complaints and, there-fore, in the presence of the kadi, the administrator of the official grain distribution centre and the masters involved, the price of the *okkalık* was set at 2 *paras*. Furthermore, bakers of 'regular' bread who owed money to the state and to the official grain-traders and had gone out of business as a result, were given the opportunity to recoup their losses and clear their debts by allowing them to produce the *okkalık* variety of fine white bread.[124]

However, two years later, it was decided that the increased number of *francala* bakers reduced the demand for regular bread and therefore the manufacturers of *okkalık* were told to produce *hâs*-quality *francala* instead. And a further two years later, the old prohibition was reinstated with the argument that 'the holy and beloved bread produced in Istanbul and its surroundings, being of high quality and well baked, there is no need for *francala*. Moreover, as these latter breads are often underweight, it has been decided to close down the bakeries producing them.'[125] In consequence, apart from the nine bakeries then producing for the different embassies and seven establishments in a variety of locales deemed indispensable, the bakeries of *francala* ceased operations. However, the relevant masters sent petitions to the Sultan's Council to the effect that this measure deprived them of their livelihoods and that the administrators of pious foundations were losing rental revenues. In response to these complaints, bakeries that had been producing *francala* were allowed to reopen over the years, one after the other.[126]

Enterprises producing ring-shaped rolls and sweetened breads

As has been noted in a different context, even though producers of these two varieties of baked goods were administered by one and the same *kethüda*, their guilds were considered separate

organisations. This meant that ring-shaped rolls could not be made by a baker of sweetened breads and vice versa.[127] But even so, as these goods could function as substitutes for one another, members of the relevant guilds were not happy if new shops were opened by their close competitors. Of course, given the separation of guilds, these concerns could not be voiced openly and therefore the affected craftsmen searched for roundabout ways of closing down newly established shops belonging to their rivals. This included the claim that additional bakeries, often located in residential quarters, increased the danger of fire. Or it was suggested that owners of such enterprises would secretly purchase additional wheat and thereby raise prices.[128]

In addition, the makers of these baked non-bread goods were, of course, forbidden to produce bread of any variety except in an emergency. Sultanic rescripts inform us that the shops of those masters who did not conform to this ruling would be closed down and the all-important 'slots' (*gediks*), without which they could not have continued in business, would be taken from them.[129] As in the case of *francala*, the standard weights of ring-shaped rolls and sweetened breads were determined in relation to the 'regular' loaf, that is, they were supposed to weigh half as much as the latter item. Only those varieties which contained 3.8 *vakiyyes/okkas* of edible fats to a *kile* of flour (25.6 kg) were considered exceptional and could weigh but 33.3 percent of a regular loaf.[130]

Bakers had to declare to the kadi how much of their product was to be 'normal' and how much was to contain a high percentage of edible fats.[131] But even so, in certain periods, the Ottoman state did not allow the manufacture of rolls with a high fat content.[132] However, manufacturers were told that the baking of sesame rings, presumably of the kind that are still popular today, was to be permitted if the standard weight of these items corresponded to that of the rolls with a high fat content. But a list of administered prices dated 21 May 1833 fixed the standard weight of sesame rings at one quarter of that established for 'regular' loaves. Thus the bakers must have been able to convince the administration that some concessions were in order.[133] Sometimes these bakeries also produced the biscuits needed by the military establishment. In 1204/1790 15,000 *kantars* of these goods, which were to feed the sailors on board the navy galleons,

were ordered from the bakeries of sweetened breads and ring-shaped rolls in Istanbul, Üsküdar, Eyüp and Galata.[134]

In 1768, 156 bakers of ring-shaped rolls and sweetened breads were active in Istanbul. In 1787 this figure had barely changed and now stood at 155. The vast majority produced sweetened breads. In 1768, 129 bakeries were involved in this business and, in 1787, there were 113 in operation. Thus, in 1768, the bakers of ring-shaped rolls numbered 27 and, in 1787, they were 42 in number. This may indicate a change of taste among consumers or it was a result of internal rivalries; we have no way of being sure.[135] A document dated 1218/1803 tells us that the bakers of these items, in addition to those producing the flat bread known as *gözleme*, added up to a total of 186 artisans.[136] Different from the bakers of 'regular' bread and *francala*, the artisans making ring-shaped rolls and sweetened breads were, for the most part, Muslims.[137]

Selling bread in shops and on the streets

Baked goods could be sold directly from the bakery in which they had been produced. But every owner of such an enterprise could also offer his products for sale in separate shops or stands, such places being known as *iskemles*, or entrust them to hawkers (*tablakâr*), who would find their customers in the street.[138] The regulations of the craft determined the areas in which hawkers associated with any given bakery might sell and also the number of *iskemles* to which a baker might deliver. It was strictly forbidden to transgress these limits.

Establishments known as *iskemles* could specialise in baked goods, but bread and related items could also be retailed by owners of general stores or else in shops selling roast meat and other similar items.[139] However, the holders of such consignments of baked goods were obliged to sell merely in their own shops or stands and nowhere else.[140] Only certain bakeries operating from premises belonging to pious foundations were, at times, exempted from this rule, the reasoning being that their owners needed to earn more money so that they would be enabled to pay their rents to the foundations in question. As things stood, the latter were losing money due to defaulting tenants.[141] Hawkers were expected to carry their goods through the streets

and were forbidden to sell from fixed stands, this being the sole privilege of the *iskemle* holders whose interests were also protected by the rule that hawkers could not set themselves up in front of established bakeries or *iskemles*.[142] At the same time, the latter were forbidden to stand at street corners and in other places where they obstructed traffic and inconvenienced passers-by.[143]

In 1211/1796, the bakers of Greater Istanbul marketed their bread with the aid of 768 hawkers (there were 547 hawkers registered for Istanbul *intra muros*, 34 in Eyüp, 55 in Üsküdar and 132 in Galata). These numbers were subject to some variation, largely caused by infringements on the part of the bakers. In Istanbul, every bakery of fine white bread employed 20 hawkers, while in the Three Towns, the average was ten apiece.[144] Bakers of fine white bread generally were not permitted to sell their product through a sizeable number of *iskemles*, this right being confined to a few general stores.[145] Hawkers had to be known to the *kethüda*, the *yiğitbaşıs* and the 'experienced masters' of the bakers' guild before they could begin their work since these latter artisans were expected to stand surety for the men to whom they delivered baked goods. As a first step, the hawker was issued a permit by the *kethüda* for which the latter was not supposed to charge any money. Then, the dealer's name was entered into the register of the craftsmen and his employment was thus officially recognised.[146] After the Trade Ministry had been founded, this practice was modified: permits were now issued directly by the Ministry and a one-time fee of 25 *kuruş* was demanded from applicants.[147]

While retailers of baked goods were tied to specific bakeries and not permitted to sell the products of their suppliers' competitors, it was not unknown for these rules to be infringed upon.[148] When retailers secretly sold baked goods from bakeries to which they had not been assigned, disputes occurred between the relevant artisans which sometimes had to be resolved by the kadi. This official tended to side with the owners of bakeries.[149] But if a baker refused to deliver bread to 'his' salesmen, thus putting them in a difficult position, the latter might lodge a formal complaint and thus ensure that they received the bread to which they were entitled.[150] When a bakery closed or was shut down by the authorities, some of the hawkers who normally worked for this enterprise could, with the permission of the

kethüda and the 'experienced masters', be temporarily assigned to other bakeries.[151] If they wished, the holders of the shops and stands known as *iskemle* could also renounce their privileges and operate as hawkers for the duration.[152]

Throughout Ottoman times, these retailers played an important role in distributing baked goods to the population. Where they did not exist, as in the Bosphorus village of Kuzguncuk, life could become quite difficult. As a result, in a petition the inhabitants of this village complained and asked for hawkers who would offer bread for sale both mornings and evenings: 'differently from what is practised in Istanbul, Üsküdar and other places, the local village bakery does not send out hawkers selling bread from trays and horses or donkeys. Therefore all those who cannot go to the bakery such as the old, the lame, women and children are having trouble supplying themselves with bread, especially during the winter months.'[153] Retailers' and hawkers' profits varied from one area of Istanbul to the other. While the *iskemle*-holders of Istanbul *intra muros* could count on a profit of 10 percent, this gain was reduced to 6 in Hasköy and even to 5 percent in the Bosphorus villages,[154] since in these areas with lower population density sellers' expenses were higher. Moreover, upon demand, the servants of the bakeries were expected to deliver baked goods to customers' homes.[155]

Controlling the quality of baked goods

The Ottoman state carefully monitored both the mechanisms by which Istanbul was supplied with baked goods as well as the quality of these goods themselves. Among the measures taken for this purpose, the following deserve special notice. Limited quantities of grain were remitted from the producing provinces as samples and bread was baked from them. Once it had become clear what kind of bread could be made from these samples, orders were placed in the provinces.[156] In addition the quality of the grains found in the state granaries and the official distribution centre was checked every month by having sample breads baked from these supplies. For the remainder of the month, the bakers were not to produce bread of a lower standard than that which had thus been determined.

It was customary to present these sample breads to the sultan, the kadi of Istanbul and the official responsible for order in the marketplace (*ihtisap ağası*).[157] After having seen the samples and consulted the relevant letter from the grand vizier, Sultan Selim III (r. 1789–1807) penned the following warning: 'My vizier, there is something about which I have written to you in the past, but I do not seem to have made my meaning clear: the bakers just do not provide bread according to this sample. Pay attention to the matter and make them produce according to the prevailing standard.'[158] In another order bearing writing in his own hand, the same ruler repeated his warnings: 'My vizier, I have seen the sample. But to ensure that well-baked bread of the proper weight and conforming to this standard is [actually] issued, you will have to make a [special] effort. For this is how things are this year, by the order of Allah. Take the appropriate measures that it [i.e. the bread] is well-baked and those who eat it do not fall sick. If I find the bread below the standard established by the sample, you will have to bear the consequences. Take good care and be attentive to this matter.'[159]

Similar warnings were issued in another text from the same ruler: 'My vizier, make sure there is no profiteering and pay careful attention that all bakeries work according to the same standard. For that is not presently the case; especially on the margins of the city and in the surrounding villages there are bakers who produce sub-standard goods and who must be punished.'[160] And yet another command says: 'My vizier, what people demand is bread that is white and well-baked. As to the weight, you will have to determine it according to circumstances. Issue the appropriate commands and make sure that everything is in order. As to the weight, a certain amount of indulgence is necessary for the bakers are not able to prosper and thus go bankrupt. It is hard to deal with this situation. That has been my experience, do what you consider necessary.'[161]

Not content with these measures, Selim III was also known to disguise himself and check the sellers in person. Thus in 1213/1798 the sultan found a baker in the Istanbul district of Mercan who sold underweight bread. He wrote to the grand vizier demanding that the man be punished.[162] Moreover, it was not only the sultans who visited the city incognito to check the bakeries, the grand viziers also resorted to similar measures.[163]

For this purpose, the sultans would grant special and wide-ranging powers to these high-level dignitaries. An order from Sultan Selim III ran as follows: 'To the substitute Grand Vizier, discuss [the matter] with the respected şeyhülislam. If the kadi of Istanbul is at fault, change him for some suitable person. If one of the bakers or other such people proves to be guilty, you have my sultanic permission to punish him by execution. Do whatever is necessary to put this bread affair in order.'[164] His successor Mahmud II (r. 1808–1839) issued similar commands: 'To the substitute Grand Vizier, you should go today on a special incognito tour in order to investigate the bread [on the market]. Warn them to not produce low-quality stuff. Take special care.'[165]

Interventions by the highest authorities apart, the kadi of Istanbul was principally responsible for the control of the quantity and quality of the bread sold to the inhabitants of Istanbul. When the sultan was informed that the bakers had disobeyed the rules, the kadi was ordered to invite the masters to his court and call them to order.[166] As we have seen, kadis who failed in this task were soon deposed.[167] From time to time, kadis were enjoined to call many artisans, including the bakers, to their courts in order to check and adjust weighing scales.[168] During the Tanzimat period attempts were made to prevent the selling of underweight bread by ordering that every bakery place such scales at the disposition of its customers. Those who bought more than one loaf and suspected that the weight was insufficient could check the quantity sold and demand a supplement if necessary.[169]

Whenever substandard bread appeared on the Istanbul market, state officials immediately investigated the reasons. Such occurrences could be due either to the poor quality of the grain delivered to the bakers or to adulteration on their part. In the first instance, it was common practice to call the local authorities of the producing region to the kadi's court and to warn them. Officials in charge of grain deliveries (zahire mübaşiri), local power holders (ayan, zabıt), financial administrators (voyvoda) and tax farmers would be obliged to formally commit themselves not to send any low-quality grains in the future.[170] As to the second instance, we have already seen that it was the bakers who would be admonished in court and those who disregarded these warnings would be punished in a variety of ways. Moreover, the strict

application of quality standards in Istanbul tended to spread to the surrounding settlements as well. Thus we encounter orders that bread produced in Gebze, Kartal and Pendik should conform to the norms which governed bread sold in the Ottoman capital.[171]

Punishments meted out to offending bakers

Due to official concern with the quality of bread, bakers who did not meet the standards were liable to punishment. This was always a matter for the highest authorities. The leaders of the guilds were not permitted to deal with such matters in their own right. They could only turn to the kadi of Istanbul or to the Sultan's Council and demand that proceedings be opened against masters who did not abide by the rules.[172] While, in the case of other artisans, severe penalties were rarely applied, the sale of adulterated bread could get the culprits into very serious trouble indeed. Through beatings and even executions of certain offenders, the Ottoman government made it clear that such transgressions were not taken lightly.

After the Trade Treasury had been established, controlling the quality of bread became the responsibility of officials appointed by this authority. The controllers collected samples from every bakery and checked them for conformity to official standards. If substandard bread was found, first offenders were imprisoned for twenty days in the jail belonging to the Sultanic Trade Office (Ticarethane-i Amire). Those who were caught a second time were to be imprisoned for two months. In case of need, offenders could be made to work as public cleaners while those who did not improve were threatened with what was probably a year's hard labour in the Naval Arsenal. This was known by the archaic term of 'sentencing to the galleys'.[173]

In earlier periods, the lightest punishment had consisted of a beating. If a loaf of bread turned out to be 8–10 *dirhems* below standard, this was sometimes considered tolerable and sometimes punished by such a beating. If the bread was more than 10 *dirhems* underweight or if the scales had been tampered with, more serious penalties were meted out.[174] In such cases, Muslim bakers were normally imprisoned in a fortress, usually Lemnos, Seddülbahır on the Dardanelles or Magosa in Cyprus, while

non-Muslims were 'sentenced to the galleys'.[175] Bakers who endangered the health of their customers and did not mend their ways even after repeated warnings might be nailed by an earlobe to a post in front of their shops or even hanged, as a warning to others. A report from the grand vizier to the sultan describes this procedure in the following terms: 'yesterday your obedient servant checked the bakeries and, incognito, visited the locales which need to be viewed in order to control the quality of the dear and noble bread. In one place, the bread had not been prepared as it should have been and therefore I had the baker nailed by his ear [to a post] close to his shop as a punishment to himself and an example to the others. I wish to inform Your Majesty of this penal measure.'[176] From another report, we learn that 'once again, a well-known "experienced master" from among the non-Muslims has been executed by hanging and [without limit] is the number of those who up to the present time have, every now and then, been imprisoned in a fortress or else on the galleys. [Equally numerous are] those who are punished every day by beatings.'[177]

Bakers who were imprisoned because of their infringement of craft rules could, after a certain time, present a petition in which they declared having learned their lesson. If the bakers' *kethüda* and the 'experienced masters' were willing to stand surety for them, they would then be released.[178] In 1209/1794–1795, certain Armenian and Albanian bakers had been imprisoned in various Cyprus fortresses. But after seven or eight months their 'experienced masters' came and interceded for them and declared that they were willing 'to guarantee and stand surety for [the culprits], who would not commit such transgressions in the future.' The imprisoned craftsmen's wives also asked for a pardon and, as a result, the errant artisans were released with the ad-monition to avoid such law-breaking. If they did not abide by the rules, so they were warned, yet more serious penalties were in store for them.[179]

Indebtedness: how bakers and millers owed money to the state and licensed grain-traders

When the Ottoman state and the officially licensed grain-traders (*kapan tüccarı*) purchased grain from the producers, the price

was paid immediately. By contrast, millers and bakers paid in instalments for the grain that they had purchased and many of them owed money to the state and to the licensed traders. When deliveries were made, the debts of millers and bakers were recorded in a special register for later collection on the part of the *kethüda* of the sea captains, the official in charge of the distribution centre and the *kethüda* of the bakers. Payments were made on a weekly or monthly basis. In the case of the millers, the sums to be paid depended upon the number of millstones operated by these craftsmen.[180] In 1207/1792–1793, the latter paid off their debts to the licensed grain-traders at the rate of 40 *kuruş* per millstone. When grain arrived at the official grain distribution centre, these instalments were, however, halved, presumably in order to allow the millers to pay the expenses of transporting their respective shares to their mills and granaries.[181]

Even so, defaulters were not uncommon.[182] As the millers and bakers were not punctual in paying their debts to the fisc, deficits kept on increasing and, as a result, the state sometimes employed the salaries of its own officials in order to pay for grain purchases.[183] At times the Sultan's Council would send an order issued in the name of the ruler to the kadi of Istanbul, enjoining him to call the bakers and millers into his court and make sure that they paid off at least part of their debts. The names of those who did not do so were to be forwarded to the Sultan's Council.[184] In 1776, the bakers and millers formally promised to pay 130 purses (*keses*) every month to reduce their debts vis-à-vis the state, while their payments to the licensed grain-traders were to amount to 70 *keses*.[185]

When a miller or a baker died leaving debts or when he fled the city, his enterprise was sold to a Muslim colleague if the debtor had been a Muslim or to a non-Muslim if the opposite had been true. From the proceeds of the sale, debts to the state or to the officially registered grain merchants (*kapan tüccarı*) were discharged.[186] If necessary, the state might consent to payment in instalments, which might be extended over many years.[187] In the documents at our disposal, we find many bakers and millers who found themselves in this situation: either they fled because they were bankrupt or they died deeply in debt.[188]

In such cases, the 'slots' (*gediks*) of the deceased or absconding masters, along with their implements and animals,

were to be sold at auction with the consent of the *kethüda* and the 'experienced masters'.[189] In order to ensure that the licensed traders would not hesitate to deliver grain to the producers of bread and the Istanbul consumers be supplied without any risk of interruption, a miller's or baker's *gedik* was used as a guarantee for his debts. If the value of the *gedik* was insufficient, creditors could seize the dead or absconding master's remaining property as well and, if debts remained unpaid even after that, the debtor's guarantors would be required to step in. The heirs of the deceased only received their shares after all debts had been cleared.[190]

When a *gedik* needed to be sold, the *kethüdas* of the millers' and bakers' guilds normally functioned as trustees, with a specially appointed superintendent checking up on the guild officials.[191] As the sale of the *gedik* against a cash payment normally would not have sufficed to extinguish the deceased or absconding master's obligations, the *gedik* in most cases was turned over to any person who was prepared to shoulder the debt. Payment by the new *gedik*-holder was normally in instalments calculated according to the size of the relevant obligation.[192]

It was the responsibility of the cashiers of the official distribution centre for grain to collect money which the millers and bakers owed to the Ottoman state.[193] Debts to the state always had priority with respect to those payable to the licensed grain-traders. Other creditors could only obtain their due after these two had been satisfied.[194] Sometimes, the officially recognised traders, although they were supposed to deliver grain to millers and bakers according to the capacities of the latter's establishments, refused to do so in the case of heavily indebted artisans who had not been able to extinguish at least part of their debts.[195] Often the delays in collecting money owed to them by millers and bakers made it very difficult for the licensed traders, in their turn, to purchase the grain that they were supposed to bring into the city.[196]

In order to facilitate payment of debts by millers and bakers, they were accorded a variety of special privileges. Thus it was not unusual to allow a master whose enterprise had been closed because of unpaid debts to reopen if he promised to discharge his obligations.[197] As seen, in spite of official misgivings against the spread of workshops producing fine white bread, special permission was even accorded to those who wished to convert a

bakery producing 'standard' loaves into an enterprise working for the 'luxury' market, if that measure was to facilitate payment of debts. In a different vein, the bakery which had belonged to an indebted master who was now deceased or in flight could not be converted into a different enterprise by the owner of the property from which the master in question had rented his shop. It was suspected that such a changeover would make it even more problematic for the Ottoman state and licensed traders to collect outstanding debts.[198]

Conclusion

This rich documentation has shown how a complicated system of rules and regulations, even in the extremely difficult times before and after 1800, was applied in order to secure a satis-factory supply of bread for the inhabitants of Istanbul. The surviving documents show, above all, initiatives taken for this purpose by the Ottoman rulers, grand viziers and particularly the kadis of Istanbul. Guildsmen were recorded by name, made to provide sureties and obliged to maintain constant liaison with the official grain distribution centre. Control was omnipresent, opportunities for profit were limited and those who contra-vened the numerous rules were not only punished informally by officers of their own guilds, but especially by the heavy hand of the state apparatus. Beatings, imprisonment in a fortress or hard labour in the service of the Ottoman navy, public humiliations and occasionally even executions all formed part of the arsenal of penalties threatening bakers and millers who were caught contravening the rules.

Such official measures apart, the institution of debt formed a significant element in this intricate mechanism of control. Being in debt was not a temporary situation which a business-like craftsman was largely able to avoid. Quite to the contrary, bakers and millers normally owed large amounts of money either to the recognised grain merchants or directly to the state. Our sources very often refer to partial payment of debts and quite rarely to full payment on the part of a master as yet alive and in business. At times, these debts could not even be entirely repaid after the death or flight of a master and had to be

shouldered by his successor. Thus, it would appear that the business of being a miller or baker in late eighteenth or early nineteenth century Istanbul was not lucrative and one can imagine that at the deaths of their respective breadwinners, quite a few families of bakers and millers must have been destitute. In a sense, they paid the price for the successful functioning of the system, for it is indeed remarkable that during those years of Janissary uprisings, unremitting wars with Russia and the Napoleonic occupation of Egypt, the Ottoman government was still able to continue supplying bread to the inhabitants of its capital.

Appendix:
Official regulations governing the activities of millers and bakers[199]

Every craft guild possessed its own rules, which had been established either at the time of its foundation or at a later date. Once these regulations had been officially confirmed, it was obligatory for all guildsmen to abide by them and those who did not do so were penalised in a variety of ways. As for the rules concerning millers and bakers, we can summarise them in the following manner:

Every bakery was supposed to possess a mill. In order to avoid deficiencies in winter, the necessary grain was to be purchased in the summer, ground to flour and stored. All the flour employed was to be pure, white and unmixed with foreign substances, and never to be turned over to outside buyers.

Excuses proffered by bakers who did not abide by the afore-mentioned rules or who sold bread that was not in conformity with official standards were not be accepted. Having contravened sultanic commands, these men lost their bakeries, implements and mills.

Bakeries and mills taken from their owners for the afore-mentioned reasons were to be turned over to the guarantors of the offending guildsmen, who were then to operate them according to the stipulated conditions.

Should the guarantors also contravene the rules of the craft, then the bakeries and mills, with all the implements contained

in them, were to be confiscated and sold at auction in the official distribution centre for grain (*unkapanı*).

Purchasers of such confiscated enterprises had to conform to the aforementioned laws and conditions and had to be masters of their respective crafts. As for the guarantors, they had to be both wealthy and trustworthy.

When a mill or bakery had been sold in this fashion, the former owner was to receive its sale price, while the new owner was to take possession and be accorded a document to prove that he was now the proprietor.

Both the producers of sweetened bread with a high content of edible fat and the bakers of 'standard' loaves were to refrain from interfering in one another's businesses.

If a baker or miller destroyed the property of a merchant, was close to death, appeared to be approaching bankruptcy, became [seriously] ill or absconded, then everything to be found in his mill or bakery was to be turned over to his surety, who was responsible for the debts that the enterprise had incurred towards the grain merchants.

If a mill or bakery was owned by a partnership, the *kethüda*, *yiğitbaşıs*, 'experienced masters' and the court were to intervene to find [suitable] guarantors. Once the latter agreed to serve and had testified accordingly, a declaration (*ilam*) on the part of the kadi and a judicial affidavit (*hüccet*) were to be issued and entries made into the register. [The partners] were then to receive documents confirming their situation.

The owners of mills and bakeries were to refrain from interfering with the rent that was being paid [regularly] and all matters concerning removal [of grain and bread?].

On the other hand, tenants were to pay their rents regularly every month and to refrain from anything that might hurt the owner of the property. Those who did not comply with this rule were liable to punishment.

The aforementioned rules had been laid down with the consent of the millers and bakers. Nobody apart from these craftsmen was to be permitted to engage in the production of bread. If [by chance someone outside the craft] had managed to have himself registered [as a miller or baker], these entries were to be deleted. Even [if the person in question presented] a twice-confirmed sultanic command [this] was not to be considered valid.

Bakeries were to produce bread from the flour at their disposal, sell it and, from the proceeds, pay their debts to the merchants. In consequence, the rules of the craft demanded that no new mills or bakeries should be instituted. Contravention was to lead to the abolition of the guild regulations.

The millers and bakers, who had consented to these rules out of their own volition, were to proclaim that they accepted the appropriate punishments in case of infringement. They were also to agree that, in such an instance, their excuses were not to be deemed receivable.

When grain arrived at the weighing and distribution centre, it was to be assigned an official price (*narh*) according to market conditions. The guild masters were to find out whether there had been any changes in this respect. If any master did not adhere to this officially promulgated price, he was to receive the appropriate punishment.

Abbreviations

Lunar Months

M. Muharrem
S. Safer
Ra. Rebiulevvel
R. Rebiulâhır
Ca. Cemaziyelevvel
C. Cemazielâhır
B. Receb
Ş. Şaban
N. Ramazan
L. Şevval
Za. Zilka'de
Z. Zilhicce

Archives

BA Başbakanlık Arşivi
HH Hatt-ı Hümayun
İAD İstanbul Ahkâm Defteri
İKS İstanbul Kadı Sicilleri

KK Kâmil Kepeci
MAD Maliyeden Müdevver Defteri
MÜD Mühimme Defteri
ÜKS Üsküdar Kadı Sicili
ZD Zahire Defteri

Notes

1 Translated by Suraiya Faroqhi.
2 Mills did not limit themselves to the milling of wheat. If necessary, barley and millet were also ground up and baked into bread, albeit of an inferior quality. But the Ottoman state did not intervene if the poor quality of bread was due to a clear emergency: BA, HH, n° 4623 (1217/1802-1803).
3 İKS, n° 26, fol. 102.
4 İKS, n° 26, fol. 102.
5 Güçer, 1949-1950, p. 405.
6 İKS, n° 59, fol. 12; n° 64, fol. 38.
7 BA, MAD, n° 8571, p. 5, order n° 1 (1 M. 1214/3 June 1799).
8 BA, Cevdet Belediye, n° 4757.
9 BA, Cevdet Belediye, n° 829 (1207/1793).
10 BA, MAD, n° 203, fol. 16 (1140/1727).
11 BA, Cevdet Belediye, n° 4757.
12 BA, Cevdet Belediye, n° 4767 (1211/1797).
13 BA, Cevdet Belediye, n° 5783 (1221/1806).
14 İKS, n° 26, fol. 45.
15 BA, Cevdet Belediye, n° 6576 8 (1198/1784).
16 BA, Zahire Defteri (hereafter ZD), n° 11, p. 166, order n° 508.
17 İKS, n° 94, fol. 71, 16B (1223/September 1808).
18 BA, MAD, n° 8571, p. 38, order n° 3 (25 Za. 1234/15 September 1819). The term 'experienced masters' is used here for *nizam ustaları*, who, with the official warden (*kethüda*) and his aides, the *yiğitbaşıs*, shared the responsibility for running guild affairs.
19 BA, İAD, n° 16, p. 88, order n° 75 (mid-S. 1220/4-13 November 1805).
20 BA, İAD, n° 17, p. 29, order n° 65 (mid-S. 1225/18-27 March 1810).
21 İKS, n° 65, fol. 49 (11 C. 1201/31 March 1801).
22 BA, Cevdet Belediye, n° 2134 (15 R. 1234/11 February 1819).
23 İKS, n° 29, fol. 71 (12 Ra. 1181/7 September 1767).
24 İKS, n° 30, fol. 66 (Ra. 1182/31 August 1768).

25 BA, MAD, n° 7, p. 104, order n° 273.

26 Aynural, 1992, p. 115.

27 BA, Cevdet İktisat, n° 6816.

28 İKS, n° 65, fol. 43 (1201/1786–1787).

29 BA, Cevdet Belediye, n° 2412. As we have seen, if the owner of a
 mill was unable to rebuild, the millers, with the permission of their
 kethüdas and the yiğitbaşıs, transferred the millstones to another
 establishment: BA, Cevdet Belediye, n° 646 (20 Ra. 1210/24
 September 1795), Cevdet Belediye, n° 1837. In the same fashion,
 the millstones of an unused mill could be transferred to another
 enterprise. However, if originally installed in a mill located intra
 muros, they could not be placed in a mill outside the city walls: İKS,
 n° 154, fol. 56 (3 Ca. 1243/23 November 1827).

30 İKS, n° 154, fol. 58.

31 BA, Cevdet Belediye, n° 1988 (22 R. 1200/22 February 1786).

32 Tabakoğlu, Kal'a, Aynural et al., ed., 1997, v. 1, p. 285, order n° 924.

33 İKS, n° 26, fol. 1.

34 BA, KK, n° 7440.

35 İKS, n° 80, fol. 13 (3 S. 1218/25 May 1803).

36 The totals given in the register and those arrived at by adding up
 the individual figures do not tally. I have preferred the corrected
 figure: İKS, n° 26, fol. 1–9.

37 BA, Cevdet Belediye, n° 1207 (29 R. 1124/5 June 1712).

38 BA, MAD, n° 10015, fol. 41; İKS, n° 40, fol. 38 (10 Ra. 1191/18
 April 1777).

39 İKS, n° 36, fol. 44 (3 S. 1187/26 April 1773).

40 BA, Cevdet Belediye, n° 1207 (29 R. 1124/5 June 1712).

41 İKS, n° 59, fol. 50 (10 S. 1206/10 October 1791); BA, Cevdet
 Belediye, n° 5399 (16 S. 1178/15 August 1764).

42 BA, Cevdet Belediye, n° 5399 (16 S. 1178/15 August 1765).

43 BA, MAD, n° 9926, fol. 55.

44 BA, Cevdet Belediye, n° 5399.

45 BA, MAD, n° 9926, p. 55. However, when there was a lack of bread,
 these rules might be suspended: İKS, n° 58, fol. 12 (8 C. 1203/6
 November 1789).

46 BA, MAD, n° 9926, fol. 55.

47 İKS, n° 26, fol. 26–30.

48 BA, MÜD, n° 45, fol. 38 (18 B. 1193/1 August 1779).

49 BA, MÜD, n° 45, fol. 10 (24 R. 1193/11 May 1779).

50 İKS, n° 94, fol. 69 (11 B. 1223/2 September 1808).

51 İKS, n° 135, fol. 20 (22 M. 1225/27 February 1810).

52 İKS, n° 94, fol. 75.

53 Tabakoğlu, Kal'a, Aynural *et al.*, ed., 1997, v. 1, p. 1, order n° 1.
54 Tabakoğlu, Kal'a, Aynural *et al.*, ed., 1997, v. 1, p. 1, order n° 1.
55 Aynural, 1992, p. 115.
56 BA, Cevdet Belediye, n° 1741.
57 Tabakoğlu, Kal'a, Aynural *et al.*, ed., 1997, v. 1, p. 315, order n° 345.
58 BA, Cevdet Belediye, n° 969 (19 L. 1257/4 December 1841).
59 BA, Cevdet Belediye, n° 6927.
60 BA, Cevdet Belediye, n° 4331 (1 M. 1235/28 October 1819).
61 BA, Cevdet Belediye, n° 3513 (22 Za. 1181/10 April 1768).
62 BA, HH, n° 9093.
63 BA, HH, n° 15652.
64 BA, Cevdet Belediye, n° 277 (1176/1763).
65 BA, Cevdet Belediye, n° 1152 (6 S. 1261/11 August 1845).
66 BA, İAD, n° 8, p. 347, order n° 1141.
67 BA, Cevdet Belediye, n° 2586 (17 M. 1220/17 April 1805).
68 BA, Cevdet Belediye, n° 2952 (17 Ca. 1221/2 August 1806).
69 Aynural, 1999, p. 565.
70 BA, İAD, n° 16, p. 344, order n° 771 (early R. 1223/late May or early June 1808).
71 İKS, n° 135, fol. 46 (20 L. 1231/13 September 1816).
72 İKS, n° 154, fol. 25 (beginning R. 1240/23 November 1824).
73 BA, Cevdet Belediye, n° 3038.
74 Tabakoğlu, Kal'a, Aynural *et al.*, ed., 1997, v. 1, p. 32, order n° 977.
75 BA, İAD, n° 7, p. 253, order n° 777.
76 Tabakoğlu, Kal'a, Aynural *et al.* ed., 1997, vol. 1, p. 262, order n° 614.
77 BA, İAD, n° 8, p. 216, order n° 705; n° 8, p. 239, order n° 774.
78 İKS, n° 106, fol. 61 (19 M. 1228/22 January 1813).
79 The *ruz-ı kasım* was the date at which the Ottoman navy returned to port for the winter.
80 BA, MÜD, n° 165, p. 405, order n° 1 (mid-Z. 1181/29 April–8 May 1768).
81 İKS, n° 201, fol. 249.
82 BA, Cevdet Belediye, n° 969.
83 İKS, n° 25, fol. 55 (15 Z. 1179/25 May 1766), see also fol. 91 and 99.
84 İKS, n° 34, fol. 61 (Ra. 1185/July 1772), n° 40, fol. 36 (25 S. 1191/4 April 1777).
85 İKS, n° 37, fol. 43 (4 C. 1189/2 August 1775).
86 İKS, n° 32, fol. 8 (selh-i Şevval 1182/8 March 1769).
87 BA, Cevdet Belediye, n° 5707 (7 Ra. 1174/7 October 1760).
88 Only those bakeries combined with mills received their grain from the official distribution centre or from the state granaries. Bakeries without such facilities received their flour from other bakeries.

89 BA, Cevdet Belediye, n° 25 (2 C. 1237/24 February 1822).

90 BA, HH, n° 4673 (1212/1797).

91 Aynural, 1992, p. 116.

92 BA, MÜD, n° 165, p. 405 (mid-Z. 1181/1729 April–8 May 1768).

93 BA, Cevdet Belediye, n° 1207 (29 R. 1124/5 June 1712). The bakeries of Alacahamam, Balıkpazarı, Balat mahkemesi, Bahçekapı, Gedikpaşa, Valide camii and the Ayasofya shopping district did not possess any mills and received their flour from other establishments.

94 BA, MAD, n° 10015, fol. 11–32.

95 BA, Cevdet Belediye, 1208 (1124/1712).

96 İKS, n° 249, fol. 249 (late S. 1195/24 February 1781).

97 BA, HH, n° 16066 (1047/1790).

98 Aynural, 1992, p. 117.

99 BA, Cevdet Belediye, n° 6816 (5 B. 1197/6 June 1783).

100 BA, HH, n° 647A (1203/1788–1789).

101 İKS, n° 65, fol. 79; BA, HH, n° 12399; İKS, n° 135, fol. 5.

102 BA, HH, n° 10076 (1205/1791).

103 İKS, n° 92, fol. 11.

104 BA, İAD, n° 18, p. 1, orders n° 1 and 2.

105 BA, İAD, n° 20, p. 284 order n° 66 (26 C. 1247/2 December 1831).

106 İKS, n° 32, fol. 2; İKS, n° 65, fol. 65; İKS, n° 80, fol. 13 (3 S. 1218/20 September 1803); BA, Cevdet Belediye, n° 719; BA, İAD, n° 18, p. 220, orders n° 444 and 445, BA, HH, n° 17547.

107 BA, İAD, n° 18, p. 220, order n° 444.

108 BA, HH, n° 11634 (1204/1790).

109 İKS, n° 80, fol. 21 (1218/1803).

110 İKS, n° 154, fol. 32 (3 R. 1241/12 February 1826).

111 BA, İAD, n° 18, p. 1, order n° 2.

112 İKS, n° 135, fol. 76 (25 Ra. 1237/19 December 1821).

113 BA, HH, n° 17547 (1232/1817); İKS, n° 135, fol. 25 (beginning R. 1230/13 March 1815; see also fol. 41).

114 Aynural, 1992, p. 118.

115 BA, HH, n° 9707.

116 BA, HH, n° 10110.

117 Aynural, 1992, p. 118.

118 Aynural, 1992, p. 118.

119 İKS, n° 135, fol. 76 (8 R. 1237/2 January 1822).

120 İKS, n° 94, fol. 21 (25 Z. 1122/28 February 1808).

121 BA, İAD, n° 7, p. 273, order n° 840.

122 İKS, n° 73, fol. 81 (26 R. 1215/16 September 1800).

123 Aynural, 1992, p. 118.

124 Aynural, 1992, p. 119.

125 İKS, n° 92, fol. 89.
126 Aynural, 1992, p. 119.
127 Aynural, 1992, p. 119.
128 BA, İAD, n° 12, p. 210, order n° 615 (mid-C. 1209/22 December 1794-1 January 1795).
129 İKS, n° 65, fol. 72 (21 Ra. 1203/20 December 1788).
130 İKS, n° 80, fol. 56.
131 İKS, n° 201, fol. 120 (3 S. 1224/13 September 1809).
132 İKS, n° 135, fol. 5 (21 Ra. 1229/20 March 1814).
133 İKS, n° 106, fol. 6 (early R. 1226/25 April 1811).
134 ÜKS, n° 528, fol. 93 (18 C. 1204/5 March 1790).
135 Aynural, 1992, p. 120.
136 İKS, n° 80, fol. 13 (3 S. 1218/25 May 1803).
137 BA, MAD, n° 10015, fol. 34-36.
138 Apart from general stores, among the holders of *iskemles* offering bread and other baked goods for sale, one finds sellers of soup and roast meat as well as *helva* vendors.
139 BA, İAD, n° 7, p. 90, order n° 285; İKS, n° 38, fol. 25.
140 Tabakoğlu, Kal'a, Aynural *et al.*, ed., 1997, v. 1, p. 31, order n° 884; Aynural, 1992, p. 121.
141 İKS, n° 43, fol. 12 (7 Z. 1192/27 December 1778).
142 BA, İAD, n° 7, p. 99, order n° 298; İAD, n° 9, p. 16, order n° 71.
143 İKS, n° 43, fol. 13.
144 Aynural, 1992, p. 121.
145 İKS, n° 47, fol. 97(7 S. 1195/29 July 1781).
146 Aynural, 1992, p. 121.
147 BA, Cevdet Belediye, n° 969 (19 L. 1257/4 December 1841).
148 İKS, n° 37, fol. 1 (15 S. 1182/21 October 1774).
149 BA, İAD, n° 112, order n° 336.
150 BA, Istanbul Atik Şikâyet Defteri n° 40, p. 193, order n° 955 (early Z. 1115/5-6 April 1704).
151 İKS, n° 94, fol. 25 (3 Z. 1222/1 February 1808).
152 İKS, n° 29, fol.17 (15 L. 1180/16 March 1767).
153 Aynural, 1992, p. 121.
154 İKS, n° 38, fol. 25 (17 Ca. 1190/4 July 1776), BA, İAD, n° 16, p. 217 order n° 477(mid-Ca. 1222/17-26 July 1807).
155 BA, Cevdet Belediye, n° 7055 (2 Ra. 1191/10 April 1777).
156 BA, HH, n° 10794 (undated).
157 İKS, n° 213, fol. 43 (25 S. 1254/22 May 1838); BA, MAD, n° 8571, p. 185, order n° 3 (4 Ra. 1218/24 June 1803).
158 BA, HH, n° 13362 (1210/1795-1796).
159 BA, HH, n° 55116.

160 BA, HH, n° 1856 (1215/1800).

161 BA, HH, n° 4646 (1218/1803). Two sultanic orders whose authors remain unknown run as follows: 'To the Grand Vizier's substitute, the Kaymakam Paşa: this bread is black and crumbles. Praise be to Allah, grain is abundant. I will not permit the production of such a thing. Warn [the bakers] to prepare well-baked white bread. Once again, send me a sample. Recently I have visited the areas of Galata, Tophane and Tersane incognito; both flat breads and loaves were of poor quality. It [probably the sample] should be given to them. Those who mix [poor quality flour into the dough], I will punish severely. When – praise be to Allah – grain is abundant, it is not acceptable to eat such bread' (BA, HH, n° 15945). Equally unknown is the ruler who wrote the following: 'My vizier, for a while, there were campaigns and then Allah sent us a bad harvest. But now we have no campaign and no bad harvest either and yet the bread is inedible. Allah does not permit this. There has been a considerable adulteration of grain. How can it happen that grain of such poor quality is being sent? Whatever you do, make sure that the bread is clean, white and well-baked' (BA, HH, n° 10794, undated).

162 BA, HH, n° 15705.

163 Controlling the bakeries was typically carried out in secret: BA, HH, n° 15945.

164 BA, HH, n° 15437 (1204/1790).

165 BA, HH, n° 53902 (1223/1808).

166 İKS, n° 65, fol. 85 (11 S. 1205/Oct. 1790); BA, HH, n° 647B (1203/ 1789); BA, HH, n° 14533. Lower-level officials who did not carefully attend to the inspection of Istanbul's bread supply might even be imprisoned. This happened to certain *tebdil çukadars* who neglected to make sure that bread was sold at the officially promulgated price (*narh*): BA, Cevdet Belediye, n° 878 (25 Z. 1220/16 March 1806).

167 BA, HH, n° 15398 (1204/1790).

168 İKS, n° 135, fol. 51 (23 Ca. 1233/31 March 1817).

169 BA, Cevdet Belediye, n° 969.

170 BA, Cevdet Belediye, n° 137 (no date).

171 BA, ZD, n° 11, p. 22 order n° 2.

172 İKS, n° 94, fol. 2 (17 S, 1222/16 October 1807).

173 BA, Cevdet Belediye, n° 969.

174 BA, HH, n° 15434 (1204/1790).

175 BA, Cevdet Belediye, n° 467; BA, HH, n° 15434; BA, Cevdet Belediye, n° 4518 (3 S. 1225/10 March 1810); BA, Cevdet Belediye, n° 145; BA, Cevdet Belediye, n° 2071 (mid-B. 1209/10 February 1795).

176 BA, HH, n° 647 (1203/1789).

177 BA, HH, n° 14889 (1207/1793). A slightly earlier sultanic rescript tells the same story: 'Recently your obedient servant has made an incognito inspection tour and arrested those bakers who produce underweight dark bread. The Muslim Albanians involved have been sent to a fortress and the Christians to the galleys. Some of them have been beaten with a stick, some of the Albanians have been strangled in the fortresses [in which they had been imprisoned] and some of the non-Mulims have been hanged' (BA, HH, n° 15434).

178 İKS, n° 25, fol. 2 (6 B. 1179/19 December 1765).

179 BA, Cevdet Belediye, n° 5243 (15 M. 1210/1 August 1795).

180 İKS, n° 65, fol. 105; BA, MAD, n° 10015, p. 124.

181 İKS, n° 65, fol. 105 (12 M. 1207/30 August 1792).

182 İKS, n° 165, fol. 107 (1207/1792).

183 İKS, n° 165, fol. 106 (13 R. 1207/28 November 1792).

184 İKS, n° 25, fol. 55 (16 Z. 1179/26 July 1766).

185 BA, Cevdet Belediye, n° 7029 (16 B. 1190/31 August 1776).

186 BA, Cevdet Belediye, n° 2296 (28 C. 1239/29 February 1824).

187 BA, Cevdet Belediye, n° 324.

188 İKS, n° 47, fol. 8 (16 Za. 1194/3 November 1781).

189 The term *gedik* had two different meanings. Apart from the 'right to do a certain job in a certain place', which we have already encountered several times, the term could also denote all the implements present in a certain shop. Compare a similar example from late nineteenth century Damascus, where *gedik*, locally known as *kadak*, was thus described in a *waqfiyya* regarding the rent of a shop (*dukkân*) in central *intra muros* Damascus: '...Its kadak comprises its façade [of the shop], the shelves, all the locks and padlocks, the post beams, a wooden niche, the keys and the legal amenities.' In Damascus, at this time, *kadak* was closely associated with *khulûw*. Randi Deguilhem-Schoem, *History of Waqf and Case Studies from Damascus in Late Ottoman and French Mandatory Times*, PhD dissertation, New York University, 1986, pp. 350, 395.

190 Aynural, 1992, p.122.

191 İKS, n° 47, fol. 75 (17 R. 1195/12 April 1781); İKS, n° 25, fol. 208 (16 L. 1179/28 March 1766).

192 İKS, n° 47, fol. 20 (early Z. 1194/28 November 1780); İKS, n° 47, fol. 29, 59, 75.

193 BA, MAD, n° 8571, fol. 33, order n° 1 (1214/1799–1800), BA, Cevdet Belediye, n° 2134 (15 R. 1234/11 February 1819).

194 İKS, n° 42, fol. 10 (27 N. 1191/29 October 1777).

195 İKS, n° 25, fol. 200 (C. 1180/20 November 1766).
196 Aynural, 1992, p.122.
197 BA, Cevdet Belediye, n° 1010 (1257/1841).
198 BA, Cevdet Belediye, n° 1177 (1206/1791-1792).
199 The following regulations come from: BA, MAD, n° 9926, p. 45.

Bibliography

Primary Sources

Istanbul
Başbakanlık Arşivi, Osmanli Arşivi:
İstanbul Kadı Sicilleri
Üsküdar Kadı Sicilleri
Hatt-ı Hümayun

Secondary Sources

Aynural, Salih, 'XVIII. ve XIX. Yüzyıllarda İstanbul Değirmenci ve Fırıncı Esnafının Nizamları', *Türk Dünyası Araştırmaları*, December 1992, no 81, pp. 111–122.

Aynural, Salih, 'XVIII. ve XIX. Yüzyıllarda Osmanlı Esnafında Üretim Anlayışı ve Organizasyonu', *İstanbul Üniversitesi İktisat Fakültesi Mecmuası*, n° 46, 38/13–93, 1996, pp. 354–362.

Aynural, Salih, '18. Yüzyılda İstanbul'un Odun Kömür İhtiyacının Karşılanması', *Osmanlı*, Ankara, Yeni Türkiye Yaynları, v. 5, pp. 563–569.

Aynural, Salih, *İstanbul Değirmen ve Fırınları*, Istanbul, Tarih Vakfı Yurt Yayınları, 2001.

Güçer, Lütfi, 'XVIII. Yüzyıl Ortalarında İstanbul'un İaşesi için Lüzumlu Hububatın Temini Meselesi', *İstanbul Üniversitesi İktisat Fakültesi Mecmuası*, XI, 1949–1950, pp. 397–416.

Tabakoğlu, Ahmet, Ahmet Kal'a, Salih Aynural *et al.*, ed., *İstanbul Külliyatı I, İstanbul Ahkâm Defterleri, İstanbul Esnaf Tarihi*, 1997, v. 1, Istanbul, İstanbul Büyükşehir Belediyesi.

CHAPTER 7

A Pound of Flesh:
The Meat Trade and
Social Struggle in
Jewish Istanbul, 1700–1923

Minna Rozen

Meat has always featured prominently in the diet of the inhabitants of Asia Minor and the Balkans. Certainly, the poor ate and eat it in lesser quantities than the well-to-do, with grains, vegetables and dairy products making up the basket of foods available to the average inhabitant of the eastern Mediterranean coastlands. However, even the poor occasionally consumed meat, particularly, on religious festivals and, if they lived in the Ottoman capital, their chances of doing so were higher than anywhere else. In practical terms, if not necessarily in theory, the sultan's subjects living in Istanbul had come to enjoy almost an entitlement to meat. The reasons for this privilege were ideological, religious and pragmatic. They were ideological because the sultan was considered responsible for his subjects' well-being and a person going to sleep on an empty stomach was not a happy man or woman. They were religious because, at the Feast of Sacrifices, Muslim religious rites required the slaughtering of a sacrificial animal and they were pragmatic because dissatisfied townsmen living close to the seat of power were more than likely to start riots and socio-political unrest.

Therefore, the rulers of the Empire periodically passed regulations in order to ensure a steady supply of meat to the capital at controlled prices. A regular supply was ensured through the services of the *celepkeşan*, wealthy men who could provide the necessary interim funding. These personages were required by the authorities to purchase livestock from cattle-breeders in

Anatolia and the Balkans and arrange for the transfer of sheep to the city, sometimes from a distance of up to a thousand kilometres. Many animals perished on the journey, which normally lasted several months. As a result, the profits of these sheep and cattle drovers often depended less on their organisational skills and veterinary knowledge than on luck. After the flocks and herds had reached Istanbul, city butchers purchased them at controlled prices for slaughter in official slaughterhouses. The meat was then delivered to the shops for sale to the consumer, once again at controlled prices.

Studies on the meat trade in Anatolia and Istanbul in the sixteenth and seventeenth centuries show that sheep and cattle drovers frequently went bankrupt, while Muslim butchers barely made a living. As prices did not respond sufficiently to changes in supply and demand, butchers were unable to make a profit even when meat was scarce and they incurred heavy losses when it was plentiful.[1] Around the mid-seventeenth century, however, the situation of sheep drovers and butchers began to improve due to a change in government attitude toward meat provisioning. This trend became even more pronounced in the eighteenth century[2] when suppliers of meat farmed the taxes imposed on provinces required to provide sheep. From the money thus collected, they purchased livestock which they then sold at market prices. At that time, the Ottoman provinces of Wallachia and Moldavia were turning into rich sources of meat supply but, since the meat from these provinces was almost certainly purchased at market prices, it was no doubt more expensive in the eighteenth century than it had been in the sixteenth.[3] Be that as it may, there is no evidence in any of the sources, Jewish or non-Jewish, of any coercion exercised against the suppliers of meat to the capital. Forcible transfers of cattle to the city were unknown in the eighteenth century and the same applies to the nineteenth century as well.

Irrespective of religion, butchers, like other Istanbul tradesmen, were organised into guilds (*hirfet*), which supervised their members' professional activities and provided them with social support.[4] However, the Jewish meat trade in the Ottoman Empire was more complex than its Muslim counterpart. Due to *kashrut* requirements, the meat sold to Jews had to undergo additional processing stages in order to render it fit for consumption. It

was, therefore, more expensive and the imposition of indirect taxes on the sale of meat rendered it even more costly. The price of meat and its use as a means of taxation turned the sale and consumption of this foodstuff into an issue of paramount importance not only in the day-to-day affairs and economy of Istanbul's Jewish community, but also in its political life.

In this context, the role played by the meat trade and its representatives is of special interest.

Istanbul's meat trade, in general, and that of Istanbul's Jewish society in particular, took place at the interface between economy, religion and politics. In the Jewish and non-Jewish segments of the capital's society, interaction between these three major sectors of human activity certainly took place in a rather different fashion. Among Jews and non-Jews, however, meat consumption acted as a sort of litmus test indicating the nature of the relationship between ruler and subjects.

The records of the Istanbul Jewish community, which are coming to light in ever larger numbers, afford us some insight into the world of urban meat-traders in the eighteenth and nineteenth centuries, their role in the community's life and the impact of the meat trade on the community's social and political history. Today, most of the available documentation derives from the court records of the 'Rabbis Supervising Rituals and Ethics' (1710–1903), published by Leah Bornstein-Makovetsky, as well as seven other registers belonging to the city's various courts (1833–1934), which are still in manuscript form and which I am preparing for publication. Community marriage registers for the years 1912–1922 shed new light on private lives as well as on the socio-economic status of the butchers of Istanbul at the end of the Ottoman period.[5]

The way of all flesh

At the dawn of the eighteenth century, Istanbul's central slaughterhouse in the Yedikule quarter near the city walls also served the Jewish community.[6] However, in 1707, local Jews asked for and received permission to move 'their' slaughterhouse to Galata.[7] By 1784, Jewish slaughterhouses were operating in the Istanbul districts of Ortaköy, Hasköy and Balat.[8] Evidently, it was

in these places that most official Jewish slaughtering took place. Jewish slaughterhouses either belonged to Jews or were rented by them.[9] In the second half of the nineteenth century, the use of non-Jewish slaughterhouses came back into fashion, perhaps because of certain technical innovations that were available there, but which had not as yet been introduced into Jewish installations.[10] Despite government and community bans, animals were slaughtered in other places as well; this practice, of course, deprived the state and the Istanbul Jewish community of their revenues from the tax on the sale of meat.[11]

Under 'normal' circumstances, namely, when the approval of community institutions and city authorities had been obtained, the livestock (mainly sheep in the sixteenth and seventeenth centuries, with a rise in the consumption of cows, oxen and buffaloes in the early 1700s) was brought to the slaughterhouse by people called *sayigis* in the Hebrew documents (from the Ottoman term *saya* – collector of sheep tax). The *saya's* representatives used to patrol the city in groups called *saya ocağıs*. Our documents indicate that the *sayacıs* were Jewish and that each quarter had its own team of *sayacıs*. It is possible that the term *sayigi* is a corruption of *saya ocağı* with the Judeo-Spanish plural ending appended. Another, more likely explanation is that the word is a corruption of the term *sayacı* which is, itself, a combination of the word *saya* and the Turkish suffix -*ci* denoting a profession, with the Judeo-Spanish plural ending added on to it. In any case, the *sayigis* or *sayacıs* purchased the animals from the drovers and then themselves drove sheep and cattle to the slaughterhouse. Like all other practitioners of the meat trade, the *sayacıs* were subordinate to the Istanbul rabbinate and were expected to abide by its rulings.

The *sayacis* sold the cattle at the slaughterhouse to various meat merchants, taking care to deduct the governmental tax.[12] Only then did the actual slaughtering take place. I expressly use the term 'meat merchants' rather than butchers since Jewish Istanbul had a complete hierarchy of specialists involved in the meat trade. At the top of the ladder were the butchers (*kasap*), who were entitled to purchase the choicest part of the slaughtered animals, namely, the hindquarters. Next in the hierarchy were the sellers of 'inferior' cuts of meat known as the *işkembecis* (the Turkish word for 'vendor of tripe' with a Judeo-Spanish plural

suffix). This group sold the offal (internal organs) either raw or in the form of ready-cooked dishes. Next on the list were the *barsakcıs* (from the Turkish word for 'vendor of intestines' with the Judeo-Spanish plural), who sold the viscera of the slaughtered animals. At the bottom of the ladder were the *sakatcıs*, who sold ritually proscribed meat – that is, animals whose internal organs were diseased or those which had been defectively slaughtered (*sakat* being the Turkish term for waste). Thus, in descending order of importance, one has the butcher, (*kasap*) who received the best cut of the animal, followed by the offal-vendor (*işkembeci*), the tripe-vendor (*barsakcı*) and, finally, the purveyor of ritually proscribed meat (*sakatcı*).[13]

Only professional slaughterers who had passed an examination were accredited by the city's supreme Jewish institutions to kill sheep and cattle. They were subject to ongoing supervision and control not only by the public, but also by the community establishment. In order to ensure that sheep and cattle were slaughtered according to ritual requirements and that the communal institution received its allotted share in the form of taxes, a guard was appointed to each slaughterhouse to stamp the meat.[14] This stamp showed the consumer that the meat had been slaughtered in accordance with ritual requirements and, by having the stamp affixed to the meat, the community made sure that it was receiving its rightful share of the meat's price. It was at this point that the meat tax (*gabela*) was turned over to the community's coffers or, at least, that a record was made to that effect. The butchers actually paid the tax at different times, sometimes in advance upon receipt of the merchandise, or later on, after selling it.[15] In any case, the slaughterer was not allowed to slaughter without the presence of a guard in order to ensure that there existed an official record for the collection of the *gabela* concerning the amount of meat made available to the customers.[16]

Immediately after the animal had been slaughtered, a *sakatcı* removed the kidneys for inspection and, if they were found to be diseased, the slaughterers were immediately informed. The on-duty *sakatcı* had to be on call during slaughtering shifts and only *force majeure* permitted the slaughterers to slaughter without him. In case of negligence, the *sakatcı* was subject to penalties meted out by the rabbis of the times. If there was any doubt concerning the condition of the lungs, the on-duty *sakatcı* or, in

his absence, the slaughterer – but never the *sayacı* – was required to inflate them.[17] As we shall have occasion to see, the regulation requiring the *sakatcı* to remove and inspect the kidneys was not often observed due to frequent absences on the part of the *sakatcı* for reasons both within and beyond his control.[18]

Before the meat was ready for sale, it had to undergo one final stage in order to render it ritually fit for consumption: certain sinews and forbidden fats had to be removed in a process known as porging (*niqur* in Hebrew or *kanadarlık* in Turkish).[19] It is also noteworthy that a Turkish name took precedence over a Hebrew one. Porging was occasionally performed in the slaughterhouse, but more often in the butcher's shop, either by professional porgers or by butchers who had mastered the art. The fact that Jews used the Turkish word, *kanadar*, rather than *kasap*, when referring to a butcher would seem to indicate that most butchers did their own porging to the extent that the word porger (*kanadar*) became synonymous with butcher. Evidently, porgers found it hard to make a living[20] and, therefore, the butchers took to porging their own meat. The Istanbul rabbinate was not too happy with this state of affairs, fearing that butchers who had a vested interest in selling meat for which they had already paid would be tempted to offer meat to their customers that had become ritually unfit for consumption during the porging process. To prevent this, the rabbis periodically passed regulations ordering butchers to hire porgers rather than porge the animals themselves.[21] The evidence indicates, however, that these regulations were disregarded and that a large percentage of the meat sold to local Jews was porged by the butchers themselves. Down to the late eighteenth century, certain porgers branched out and took to manufacturing meat products, especially *sarsıca* or spiced sausage (probably from the Italian *salsiccia*). By the end of the century apothecaries and tavern-owners also manufactured and sold *sarsıca*.[22]

Up until the late eighteenth century, there are numerous references in the sources to all these practitioners of the meat trade. However, the Istanbul rabbinical court records for the years 1833–1923, including the records of the courts presiding over matters of 'Rituals and Ethics', refer but sparingly to most of these people. Apart from the slaughterers, slaughterhouse hands and livestock merchants (*sayacıs*), one finds only butchers

(*kanadars*) and offal vendors (*işkembecıs*). Quite possibly, tripe-vendors (*barsakcıs*) had merged with sellers of offal, while the function of *sakatcıs* (vendors of ritually disqualified meat) was taken over by Muslims. In any case, the disappearance of these various subprofessional groups from our records may indicate a decline in their status and earnings. This hypothesis is supported by other economic, social and political trends which shook the base of the Jewish meat trade in Istanbul; these developments will be discussed below.

In 1903, another link was introduced into the meat chain when the Jewish butchers of Istanbul asked permission to use Istanbul's cold storage facility (*buzhane*). A delegation of three rabbis went to inspect this installation and presented its recommendations to the acting Chief Rabbi (*kaymakam* in Ottoman), Rabbi Mosheh HaLevi. The rabbis were in favour of allowing the cold storage room to be used but only in the summer during the months of Av and Elul, provided that a rabbinical supervisor was present from morning to evening to stamp the meat as it entered and left the premises. In addition, beef and mutton were not to be left in the facility for longer than two days. In support of their recommendation, they invoked 'hard times, inflation and the fact that most of the public [are unable to afford meat]'.[23]

The number of meat-vendors' and particularly butchers' shops (*kanadarlıks*, which sold the choicest cuts) was fixed by the community's supreme institutions, together, no doubt, with the 'Rabbis Supervising Rituals and Ethics'. The Jewish population of the Ottoman capital lived in different districts of Greater Istanbul, each of which had a set number of butchers' shops at specified distances from one another. The right to own such a shop, indeed, the right to perform any gainful activity in the towns of the late Ottoman Empire was known as a *gedik*. This entitlement could be purchased from a fellow guildsman or his heirs; it could be also rented or inherited. A new shop could be opened only if the current *gedik* had fallen vacant (*mahlul*), that is, if the holders of the *gedik* had died without heirs or other legitimate claimants.[24]

Butchers' and slaughterers' guilds

All the aforementioned meat practitioners were organised into professional guilds known in Hebrew as '*edah* and in Turkish as *hirfet*. Less is known about the meat guilds than about those concerned with other foods, raw materials or services since many of the functions normally discharged by the guild itself were, in the butchers' case, performed by the 'Rabbis Supervising Rituals and Ethics' and by the city's supreme Jewish institutions. Nevertheless, these guilds existed and played an important role in butchers' lives.

In terms of their guild organisation, meat practitioners can be divided into two main groups, namely, the slaughterers and the merchants, the reason being that slaughterers were absolutely forbidden to trade in meat whether singly or in partnership with a Jew or a non-Jew. A slaughterer who was caught dealing in meat, even if the meat had been given to him as a present by an individual for whom he had slaughtered, was considered to have violated the community regulations and could expect his work permit to be revoked.[25] The 'Rabbis Supervising Rituals and Ethics' and the supreme institutions of the Istanbul Jewish community exercised extremely strict supervision of the slaughterers, both to ensure *kashrut* and to safeguard communal income from the *gabela*.[26] Unlike other guilds, membership in the slaughterers' guild was not inherited and did not require authorisation from the guild's elders. Accreditation was dependent on the length of study and training, the duration of which is not specified in available sources. Aspiring slaughterers had to pass an examination set by the 'Rabbis Supervising Rituals and Ethics'. These rabbis also awarded them work licences, assigned them to districts and determined their duty rosters.[27] In 1781, Istanbul had ten Jewish slaughterers.[28] By the early nineteenth century, there were 11 slaughterer entitlements and this had evidently been the case for several generations already.[29] According to Avraham Galanté, the city had 16 slaughterers in 1827.[30] However, by 1893, this number had dropped to 12.[31]

The slaughterers were required to adhere to the code of behaviour specified by the 'Rabbis Supervising Rituals and Ethics'. This included periodically reviewing the laws of ritual slaughter,[32] regularly inspecting the tools of their trade and

determining the cases where the presence of two slaughterers – one who slaughtered and the other who checked the process – was imperative.[33] When the slaughtering took place in a non-Jewish slaughterhouse, two Torah scholars had to be present in a supervisory capacity.[34]

Despite being subjected to such close supervision, the sources indicate that slaughterers had a well-developed social system of their own,[35] including an organisational framework that promoted their own specific group interests. This state of affairs is apparent from our documentation on the strike conducted by the slaughterers' guild in Istanbul during the incumbency of the *dayanim* R. Yehudah Meyuhas and R. Efraim Navon.[36] In the course of the nineteenth century, the slaughterers, who were barely earning a living, had begun taking larger cuts of meat for themselves. In 1893, the *sayacıs* (cattle merchants) protested, but the slaughterers claimed that, without these perks, they could not make ends meet. After both the *sayacıs* and slaughterers had threatened to strike, the slaughterers' salaries were raised to 500 *kuruş* per month and they were granted a rental entitlement belonging to the community's supreme institutions in order to supplement their income.[37] Following this incident, any slaughterer who applied for accreditation after 1893 was required to declare, under oath, that he would not appropriate any meat for himself.[38]

An earlier regulation renewed by the butchers-porgers' guild (*kanadaris*) on 4 Nissan 5480 (12 April 1720) with the approval of the 'Rabbis Supervising Rituals and Ethics' provides welcome insight into the guild's structure, internal arrangements and objectives. The regulation contains a number of clauses, the first of which reads: 'A master porger may not impart the secrets of his trade to anyone but his son, son-in-law or brother. If, God forbid, a member of the community [of porgers] passes away and his son or son-in-law wishes to study the profession, the entire community must teach him the profession. However, anyone whose father was not a porger may not study the trade.' The reason cited for this regulation is that 'the children of Israel should not come to eat forbidden food, God forbid', i.e. to ensure that the Jews of Istanbul consume only kosher meat. In practice, the major purpose of this regulation was to safeguard the economic interests of the porgers and their families and to

protect the tradesmen's livelihoods by restricting the number of people allowed to take up this type of work. The regulation further stated that a butcher who was not familiar with the art of porging could not sell *kanadar* (porged meat). Although, here too, the ostensible reason was to ensure the *kashrut* of the meat, there was another barely veiled motive behind this injunction, namely, to provide the porgers, their sons and sons-in-law with a monopoly control over the butcher's trade. These concerns not-withstanding, family ties alone were not enough. All porgers had to receive accreditation by the 'Rabbis Supervising Rituals and Ethics' and, without such accreditation, family ties were of no avail.[39]

This section of the guild regulation ends with a warning that any member who cursed or raised his hand against a colleague would be punished at the master porgers' discretion. This formulation provides historians with some fascinating insights into guild structure. First, we see that the butchers-porgers, like all Ottoman guildsmen, had their own internal hierarchy, with the master porgers at the top through the regular porgers down to the apprentices. Second, it teaches us that, in addition to the supervision of the rabbinical court that presided over matters of 'Rituals and Ethics', the master porgers operated their own internal arbitration system within the framework of their guild.

The third clause of the regulation ordered all members of the butchers-porgers' guild to pay a fee toward the guild's benevolent fund, which was used for joyous occasions such as weddings as well as for necessities such as assisting the sick. The fee was set at four *akçe* for a *kanadar* (butcher-porger) and at three *akçe* for a porger who did not own a butcher's shop. In the same clause, Yonah Ibn Rey, Shabbetai Bakhar, Avraham Gabbai and Hayim Qamhi, from the 'Rabbis Supervising Rituals and Ethics', explained that all butchers had, of necessity, to be porgers as well. Anyone unable to porge was not allowed to sell meat unless he employed a porger in his shop. This stipulation, together with the sliding fee scale for the various practitioners, confirms our hypothesis that the *kanadar* was a butcher-porger and that simple porgers did not own a butcher's shop.[40] To sum up, the above regulation shows that the butchers-porgers' guild safeguarded its members' interests, arbitrated in cases of dispute and looked after the social well-being of its members.

About twelve years later, around the middle of August 1732, guild members convened to discuss the deterioration of their craft organisation. The previous generation of leaders had passed away and no new leadership had taken over or had been elected. As the guild members themselves put it: 'The members of the *rufit* (corruption of the Turkish *hirfet* or guild) are behaving badly, for each man does as he wishes, and those who are violent get their own way; the youngsters insult their elders without an ounce of shame. We are like sheep without a shepherd. And this is the reason for the poor relationship between us.'[41]

The guild members therefore decided to elect seven master porgers as their elders and as arbiters in matters pertaining to the guild. They agreed to accept the elders' authority and to pay fines and other penalties meted out by them in disputes between guild members, ranging from purely personal verbal arguments to matters directly concerning the guild itself. Moreover, the guild members promised to abide by the rule forbidding master porgers from taking on apprentices without the elders' permission. They further agreed that apprentices should not be given more than one meal a day until they were qualified. Finally, the porgers undertook not to work as butchers unless a butcher's shop fell vacant, in which case the elders' permission would still be required.

In addition to the seven elders, guild members elected three executives whose job it was to implement the elders' decisions. This structure paralleled that of the Jewish congregations of the Istanbul community during its formative years in the sixteenth century. At that time, each congregation had had its seven aldermen corresponding to the seven guild elders chosen to assist the three executives and, at the same time, a handful of *parnasim*, counterparts to the three executives of the butchers' guild of later centuries.[42] Power to enforce the elders' decisions was vested in the three executives, who could handle all matters relating to the collection and administration of funds. According to the agreement, anyone who refused to accept the authority of the three executives or who transgressed any of the guilds' regulations would be dismissed and barred from working in any branch of the meat trades. In addition, the miscreant would be required to pay a fine of 25 *kuruş* to the girls' orphanage endowment in Balat.[43] Thus, one sees that the guild had a

hierarchical structure comprising a legislative council (the elders) and an executive arm, while the 'Rabbis Supervising Rituals and Ethics' granted licences, supervised the implement-ation of the laws of *kashrut* and, in general, acted as a kind of Supreme Court.

This was not the whole picture, however. The butchers' guild was also subject to the authority of the '*gabeleros*': lay leaders (*parnasim*) who formed the Jewish community's executive arm. The *gabeleros* belonged to the moneyed class whose members paid direct property and capital taxes. Although they formed only a small proportion of all adult men in the community, they played a key role in its political life. The word *gabelero* comes from the word *gabela*, the indirect tax levied on kosher cheese, wine and meat. These taxes, especially the meat tax, together with direct taxes paid by the rich (*qitzvah* or '*arikhah* in Hebrew), constituted the community's main source of income. However, in order to function properly, the community needed a regular source of income independent of the vagaries of the meat trade; therefore, the *parnasim* became *gabela* farmers. They financed community institutions and, out of their own pockets, paid the salaries of religious ministrants and teachers as well as taxes due to the authorities. In addition, they distributed funds to the sick, the poor, orphans and widows. At a later stage, they recuperated their money through the *gabela*, which they collected from the butchers. The *gabela* was imposed in a similar way to that in which the European VAT (Value Added Tax) is levied today – the butchers added the *gabela* to the prices of their products and then paid their shares to the *parnasim*. Thus the *parnasim* became known as *gabeleros*. The latter possessed the power to enforce all rulings of the 'Rabbis Supervising Rituals and Ethics' and had the authority to ensure that butchers who defaulted on payment of the *gabela* were struck off the register. In these matters, the *gabeleros* had the backing of the Ottoman ruler.[44]

For the purpose of this study, it is important to bear in mind the following two facts. First, there was no intrinsic relationship between the *gabeleros*' investment in the community and the money that they retrieved via the *gabela*. In other words, as with any other *iltizam* in the Ottoman Empire, it was normal for the *gabeleros* to make a profit on their investments. Second, the *gabeleros* were usually extremely wealthy men who had intimate

ties with the sultan's court and the army and who used these connections to impose their authority on the community.

Clashes between the various participants in the meat trade

Apart from conflicts between butchers and porgers, there were endless disputes over boundaries between different branches of the meat trade, with each branch seeking to extend its boundaries at the expense of others. From the eighteenth to the mid-nineteenth century and possibly even later, the 'Rabbis Supervising Rituals and Ethics' had to constantly protect boundaries between different guilds in order to safeguard the livelihoods of the various practitioners. Thus, in 1745, members of the *sakatcıs'* guild succeeded in getting a verdict which forbade the butcher Shabbetai Russo to sell *sakat* himself or to allow someone to do the selling on his behalf. Russo was ordered to deliver the *sakat* to the *sakatcıs*.[45] However, other regulations indicate that protecting practitioners of certain trades was not in itself the primary concern of the rabbis and community leaders. Thus, in August 1807, the 'Rabbis Supervising Rituals and Ethics', namely, Hayim Ya'aqov Ibn Yaqar, Hayim Pinto and Eliyah ben Eli'ezer, signed a regulation which renewed the *sayacıs'* obligation to deliver ritually banned animals to the *sakatcıs*, who were experts in the laws of ritual prohibition. The regulation indicates that the *sayacıs* paid the *sakatcıs* a small fee for removing the animals from the Jewish market. During the year in question, the *sakatcıs* demanded an increase of half a *kuruş* per animal, claiming they were unable to support their families on less. In all probability, therefore, the 'Rabbis Supervising Rituals and Ethics' were concerned lest the impecunious *sakatcıs* sell ritually banned meat as kosher in order to supplement their income.[46] Religious concerns thus induced the rabbis to protect the livelihoods of the *sakatcıs*.

Another ruling about boundaries between guilds involved in the meat trade also concerns the issue of *kashrut*. On 30 October 1796, the 'Rabbis Supervising Rituals and Ethics', namely, Ya'aqov Menasheh, Eliyah Bakhar Eli'ezer and Eliyah Bakhar Ya'aqov, once again attempted to separate butchers and porgers in order to safeguard the porgers' livelihoods and the *kashrut* of the

meat. With these aims in mind, the rabbis tried to supplement the porgers' income as these men played such a vital role in ensuring the *kashrut* of meat. They ruled that a porger could not work for more than three butchers at a time, a measure aimed not only at safeguarding the quality of his work, but also at ensuring a fair distribution of jobs. They further ruled that if the number of porgers grew, each practitioner of this trade would be allowed to work for only one butcher so as not to deprive his colleagues of a livelihood. Likewise, the rabbis ordered the butchers to sell sinews and offal used for sausages (*sarsıca*) to the porgers. The butchers replied that although they had controlled the sausage trade in the past, outsiders such as apothecaries, spice-vendors (*aktarcıs*) and tavern-keepers (*meyhancıs*) had now begun to purchase *sakat* and compete with them. Even if they were to sell the *sakat* to the porgers, they could not guarantee them a monopoly. Accordingly, the 'Rabbis Supervising Rituals and Ethics' forbade tavern-keepers, apothecaries and spice-vendors from selling sausages to Jews and forbade Jews to buy sausages from them. Henceforth, Jews would be permitted only to purchase sausages from butchers and only porgers employed by butchers would be licensed to manufacture sausages. Even sausages from outside Istanbul could not be sold to tavern-keepers or grocery stores, but only to butchers or directly to the public. The rabbis instructed each butcher to pay a third of the profits on the sale of sausages in his shop to his porger and 10 *para* for each flank of bull, 8 *paras* for each flank of cow and 5 *para* for each flank of calf, porged by the latter.[47]

The butcher's trade – a family business

Quite apart from regulations forbidding porgers to teach the trade to anyone outside their family circles, there are other indications that the art of porging passed from father to son in an unbroken chain through the generations. As a result, the only way to break into the craft was through marrying a porger's daughter. As stated above, the approval of the guild elders was required if a porger wished to acquire the *gedik* of a butcher's shop that had fallen vacant. The elders, in turn, had to defer to the 'Rabbis Supervising Rituals and Ethics', who kept a register

of all licensed butcher's shops in Istanbul. In other words, the location and number of butcher's shops was fixed by the rabbis and recorded in the registers. The sources reveal that there were butcher's shops in Hasköy,[48] Galata ('near Mercado Pinto's grocery'),[49] Mahmud Paşa,[50] Balık Pazarı,[51] Un Kapanı,[52] 'Outer Balat' (near the Selaniqiou-Sigiri synagogue),[53] inner Balat,[54] Ortaköy[55] and Kadiköy.[56]

Similar customs were current among butchers whose shops also passed down from father to son. The only way that an outsider could acquire a *gedik* was by putting in an application if a butcher died without progeny. In such a case, a porger who did not already own a butcher's shop could purchase both the butcher's title to exercise the profession and the title to the vacant premises (*mahlul*). In this way, a balance was struck between the butchers' need to make a living and the community leaders' desire to provide the public with kosher meat at a reasonable price.[57]

Note that it was extremely rare for a butcher's entitlement to become available. Even if the children of the deceased were too young to run the shop, the orphan's guardians leased out the entitlement until either a son was old enough to take over, a daughter had married or another interested family member had put forward a claim.[58] Even during the very last years of the Ottoman Empire, the right to a craft or trade was kept within the closed circle of established guild members; this is well illustrated by marriage records of the community for the years 1912–1922. In 29 of the marriages contracted during that period, the groom or bride's father were butchers. A comparative study of all professions shows that butchers were most concerned about keeping the profession within the family and that they had the highest proportion of marriages 'inside the profession'. In 12 cases out of the 29, both the groom and the bride's father were butchers.

Long dynasties of Istanbul Jewish butchers are further proof of the tendency to preserve the business within a narrow circle of relatives. The Russo family crops up repeatedly in rabbinical court records for the years 1745–1787 and not to the credit of its members, if the truth be told.[59] These records graphically illustrate how the entitlement was kept within the family. No different was the butcher dynasty of the Romi, one of whose scions, Nissim Romi, incurred the wrath of the city's rabbis in 1878. Two years

later, Mosheh Romi followed in his relative's footsteps.[60] The butchers of the Romi dynasty also figure prominently in the community's marriage records. On 30 August 1912, the butcher Daniel Romi from Arabacılar married off his son Mosheh to Sarah, daughter of Yehudah Ashkenazi from the same neighbour-hood. On 21 March 1919, the butcher Eliyah Romi from Galata had arranged the marriage of his son Meir to Senioro Eugenie, daughter of his neighbour Mosheh Ashkenazi from the same neighbourhood.[61] And on 23 September 1920, the butcher Ya'aqov Romi from Ortaköy celebrated the wedding of his son Yitzhaq to Perla, daughter of Mosheh HaLevi and also a resident of this same neighbourhood.

An even more interesting example of family continuity is provided by the case of Mosheh Kanpias versus the Meclis-i Cismanı, the lay council of the Jewish community of Greater Istanbul. For 40 kuruş per month, the trustees of the endowment belonging to the Salonika (Selaniqiou) congregation in Istanbul rented out two shops in the neighbourhood of 'Outer Balat' in the Balat district. The tenant was Kanpias, who was to hold a perpetual lease (in Hebrew: sekhirut 'Olam, a lease held for ever and ever). In the contract, the trustees accepted the responsibility for re-building the shops in the event of a fire. Accordingly, when the shops burnt down around 1865, Kanpias demanded that the trustees honour their promise. However, the council members challenged Kanpias' right to demand strict implementation of the contract, arguing that the amount of rent and rental conditions were exceptionally favourable to the tenant. As the interests of an entire congregation were thus jeopardised, the contract could not be regarded as strictly legal.

While perusing the registers of the Salonika Congregation endowment, the council members discovered that in actual fact Kanpias had not purchased the title to the shops, but only the title to the goodwill (peştamalık)[62] of the butchery business. By contrast, the actual title to the shops belonged to Bekhor Mizrahi, who had inherited them from his maternal grandfather, a sayacı (livestock merchant). Kanpias had bought animals from the grandfather until the latter's death and had arranged that his purchases from the Mizrahis would stand in lieu of rent. After the shops burnt down, Bekhor Mizrahi, who was implicated in the case, demanded that both the title to the shops and

the goodwill be returned to him. He no doubt attempted to win round the council members, some of whom were *gabeleros*, by offering to raise the rent paid to the Salonika Congregation's endowment.[63]

Even after this case was over, the Mizrahi family's ties with the Salonika endowment and with the Kanpias family continued until December 1901, when Hayim Robiro and his five sons and one daughter signed a declaration to the effect that the three butchers' shops in the 'Outer Balat' neighbourhood, whose title they had purchased from the heirs of the late Rafael Mizrahi and the late Eliyah HaKohen, known as Fundugalo, as well as from the heirs of Mentesh Kanpias and Yitzhaq Kanpias, effectively belonged to the Salonika endowment.[64] Given that, in 1865, the Mizrahi family had been butchers for at least three generations, we are confronted here with an unbroken chain of butchers who plied their trade in the same location for over a hundred years, from the end of the eighteenth to the early twentieth century.

This continuity was a facet of the Ottoman way of life and did not indicate that the butcher's trade was particularly profitable. A study of dowries granted by butchers to their daughters has been undertaken and the relevant sums of money have been compared to those allotted by other Jewish merchants, craftsmen and professionals. Out of 3,427 fathers who married off their daughters during the years under examination, the butcher who was the most generous toward his offspring was in fifty-fourth place while the most generous cattle merchant was in forty-ninth. Moreover, the dowry of the butcher's daughter amounted to only 0.00072 of the highest dowry, received by a lawyer's daughter, and to 0.05 of the second most generous dowry, which an apothecary's child took to her husband.[65] Yet one has reason to believe that the practitioners of the meat trade felt quite secure financially. In consequence, they did not hesitate expressing their dissatisfaction with the establishment in various ways, as is apparent from their social, professional and political behaviour.

Meat, blood, beer and wine

Slaughterers and other practitioners of the meat trade had a predilection for wine and beer both during and after work hours,

as attested by numerous archival sources. To cite but one example, the reprobate butcher Mosheh Romi was made to swear that he would restrict his intake of wine or beer to non-working hours.[66] In 1785–1786, the 'Rabbis Supervising Rituals and Ethics' accused the slaughterers of Istanbul of imbibing alcohol from dawn to dusk, of continuing to drink through the night, of carousing in taverns (*meyhane*), streets, parks and orchards and thus acquiring a reputation of being thorough drunkards. The *sayacıs* (cattle merchants) protested that drunken slaughterers could not be relied upon to do their jobs properly and that their opinions regarding the animals' ritual acceptability – even if correct – could not be trusted. Repeatedly, the 'Rabbis Supervising Rituals and Ethics' attempted to get this problem under control. Regulations intended to limit the slaughterers' consumption of alcohol forbade the latter from working before they had sobered up; heavy drinking was allowed only after work hours.[67] Alcohol addiction as a social problem characteristic of the meat trades can seemingly be explained merely on psychological grounds. Apparently, after having dealt with dead and dying animals all day long, slaughterers felt a need to 'drown' their visions of blood and gore in wine or beer. In any case, alcohol addiction and the rabbis' inability to put a stop to it are in themselves highly suggestive phenomena. Although on the surface an integral part of the Jewish establishment – bound as they were by hundreds of *kashrut* rules and strictures – the practitioners of the meat trades were actually a marginal, defiant and even a subversive group.

The interface between meat, religion and politics

Throughout the eighteenth and nineteenth centuries, a striking aspect of the registers of the 'Rabbis Supervising Rituals and Ethics' and the rabbinical court records, in general, is the re-curring criticism of the slaughterers and their professional expertise. A fair number of known court cases were brought against butchers; many of them were guilty of repeated mal-practice and the culprits were barred from exercising their crafts, at least on a temporary basis. The registers specify some but not all of the offences which usually involved the sale of ritually banned

meat (cf., below, the cases involving Russo and so on). One may assume, however, that even where the charges are unspecified, the accused were guilty of violating a rabbinical ruling of one sort or another.

The various cases may be broken down as follows:

butcher's name	charge	date	ruling	reference
Shabetai ben Ya'aqov Russo	guilty of selling *sakat*	1745	must sell *sakat* to *sakatcıs* or be barred from his trade	Bornstein-Makovetsky, 1999, doc. n° 9, p. 122
Menahem Russo	prohibited meat found in his possession on several occasions	Jun. 1769	barred from his trade	*ibid.*, doc. n° 11, pp. 125–127
Ya'aqov ben Menahem Russo	prohibited meat found in his possession on several occasions	1786	barred from his trade	*ibid.*, doc. n° 11, pp. 127–128
Mosheh Babani	found selling ritually banned meat	1788	barred from his trade	*ibid.*, doc. n° 14, pp. 131–132
Yehudah, alias Baş Oğlan	found selling ritually banned meat	Jul. 1790	barred from his trade	*ibid.*, doc. n° 14, pp. 132–133
Mordekhai Barukh	found selling ritually banned meat	Aug.–Sept. 1835	employ an honest associate or be barred from his trade	*ibid.*, doc. n° 15, pp. 133–134
Mordekhai Ashkenazi	sold forbidden fat (*helev*) instead of permitted fat and unporged meat	Feb. 1846	barred from his profession	*ibid.*, doc. n° 16, pp. 135–136
Nissim Romi	unknown	11 Shevat 5638/ 15 Jan. 1878	allowed to exercise his profession on condition that Nissim Sinai stay with him in the shop	Rabbinical Court Register, n° 4 (1871–1894), §5, p. 75

butcher's name	charge	date	ruling	reference
Mosheh Romi	guilty of malpractice	25 Av 5640/ 2 Aug. 1880	allowed to exercise his profession on condition that he work in partnership with Yehudah Tzarfati[68]	*ibid.*, §3, p. 97
Menahem Nipotzi	sold animals that were not ritually slaughtered (*nevelot*) and animals that were not ritually fit for consumption (*terefot*)	5 Adar I 5630 6 Adar I 5630/ 6–7 Feb. 1870	barred from his profession	*ibid.*, n° 3 (1853–1871), after §9, pp. 274–275
Ya'aqov Tzarfati	bought meat from a non-Jewish person and sold it as kosher on several occasions	Av 5660/ 27 Jul. 1900	allowed to continue under the supervision of a porger	*ibid.*, Register n° 5, (1894–1915), § 7, p. 39
Hayim Bitran	co-operated in evading the *gabela* and had taken pieces of meat and fat for himself	26 Tevet 5675/ 1 Jan. 1915	his working permit was revoked for 30 days, after which he had to work under the supervision of Yosef Niego until Shavu'ot (Pentecost). A reassessment of his working permit by the rabbis and by the Committee of the Gabela would take place after the holiday.	*ibid.*, n° 6 (1912–1919), p. 23
Yisrael Palombo	porger at Mr. Foa's shop in Yüksek Kaldırım charged with selling unporged meat	25 Shevat 5675/ 9 Feb. 1915	hiring of an assistant porger recommended	*ibid.*, n° 6 (1912–1919), pp. 33–34

butcher's name	charge	date	ruling	reference
Yitzhaq Ashkenazi	went back to sell ritually forbidden meat in Haydar Paşa in non-Jewish shops and from house to house	7 Tevet 5676/ 14 Dec. 1915	his transgressions should be made public to protect God-fearing customers	ibid., n° 6 (1912–1919), p. 77
Mercado Abrabalia	opened a butchery shop where he sells ritually forbidden meat	14 Hesh-van 5677/ 10 Nov. 1916	was decided to to look for ways to make him comply with the Chief Rabbinate's rules	ibid., n° 6 (1912–1919), p. 158

The above 14 cases came to court over a period of slightly more than 160 years, a period during which the number of butcher entitlements remained more or less constant. Most of the disqualifications took place between 1835 and 1916. Almost all the offenders had been involved in various kinds of malpractice for many years until they received stern official warnings or were even barred from practising their trades. Quite a few of them, however, were allowed to continue in their crafts under supervision despite being severely reprimanded by presiding rabbinical judges. Clearly the rabbis, despite their alleged concern with strict adherence to *halakhic* (Jewish legal) prescriptions, were fairly lenient toward the butchers as well as towards the slaughterers. This leniency was an expression of a certain impotence that the rabbis, the *gabeleros* and members of the lay council experienced in their dealings with the butchers and the slaughterers, as evidenced by their failure to effectively combat the latters' drinking habits. But why were both the religious and the lay establishments unable to stand up to the butchers and slaughterers? The answer is to be found at the interface between meat, politics and religion.

Some of the components of this puzzle have already been introduced. Now, other parts of this complex and colourful mosaic will be investigated in order to gain a better understanding of the place of the meat trade in the politics of the Jewish community. First, it should be recalled that the meat trade was one of the community's main sources of income. However, in

order to understand the full social and political implications of this dependence, the meat trade must be situated in relation to the community's other sources of income. In addition to this, revenues derived from the meat trade must be linked to power struggles between the community's various social strata.

The Istanbul Jewish community, like most Jewish communities in the Ottoman Empire, drew its funds from two types of taxes: a direct tax on property and income known as the *qitzvah* and an indirect tax, namely the *gabela*. As discussed previously, the *gabela* was due on foods that required a rabbinical stamp of approval such as cheese, wine, meat and unleavened bread (*matzot*). Of these, the most important and expensive commodity was meat. It should be recalled that although the poorer strata of society were not great consumers of beef or mutton, it was customary to eat lamb on Jewish festivals and often on the Sabbath as well.

During the formative period of the Istanbul Jewish community, that is, from the Ottoman conquest of Constantinople to the last third of the sixteenth century, the Jewish community of Istanbul was governed by a plutocracy which also shouldered most of the community's financial burden. The congregations and the community as a whole derived most of their income from direct taxes and from the philanthropy of its wealthy members, such as Don Joseph Nasi, the Hamon family, Don Solomon Ibn Ya'ish, the Vileisids and the Ibn Shanjis.[69] The situation already began to change in favour of indirect taxation in the seventeenth century. By the mid-eighteenth century, indirect taxes comprised as much as 45.15 percent or almost one-half of the community's entire revenue.[70] Obviously, this transformation did not happen overnight, but was the result of a slow process that continued over decades. Put differently, by the mid-eighteenth century, the rich had succeeded in shifting at least half of the burden of the community's upkeep on to the shoulders of the poor. In order to accomplish this, the rich had had to gain control of the congregations and the community's supreme institutions.

The connection between control of the Jewish community's supreme institutions and distribution of the tax burden between rich and poor is well illustrated by a regulation passed in Istanbul in 1773. Without the authority wielded by affluent members of the community, this regulation, which abolished rigorous tax assessments, could never have been passed. The regulation stated:

'Henceforth, members of the community shall not be assessed according to their wealth, but shall be taxed on an approximate basis, as they [the leaders] see fit. From now on, assessments of wealth will be abolished.'[71] This regulation effectively gave legal force to a custom that had already taken root within the community. It waived the former '*arikhah* (the detailed assessment of property and income for tax purposes) and replaced it with an approximate appraisal 'based on appearances'. Although the rationale for this regulation was not to draw unwelcome attention to Jewish property, the true reason was to fix an upper tax ceiling beyond which the wealthy could not be assessed. Paradoxically, therefore, in order to shift the burden of community expenses on to the poor, the rich had to control the community's institutions; whereas the only valid justification for such control was precisely the financing provided by wealthy members of the community. Participation in political life was effectively restricted to those who paid the *qitzvah*, despite the steady decline in the *qitzvah* and the corresponding rise in the *gabela*.

Control of the city's supreme Jewish institutions by the affluent had yet another advantage for the well-to-do. Among the small group of wealthy men who directed the community's affairs, one finds the *gabela* farmers, frequently referred to in the sources as the 'wealthy *gabeleros*'. These *gabeleros* benefited twice over: first, by determining the level of taxes that they paid and, secondly, by reaping hefty profits from the meat tax.

This corrupt state of affairs continued unchallenged until 1826, when Sultan Mahmud II liquidated the Janissaries as part of his efforts to reform the army and administration. Prior to 1826, the Jewish community had been led – both directly and in-directly – by the heads of a small number of Istanbul families, such as Yehezqe'el Gabbai, Bekhor Yitzhaq David Carmona and Yeha'ayahu Ajiman, who all had connections with the sultan's court and the heads of the imperial army and administration. However, the increasing hold of Christian Europe over the Ottoman Empire and the concomitant empowerment of Ottoman Christian communities bred fierce competition between Jewish and Armenian financiers over positions of economic power. The Jewish bankers lost this struggle. Between 1822 and 1826, they were all murdered in swift succession at the government's initiative and their sizeable wealth impounded to swell the sultan's

coffers. All three, Gabbai, Carmona and Ajiman, had been closely affiliated with the commanders of the disgraced Janissaries and the emergence of a new class of Armenian financiers made them easily expendable.

Certainly, affluent Jews (and non-Jews) had been executed for their wealth in the past. But, since the Jewish bankers were killed along with numerous Janissaries, what happened in 1826 was no less than the destruction of the entire political-military apparatus that had backed such Jewish financiers and leaders for hundreds of years. This new turn of events was not merely unprecedented, but also extremely alarming: the bankers' assassination left its mark on the Jews of the Empire in general, and on the Jews of Istanbul in particular. These were the people to whom Istanbul Jews had turned whenever they felt that their interests were threatened. These were the people who had been able to contain the forces of social delinquency and anarchy always present in urban life. Their disappearance left the community bereft. It no longer had anyone to intercede on its behalf before the imperial rulers or to restrain those who flouted the community's accepted social conventions.

Reforms, budgetary crisis, taxpayers' revolt against the gabela and the butchers

Before the assassination of the Jewish bankers, any protest – whether active or passive – by ordinary taxpayers against the leaders of the community was inconceivable. Since community leaders derived their authority from the sultan, with whom they were considered to be on familiar terms, any attempt to change the administration was doomed to failure. This explains why the authority of the Carmona, Ajiman, Gabbai or Ibn Zonanah families went unchallenged, especially if one bears in mind that the Ajiman and Ibn Zonanah families were also *gabela* farmers.

Suddenly, however, the heads of the first three families were assassinated, leaving chaos in their wake. The impact of this event on the political status of the Jews within the Empire is beyond the scope of the present work. Only one aspect will therefore be discussed here, namely, how this event made it impossible for community leaders to discipline their 'flock'. After the bankers' assassination, there was no one left to enforce payment of the

qitzvah for the Jewish community's supreme institutions or to enforce rabbinical supervision of the butchers and slaughterers. No longer was there a Carmona who, at a mere word, could have an insubordinate butcher flung into jail.[72]

Gradually, however, the political vacuum left by the bankers' assassinations was to be filled.[73] In 1835, the Ottoman administration reintroduced the office of *hahambaşı* (chief rabbi) and demanded greater transparency from the Jewish community, along with the other communities, in order to facilitate direct control by the central administration of their activities. A new leadership that had hitherto refrained from entering into community politics stepped into the breach. It comprised the so-called Francos or foreign subjects residing in Istanbul, who owed allegiance to the country of which they were subjects. Of these, the most outstanding was Avraham Camondo, an Austrian subject, who after Italian unification was awarded a hereditary title by the king of Italy. Under the influence of business associates like Moise Allatini, another Franco from Salonika, and the Rothschilds he devoted himself to the task of improving the lot of the city's Jews and, particularly, modernising Jewish education. The graduates of the modern schools which he aspired to establish were to speak French and Turkish; thus, they would be equipped to participate in the modern world and to successfully compete for economic and political positions with members of other religious groups in the Empire. Camondo invested enormous effort and money into this project; however, the local plutocracy had grown used to paying less and less and was quite happy with the status quo.

Between 1858 and 1865, a battle was fought over the future of Istanbul's Jewish community. The central issue in this struggle was the price of modern education as promoted by Camondo and his circle, who tried to make the local notables contribute their share to the communal budget. However, the newcomers made little headway. In 1862 the Francos gave up, and founded a separate congregation of their own. In 1865, nine years after the Hatt-ı Hümayun had demanded the reorganisation of the various religious communities in the empire, the Jewish community finally succeeded in formulating its new constitution. Between 1865 and 1880, the Ajiman and Ibn Zonanah families once again ruled the community as members of the Meclis-i Cismani and as

gabela farmers. In 1867 they paid lip service to the establishment of a modern school and, in order to secure funding, increased both direct and indirect taxation by 15 percent. Thus it was Camondo's effort to introduce modern education to the poor and to force the local notables to pay their share which made the social gap between rich and poor obvious to all and paved the way to the '*gabela* rebellion'.

The share of indirect taxes in the communal budget was increased until the *qitzvah* constituted, in 1872, only 1.57 percent of the community's entire income. In short, the poor, who spent most of their income on food, financed the community in-stitutions through indirect food taxes while the rich still held on to the reins of power.[74] It was at this juncture that the slaughterers and butchers entered the picture and we return to the lives and actions of the guildsmen.[75] Ordinary Jewish taxpayers realised that they were being deceived, although they may not have understood exactly how this was happening. They were certain, however, of one thing: meat was expensive and it was expensive because it was helping to finance a system that was not working to their advantage. Although they had no concrete proof, they were con-vinced that some of the money that they paid for meat found its way back into the pockets of rich *gabeleros* who were members of the Meclis-i Cismani instituted by the new Constitution of 1865, the 'Council of Whips and Scorpions' as the poor Jews more graphically called it.[76] The latter expressed their discontent by action as well: they increasingly began to consume ritually banned meat or at least meat that did not bear the rabbinate's stamp of approval. Thereby they not only evaded payment of the *gabela*, but also showed their dissatisfaction in a form of passive social protest.[77]

Within this scheme of things, the butchers and slaughterers served as mediators for translating the public's discontent into action. They were excellent candidates for this role. They always had something to eat and, thus, they were never as downtrodden as were the 'regular' poor. In addition, with their history of dis-obedience and defiance and their constant exposure to blood and gore, they had become hardened people, not easily intimidated. The available sources indicate not only a rise in the sale of ritually banned meat, but also the development of a fruitful co-operation between slaughterers, butchers and customers. Together, these

people made sure that the proceeds from the *gabela* reaching the coffers of the chief rabbinate decreased substantially.

On 7 Heshvan, 5638 (15 October 1877), the spiritual council headed by Rabbi Mosheh HaLevi and leading laymen convened to discuss this situation. Although the minutes of the meeting, preserved in the rabbinical court records of Istanbul, make no reference to the erosion of the *qitzvah*, they make much of the decline of the *gabela*. Council members accused the butchers of pocketing the *gabela* but quite obviously such an act would have been impossible without the co-operation of the slaughterers. Since the acting chief rabbi's (*kaymakam*) salary was paid from the *gabela*, it is not surprising that he was concerned about its erosion. In the end, the *kaymakam* and the council members forced the slaughterers to take an oath, renouncing their title to slaughter in favour of the community and warned them that their work permits would be revoked if they failed to pay the *gabela*.[78] After nine slaughterers had taken the oath, Rabbi Mosheh HaLevi heaved a sigh of relief.[79] Potential slaughterers were also made to swear that they would have no part in the evasion of the *gabela*. However, the leadership did not seem to grasp how impaired was its legitimacy, on the contrary, on 10 Sivan, 5639 (1 June 1879), the council members decided that the *hahambaşı* deserved a magnificent mansion 'like all the patriarchs'. To raise the necessary money, the meat tax was increased from 20 to 30 *paras* per ounce.[80] This of course promised increased revenues to the *gabeleros* as well and, during the next year (1880), Avraham Ajiman, head of the lay council in 1880, waged a fierce fight to secure for himself the right of *gabela* collection.[81] The meaning of all these facts and affairs was well understood by ordinary Jews, who avoided payment whenever they could and in the early 1880s the community faced total financial collapse.

In order to rectify this situation Jews who held administrative and army posts under the Hamidian regime were recruited to serve in the Meclis-i Cismani. They were the products of the very same educational reform that the community leadership had refused to finance. However, most of them were descendants of affluent families that could afford private education for their sons. Whereas a revolt against corrupt businessmen might have been conceivable, a revolt against the sultan's minions was not a good idea. The ruling elite hoped that

this understanding would restrain the poor, and force them to pay taxes. Thus loyalty to and identification with the Ottoman ruler formed an integral part of the value system of Jewish society in Istanbul, along with an equally persistent class rigidity. Together these two elements formed the basis of the 'correct' social order that continued even after the community resolved and 'worked through' the 1826 crisis. However, the efforts to impose the excessive *gabela* tax on slaughterers, butchers and customers through an authority backed up by links to the Ottoman state apparatus led to a build-up of covert resentment. This resentment erupted in 1899, when the butchers openly rebelled, claiming that the 30 *paras* tax on each ounce of meat, on top of the 8 percent tax that they already paid to the government, was excessive. They refused to sell meat until the *gabela* was lowered to 20 *paras* per ounce, which, in effect, was the rate prior to the construction of the *kaymakam*'s new mansion. They also refused to pay the *gabela* in advance – it was to be due only after eight days had elapsed from the date of sale.[82]

Although the sources provide no clear picture of how the strike ended, it is clear that social unrest continued. The butchers had a hard time selling meat that was so expensive. During the reign of Abdülhamid II, when the lay council was composed almost exclusively of government functionaries, wholesale *gabela* evasion was even more widespread than it had been under the 'Council of Whips and Scorpions'. In other words, harnessing the new Ottoman officials to the communal wagon may have helped the traditional elite continue to evade paying direct taxes, but it did not help them to subdue ordinary taxpayers and force them to pay the *gabela*. The days of the great *sarrafs* and *bazırgans* were over.

With the revolt of the Young Turks on 24 July 1908, the leaders of the Jewish community who were also Ottoman functionaries immediately sided with the revolutionaries and appointed Hayim Nahum Efendi as the new *locum tenens* (*kaymakam*), soon to become the chief rabbi (*hahambaşı*). Hardly had the new appointee assumed office when 'the entire guild of butchers rose up and conspired and refused to pay...'.[83] Upon his accession, the new *kaymakam* inherited empty coffers. In this situation, he had to confront an economic elite that had long since ceased paying taxes and a group of unruly butchers who naively believed that freedom for all meant freedom from paying taxes, both for

them and for their customers. To all intents and purposes, there-
fore, the leadership that had catapulted Rabbi Hayim Nahum
Efendi into power did not change but continued to represent the
interests of an oligarchy closely connected to the Ottoman govern-
ment. This leadership was a natural continuation of the old system
which, since 1876, had adapted to the needs of the times and
had grown increasingly sophisticated in the process.

From 1912 onwards, the cold winds of war were blowing
outside the walls of the *hahamhane* (rabbinate). The *qitzvah*
collection had not improved and the butchers still refused to levy
the *gabela* upon their impoverished customers. However, the
forms of this struggle had changed. Since the 1880s the influx of
Ashkenazi immigrants fleeing from the pogroms in Russia and
Romania added fuel to the fire. The Ashkenazim of Istanbul were
the standard-bearers of Zionism, a dangerous, unwelcome idea
as far as the local leadership was concerned. Zionism meant not
only Jewish nationalism but social justice as well and this, the
Ashkenazim felt, did not exist in Istanbul. Since they sensed that
the community was not doing anything on their behalf, they were
not interested in levying the *gabela* or delivering it to the com-
munity's leaders. They had their own slaughterers who worked
independently of the chief rabbinate and who apparently earned
less than their Sephardi counterparts.

A surprising number of these newcomers started butchers'
shops. The aforementioned marriage register of the Istanbul com-
munity lists 6,854 men, of whom 222 or approximately 3.2 percent
were Ashkenazi. However of the 29 butchers specified in the
register, five or about 18 percent were Ashkenazim who had
recently moved to Istanbul. The disproportionately high rep-
resentation of Ashkenazim in the butchering trade may indicate
a fruitful co-operation between them and the destitute ordinary
people of whom they were an integral part.[84] These poor people
were able to afford the tax-free meat, possibly also of an inferior
quality, which the Ashkenazi butchers offered them. Be this as it
may, clearly a group of butchers, unconstrained by the norms of
the chief rabbinate, had penetrated the profession and influenced
the behaviour of the other butchers. Under these circumstances,
the *gabela* did not stand a chance.

Throughout this period, the leadership acted as an inter-
mediary between the community and the outside world, while

preserving the interests of the well-to-do. On the internal level, however, it achieved very little. Direct taxes were not paid while the passive revolt spearheaded by the butchers and slaughterers continued. The poor managed their affairs to the best of their ability while continuing to avoid paying the *gabela*.[85]

Conclusion

On the eve of the First World War, the community elite's reluctance to shoulder the social burdens of the community led to the latter's disintegration. The butchers and slaughterers of Istanbul played a key role in this process. They were the mediators who made it possible for the lower classes to express their dissatisfaction with the existing order. With this consideration in mind, a study of Jewish society in nineteenth and early twentieth century Istanbul – particularly the behaviour of the butchers and slaughterers and the establishment's attitude toward them – acquires a new significance. The butchers and slaughterers exploited the fact that they were indispensable to the community and its leaders. Perhaps the rabbis could replace them as individuals, but this was no easy matter. For, at least in the case of the butchers, the trade was kept within a limited number of families. In any case, there was no reason to believe that a new appointee would behave any differently from his predecessor, even though he knew perfectly well that the rabbis had recently barred this man from the trade.

The butchers and slaughterers were simple, coarse men whose constant dealings with meat and gore rendered them impervious to threats or pressure of any kind. Therefore, if the community leaders wished to control the community, they first had to accommodate these tradesmen. This explains why the establishment was prepared to turn a blind eye for so long towards violations of ritual law, infringements of community regulations, drunkenness and the like. When the butchers and slaughterers realised that obedience to community leaders would deprive them of their livelihoods, they did not hesitate to co-operate with their customers, whom they considered their own 'flesh and blood', both economically and socially. Thus, in the encounter between religion, politics and meat, it was meat that won the day.

Notes

1 Altınay, 1987, doc. n° 1, p. 114 (1599); n° 4, p. 116 (1560); n° 10,
 p. 120 (1563); n° 11, p. 121 (1564); n° 13, p. 123 (1565); n° 15,
 p. 126 (1565); n° 6, p. 127 (1566); n° 17, p. 127 (1566); n° 18, p. 128
 (1566); n° 19, p. 128 (1566); n° 20, p. 129 (1566); n° 23, p. 130
 (1568); n° 25, p. 132 (1572); n° 28, p. 135 (1575); n° 31, p. 137
 (1577); n° 32, p. 137 (1577); n° 34, p. 138 (1579); n° 35, p. 139
 (1580); n° 36, p. 140 (1581); n° 38, p. 143 (1584); n° 42, p. 148
 (1585). On the way, meat was supplied to the large cities of the
 Ottoman Empire, see Cvetkova, 1970; Cvetkova, 1976; Mantran,
 1956, pp. 218–220; Faroqhi, 1984, pp. 228–233; Greenwood, 1988;
 Kal'a, 1985. On early sixteenth century procedures as documented
 in Hebrew sources, see Mizrahi, 1657, § 20. A sultanic order to the
 kadi of Istanbul in 1593 claiming that, in the time of Fatih Mehmed,
 Jews had not been allowed to serve as butchers (Altınay, 1933, 1)
 reflects the reality of Fatih Mehmed's time. This is supported by
 Jewish sources (cf. Gerber, 1982, pp. 100–101). On a Jewish butcher
 who also traded in oxen and drove them between Istanbul and
 Plovdiv (currently in Bulgaria) in the second quarter of the sixteenth
 century, see Ibn Yahya, 1622, § 74. On the role of Jews in the meat
 supply system in the sixteenth and seventeenth centuries, see also
 Rozen, 1993, pp. 299–301 and bibliography in the notes.
2 Faroqhi, 1997, pp. 496–499.
3 McGowan, 1997, pp. 719–720; Kal'a, 1997, pp. 323–325 (1777).
4 On these guilds in the sixteenth and seventeenth centuries, see
 Evliya Çelebi, 1896, pp. 562–564; Faroqhi, 1984, pp. 228–233; Baer,
 1971, p. 189. On the Istanbul guilds of butchers in the eighteenth
 century, see the material amassed from the Ottoman archives by
 Kal'a, 1998, p. 197 (1726); with respect to the nineteenth century,
 compare p. 48 (1815). Also see Kal'a, 1998, pp. 52, 54. For material
 on butchers' guilds in other localities in the Ottoman Empire, see
 the following: for Jerusalem in the sixteenth century: Cohen, 1989,
 pp. 18–36; Cairo in the 1700s: Raymond, 1973, v. 1, p. 312; Bursa
 in the 1600s: Gerber, 1976.
5 The seven registers of the rabbinical court of Istanbul as well as the
 marriage register are part of the Documentation Project of Turkish
 and Balkan Jewry, Diaspora Research Institute, Tel Aviv University.
6 In 1577, a sultanic decree forbade the Jews of Istanbul to
 slaughter animals anywhere but in the Yedikule slaughterhouse on
 the grounds that they were selling meat slaughtered elsewhere at

inflated prices (Altınay, 1987, doc. n° 30, pp. 136–137). See also Altınay, 1987, doc. n° 37, p. 143 (1584); n° 21, p. 129 (1560); n° 29, p. 135 (1577). On the slaughterhouse at Yedikule, see Kömürciyan, 1988, p. 25.

7 Karmi, 1990.

8 Bornstein-Makovetsky, 1999, doc. n° 12, p. 128 (1784); doc. n° 28, pp. 156–157 (14 December 1813).

9 Bornstein-Makovetsky, 1999, doc. n° 12, p. 129 (1784); n° 28, p. 156 (1813).

10 Bornstein-Makovetsky, 1999, doc. n° 23, p. 148–149 (February 1873).

11 Altınay, 1987, doc. n° 30, pp. 136–137 (1577); n° 16, p. 127; n° 21, p. 129; n° 29, p. 135; n° 37, p. 143.

12 Bornstein-Makovetsky, 1999, doc. n° 25, p. 156 (14 December 1813); n° 29, p. 157 (1785–1786); n° 39, p. 173 (February 1752); n° 40, p. 175 (February–March 1757); n° 43, p. 181 (January 1797); n° 80, p. 237 (August 1807); n° 81, p. 238 (July–August 1800); n° 82, p. 239 (1800–1801).

13 Bornstein-Makovetsky, 1999, doc. n° 82, p. 239 (1800–1801).

14 Register of the Rabbinical Court of Istanbul, n° 4 (1871–1894), § 3, p. 97 (25 Av 5640/2 August 1880); n° 5 (1894–1915), § 7, p. 39 (Av 5660/27 July 1900) and § 8–9, p. 41 (28 Heshvan 5661/21 October 1900).

15 *Ha-Magid le-Yisrael*, Year 9, Av 5659/1899, publ. Cracow, n° 29–30, p. 151.

16 Registers of the Rabbinical Court of Istanbul, doc. n° 4 (1871–1894), § 4, p. 70 (7 Heshvan 5638/15 October 1877); Bornstein-Makovetsky, 1999, doc. n° 35, p. 136 (1810/1811).

17 Bornstein-Makovetsky, 1989, doc. n° 3, p. 102 (11 August 1768).

18 See below.

19 This word does not appear in Turkish dictionaries. It seems that this is a 'Jewish made' term, invented by Jewish meat-traders who were very much involved in their Turkish-speaking working milieu and who had to explain their special duties to their Muslim fellow-traders. These Jewish practitioners took the word *kan* (blood in Turkish) and appended to it an Iranian-Turkish suffix: *dar* which means 'he who holds' (such as in *defterdar* [he who holds the accounting book, namely the treasurer]). Thus was created a new term which meant: 'he who holds the blood'. The command to purge the meat of blood exists only in the Jewish religion, which explains the uniqueness of the word and its invention in a Jewish milieu.

20 Bornstein-Makovetsky, 1989, doc. n° 10, pp. 123–125 (30 October 1796). The original regulation was promulgated in July 1732.

However, according to this document, the regulation was never obeyed. I do not agree with Bornstein-Makovetsky's conclusion that the wording: 'Concerning the *kanadaris*: they shall have porgers in their shops; they shall not porge themselves, but the *kanadar* [will do it] alone and porger alone' means that the *kanadar* porged the hindquarters of the animal while the porger dealt with the rest. There is no evidence to support this thesis in any of the documents under discussion. The somewhat unusual use of a single word (*kanadar* or *menaqer* [porger]) to designate two professions would seem to indicate that the Turkish word *kanadar* became synonymous with butcher while the Hebrew word *menaqer* retained its original meaning of porger.

21 Bornstein-Makovetsky, 1989, doc. n° 10, p. 125 (30 October 1796).
22 Bornstein-Makovetsky, 1989, doc. n° 10, pp. 123–125.
23 Registers of the Rabbinical Court of Istanbul, n° 5 (1894–1915), § 3, p. 59 (Tamuz 5663/July 1903).
24 Bornstein-Makovetsky, 1999, doc. n° 9, p. 121 (1745); Register of the Rabbinical Court of Istanbul, n° 3 (1853–1871), ca. January 1869, p. 251, which mentions the goodwill (*peştamalik*) of the three butcher shops belonging to the *vakıf* of the Selaniqiou-Segiri Congregation. See also below.
25 Bornstein-Makovetsky, 1999, doc. n° 18, pp. 138–140 (3 November 1726); Register of the Rabbinical Court of Istanbul, n° 4 (1871–1894), p. 201 (15 Shevat 5653/1 February 1893); n° 5 (1894–1915), § 2, p. 53 (18 Adar II 5661/9 March 1901); § 4, p.53 (1 Tamuz 5661/18 June 1901) and § 3, p. 59 (5662/1902). Also see versions of a bill of ordination for a ritual slaughterer in Istanbul in Bornstein-Makovetsky, 1989, p. 94, doc. n° 1 and doc. n° 2.
26 During the seventeenth century, the congregational organisation of Jewish Istanbul had been transformed into an organisation of supra-congregational districts, each one having its own court of law in addition to a central court headed by a *rav-ha-kolel* (The Rabbi of the Entire City). This religious authority was not recognised by the Ottomans as Chief Rabbi until 1835. The high court acted in different capacities and combinations such as the 'Rabbis Supervising Rituals and Ethics' and 'The Judges of Entitlements' (*dayanei ha-hazaqot*). Parallel to the judicial system, there existed a lay leadership called *señores gabeleros* ('The Lords of the Gabela') or *señores dos ma'amd* ('The Lords Present'), which was an executive committee. This leadership was nominated by co-optation from among the highest payers of direct taxes. On the communal leadership after 1826, see below.

27 Bornstein-Makovetsky, 1999, pp. 26–32; *ibid.*, doc. n° 9, pp. 120–122.

28 Bornstein-Makovetsky, 1999, doc. n° 26, p. 153.

29 de Toledo, 1865, *Hoshen Mishpat*, § 43.

30 Galanté, n.d. (1985), v. 1, p. 222.

31 *El Tiempo* n° 36 (7 February 1893), pp. 320–322.

32 Bornstein-Makovetsky, 1999, doc. n° 26, pp. 152–154 (1781–1782).

33 Bornstein-Makovetsky, 1999, doc. n° 18, pp. 138–140 (3 November 1726) and confirmation in 1733; doc. n° 19, pp. 140–142 (1735); doc. n° 20, p. 143 (November–December 1786); doc. n° 21, pp. 144–145 (July–August 1768); doc. n° 22, pp. 146–147 (6 December 1769); doc. n° 25, pp. 150–151 (July 1781).

34 Bornstein-Makovetsky, 1999, doc. n° 23, pp. 148–149 (Shevat 5533/ February 1873).

35 See section below, 'Blood, Beer and Wine'.

36 Navon, 1740, § 62. Also see Bornstein-Makovetsky, 1999, p. 153, note 78.

37 Register of the Rabbinical Court of Istanbul, n° 4 (1871–1894), p. 201 (15 Shevat 5653/1 February 1893).

38 Register of the Rabbinical Court of Istanbul, n° 5 (1894–1915), § 1, p. 69 (20 Av 5663/13 August 1903).

39 Bornstein-Makovetsky, 1989, doc. n° 3, p. 94; n° 4, p. 95.

40 Bornstein-Makovetsky, 1999, doc. n° 8, pp. 119–120.

41 Bornstein-Makovetsky, 1999, doc. n° 9, p. 120.

42 See Rozen, 2002, chapter 6.

43 Bornstein-Makovetsky, 1999, doc. n° 9, pp. 121–122.

44 Bornstein-Makovetsky, 1999, doc. n° 9, p. 122; doc. n° 13, p. 130 (May 1787); doc. n° 15, p. 135 (August–September 1835); doc. n° 17, p. 136 (December 1846).

45 Bornstein-Makovetsky, 1999, doc. n° 9, p. 122.

46 Bornstein-Makovetsky, 1999, doc. n° 80, p. 237.

47 Bornstein-Makovetsky, 1999, doc. n° 10, pp. 122–125.

48 Register of the Rabbinical Court of Istanbul, n° 1 (1833–1841), § 6, p. 31 (5596/1836).

49 Register of the Rabbinical Court of Istanbul, n° 1 (1833–1841), § 5, p. 42 (1837).

50 Register of the Rabbinical Court of Istanbul, n° 4 (1871–1894), § 5, p. 75 (5638/1878).

51 Bornstein-Makovetsky, 1999, doc. n° 16, p. 134 (1846).

52 Bornstein-Makovetsky, 1999, doc. n° 11, p. 125 (1769).

53 Register of the Rabbinical Court of Istanbul, n° 3 (1853–1871), § 7, p. 251 (5629/c.1869).

54 Bornstein-Makovetsky, 1999, doc. n° 15, p. 133 (5595/1835).

55 Register of the Rabbinical Court of Istanbul, n° 5 (1894–1915), § 4, p. 31 (5660/1900).

56 Register of the Rabbinical Court of Istanbul, n° 5 (1894–1915), § 7, p. 39 (1900).

57 Bornstein-Makovetsky, 1999, doc. n° 9, p. 121 (August 1732).

58 Thus, for example, the butcher Yitzhaq Palombo passed away leaving behind a widow and a minor daughter who were first in line to collect their shares of the deceased's goods: the widow would collect her widow's dues and the orphan would receive her maintenance allowance. For a period of five years, Avraham Ortas and Ya'aqov Ashkenazi, the orphan's guardians, rented out half of the *gedik* of the butcher's shop in Hasköy, formerly owned by the deceased, to one of his creditors. It was understood that, for eighteen months, the tenant would not pay rent in order to recuperate his loan and that, if at a later stage, the orphan demanded back rent for this period, she would first have to repay the above loan (Register of the Rabbinical Court of Istanbul, n° 1 (1833–1841), § 6, p. 31 (4 Av 5596/18 July 1836). See also the rental of such a *gedik* owned by Dona, widow of Shelomoh 'Amram, and her son, Shelomoh, to Mercado Pinto in Galata for the sum of 10 *kuruş* per month (*ibid.*, §5, p. 42 [4 Av 5597/ 5 August 1837]).

59 Shabetai ben Ya'aqov Russo is mentioned in 1745 as a butcher who deprived the *sakatcıs* of their right to sell waste meat (Bornstein-Makovetsky, 1999, doc. n° 9, p. 122). In June 1769, the 'Rabbis Supervising Rituals and Ethics' charged Menahem Russo, a butcher in Unkapanı, with disobeying their orders; his right to exercise the trade was revoked (*ibid.*, doc. n° 11, pp. 125–126). His son, Ya'aqov ben Menahem Russo, was accused of the same misbehaviour and his right was likewise revoked in 1787 (*ibid.*, doc. n° 11, pp. 127–128).

60 See table below.

61 Marriage Register of Istanbul Jewish Community, 1912–1922, entries n° 330, 512, 2363.

62 The *peştamalık* is the equivalent of what is called *hava parası* in modern Turkish, in other words, it is the good name of the business, its reputation. This is a material asset which is bought, sold and bequeathed like any other asset

63 Register of the Rabbinical Court of Istanbul, n° 3 (1853–1871), § 7, p. 251 (Shevat 5629/January 1869).

64 Register of the Rabbinical Court of Istanbul, n° 5 (1894–1915), § 4, p. 57 (8 Tevet 5662/18 December 1901).

65 Istanbul Community Marriage Register, 1912–1922.
66 Register of the Rabbinical Court of Istanbul, n° 4 (1871–1894), § 3, p. 97 (25 Av 5640/2 August 1880).
67 Bornstein-Makovetsky, 1999, doc. n° 29, pp. 157–158 concerning regulations prior to 1785, those of the year of 1785 itself and in addition those of May 1816. For further references to alcohol addiction among ritual slaughterers in Ottoman communities, see *ibid.*, p. 160, note 109.
68 Tzarfati was made to swear that he would not accept any meat other than that bearing the stamp of the rabbinical clerk, he would not allow Romi to porge and he would not leave him alone in the shop. Romi swore to abide by these conditions and to restrict his consumption of wine and beer to after hours.
69 On the political culture of the Istanbul community in the years 1453–1566, see Rozen, 2002, chapters 6 and 9. The *gabela* was hardly mentioned in those years, while direct taxes played a decisive role in communal life.
70 Avigdor, 1827, § 57; Galanté, n.d. (1985), v. 1, p. 281; Benbassa, 1996, pp. 59–60. Also see Barnai, 1981, pp. 56, 62–63.
71 Avigdor, 1827, § 57.
72 For a detailed study of these events, see Rozen, 2004, v. 1, chapter 5.
73 For a detailed study of the socio-political history of the Istanbul community between 1835 and 1922, see Rozen, 2004, v. 1, chapter 5 and the bibliography cited there.
74 See above, note 70. Cf. Rozen, 2004, v. 1, chapter 5, pp. 92–94.
75 For a detailed study of the communal balance sheet in the years 1872–1911, see Benbassa, 1996, pp. 56–67. However, she fails to see the social context of tax evasion on the part of the butchers (see especially p. 30) and she makes no reference to the role of the ritual slaughterers in this saga. For another interpretation of the balance sheet see Rozen, 2004, v. 1, chapter 5.
76 See Levi, 1996, pp. 241–244, 256–259.
77 *Ha-Levanon* 2, 1865, Paris, p. 213.
78 In practice it was not the slaughterers who paid the tax and the actual meaning of this prohibition was that they would not co-operate with butchers and customers in evading the *gabela*.
79 Register of the Rabbinical Court of Istanbul, n° 4 (1871–1894), § 4, p. 70.
80 *Ibid.*, § 11, p. 77.
81 Levi, 1996, pp. 259–260.
82 See above, note 15.

83 Register of the Rabbinical Court of Istanbul, n° 5 (1894–1915), § 8, p. 95. Compare with *Ha-Mevaser* 1/9 (20 Adar Alef 5670/1 March 1910), p. 143.

84 Dr. Shimon Marcus, the Ashkenazi rabbi, performed four out of these five marriages. The couples did not pay the marriage tax to the community, either because Marcus did not levy it or because of their destitution. In these marriages the average dowry that the brides' fathers gave to their daughters was way behind the average dowry given by Ottoman subjects; in fact, it was less than 5 percent of the average dowry.

85 Register of the Rabbinical Court of Istanbul, n° 6 (1912–1919), p. 10 (2 Elul 5679/15 August 1912); p. 16 (23 Tamuz 5674/17 July 1914).

Bibliography

Primary Sources

Unpublished

Istanbul: Private collection:
Register of the Rabbinical Court of Istanbul, n° 3 (1853–1871),
n° 4 (1871–1894),
n° 5 (1894–1915) and
n° 6 (1912–1919)

Istanbul Community Archives:
Community Marriage Registers (1912–1922)

Published

Journals
Hebrew:
Ha-Levanon, Jerusalem, Paris, Mainz, London, 1863–1886
Ha-Magid le-Yisrael, Lyck, Berlin, Cracow, Vienna, London, 1856–1903
Ha-Mevaser, Istanbul, 1910–1911

Ladino:
El Tiempo, Istanbul, 1871–1930

Books and Collections of Documents

Altınay, A. Refik, *Hicri On-Birinci Asırda İstanbul Hayatı*, Istanbul, 1933.

Altınay, A. Refik, *Onuncu Asr-ı Hicride Istanbul Hayatı*, Ankara, Kültür ve Turizm Bakanlığı, 1987.

Avigdor, Avraham Bakhar (Rabbi), *Responsa and Novellae, Zakhor le-Avraham*, Istanbul, 1827.

Bornstein-Makovetsky, Leah, 'Remnants of the Balat Court Register in Istanbul, 1839' (in Hebrew), *Sefunot* 19, 1989, pp. 53–122.

Bornstein-Makovetsky, Leah, *The Istanbul Court Record in Matters of Rituals and Ethics 1710–1903* (in Hebrew), Lod, Orot Yahadut ha-Magreb, 1999.

Evliya Çelebi, *Seyahatname*, v. 1, Istanbul, 1896.

Ibn Yahya, Tam (Rabbi), *Responsa, Tumat Yesharim*, Venice, 1622.

Kal'a, Ahmed, ed., *İstanbul Ahkam Defterleri: İstanbul Ticaret Tarihi*, v. 1 (1742–1779), Istanbul, Büyük Şehir Belediyesi ve İstanbul Araştırmaları Merkezi, 1997.

Kal'a, Ahmed, ed., *İstanbul Esnaf Birlikleri ve Nizamları*, v. 1, Istanbul, İstanbul Büyük Şehir Belediyesi ve İstanbul Araştırmaları Merkezi, 1998.

Kömürciyan, Eremya Çelebi, *İstanbul Tarihi XVII Asırda*, trans. from Armenian by H.D. Andreasyan, Istanbul, Eren, 1988.

Mizrahi, Eliyahu (Rabbi), *Responsa, Mayim 'Amuqim* (included in the *responsa* of Rabbi Eliyahu Ibn Hayim), Venice, 1657.

Navon, Efrayim (Rabbi), *Responsa Kehunat 'Olam*, Istanbul, 1740.

Toledo, Eli'ezer de (Rabbi), *Mishnat de-Rabbi Eli'ezer*, v. 2, Izmir, 1865.

Secondary Sources

Baer, Gabriel, 'The Structure of Turkish Guilds and its Significance for Ottoman Social History', *Proceedings of the Israel Academy of Sciences and Humanities*, Jerusalem, 1971, v. 4, n° 12 , pp. 186–201.

Barnai, Jacob, 'On the History of the Jewish Community of Istanbul in the 18th Century', in Jacob Barnai, Joseph Chetrit, Bustenai Oded, Aliza Shenhar and Tzevi Yehuda, ed., *Miqqedem Umiyyam* (in Hebrew), Haifa, Haifa University, 1981, pp. 53–66.

Benbassa, Esther, *The Ottoman Jewish Community between Occidentalism and Zionism* (1908–1920) (in Hebrew), Jerusalem, Zalman Shazar Centre, 1996.

Cohen, Amnon, *Economic Life in Ottoman Jerusalem*, Cambridge, Cambridge University Press, 1989.

Cvetkova, Bistra, 'Les celep et leur rôle dans la vie économique des Balkans à l'époque ottomane, XVe–XVIIe siècles', in Michael Cook, ed., *Studies in the Economic History of the Middle East from the Rise of Islam to the Present Day*, London/New York/Toronto, Oxford University Press, 1970, pp. 172–192.

Cvetkova, Bistra, 'Les registres des celepkeşan en tant que sources pour l'histoire de la Bulgarie et des pays balkaniques', in Gyula Káldy-Nagy, ed., *Hungaro-Turcica, Studies in Honour of Julius Németh*, Budapest, Loránd Eötvös University, 1976, pp. 325–335.

Faroqhi, Suraiya, *Towns and Townsmen of Ottoman Anatolia: Trade, Crafts and Food Production in an Urban Setting 1520–1650*, Cambridge, Cambridge University Press, 1984.

Faroqhi, Suraiya, 'Crisis and Change, 1590–1699', in Halil Inalcik, ed., *An Economic and Social History of the Ottoman Empire*, v. 2, 1600–1914, Cambridge, Cambridge University Press, 1997 (first published 1994), pp. 413–636.

Galanté, Avraham, *Histoire des juifs de la Turquie*, Istanbul, Isis, no date (1985).

Gerber, Haim, 'Guilds in Seventeenth-Century Anatolian Bursa', *Asian and African Studies* 2, 1976, pp. 64–82.

Gerber, Haim, *Economic and Social Life of the Jews in the Ottoman Empire in the 16th and 17th Centuries* (in Hebrew), Jerusalem, Zalman Shazar Centre, 1982.

Greenwood, Antony, 'Istanbul's Meat Provisioning: A Study of the Celepkeşan System', unpublished PhD dissertation, University of Chicago, 1988.

Kal'a, Ahmed, 'Osmanlı Devletinde İstanbul'un Et İhtiyacının Temini İçin Kurulan Kasap ve Celep Teşkilatları', unpublished MA thesis, Institute of Social Sciences, Istanbul University, 1985.

Karmi, Ilan, 'The Transformation of the Jewish Community of Istanbul in the Nineteenth Century', unpublished PhD dissertation, University of Wisconsin, 1990.

Levi, Avner, 'Changes in the Leadership of the Main Spanish Communities in the Nineteenth-Century Ottoman Empire', in Minna Rozen, ed., *The Days of the Crescent: Chapters in the History of the Jews in the Ottoman Empire* (in Hebrew), Tel Aviv, Tel Aviv University, 1996, pp. 237–272.

Mantran, Robert, 'Règlements fiscaux ottomans: la police des marchés de Stamboul au début du XVIe siècle', *Cahiers de Tunisie* 14, 1956, pp. 213–241.

McGowan, Bruce, 'The Age of the Ayans, 1699–1812', in Halil Inalcik, ed., *An Economic and Social History of the Ottoman Empire*, v. 2,

1600–1914, Cambridge, Cambridge University Press, 1997 (first published 1994), pp. 639–758.

Raymond, André, *Artisans et commerçants au Caire au XVIIIe siècle*, Damascus, French Institute of Arab Studies, 1973–1974.

Rodrigue, Aaron, 'Education', in S. Schwartzfuchs, ed., *L'Alliance dans les communautés du bassin méditerranéen à la fin du 19e siècle et son influence sur la situation sociale et culturelle*, Jerusalem, Misgav Yerushalayim, 1987, pp. LIII–LXX.

Rodrigue, Aaron, *French Jews, Turkish Jews: The Alliance Israélite Universelle and the Politics of Jewish Schooling in Turkey, 1860–1925*, Bloomington and Indianapolis, Indiana University Press, 1990a.

Rodrigue, Aaron, 'Abraham de Camondo of Istanbul: The Transformation of Jewish Philanthropy', in F. Malino and D. Sorkin, ed., *From East and West, Jews in a Changing Europe, 1750–1870*, Cambridge (Mass.), Basil Blackwell, 1990b, pp. 46–56.

Rodrigue, Aaron, *Education, Society and History: Alliance Israélite Universelle and Mediterranean Jewry, 1860–1929* (in Hebrew), Jerusalem, Ben Zvi Institute, 1991.

Rodrigue, Aaron, 'The Beginning of Westernization and Community Reform Among Istanbul's Jewry, 1854–1856', in A. Levy, ed., *The Jews of the Ottoman Empire*, Princeton, The Darwin Press, 1994, pp. 439–456.

Rozen, Minna, 'La vie économique des Juifs du bassin méditerranéen de l'expulsion d'Espagne (1492) à la fin du XVIIIe siècle', in Shemuel Trigano, ed., *La société juive à travers l'histoire*, Paris, Fayard, 1993, v. 2, pp. 296–352, 529–570.

Rozen, Minna, *A History of the Jewish Community of Istanbul – The Formative Years 1453–1566*, Leiden, E.J. Brill, 2002.

Rozen, Minna, *The Last Ottoman Century and Beyond: The Jews of Turkey and the Balkans in the 19th and 20th Centuries (1808–1945)*, v. 1, Tel Aviv, Tel Aviv University, 2004.

CHAPTER 8

Organising Labour: Professional Classifications in Late Eighteenth to Early Nineteenth Century Cairo

Pascale Ghazaleh

The history of craft and trade groups (*tawâ'if hirafiyya*), in Ottoman times has justified many debates and inspired a good deal of research. For Egypt, the works of Gabriel Baer[1] and André Raymond[2] are still the most important studies of the topic due to both their scope and their eminence, but they are not the only ones. Almost every historian who has examined the urban history of this Ottoman province (which usually means the history of Cairo)[3] has been interested in the guilds: their origins, nature, functions and the reasons for their disappearance.[4] Yet, despite all this work, the very question of what constituted a guild (for instance, which criteria determined membership or the degree of economic homogeneity that characterised such a grouping) remains unanswered. Researchers have often examined these associations from a legal perspective, studying statutes or laws – most often emanating from the state – that determined their functions as pre-defined social or economic units. At other times, they have regarded them more as religious organisations, very similar to the Sufi orders. But, they have rarely asked (and this is especially true in the case of the Egyptian *tawâ'if*) which factors prompted certain individuals to form a guild in the first place: in other words, what made a *tâ'ifa hirafiyya* any different from other types of *tawâ'if*.

The problem with such an approach is most obvious when one tries to understand the nature of the borders between guild and professional specialisation, in other words, when one asks

why certain professions are divided into several guilds while other guilds bring together several professions. The same difficulty arises anew whenever one tries to understand which relations, if any, existed between the craft groups and their members' religious affiliations, geographical origins or places of work.

This study is an examination of four sources regarding guilds that offer interesting insight into such questions. All are characterised by a profound tension: between efforts to maintain order, on the one hand, and to overturn this order, on the other. Beyond this essential similarity, however, these documents reveal many unexplored aspects of the guilds as both etic entities constructed by outside observers and emic objects defined by their members through conflict and competition.

One of these sources is purely visual: the plates pertaining to *arts et métiers* in the *Description de l'Egypte*. One is descriptive: an eyewitness account of a public ceremony. Two can be considered purely 'documentary', if only because they are preserved in the Egyptian National Archives. They are, however, very different: one group, which includes the *hujaj al-mashyakha* (deeds of investiture drawn up by guild members who wished to elect a certain individual as their shaykh), consists of court documents related to the affairs of the guilds, while the *firda* (tax) is the fruit of efforts on the part of Muhammad 'Ali's administrators to draw up lists of artisans and merchants for taxation purposes.

Images of industry

Our first source, the illustrations made by the savants who accompanied Napoleon's military expedition to Egypt in 1798, opens some interesting avenues of investigation. Glancing through them, one quickly forms the impression that these plates present a purely univocal image: work looks much the same from one trade to another. One can discern no form of sociability here and even less can one see corporate organisation. There are only individuals, practising their profession in a workshop or (more rarely) outdoors. Each of the workers is isolated from the others. Even when several workers are represented within the same frame, 'far from giving an impression of unity in a common task, the figures have no communication with one another. Each

faces in a different direction; each is intent on his own work.'[5] In a plate showing a group of masons engaged in construction work, one person is ostensibly indicating something to his companions, but no one is paying him any attention and the line of his extended arm leads the spectator's eye out of the frame.

If the social dimension of work is entirely absent here, perhaps one could interpret these scenes, even the ones that draw together several artisans, as purely technical illustrations of labour, but the content of the illustrations gives the observer no clues as to how production takes place as a process. Although each plate is focused on a particular craft and each craft seems devoted to the preparation of a specific good, it is not at all clear how the different elements of a single illustration are supposed to come together to result in the manufacture of the final product. Each step is depicted clearly and each artisan is busy with a different stage of the work, but there seem to be no links making up a whole: 'we get no sense for the organization or flow of the process of production'.[6]

Another striking characteristic of these engravings is that the features of the workers are remarkably generic. Some stare blandly out of the frame as if facing the illustrator, others bend over their work. Often, their faces are in shadow or dissimulated thanks to another pictorial device. Where their features are visible, they are 'quite without personality; they are purely abstract workmen'.[7] The workshops are also surprisingly empty: at most, one sees a few jars piled in a corner. It would be unrealistic to attribute this lack of detail to the artists' ineptness, however, for the plates depicting tools and machinery, the illustrations of Egypt's flora and fauna, the architectural engravings or the portraits of various important personalities, all show great skill in observing and rendering the subjects' most minute characteristics.

Does one see in this vision of labour, this atomised world of anonymous workers, if not an accurate representation of corporate life, then a faithful technical depiction of Cairo's crafts? To answer this question, a confession is necessary. The above remarks may be valid for the plates of the *Description de l'Egypte*, but they are not strictly my own. In fact, some are comments made by William H. Sewell, Jr. in an article titled 'Visions of Labor: Illustrations of the Mechanical Arts before, in, and after Diderot's *Encyclopédie*'.[8]

How can remarks that pertain to mid-eighteenth century France be taken more or less wholesale and applied to Egypt half a century later? The two cases, it is true, share certain common characteristics: the plates, it may be argued, are almost identical. The only difference between the two groups of illustrations is that, in the case of the *Description*, the artisans wear turbans. Otherwise, even their clothes are vaguely similar to those worn by their French counterparts. I would suggest that these similarities can be attributed, at least in part, to the concerns shared by the authors of the engravings. The *Description* and the *Encyclopédie* are two works to which more or less similar people contributed at more or less the same time. These were educated Frenchmen, many of them imbued with the belief in 'a scientized, individualized, utopian projection of the world of work as imagined by the philosophes'.[9] Comparing the illustrations of labour that they offer raises another interesting point: the artists do not appear to have viewed Egyptian workers as intrinsically more 'foreign' than their French counterparts. Although they were not part of Egyptian society (nor were even the most educated Egyptians their target audience), the illustrators of the *Description* did not produce an exotic rendition of the country that their army had conquered; indeed, they portrayed conditions very similar, in the final analysis, to those that they could still observe at home.

Perhaps, then, one should not be asking to what extent the plates of the *Description de l'Egypte* (although they constitute, to my knowledge, the only graphic source that one can examine if interested in knowing about the working conditions of artisans) reflect the 'reality' seen by the illustrators. These illustrations tell us precious little about the organisation of crafts in late eighteenth century Cairo, let alone the professional lives of individual artisans. A more fruitful path of inquiry may be pursued by wondering what they reveal about the illustrators themselves and especially about their attitudes towards work, formed by the Physiocratic labour doctrines of eighteenth century France. That, however, is not the focus of this study. Yet, it would also be interesting to hypothesise that these illustrators found much in Egypt that reminded them of France; in other words, that working conditions and production processes were not sufficiently different to warrant the development of new means of representation.

Guilds on parade

We turn next to a source produced within Egypt by a native eyewitness: the description of parades held to mark certain events. Some occasions, such as the *ru'ya* (sighting of the Ramadan crescent) or the breaking of the dam that allowed the risen Nile to flow into the Khalîj (canal), do not seem to have required collective displays of joy for they involved only such personages as the *muhtasib* (market inspector), some of the high-ranking *ulama* and the chief of police. Popular rejoicing at these times was clearly a spontaneous matter and entailed the merry-making that so many chroniclers censured quite severely. The departure of the pilgrimage caravan was also an event attended by the entire city, but no special place was reserved for the productive and distributive trades.[10]

In contrast, the chronicler, al-Jabartî also describes processions that marched through Cairo to celebrate the birth, circumcision[11] or wedding of a state dignitary's child.[12] They drew on an occupational vocabulary of pageantry, reserving a special place for Cairo's artisans and merchants. Those who participated in them apparently did so at the behest of the urban authorities. As the embodiment of a segmented hierarchy with clearly defined positions assigned to clearly defined groups, such processions may be read as formal representations of the various corps that made up the city, arranged according to rank: 'In the processions that accompany official festivities, whether they are the commemoration of a victory or the celebration of a princely marriage, the arrangement of the parade reproduces the social segmentation and its itinerary respects the hierarchy of place...When urban society makes a production of itself, it shows itself in all the regalia of the constituted corps and makes perceptible the opposition between thoroughfares and closed quarters.'[13] Processions were perhaps the image that the city sought to give of itself. But, precisely whose city is this and what image does it convey? Leaving aside the crowds that watch the parade go by and 'all that remains always outside',[14] what does the procession itself say?

The double wedding of Muhammad Bey the *daftardâr* to Muhammad 'Alî's daughter and of Ismâ'îl Paşa, Muhammad 'Alî's son, to the daughter of 'Ârif Bey ibn Khalîl Paşa in

Muharram 1229 (December 1813–January 1814) was the occasion for one such procession. Cairo's artisans were instructed to build wagons or floats with which to participate in the festivities and al-Jabartî goes into some detail when describing these contraptions, which served as small stages on which merchants and craftsmen went through the motions of their trades.[15]

While he notes that 'the head of a craft would levy certain amounts of money on its members' to pay the expenses of the festivities, al-Jabartî also explains that 'everyone who let himself be seduced or was inspired by the devil to invent something did so and went to the person nominated for this purpose who would give him a piece of paper for this was not [restricted to] certain people or a given number, but on the basis of their appeals and the coercion of some by others'.[16] The chief of each craft (kabîr al-hirfa) was rewarded for his efforts with money and robes of honour; to some, the head of the reception committee 'presented a shawl and 2,000 pieces of silver; to others a roll of cotton cloth or four cubits of broadcloth according to the status of the craft and its members'.[17]

Al-Jabartî therefore states explicitly that a hierarchy exists among the different crafts; yet, beyond the ambiguous term of 'status' (maqâm), he offers no further clarification. His references elsewhere to 'respected' and 'vile' trades (al-hiraf al-mu'tabara, al-hiraf al-danîya) are no clearer, although we do know that the latter included such 'professionals' as thieves, beggars[18] and prostitutes as well as those involved in entertainment (dancers, jugglers, puppeteers, story-tellers...). It is unclear, for instance, if we should conflate the guild's position in the hierarchy with that of its members in society or, to phrase the question differently, whether the craft derived its status from that of its members or vice versa. Besides the artisans, the chronicler mentions the merchants of al-Ghûriyya, 'the group of Khân al-Khalîlî merchants' in a grand convoy, the Syrian Christian Hamzâwî merchants 'and others', without elucidating the rationale that guides either his inventory or their actual placement. One also knows that 91 wagons participated in the wedding's first parade. By the following week, when the next procession was held, the number of wagons had reached 106, implying either that the number of wagons bore no relation to the number of guilds or that not all the guilds had managed to join the procession the first time around.

If one abandons, albeit temporarily, the quest for 'facts' about the guilds and instead seeks in this pageantry the image that the city wishes to present of itself, one will be sorely disappointed. Al-Jabartî's acerbic comments leave no room for doubt: chaos is present every step of the way. The artisans, he notes, are dressed in borrowed finery; the police tear down shops and stone benches in the quarters through which the procession is to pass. The final image is one of total debacle: rain drenches the parade, participants and spectators alike are soaked through and smeared with mud, and the bride reaches her new abode only at sunset.[19]

Al-Jabartî mentions another wedding procession, but is far more terse, noting only that the 'master craftsmen were invited to construct wagons and clever or amusing devices – at their own expense'.[20] Processions, then, could be a liability to those who marched in them as the 1811 massacre of the Mamluks proves most poignantly. When Bâb al-'Azab was locked and the firing began, the amirs were not the only victims: the soldiers also massacred the common people (*awlâd al-nâss*[21] *wa-ahâlî al-balad*) 'who were dressed in [the amirs'] clothing to embellish the procession'.[22]

In word and in deed

Since neither the savants' illustrations nor the chronicler's description say much about the guilds, then perhaps one should turn instead to written archival sources. Of these, the most useful are the deeds of investiture registered in court by artisans wishing to change or to confirm the leadership of their guild. Secondary sources suggest that leadership was usually hereditary.[23] However, the investiture deeds show intense conflicts over leadership. These deeds and others concerned exclusively with guild affairs also demonstrate that the artisans often disagreed sharply over the way that the guild was organised and run. Battles raged over such fundamental matters as the shaykh's identity, authority and pricing policies; indeed, the very definition of the guild could be at stake. The registration of such documents, in fact, was often merely a pretext for conflicts over issues that were far more fundamental than the confirmation of an accepted fact.

The documents discussed here were registered by guild members in the court of al-Bâb al-'âlî, the main court of Cairo during the Ottoman period and during a good part of the nineteenth century. The court derived its importance from its geographic centrality, the number of cases presented there and the diversity[24] of those who went there to request justice or obtain the notary services[25] that were such an important element in the Ottoman judicial system. These documents constitute written traces, among the few available to the historian, of matters recorded in court by members of guilds who were present there and asserted their presence as such. Sometimes, the cases were motivated by a conflict within the guild or between it and other representatives of the urban administration. Occasionally, they were recorded in an explicit bid to pin down in writing – to make real, in other words – the result of negotiations already enshrined by action, either because the majority of the guild members had recognised it or to impose it upon those liable to contest it.

The documents chosen here represent three non-consecutive moments in the life of a professional group. The first[26] is one of consensus around a given act: here, the guild acts as a homogeneous entity (perhaps at the expense of the voices that the document excludes, but there is no way of recovering those). The sugar-makers[27] of Bâb Zuwayla and Bayn al-Qasrayn appeared in court to affirm that a *ratl* of sugar equalled 144 *dirhams* and not 150 as the *muhtasib* claimed. The document indicates clearly that this was not the first time that they had taken a united stand. The same question, it transpires, had caused several previous conflicts between the guild and different *muhtasibs*. In this lengthy battle, the guild had sought the assistance of the pasha, the Diwân 'Âl and the four muftis, as well as the chief judge *qâdî al-qudâh*. It used all the means available to it: reference to 'ancient customs' and to 'the noble sharî'a', as well as written proof of its claims' legitimacy – proof that its repeated victories in every previous conflict came to buttress, as inscribed in the court *sijill*.

The second case[28] also brings the guild members together in collective action. This time, though, they are not confronting a threat perceived as external, but one that comes from within the guild itself. Here, a 'large assembly and a numerous multitude'

of artisans whose work is linked to the production and sale of shoes and slippers present themselves in court to demand the selection of a new leader. They justify their request by citing 'the harm he has done them and their dissatisfaction with him'. The conflict, then, is internal, yet, one is dealing with several different professions involved in both productive and distributive aspects of their trade, apparently gathered within the same guild – a conjecture supported by the fact that they are under the leadership of a single shaykh, even if they are attempting to elude this authority. The problem of the relation between profession and professional community, therefore, is still unresolved.

The third case involving the same guild is neither the result of a disagreement between the guild as a united body facing an entity that it designates as external nor the enshrinement of a collective action whereby the guild, seeking to resolve its affairs, attempts to effect change at the summit of its internal hierarchy. Rather, the document – in other words, the plaintiffs and the scribe – emphasises the antagonism dividing the two parties that make up the guild. It may be more accurate, in fact, to limit our use of the term conflict to this case alone since it is here that the disagreement between the groups is most pronounced. The first of the two, the producers of shoes and slippers, complain that their colleagues, retailers who purchase the footwear and sell it to the public, buy the goods for a pittance and make a profit of 100 percent on resale. The shaykh, taking the producers' side, has carried out the qâdî's orders and summoned the guild notables to set prices of purchase and of sale to the public. The assembled elders place a ceiling on legitimate[29] profit margins, determining that 20 percent of the original purchase price is sufficient. Whatever the outcome of these negotiations, it is clear that the cohesion of each group is far greater than that of the guild as a whole.

These documents could appear more 'real' than those examined until now or, at least, more legitimate, for (besides their capacity as original administrative traces to which academic tradition grants credibility, it is always possible to challenge the objectivity of narrative sources, even contemporary ones produced by simple observers) they are emitted by authorities on the subject at hand (individuals or institutions that, for one reason or another, have acquired and managed to preserve the

right to observe, state, name, classify and finally transcribe the results of these operations). Furthermore, they often enfold the words of the actors themselves: the very guild members that we are so desperately seeking. These rights, however, are not acquired and maintained once and for all. They are, on the contrary, contested at every moment, not least by the actors themselves.

A lowest common denominator?

If even the deeds that the guilds registered in court, which, presumably, are the closest that one can come to 'hearing' the members' voices, do not help one to know what a guild really was, perhaps the documents drawn up by the state without the guilds' co-operation, can partially help one to approach the guilds. Here, we turn to the *firda* of 1822–1823.[30]

The most frequent explanation for the juxtaposition or segregation of professions by the guild structure has been the extremely fragmented nature of the production process. The last document discussed here seems to indicate that this is an erroneous assumption. Fortunately or unfortunately, however, the *firdat al-'a'tâb* of 1822–1823 only confuses the question further. It is, nevertheless, the most complete list that we have to date, comprising a considerable number of guilds and government departments: in total, 228 identified groups, employing almost 33,000 individuals. Almost 26,000 of these were members of guilds (*tawâ'if*), while a little under 7,000 were employed in state establishments (*masâlih*). These 228 institutions are divided into 186 *tâ'ifa* and 42 *maslaha*.

E.W. Lane, a traveller who visited Egypt during the first half of the nineteenth century, explains: 'The income-tax, which is called 'firdeh,' is generally a twelfth or more of a man's annual income or salary, when that can be ascertained. *The maximum, however, is fixed at five hundred piastres* [emphasis added]. In the large towns it is levied upon individuals, in the villages upon houses. The income-tax of all the inhabitants of the metropolis amounts to eight thousand purses, or about forty thousand pounds sterling.'[31]

The *firda* list, furthermore, is the first instance found to date of an exhaustive compilation of the number of members included

in each of the units enumerated by the financial administration with the purpose of tax collection. It also gives a total figure for all those involved in production and distribution as long as they earned taxable revenue. This is particularly interesting since it allows one to compare with other estimates: for instance, those of Susan Staffa, who estimates that in 1839, Cairo held a gross total of 30,000 merchants and artisans.[32] This figure coincides fairly well with the 32,485 taxpayers that the *firda* lists and that of 27,015 artisans and industrial workers counted in the census of 1846–1848.[33]

For our purposes, however, the fact that the number of guild members could vary between only two and a staggering 1,040 members, undermines the unprecedented information offered by the *firda*. As for the state's establishments, they employed between four and 1,135 staff. The problem of the *masâlih* may be dealt with separately, but as far as the guilds are concerned, these numbers force one to examine the question of how groups varying so widely in size could be thrown together under the common denominator of *tâ'ifa*.

An obvious dislocation between profession and professional organisation compounds this problem in some cases. Tobacconists, for instance, are divided into two different groups: there are 622 tobacco sellers (*dakhâkhniyya*) and only eight sellers of local tobacco (*dakhâkhniyya baladî*). The confusion is even more pronounced when it comes to trades related to coffee: the list includes five guilds, with a total of 952 members, divided into coffeeshop owners; grinders of coffee beans and perfume essences; merchants of coffee in the *wikâlas* (khans); merchants of soap at Wikâlat al-Sâbûn; merchants of coffee; and, finally, makers of locks and operators of coffee mills. Evidently, the basis for distinction among these different guilds is not the way in which they deal with coffee as a product. The merchants who deal with the distributive aspect of the trade are divided into two groups, one of which also includes soap merchants, while the grinders of coffee beans and operators of coffee mills who transform the primary product are also divided.

If the production process does not appear to be the reason for guild definition, neither does ethnic origin play a part in either separation or agglomeration: while the Orthodox Christian Anatolian carpenters (*najjârîn arwâm*) form a *tâ'ifa* of

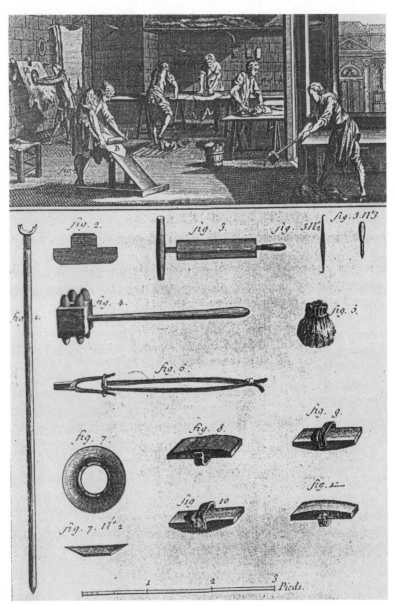

Tanning: workshop and tools, from Diderot's *Encyclopédie* (in William H. Sewell, Jr, 'Visions of Labor: Illustrations of the Mechanical Arts before, in, and after Diderot's Encyclopédie', S.L. Kaplan and C.J. Koepp, ed., *Work in France: Representations, Meaning, Organization, and Practice*, Ithaca and London, Cornell University Press, 1986 pp. 258–286)

their own, Turkish and Maghribi carpenters (*najjârîn atrâk wa-maghâriba*) are grouped together, as are the Egyptian and Turkish brokers (*mutasabbibîn wa-dallâlîn atrâk wa-awlâd 'arab bi'l-wakâyil wa'l-dakâkîn*).

To understand the logic behind the process of classification, one can compare the *firda* with other lists of guilds. Such a comparison, however, first shows the extent to which any taxonomy depends on the understanding of its compilers, in this instance, Muhammad 'Alî's financial administration. The list drawn up in 1801 by the administrators of the French Expedition, published by André Raymond,[34] corresponds on many points to that of the *firda*. Yet, the list of 1801 details 177 guilds. It is riddled with repetitions and subdivisions that do not exist in the *firda* list and that seem to indicate the compilers' desire to pin down guilds more loosely defined in the *firda*: for instance, while there are ten guilds of grave-diggers, defined according to geographical jurisdiction in the list of 1801, there is only one in the *firda*.

In keeping with this tendency to compile or aggregate what was kept separate by the French administration, the *firda* occasionally overrides one criterion of classification in favour of another, for instance, counting as one guild several professions carried out by Jews: moneychangers employed by the

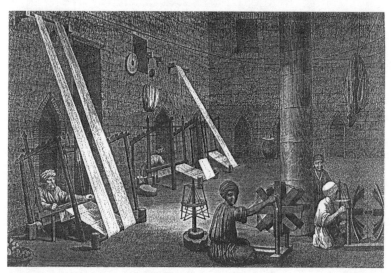

Interior of a weaver's workshop, from the *Description de l'Egypte* (plates reproduced B. Taschen, *Description de l'Egypte*, 1994)

state, moneychangers who provided services to shopkeepers, merchants, silk traders, tobacco sellers, butchers, sellers of cheese, undertakers (*hânûtiyya*) and fruit vendors, among other trades, are all subsumed within one vast category. Not all these trades have to do with kosher regulations so that is not the reason for what could be seen as administrative legerdemain; nor, however, is it possible to explain this through reference to the segregation or isolation of the Jews, who are included in other guilds defined by profession, such as that of the silk merchants (*al-harîriyya al-sandaljiyya bi'l-tarbîya bimâ fîhi asmâ' al-yahûd al-harîriyya bi-Wikâlat al-Bihâr*).[35]

Since the guilds, therefore, do not seem to have been defined and classified according to profession, origin or religion, perhaps they were constituted on the basis of the level of earnings, with relatively wealthier members of a profession making up a separate guild. It has been argued, in fact, that the guilds were relatively internally homogeneous in terms of wealth. This homogeneity has been, notably, cited as both proof of and reason for the absence of any class struggle.

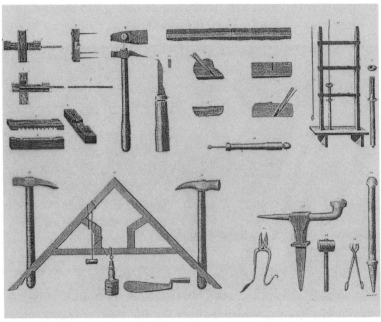

Assortment of locks and tools, from the *Description de l'Egypte* (*ibid.*)

Again, our expectations are confounded. The *firda* list of 1823 reveals vast inequalities both between and within the guilds. The *firda* tax seems to have been based on income or property ownership. In either case, it was clearly an indicator of wealth for it was divided into categories (*fi'ât*), ranging between 1 and 500 *qirsh*. As an example of inequality within individual guilds, one may perhaps take the most extreme case: that of the silk-weavers (*qazzâzîn bi-anwâl al-harîr*). This, of course, is merely one indicator of a general trend.

Only 55 of the 228 known *tawâ'if* and *masâlih* have any members paying the highest category of 500 *qirsh*. This creates a clear division between the wealthiest group as a whole, taking all guilds and state establishments into account, and all other groups combined. Within the guilds as a group, the average *firda* ranges between only 6 *qirsh* (paid by the *hajjâna*, which, although it is specified that their profession is related to camels owned by the state, are classified as a guild and not as a *maslaha*) and 196 *qirsh* (paid by the coffee merchants: *tujjâr al-bunn bi'l-wakâyil*). The four highest averages were paid by guilds of merchants, which confirms trends noted by Raymond for the sixteenth to the eighteenth centuries and would seem to indicate that, at least at this relatively early date, the wealthy merchants of coffee and spices had not lost their economic supremacy, contrary to common belief.

When one looks beyond these generalisations, the picture of inequality becomes even more focused. Among the guilds, two pay an average *firda* of less than 10 *qirsh*. These represent a total of 280 members or less than 1 percent of all guild members. By far the largest group pays an average of 20–50 *qirsh*: 95 guilds with 14,714 members or almost 57 percent of the total number of members. The group paying 100–200 *qirsh* consists of only eight guilds with a total of 656 members: 2.5 percent of the total. More revealing, however, is the fact that the poorest 20 percent of the guild members pay only 8 percent of the total *firda*, while the wealthiest 20 percent pay a staggering 40 percent of the total. Keeping in mind that the ceiling on the *firda* was 500 *qirsh* and that this figure represented one-twelfth of yearly revenue, there must have been those who made well over 6,000 *qirsh* a year.

The same disparities are evident within the state establishments. There, however, the average *firda* ranges between 16

qirsh (paid by the undertakers) and 285 *qirsh* (paid by the scribes in the Dîwân al-Muhimmât) or the Department of Matériel. Clearly, both these averages are considerably higher than their counterparts calculated for the guilds.

Between these extremes, the picture is equally revealing. No *masâlih* pay less than 10 *qirsh* as average *firda.* Nine departments, representing almost 30 percent of all employees, pay an average of 20–50 *qirsh.* There are 11 groups of employees or almost 50 percent of the total, paying 50–100 *qirsh.* The final stratum applies only to the state employees since there are no guild members paying 200–300 *qirsh* on average. Nine groups belong to this highest category, representing 5 percent of the total number of people employed by the state.

Clearly, therefore, taxes paid by employees of the state *masâlih* were higher, on the whole, than those paid by guild members. If the *firda* did reflect individual income, it is safe to say that one may find in this conclusion a clue to the establishment of these *masâlih* and the effect that they had on the guilds. Several *masâlih* entirely replaced sectors of economic activities that the guilds had engaged in up until that point. This is evident, for example, in the case of the state slaughterhouse (*salakhâna*) and its appendages: the professions that they encompass do not appear among the list of guilds, although they had been recorded as such in 1801. There may well have been little resistance to these new institutions because they offered such high pay in comparison to what artisans could earn as members of a guild.[36]

Conclusion

Perhaps the most difficult question arises now: was any one of these visions of labour in late eighteenth and early nineteenth century Cairo somehow more factual than the others?[37] I have implied that the answer to this question is a qualified yes because it seems reasonable to assume, if only on an instinctive, in-coherent level, that a court document recording the appearance and litigious behaviour of a group of artisans, partly in their own words, gives us more accurate, less mediated insight into their actions, if not their intentions or views, than does, for example, the account of a chronicler describing these artisans

in a very different situation – a public appearance that was in almost every respect staged for the benefit of others.

In turn, one assumes that al-Jabartî's representation of the events that he witnesses is informed by an understanding of the society that produces them and therefore that he is somehow more 'reliable' than the illustrators of the *Description*, although the desire to ascribe absolute truth-value to scenes that one apprehends visually ('seeing is believing') is compelling.

Finally, the statistical rendition of Cairo's formally organised working population is perhaps the most insidious source of all: steeped as we are today in the world of polling and percentages, we are sufficiently savvy to realise that numbers can be tweaked, but a nineteenth century statistic seems less instant, more small-scale, altogether more serious than a twenty-first century sound-bite. It is necessary, however, to disregard the *firda*'s allure, if only temporarily, and remember that it is not just a transparent source of raw information. It was produced under specific circumstances, over a relatively long period; its elaboration included stops and starts and changes of heart, all of which the final product glosses over. The *firda*, in that light, may embody (and reproduce) a transitional stage between an administration based on corporate identification, a society of orders, and one that seeks to unify and homogenise, breaking down old barriers and instituting new ones.

More importantly, it is structurally incapable of revealing certain characteristics of professional life; for that, a comparison with other sources is necessary. Among its most eloquent silences, one must reckon with the absence of children, women and slaves (even those employed as domestic servants). One group is excluded not because child labour did not exist, but because one cannot assume that the lowest-income guild members were also the youngest; the second either because no women were guild members or because no guilds were exclusive to women (and, in either case, they are not tallied explicitly as women); the third because of its subordinate juridical and economic status. There are other more complex elisions. The population census of 1846–1848 shows that, in certain parts of Cairo, origin over-lapped with profession and residential behaviour: for instance, tanners concentrated around 'Abdîn, Abû 'l-Sibâ' and Hikr were exclusively urban in origin; in the Coptic areas of 'Abdîn

and Hârat al-Nasâra, scribes predominated.[38] The *firda* cannot reveal such information. Still, these and other specificities tell one little about the guilds as organisations. But, they do reveal residential patterns and the occasional coincidence of religion with professional specialisation, immigration and level of wealth. They show the grids, whether city-wide or individual, within which the guilds were inscribed.

One must also avoid vacuous cynicism, however, and this is even more difficult. I have spoken of what these four sources do not tell us, but have said little about what one can glean from them. They give four very different pictures and perhaps this is where one might begin to search for clues. By contradicting each other, the sources that I have presented show that the guilds were not many of the things that it has been said they were. One can infer from both challenges to guild leaders and endorsements of their authority, for example, that leadership was not necessarily hereditary. The court documents involving artisans and merchants indicate that the guilds were not simply structures imposed from above by the state, empty administrative categories that oppressed their members and served as instruments of control. The engravings, the procession and the *firda* suggest in different ways that the guilds did not reflect the fragmentation of the production process; they were not organised along ethnic, religious or geographical lines alone.

My intention is not to state that all the sources that I have used are intrinsically untrustworthy and, therefore, that one can 'know' nothing about work and its organisation in Cairo at the turn of the nineteenth century. It is very easy to pick holes in just about anything; more difficult is to begin reconstructing another picture, a problem that must be addressed. Instead of regarding the guilds as none of the 'realities' produced by the sources discussed here or even as a patchwork of the discrete pictures that I have drawn above, perhaps one can see them as the articulation that these images form together; as quintessentially urban forms in which the practice of a trade loosely defined is the only common point, but one that gives rise to specific types of behaviour and modes of solidarity. Each of these sources, by their nature, and because of the conditions of their production, privileges only one principle of classification to the exclusion of all other possible criteria: the *Description* orders the world of

labour in purely visual terms, the chronicler's narrative subsumes the guilds within the larger entity that is the city, the court documents focus on legality and the *firda*'s hierarchy is defined by income.

None of these criteria and none of the realities that they construct separately is autarkic. Together, they allow one to see the guilds not as exclusionary mechanisms, but as institutions bringing together differences (of wealth, religion, origin, narrow professional specialisation...) and, by contextualising them occupationally, reproducing them in specific terms. By virtue of their profession, Jews and Christians worked and socialised with Muslim colleagues and clients, while some saddle-makers shared their poverty with camel-drivers and grave-diggers. Inversely, Greek carpenters were divided from their native counterparts by their higher income and their membership in two different guilds. Labour contractors and the workers whom they hire out belong, in contrast, to the same guild, yet are divided by disparities in income. The court documents do show clearly that artisans acted in a certain way at certain times because they viewed themselves and were viewed by others as belonging to specific associations. Yet, collective action and conflict were determined on a case-by-case basis, occasionally dividing a guild against itself and, at other times, pitting it as a homogeneous body against other urban authorities.

One way to start applying this hypothesis is by examining the term *tâ'ifa*, which one must study as it is used by the chroniclers, the administrative apparatus, the courts and the guild members. 'Alî Mubârak uses the same word to indicate a community of religion or origin, a professional corps or a political faction.[39] Today, the term's connotations are mainly pejorative. The adjective *tâ'ifî* refers primarily to factionalism and fragment-ation. The term, in itself, did not necessarily refer to a guild or any institutionalised corps. Only in context can one even decide how to translate it.

If my remarks offer any scope for a conclusion, it is that one must revise, quite radically, the way that we have looked at labour in nineteenth century Egypt. Instead of studying the guilds as ready-made units of social, economic or political organisation, wondering whether they were created by the state or controlled by the artisans, if they fulfilled taxation requirements or stifled

competition, perhaps one would do well to ask what prompted people to form, join and attempt to shape specific associations, distinguishing them from others.

Notes

1 Baer, 1964.

2 Raymond, 1999.

3 A sort of synecdoche conflated Cairo with its environs and vice versa; nor was this an innovation introduced under Ottoman rule: 'The capital of a large province or district was often identified in terms of the region it dominated. Throughout the Geniza papers, Fustat is often called Misr (Egypt). Only in legal documents is *Fustat Misr* (Fustat of Egypt) used to differentiate it from Cairo...': Goitein, 1999, p. 42. This convention of administration and common usage has long influenced academic research as well.

4 Apart from specialised studies of the topic, in European languages and Arabic (for example, Harîdî, 1985), recent general studies include Denoix (2000, p. 930), in which she quotes Claude Cahen's assertion that 'the term "guild" was inappropriate for the medieval Muslim world for these were not private associations bringing together all the masters of a trade, regulating its practice itself and providing a framework, even outside professional life *stricto sensu*, for a certain number of their members' activities...'. While cautioning that this statement does not imply a complete absence of professional organisation, Denoix seeks structures of solidarity elsewhere, in Sufi orders or *futuwwa* groups.

5 Sewell, 1986, pp. 270, 272.

6 Sewell, 1986, pp. 269–270.

7 Sewell, 1986, p. 270.

8 Sewell, 1986.

9 Sewell, 1986, p. 277.

10 For example, the departure of the caravan in Shawwâl 1193 (October 1779): see Philipp and Perlmann, 1994, v. 2, p. 82.

11 In contrast, the festivities held for the circumcision of the *qâdî*'s son in Sha'bân 1177 (1764), which elicited displays of respect from personages including 'scholars, amirs, grandees, and merchants', did not feature the guilds at all: Philipp and Perlmann, 1994, v. 1, pp. 420–421.

12 Among the factors that al-Jabartî cites in 'Alî Bey Bulût Kapan's rise to prominence is the splendid wedding that he organised in

1174 (1760–1761) for Ismâ'îl Bey, whom he married to Khânim, the daughter of his master Ibrâhîm Katkhudâ. The festivities included 'a great wedding procession through the centre of the city, accompanied by all manner of diversions, with acrobats and harps and drums'. No artisans or merchants are mentioned as having marched in this parade; rather, household retainers and military personnel played the most important parts: see Philipp and Perlmann, 1994, v. 1, pp. 417-418. The wedding in 1190 (1776–1777) of Ismâ'îl Bey and Khânim's daughter included a procession in which an elephant marched, but no guilds: Philipp and Perlmann, 1994, v. 2, pp. 2-3.

13 Alleaume and Fargues, 1998, p. 78.
14 Alleaume and Fargues, 1998, p. 78.
15 For the account of the festivities organised for the wedding of Muhammad 'Alî's daughter and son to Muhammad Bey the *daftardâr* and the daughter of 'Ârif Bey respectively, see al-Jabartî, n.d., v. 3, pp. 339–441. The translation of this passage may be found in Philipp and Perlmann, 1994, v. 4, pp. 276–278. Although they pertain to Turin, Simona Cerutti's (1990, p. 27) remarks about the central role of the productive and distributive sectors in the city's 'representations of itself' seem relevant here: in ceremonial processions, the predominance of the Municipality gives way from the beginning of the eighteenth century onward to 'a myriad of small groups, each corresponding to a professional corps, to the associations of masters, apprentices and journeymen. The city itself is divided into professional quarters decorated with the banners and symbols of each corps.'
16 ... *fa-kâna kull man sûlat lahu nafsahu wa-haddathahu al-shaytân bi-ihdâth shay' fa'alahu wa-dhahaba ilâ al-muta'ayyin li-dhâlika fa-yu'tîh waraqa li-anna dhâlika lam yakun li-anâs makhsusa aw-'adad muqaddar bal bi-tahâkumâtihim wa-ilzâm ba'duhum al-ba'd...* (al-Jabartî, n.d., v. 3, p. 440). The translation in Philipp and Perlmann (1994, v. 4, p. 277) states: 'the money had not been assigned on the basis of specified persons or predetermined numbers but arbitrarily, on the basis of influence and connections' and thereby conveys a false impression: that these festivities were entirely commissioned, controlled and funded by state-appointed agents. Al-Jabartî's account seems to imply that the artisans were eager to participate in the festivities, which may have provided them with an opportunity to advertise their wares and to curry favour with the authorities. The shaykhs of the guilds may also have stood to benefit financially from this celebration since the wagons were built with money

collected from the guild members while only the shaykhs seem to have been recompensed for their efforts. The difference is one of emphasis, reinforced by Philipp and Perlmann's interpretation of the phrase *li-anna dhâlika lam yakun li-anâs makhsûsa* as meaning 'the money had not been assigned on the basis of specified persons...', whereas *dhâlika* seems to refer only to participation.

17 ...'*alâ qadr maqâm al-sana'a wa-ahlihâ:* al-Jabartî, n.d., v. 3, p. 441.

18 Much has been made of the thieves' and beggars' guilds; yet, equivalents were known in Europe too. See, for instance, Nicassio, 1991, p. 425, who mentions 'lists of licensed beggars in Modena [Italy] in the 1770s', adding that not all beggars were licensed, 'despite regular threats to arrest and expel unauthorized supplicants'. In Cairo, al-Jabartî mentions the shaykh of the beggars and his deputy in the necrology of Ibrâhîm Bey Abû Shanab: see Philipp and Perlmann, 1994, v. 1, pp. 171-172.

19 Al-Jabartî, n.d., v. 3, pp. 445–446.

20 Philipp and Perlmann, 1994, v. 3, p. 530.

21 These are the Mamluks' children who, by definition, are forbidden to bear arms. By this time, so many had married Egyptian women and established businesses in the only homeland that they had ever known that they belonged to the native population far more than to the military ruling class. See Haarmann, 1998, p. 77, for an analysis of *awlâd al-nâss* as a clearly defined group in Mamluk times.

22 Philipp and Perlmann, 1994, v. 4, p. 180; al-Jabartî, ed. v. 3, p. 321.

23 See, for instance, 'Abd al-Latîf, 1980, p. 66. Walz (1978, pp. 135–136), following Baer (1964, p. 70), also argues that 'the common practice in Egypt was for the shaikhship to pass from father to son...'. Yet he notes that, at least with respect to Wikâlat al-Jallâba, 'each shaikh can be proved to have been long concerned with the market and with market practices and would almost certainly have been elected head of the guild if the choice were unquestionably free' (Walz, 1978, p. 136). Among merchants, at any rate, and especially among the wealthiest, most influential import-export merchants, the selection of leaders does not seem to have operated exactly as it did among artisans.

24 See Hanna, 1991, pp. 21–22.

25 The importance of the notarial services which the courts provided has been noted for other Arab provinces of the Sultanate. For Aleppo, see Marcus, 1989, especially p. 107: 'The importance of the Sharî'a court in enforcing the law rested in good measure on its function as a notarial office ... Residents went there routinely to

register loans, divorce settlements, business partnerships, purchases of real estate, and various other transactions and contracts.' This was neither a specificity of the courts of Cairo and Aleppo nor a characteristic of the Ottoman system or even sharî'a; rather, one must see here a trait shared by the judicial system generally before the great reforms of the nineteenth century. The same is true of the absence of lawyers in the courts.

26 Al-Bâb al-'âlî, register 124, p. 16, case 68, 15 Rabî' I 1054/1644. For a full discussion of these and similar cases, see Ghazaleh, 1999, especially pp. 73–74 and 87–89.

27 Perhaps sugar-sellers: professional terminology often makes it impossible to distinguish between productive and distributive aspects of a trade. Perhaps the same individuals practised both, as Raymond argues, seeing in this possibility the sign of Egypt's technical retardation as manifested in the failure to separate production from commerce (the 'confusion of activities') and the paradoxical extreme division of labour: Raymond, 1999, pp. 213–215.

28 Al-Bâb al-'âlî, register 128, p. 389, case 1549, 14 Muharram 1060/1650.

29 Interestingly, nowhere is the word *ribâ* (usury) mentioned.

30 On the production of the *firda* registers, see also Hâkim, 2000. This section is partially based on Ghazaleh and Hâkim, 1998.

31 Lane, 1978, pp. 136, 534. A purse is equivalent to 500 *qirsh*.

32 Sonbol, 2000, pp. 37–38.

33 Alleaume and Fargues, 1998, p. 101.

34 Raymond, 1957

35 This phrase suggests that Jewish silk merchants at Wikâlat al-Bihâr, the spice caravanserai, formed a loosely defined subgroup while belonging to the overarching category of 'silk merchant'. Silk weaving, dyeing and trade were Jewish specialisations for a long time: see Goitein, 1999, p. 170: 'Since the Jews were so conspicuous in the silk industry, they were no doubt the best qualified to collect taxes levied on it.' The court documents mention similar religion-based subgroups within the same guild. See for instance in al-Bâb al-'âlî, register 135, p. 151, case 569, '*tâ'ifat tujjâr al-harîr bi-sûq al-tarbi'a wa'l-dallâlîn wa-bi-Khân al-Hamzâwî wa'l-khawâja wa-ghayrihim wa-fattâlîn al-harîr min al-muslimîn wa'l-nasâra wa'l-yahûd bi-Misr al-mahrûsa*'. Cf. Ghazaleh, 1999, p. 48.

36 This hypothesis must be tempered by what we know of the residential patterns that characterise the manufactories' employees. Many lived in 'pockets of poverty' within the city such as 'Utûf, where

metalworkers and workers in the textile manufactories were concentrated: see Alleaume and Fargues, 1998, p. 94.

37 In her analysis of three different sources dealing with sixteenth century Modena, S. Nicassio concludes that the paintings, statistical reports and parish censuses 'present an image of what was important to those individuals for whom they were prepared' and that it is therefore 'pointless to ask which of these three descriptions is more trustworthy – which city is closer to some objective reality': Nicassio, 1991, pp. 443–444. I would like to thank the author for sending me a copy of her article, which I had not read when I prepared the preliminary version of this study.

38 Alleaume and Fargues, 1998, p. 87.

39 Alleaume and Fargues, 1998, p. 77.

Bibliography

Primary sources

Cairo

Al-Bâb al-'âlî, register 124, p. 16, case 68, 15 Rabî' I 1054/1644

Al-Bâb al-'âlî, register 128, p. 389, case 1549, 14 Muharram 1060/1650

Al-Bâb al-'âlî, register 135, p. 151, case 569, 12 Rajab 1068/1657

Firdat al-'a'tâb, 1239/1823.

Secondary sources

'Abd al-Latîf, Lailâ, *Dirâsât fî târîkh wa-mu'arikhî Misr wa'l-Shâm ibbân al-'asr al-'uthmânî*, Maktabat al-Khanjî, Cairo, 1980.

Alleaume, Ghislaine and Philippe Fargues, 'Voisinage et frontière: résider au Caire en 1846', in Jocelyne Dakhlia, ed., *Urbanité arabe. Hommage à Bernard Lepetit*, Sindbad /Actes Sud, Paris, 1998, pp. 77–112.

Baer, Gabriel, *Egyptian Guilds in Modern Times*, Jerusalem, Israel Oriental Society, 1964.

Cerutti, Simona, *La Ville et les métiers. Naissance d'un langage corporatif (Turin, 17e–18e siècle)*, Paris, Ecole des Hautes Etudes en Sciences Sociales, 1990.

Denoix, Sylvie, 'Unique modèle ou type divers? La structure des villes du monde arabo-musulman à l'époque médiévale', in Claude Nicolet, ed., *Mégapoles méditerranéennes. Géographie urbaine rétrospective*,

Rome/Aix-en-Provence, École Française de Rome/MMSH, 2000, pp. 912–937.

Ghazaleh, Pascale, *Masters of the Trade: Crafts and Craftspeople in Cairo, 1750–1850*, Cairo Papers in Social Science, v. 22, n° 3, Cairo, American University in Cairo Press, 1999.

Ghazaleh, Pascale and Muhammad Hâkim, 'Quarters and Corporations: Grouping and Classification in Cairo in the 1820s', Cairo, paper presented at the CEDEJ (Centre d'Etudes et de Documentation Economique, Juridique et Sociale) conference *Subjects to Citizens: Egypt from Muhammad 'Ali to the Present Day*, December 1998.

Goitein, S.D., *A Mediterranean Society. An Abridgment in One Volume*, revised and edited by Jacob Lassner, Berkeley/Los Angeles, University of California Press, 1999.

Haarmann, Ulrich, 'Joseph's law – the careers and activities of Mamluk descendants before the Ottoman conquest of Egypt', in Thomas Philipp and Ulrich Haarmann, ed., *The Mamluks in Egyptian Politics and Society*, Cambridge, Cambridge University Press, 1998, pp. 55–84.

Hâkim, Muhammad, 'al-'A'tâb wa'l-ru'ûs: al-takwîn al-ijtimâ'î li'l-raqam fî Misr mâ bayna 1821 wa-1824', in *Mutûn 'asriyya fi'l-'ulûm al-ijtimâ'iyya: hadîth al-arqâm*, CEDEJ, Cairo, Winter/Spring 2000, pp. 89–105.

Hanna, Nelly, *Habiter au Caire : la maison moyenne et ses habitants aux XVIIe et XVIIIe siècles*, Cairo, Institut Français d'Archéologie Orientale, 1991.

Harîdî, Salâh, *al-Hiraf wa'l-sina'ât fî 'ahd Muhammad 'Alî*, Cairo, Dâr al-Ma'ârif, 1985.

Jabartî, 'Abd al-Rahmân al-, *'Agâ'ib al-athâr fi'l-tarâjim w'al-akhbâr*, Beirut, Dâr al-Jîl, n.d., 3 v.

Lane, E.W., *An Account of the Manners and Customs of the Modern Egyptians, Written in Egypt during the Years 1833–1835*, The Hague and London, East-West Publications, 1978.

Marcus, Abraham, *The Middle East on the Eve of Modernity. Aleppo in the Eighteenth Century*, New York, Columbia University Press, 1989.

Nicassio, Susan, 'A Tale of Three Cities? Perceptions of Eighteenth-Century Modena', *Journal of Interdisciplinary History* XXI, n° 3, Winter 1991, pp. 415–445.

Philipp, Thomas and Moshe Perlmann, ed., *'Abd al-Rahmân al-Jabarti's History of Egypt. 'Ajâ'ib al-Athâr fi'l-Tarâjim wa'l-Akhbâr*, Stuttgart, Franz Steiner Verlag, 1994.

Raymond, André, 'Une liste des corporations de métiers au Caire en 1801', *Arabica*, IV, 1957, pp. 150–163.

Raymond, André, *Artisans et commerçants au Caire au XVIIIe siècle*, Damascus, Institut Français de Damas, 1973–1974, 2 v.; reprint, IFAO/IFEAD, Cairo, 1999.

Sewell, Jr., William H., 'Visions of Labor: Illustrations of the Mechanical Arts before, in, and after Diderot's *Encyclopédie*', in Steven Lawrence Kaplan and Cynthia J. Koepp, ed., *Work in France: Representations, Meaning, Organization, and Practice*, Ithaca/London, Cornell University Press, 1986, pp. 258–286.

Sonbol, Amira El-Azhary, *The New Mamluks. Egyptian Society and Modern Feudalism*, New York, Syracuse University Press, 2000.

Walz, Terence, *Trade between Egypt and Bilâd as-Sudân, 1700–1820*, Cairo, French Institute of Oriental Archaeology (IFAO), 1978.

CHAPTER 9

Shared Space or Contested Space: Religious Mixity, Infrastructural Hierarchy and the Builders' Guild in Mid-Nineteenth Century Damascus[1]

Randi Deguilhem

In the well-known *Dictionary of Damascene Professions*, which describes nearly all types of manual work performed in Damascus around the turn of the twentieth century, the builders' guild figured among the most prestigious and progressive professional corporations. About half a century after 1844, when the document studied in this chapter was entered into the official registers, construction work was being described as 'one of the essential professions for the progress of civilisation'.[2]

Based on a document registered with the Damascene High Advisory Council (Majlis Shûrâ al-Shâm al-'Âlî) in the middle of the nineteenth century, the following study analyses aspects relevant to the religious configuration of the builders' guild. The document has preserved the names, professional qualifications and daily wages of workmen engaged in repair work on a waqf-financed public building in central Damascus, thereby giving the researcher a window into the infrastructural organisation of the builders' guild. The present contribution takes a close look at two contrasting interpretations related to the religious composition of seventeenth to nineteenth century Ottoman guild personnel.

The first hypothesis, based on data from the Syrian provincial archives, maintains that the guilds represented a shared space for its personnel, regardless of the members' religious affiliations. It was a place where solidarity was the order of the

day. According to this hypothesis, guild members within their organisations replicated the internal structure of work behaviour, generation after generation, from the seventeenth to the nineteenth century, seemingly without major internal structural changes, its members basically pulling in the same direction.[3] This hypothesis includes the assumption that economic influence emanating from Europe, starting mostly at about the end of the eighteenth century, and the transformations that it was to spur in local and regional economies in the Syrian provinces and elsewhere in the Empire, had little effect upon the membership of local guild personnel in the two major Syrian cities of Damascus and Aleppo. This point is pertinent for the present study, which focuses upon the membership of the Damascene builders' guild in the middle of the nineteenth century.

Adherents of the second hypothesis, based on research in the imperial Istanbul archives, take the opposite view. According to a recent study based on these archives, the European economic presence as well as the political influence of France and England had already begun to weigh heavily in the Empire by the mid-eighteenth century. A powerful factor provoking far-reaching organisational changes within the Ottoman lands, one consequence of this made itself felt in substantial infrastructural transformations within eighteenth century Ottoman guilds, the evidence being supplied by the silk-thread spinners' guild in Istanbul.[4] According to this line of reasoning, European influence accentuated tensions already present between guild members of different religious and ethnic origins which had previously been stifled or placated by guild leaders along with state authorities eager to preserve the status quo. This interpretation of events and historical development holds that tensions between communities were first articulated within the competitive atmosphere of the guilds.

Two hypotheses: the first which underlines the Ottoman guild as a place of entente and cordial sharing among members of different religious identities within an atmosphere mostly impervious to external changes, while the second, in contrast, emphasises the guild's vulnerability to outside influences and its functioning as a space *par excellence* where societal tensions might surface. In relation to both of these hypotheses, one needs to strongly underline the fact that research on guilds is still in its

beginnings, despite a growing number of empirical and theoretical works which have appeared on the subject over the past two or three decades. After all, literally tens of thousands of Ottoman imperial and provincial documents have yet to be studied and analysed for the different cities and provinces in the Empire. For the moment, it is therefore quite problematic to generalise from just a few case studies. But one must begin somewhere and these two hypotheses provide a starting point.

The guild: a place of solidarity or of confrontation?

To a certain degree, one may assume that the workplace provides a neutral locale where people of different backgrounds rub shoulders during working hours, building social bridges between them. Ties of solidarity will especially be formed by individuals on the same hierarchical level in the work space whose socio-economic situation is therefore similar. On the other hand, spending hours within a shared work environment – or competing for one's place within that space – can, on the contrary, elicit and bring to the fore various dimensions of societal dissension between co-workers of different religious or ethnic backgrounds. In this situation, solidarity between co-religionists may come into play and tensions between different religious communities which might have otherwise been left simmering under the surface may well turn into open conflict.

In the first situation, shared time spent together at the workplace will lead towards the construction or social replication of specific features of belonging among individuals who strengthen and reproduce their relational ties within the established system, in the manner of Bourdieu.[5] In some ways, these ties transcend religious or ethnic divergences in the sense that striving for common goals in the workplace makes these other differences seem unimportant. Attributes and characteristics of group solidarity engendered in the workplace are typically expressed in the work space as well as outside it. Solidarities largely develop around the most obvious common point of interest, namely, the job at hand as well as future projects: it is the work done that provides the common marker of identity among members of the relevant personnel. These bonds of

solidarity will, at times, result in collective forms of action taken by these individuals in the public sphere. As guilds also embody an externally recognised and differentiated group separate from the rest of society, members are encouraged to think of themselves as sharing common space.

Belonging to a particular level of the labour hierarchy is strongly reinforced by ritual behaviour performed at regular intervals both in the workplace as well as outside – the latter being an especially effective marker of solidarity and identity. According to this hypothesis, doing the same kind of work has a similar effect on an individual, whether it is being undertaken within the structure of a guild[6] or within another type of labour configuration. As Ottoman documents have shown, the latter may simply function as loosely organised networks of non-guild workers, consisting of both men and women, but such arrangements involve but a minor component of the employment force. Alternatively, non-guild workers may establish closely intertwined channels connecting persons who produce a variety of goods within the confines of their respective living quarters. Strong ties may also exist between persons active in the marketplace as shopkeepers or making a precarious living as itinerant workers.[7]

Certain kinds of guild solidarity in the Ottoman Empire encompassed the entire membership. Guild waqfs whose assets were mainly cash[8] and, therefore, readily accessible for distribution to the needy among member artisans or their families, are probably the most frequent and best-known type of solidarity among guild personnel. However, monographs and micro-studies on guild waqfs based on archival documents, the only type of research to bring detailed and case-specific information, have only begun to emerge within the past two or three decades. At least, one does know that whenever the guild was multi-confessional, the collective waqf seemed to have been available to all members. Beyond the confines of the guild, cash from these waqfs was lent out at interest to outsiders as a revenue-producing venture.[9]

There were other types of collective actions which reveal the shared space mentality in the guilds. Guild personnel registered litigation and petitions in the local tribunals on behalf of their organisations; this is a telling example of solidarity that likewise

cut across religious lines. Such phenomena have been studied for seventeenth to nineteenth century Aleppo, where Muslim, Christian and Jewish guild members collectively went to the local courts in order to register various types of business-associated activities such as the appointment of new leaders to their respective organisations. In the same vein, members defended their guild whenever they perceived it to have been threatened by 'unauthorised' transactions taking place outside the framework of the official guild system.[10]

Inversely, the Ottoman archives also allow us an opposite view of guild life, i.e. that of contested space, a sphere of confrontation. Documents from seventeenth and eighteenth century Istanbul show that guilds did not only represent a place where individuals of different confessional groups worked together within a framework of shared professional goals. When comparing and cross-reading documents and analyses connected with the Ottoman archives, a far more nuanced picture emerges. One sees that the guilds were also the place where societal conflicts and antagonisms became visible, often before they showed up elsewhere in society, since making a living is frequently a stressful part of life.[11] It is especially in times of societal upheavals and adversity that the workplace frequently becomes the arena where individuals find themselves manoeuvring for space and recognition. In eighteenth century Istanbul, documents show a situation where individuals working in different professions frequently aligned themselves according to their religions.

Working from the Istanbul Ahkâm Defterleri registers dating from the middle of the eighteenth century, Yıldırım points to cases where guilds and the workplace, in general, represent an example of contested space. Here, socio-economic and religious conflicts which are otherwise largely hidden from view or which have not yet fully surfaced in other areas of society, are fought out. One of his examples, in particular, refers to ritual behaviour in the Istanbul silk-thread spinners' guild. This example is important for the present study in the sense that regular observance of time-honoured rituals or, on the other hand, changes introduced into these customs serve as markers of shared or contested space. Correspondingly, Yıldırım has studied documents registered in the Ahkâm Defterleri which record different cases lodged separately by the warden (*kethüda*) of the Istanbul

silk-thread spinners' guild as well as by Muslim and Christian masters of this guild. In the eighteenth century, separate excursions to the countryside organised by Christian masters in order to celebrate the advancement of Christian apprentices to the rank of journeymen were considered by both the Muslim masters and the Muslim guild warden to be a rejection by the Christians of their place within the guild structure – and this was undoubtedly true. According to information in these documents, the Christians upheld and justified their demand for separate rituals because of harassment and insults by Muslim co-workers – hardly the byword for shared space.[12]

Yıldırım's documents show the complexity and ambiguity of relations within the guild, while judgements by the state authorities on this matter appear to have vacillated. Indeed, a judgement was recorded in 1731 insisting that Muslim and Christian silk-thread spinners should perform their excursions together or, at the very least, they should be performed at the same time, presumably to give a semblance of unity. Subsequently, in 1759, the guild warden requested a confirmation of this decision, no doubt in order to strengthen his position against separate Christian rituals.[13] On the other hand, the Christian masters produced other judgements issued by the state authorities during the very same period, including one by the Imperial Council which permitted separate rituals for persons of different religions.

Moreover, Yıldırım's documents also refer to Istanbul Christians who left the spinners' guild at this time with the purpose of setting up businesses on their own account. Yıldırım explains this type of action as being possible because of the new atmosphere of contestation within the top levels of Ottoman Christian society, a phenomenon that he attributes to European influence.

The dispute concerning the excursions remained unresolved during the three decades or so covered by Yıldırım's documents. To some extent, the author interprets the volatility and unsteadiness of the situation as indicating the central bureaucracy's gradual withdrawal from assiduous guild supervision towards a more laissez-faire approach. In his perspective, the new policy becomes increasingly obvious from the mid-eighteenth century onwards. This observation fits in well with the growing European

presence in the Empire, which encouraged Christians, again according to Yıldırım, to no longer accept ill-treatment within their guilds.

The document[14]

The document used for the present study was recorded in the only existing register from the middle of the nineteenth century that we possess from the High Advisory Council (Majlis Shûrâ al-Shâm al-'Âlî) in Damascus.[15] Among other information, the document studied here lists the personnel who worked over a period of four days on repairs to the building that once housed the Treasury (*ûda al-khazîna*) and the office of the *nâzir mu'ajjalat al-awqâf*. In addition to an inventory of the materials used in the repairs, the document contains the names, the professional qualifications and daily wages of the men employed on the site, according to a format that Ottoman bureaucrats had been using for centuries.

Before discussing the contents of this document in relation to guild affairs, a word about the *nâzir mu'ajjalat al-awqâf*, a position newly created in 1837 within the structure of the imperial waqf (pious foundation) administration in the Empire.[16] In the words of James Redhouse, the *nâzir mu'ajjalat al-awqâf* was a personage employed by the Imperial Receiver and Controller of monies associated with waqf properties.[17] The *nâzir mu'ajjalat al-awqâf*, whose principal purpose was to act as a check-and-balance over the *qâdîs*, was directly answerable to the newly established Imperial Waqf Ministry, which paid him for his supervisory work. This meant that the *nâzir mu'ajjalat al-awqâf*, who was chosen in the provincial cities from among the local notables, was institutionally situated outside the *qâdîs* court system. This presumably reduced his susceptibility to bribes or other corrupt behaviour, making him an integral part of Istanbul's Tanzimat efforts to exert an increasing amount of direct control over the administration of public waqfs and their assets in the Empire. For the time being, there is very little published information about the position of the *nâzir mu'ajjalat al-awqâf*, but my ongoing research with the nineteenth century *awâmir sultâniyya* registers from Damascus make it certainly clear that the position

is of the highest importance in managing public and imperial waqf affairs in the city at the time.[18]

Besides the data pertinent to guild affairs, this document throws light on otherwise unknown details of Damascene urban topography in the middle of the nineteenth century, namely, by mentioning the location of the Treasury (*khazîna*) and the locale used by the *nâzir mu'ajjalat al-awqâf*. According to this document, it seems that the two offices presumably were either located in the same room or else in contiguous spaces, and were physically attached to the old tribunal building (*ûda al-khazîna al-mustakhrija min mahall majlis al-qadîm*) in the city. Unfortunately, the location of the Damascene 'old tribunal' at the present time remains unknown.

Essential for the line of inquiry followed here, the names listed in this document reveal that, in the builders' guild, religious mixity was the order of the day on all levels among both masters (*mu'allim*) as well as among labourers (*fa'âla*). It is this particular aspect, in other words, the religious composition of the guild's workforce, that will occupy us here. Workers' names were recorded by the job that they carried out on the restoration site as master builders, carpenters, lime-kiln operators/plasterers, layers of drainpipes or stone-cutters. In addition, there were various types of skilled labourers associated with each category of masters so that the data gives an insider glimpse into the hierarchical configuration and internal workings of the builders' guild in Damascus towards the middle of the nineteenth century.

The onomastic information contained in this list adds to its importance since individual workers' names provide cultural markers indicating the religious backgrounds of their bearers along with, as we have seen, their professional functions, daily wages and positions within the guild hierarchy. These names permit the researcher, in quite a number of cases, to distinguish between Muslims, Jews and Christians, but this is, nonetheless, not possible in all cases since several names such as 'Abd Allah, 'Abdu, 'Aysâ were used by all three communities. Moreover, it is nearly impossible to distinguish between Sunnis and Shi'is on the basis of names alone although, in some instances, this is feasible when one knows the social history of a given place.

A few words about the register and the document in question: it is, in fact, the sole text which contains detailed information on

guilds in the one and only register produced by the Damascus High Advisory Council (*wilâyat* al-Shâm) that has surfaced to date. The other documents in this register mostly concern transactions concerning private (*milk*), state (*mîrî*) or waqf properties. Many of these documents are also of importance both in relation to the intrinsic nature of the affair recorded but also with respect to the types of cases treated by the High Advisory Council in the middle of the nineteenth century, which concern business in the city of Damascus as well as its environs, including the Ghuta and the Beq'a. Although there may have been other registers covering sessions of Council affairs from the same year (other registers may be held by Damascene families or in the imperial archives in Istanbul or Ankara), this seems quite unlikely since, according to the internal textual evidence and organisation of the surviving register, the 12-man High Advisory Council dealt with its business on a chronological basis as a group in collective meetings. When members of the Council were not present during a session, this is usually mentioned in the document. Presumably, when guild affairs affected the public sphere, as in the case presented here, in other words, when guild work was paid for out of public waqf funds, the question would apparently come before the Council and be reviewed by its members.

The High Advisory Council, instituted by the Ottoman imperial authorities in 1840 during the opening years of the Tanzimat and on the heels of Muhammad 'Alî's retreat from Bilâd al-Shâm, was based on practices introduced by the Egyptians (this also applied to the Advisory Council instituted in the early 1840s in post-Egyptian Beirut and elsewhere in Bilâd al-Shâm).[19] The High Council did not seem to act as a mere consultative body: it apparently exercised a certain amount of real decision-making power. In several ways, the Council acted as an intermediary between Istanbul and the provincial population; its main responsibility was to treat current affairs of public interest in the province and liaise with Istanbul on these matters.

In 1844, the year when the document studied here was written, the Council was composed of 12 of the highest notables in the city of Damascus, all of them Muslim (this composition was to change after the 1860 massacres, when Christians and Jews began to participate). The Council membership is given in the register itself. In 1844, the members included both

the Hanafi and Shaf'i *muftîs* of Damascus, respectively, Husayn afandî al-Murâdî (member of the council from 1840 to 1850) and 'Umar afandî al-Ghazzî (1840–1860), as well as the *naqîb al-ashrâf* of the province, 'Abd al-Muhsin al-'Ajlânî (1840–1847). The other members included Khalîl bey al-'Azm (membership dates unknown), Muhammad bey al-'Azma (?–1860), Abû al-Sa'ûd afandî al-Ghazzî (?–1846), Nasîb b. Husayn b. afandî Hamza (1840–1849), Ahmad afandî al-Hasîbî (membership dates unknown), Muhammad b. 'Uthmân al-Jâbî (1844–?), Mustafâ Jalabî (membership dates unknown), Sâlih aghâ al-Mahâyinî (?–after 1860), Ahmad b. Sulaymân afandî al-Mâlikî (membership dates unknown) and the scribe of the Council, Muhî al-Dîn afandî.

Mixity and mingling among the builders' guild personnel

In conformity with Ottoman bureaucratic practice, the document is organised according to the daily work performed on the worksite, recording, in each case, the names of the men who had worked on the relevant day (the full list is found in the annex). The document lists four consecutive work days: Wednesday (*yûm al-râbi'*: 16 Jumâdâ Awwal 1260), Thursday (*yûm al-khamîs*: 17 Jumâdâ Awwal 1260), Friday (*yûm al-jum'a*: 18 Jumâdâ Awwal 1260)[20] and Saturday (*yûm al-sabt*: 19 Jumâdâ Awwal 1260).

To give a more precise idea of the activities of the 45 persons engaged in this workforce: 28 individuals are listed for Wednesday, 29 for Thursday, 13 for Friday and 16 for Saturday, making a total of 86. This figure obviously does not coincide with the number of individuals working on the site, namely 45, since many persons worked there for several days, some of them in different capacities. A first-hand reading of the names of these individuals reveals that about 15 percent of the total workforce was Christian, as seen by the names of these men who were named Ilyâs, Niqûlâ, Butrus or Jurjî.[21] As we have seen, Christians were found among masters as well as among labourers. In fact, the percentage of non-Muslims computed here could have been slightly higher in reality as several names given in the list such as Qudûr, 'Abdu or

'Aysâ could be borne by members of both the Muslim and Christian communities.

Taking the example of Wednesday's account, the first one in the list: 28 individuals are mentioned as having worked on the repair site, at least five of them being Christians (nearly 18 percent of that day's workforce). Six of the 28 individuals or slightly over 20 percent of that day's work-men had attained the highest level in their profession, namely, that of master (*mu'allim*). Two out of the four men listed as drainpipe layers (*qanâyyita*) held the title of master (their names show that at least one of them was Christian); the remaining two persons held no title at all. All four individuals who worked on Wednesday as masons (*mi'amâr*) were on record as holding the position of master. According to their names, at least one or perhaps two ('Aysâ Qarzûn) of these men were Christians. One might ask whether it was standard practice that masons defined as *mi'amâr* held the title of master. This certainly seems to have been the case since individuals of the *mi'amâr* rank held positions of responsibility and supervised construction work.

Immediately following the mason category, the document mentions ten persons described as labourers (*fa'âlâ*). This seems to signify that these ten workers, at least one of whom was a Christian, were specifically associated with the work carried out by the *mi'amâr* or perhaps with both the *mi'amâr* and the *qanâyyita* since another separate list of *fa'âlâ* also follows immediately after the names of the lime-kiln operators/plasterers (see below). Listing skilled labourers separately according to the work that they carried out signifies that there must have been a division of labour as well as perhaps an administrative need to classify the work according to the skills used on a particular day.

Continuing with the details from Wednesday's work, the list mentions four individuals working as carpenters (*nujjâr*) and two others as lime-kiln operators/plasterers (*kallâs*); none of these six held the title of master. Once again, the document gives the names of four workers listed immediately after the lime-kiln operators/plasterers, using the familiar term *fa'âlâ*.

It is interesting to notice a certain mobility among the skilled labourers in the builder's trades. It seems that some of them were able to move around from one section of the workplace to the next according to need. The list shows that individuals working

one day in one category of skilled labour could very well be found the next day working within a different one. Such was the case with Husayn Kharrâb and Ahmad al-Bûlî, who both worked on Friday as labourers associated with the lime-kiln operators/plasterers. But, previously, on Wednesday and Thursday to be exact, they had been employed as skilled labour with the masons and/or the drainpipe layers. Similarly, Ilyâs b. Suyûn and the same Husayn Kharrâb were both recorded on Saturday as labourers serving the lime-kiln operators/plasterers, whereas the two of them had worked before with the masons and/or the drainpipe layers.

Did these labourers possess several types of skills which enabled them to work with different masters? Or was the term 'skilled' in their job description a pious euphemism and were they really doing unskilled work? The document does not allow one to decide; however, it is worth noting that when these labourers worked with the lime-kiln operators/plasterers, the masons were not on record as having worked on that particular day. Presumably, therefore, these labourers could not have been employed in their previous capacity but were able to work in another one.

As far as concerns daily wages, those belonging to the higher categories all received the same sum. Thus, the drainpipe-layers, masons, carpenters, lime-kiln operators/plasterers and stone-cutters (who only worked on the final day) all received 7 piastres per diem, while the skilled labourers were given 4 piastres, slightly over half the wage received by the masters.

By comparing these figures with material from other sources, it is possible to evaluate wage levels in the private and public sectors. As we have seen, the repair work documented here was paid for by the state or, to be exact, by the administration of the Awqâf. A rate of 7 piastres for masters and 4 for skilled labourers is a good deal lower than the wages given to other workers in nineteenth century Damascus, as noted by John Bowring in his *Report on the Commercial Statistics of Syria*, published in 1840. However, according to information given by Bowring himself, his figures are, in reality, based on the situation in Damascus in 1836, or eight years before the document studied here was compiled, squarely placing the data within the period of the Egyptian presence in Bilâd al-Shâm.

According to Bowring, fully trained carpenters in Damascus in 1836 received between 9 and 15 piastres a day, while masons were given between 8 and 12 piastres. These daily wages are significantly higher than those received by the carpenters on the repair site documented eight years later, in 1844, when they only received 7 piastres a day. Likewise, according to Bowring's study, the labourers who worked with the masons were paid between 5 and 7 piastres a day, but those recorded in the 1844 document only took in 4 piastres daily.[22] Could this difference in wages simply be explained by the fact that Bowring's figures are related to private sector work while the document registered with the Damascene High Advisory Council in 1844 regards public employment? Or could the decrease in wages over this eight-year period be attributed to problems of inflation or to a situation where the local economy was finding its equilibrium following the retreat of the Egyptians from Syria in 1840–1841? After all, the 1844 document was written only a few short years after the withdrawal of Ibrâhîm Paşa's forces from the area.

Although the document does not discuss artisan culture and human relations on the job, the information given in it clearly shows, nonetheless, that religious mixity in the mid-nineteenth century Damascus builders' guild was quite real. Moreover, this seems to have been an ordinary occurrence, nothing in the document indicating the contrary.

Conclusion: the end of religious mixity in the Damascene builders' guild?

From this document alone, it is impossible to know whether Christian and Muslim members of the builders' guild in mid-nineteenth century Damascus celebrated their promotions together whenever one of them rose to the level of master builder. They may have celebrated such events separately but simultaneously, as the silk-thread spinners had sometimes done in eighteenth century Istanbul. On the other hand, festivities may have been completely separate, involving only the co-religionists of the new master. It is likewise impossible to know from this document alone whether Christian and Muslim masters went together to the shar'î court to register collective claims on behalf

of their guilds, nor does the document yield any information about Christian members leaving the guild to work on their own.

Nonetheless, the document does show that, in 1844, some fifteen years before the Damascus massacres, both Christians and Muslims worked on the same site and were represented on all levels of the builders' guilds, earning the same daily wages. As mentioned before, there was nothing exceptional about this. As noted by Suraiya Faroqhi in the first chapter of the present volume, in the 'central provinces', it was also not unusual for Muslims and non-Muslims to belong to the same guild.[23] Religious mixity in the economic and commercial spheres was an ordinary and routine occurrence in Ottoman Syria and in other provinces in the Ottoman lands. The tribunal registers and other bureaucratic documents record that persons of different religions routinely rented, bought and sold property from one another.[24] Whatever the situation may have been outside the marketplace, business transactions that crossed religious borders were standard procedure.

While this type of mixity in the economic and commercial spheres is hardly surprising for researchers familiar with Ottoman documents, it seems important nevertheless to underline this fact. After all, there is still a tendency among scholars who are not familiar with Ottoman realities (and sometimes even among those working on Ottoman history) to perceive this Empire as a very segmented and highly fragmented place where different religious and ethnic groups stayed within the boundaries of their own communities, hardly ever mingling with one another. Overwhelmingly true where personal and familial relationships were concerned, this was not at all the case in the economic and commercial spheres, including the labourers' world, as is apparent from the present document.

Yet, on a final note, one should mention that the composition of guilds was just as vulnerable to social upheavals as any other structure based on human relations. Ilyâs 'Abduh Qudsî, who wrote on the craft organisations in Damascus in 1883, noted that, in his time, the builders' guild was entirely Christian.[25] If we take Qudsî at his word, we can only surmise that the 1860 massacres transformed the builders' guild from a multi-confessional into a mono-religious organisation. After the trauma, Muslim and Christian artisans in the building trades may have been unable to rebuild a working relationship.

Annex: Worksite personnel[26]

Wednesday, *yawm al-arba'* 16 Jumâdâ al-Awwal 1260, a total of 28 persons:
qanâyyita (*sic*) (drainpipe layers) at 7 piastres/day
 mu'allim Niqûlâ
 mu'allim 'Abduh Mawsalî
 Shahdân Himsî
 Butrus Hamawî
mi'amâr (masons) at 7 piastres/day
 'Aysâ Qarzûn *mu'allim*[27]
 Jirjis Waddah *mu'allim*
 'Abû 'Abduh al-A'sânî *mu'allim*
 Mustafâ Mawsalî *mu'allim*
fa''âlâ (skilled labourers)[28] at 4 piastres/day
 Yûsuf Naj''ânî
 Husayn Kharrâb
 Muhammad Abû Yâsîn
 Muhammad Badawî
 Ilyâs b. Suyûn
 Husayn 'Alî
 Mustafâ Yabrûdî[29]
 Ahmad al-Bûlî
 Mahmûd b. Sâlih al-Badawî
 Qudûr al-Saydâwî
najjâr (carpenters) at 7 piastres/day
 Yûsuf al-Hamawî
 Sâlih b. 'Umar al-Dahhân
 Mustafâ Mawsalî
 Muhammad al-Idlibî
kallâs (lime-kiln operators/plasterers) at 7 piastres/day
 Mustafâ 'Amûdî
 Mahmûd 'Amûdî
fa''âlâ (skilled labourers) at 4 piastres/day
 'Alî Ghabûr
 'Atiyya Misrî
 Ahmad Badawî
 Shaykh 'Aysâ

Thursday, *yawm al-khamîs* 17 Jumâdâ al-Awwal 1260, a total of 29 persons, of which 22 had been mentioned in Wednesday's list:

mi'mâr (masons) at 7 piastres/day
 Jirjis Waddah*[30]
 Shahdân Mawsalî
 Abû 'Abduh al-A'sânî*
 Mustafâ Mawsalî*

fa"âlâ (skilled labourers) at 4 piastres/day
 Muhammad Yabrûdî
 Husayn Kharrâb*
 Yûsuf Naj"ânî*
 Mahmûd Badawî*
 Ilyâs b. Suyûn*
 Husayn 'Alî*
 Sâlih Yabrûdî
 Ahmad al-Bûlî*
 Ilyâs al-A'sânî
 Qudûr al-Saydâwî*

kallâs (lime-kiln operators/plasterers) at 7 piastres/day
 Mustafâ 'Amûdî*
 Mahmûd 'Amûdî*

fa"âlâ (skilled labourers) at 4 piastres/day
 Shaykh 'Aysâ*
 Shaykh Muhammad (Yabrûdî?)
 'Atiyya Misrî*
 Mustafâ Jalabî
 'Alî Ghabûr*
 Sâlih Yabrûdî

qanâyyita (drainpipe layers) at 7 piastres/day
 Niqûlâ Qanâyyitî*
 'Abduh Mawsalî*
 Butrus Hamawî*

najjâr (carpenters) at 7 piastres/day
 Yûsuf al-Hamawî*
 Sâlih b. 'Umar al-Dahhân*
 Mustafâ Mawsalî*
 Muhammad al-Idlibî*

Friday, *yawm al-jum'a* 18 Jumâdâ al-Awwal 1260, a total of 13 persons, of which 9 had been mentioned in lists from the two previous days:

kallâs (lime-kiln operators/plasterers) at 7 piastres/day
>Mustafâ 'Amûdî*
>Mahmûd 'Amûdî*
>Ahmad Jalabî

fa''âlâ (skilled labourers) at 4 piastres/day
>'Alî Ghabûr*
>Husayn Kharrâb* (previously listed on Wednesday and Thursday with *fa''âla mi'mâr*)
>'Atiyya Misrî*
>Muhammad Yabrûdî
>Qudûr al-Sâlihânî
>Ahmad al-Bûlî* (previously listed on Wednesday and Thursday with *fa''âla mi'mâr*)
>Shaykh 'Aysâ*

najjâr (carpenters) at 7 piastres/day
>Sâlih b. 'Umar al-Dahhân*
>Yûsuf al-Hamawî*
>'Alî b. Ahmad al-Jalabî (the son of one of the lime-kiln operators/plasterers mentioned above?)

Saturday, *yawm al-sabt* 19 Jumâdâ al-Awwal 1260, a total of 16 persons, of which 12 had been mentioned in lists from the two previous days:

kallâs (lime-kiln operators/plasterers) at 7 piastres/day
>Mustafâ 'Amûdî*
>Mahmûd 'Amûdî*
>Sâlih al-Dayrî

fa''âlâ (skilled labourers) at 4 piastres/day
>'Atiyya Misrî*
>Muhammad Yabrûdî*
>Ilyâs b. Suyûn* (previously listed on Wednesday and Thursday with *fa''âla mi'mâr*)
>Husayn Kharrâb* (previously listed on Wednesday and Thursday with *fa''âla mi'mâr*)
>Qudûr al-Sâlihânî*
>Shaykh Muhammad*
>Shaykh 'Aysâ*

najjâr (carpenters) at 7 piastres/day
 Sâlih b. 'Umar al-Dahhân*
 Yûsuf al-Hamawî*
 'Alî b. Ahmad al-Jalabî*
nahhâtîn (stone-cutters) at 7 piastres/day
 Mûsâ 'Arabjî
 'Abdu Dummar
 Sam'ân b. 'Abd Allah Marâsh

Notes

1 Parts of this work were presented at a conference organised by Brigitte Marino in honour of André Raymond at the French Institute of Arab Studies in Damascus (now IFPO) in May 1998. I would like to take this opportunity to thank Ms. Marino for her remarks given at that time.

2 al-Qâsimî, al-Qâsimî and al-'Azm, 1988, pp. 51–55.

3 Rafeq, 1991; Rafeq, 1993.

4 Yıldırım, 2002.

5 Analysed anew by Colonna, 2004.

6 Discussed recently by Yıldırım, 2002, p. 413, who quotes Giorgos Papageorgiou, *He matheteia sta epangelmata, 16–20. ai*, Athens, 1986, for a study of rituals within craft guilds in Ottoman Janina. For the Syrian case: Rafeq, 1991.

7 For various examples of this in the seventeenth and eighteenth century Ottoman Empire, see Faroqhi, 1984, pp. 280–282; Faroqhi, 1994, pp. 595–598.

8 For some of the more recent studies regarding this type of waqf, where cash formed the assets of the endowment, see Çizakça, 1994, concerning late sixteenth to early nineteenth century Bursa. Bilici, 1994, studies cash waqfs in the form of a *caisse de solidarité* at the end of the Ottoman period and their transformation into a banking system.

9 Faroqhi, 1995, pp. 97, 102–108; Akarlı, 1985–1986; Deguilhem, 2000, p. 90.

10 Rafeq, 1991; Rafeq, 1993, pp. 40, 42–43.

11 Yıldırım, 2000, *passim.*

12 Yıldırım, 2000, pp. 414–415, who cites İstanbul Ahkâm Defterleri n° 5/135, December 1759 and İstanbul Ahkâm Defterleri n° 6/135, September 1763. Also see Marcus, 1989.

13 Yıldırım, 2000, p. 414.

14 I take this opportunity once more to thank Mrs. Da'd Hakîm, former director of the Damascus Centre for Historical Archives, for her kind helpfulness and for that of the Centre's staff during my many visits to the archives over the past years.

15 Register n° 5, documents n° 68 and 69, pp. 45–47, 20 dhû al-qa'da 1260, Dâr al-wathâ'iq al-târîkhiyya (Centre for Historical Archives), Damascus, Awâmir sultâniyya series. This register, although classified with the Awâmir sultâniyya series, contains, in reality, the minutes from the meetings of the Damascene High Advisory Council from 1844 to 1845. This Council's business, which ranged widely from real-estate and waqf transactions to tax questions and matters of personal status has been studied by Thompson, 1993 and by Ghazzal, 1993, ch. 3, pp. 47–67. Hakîm, 2002, pp. 79–88, continues to list this register with the Awâmir sultâniyya series of Damascus.

16 Meier, 2002, pp. 212–213, who discusses an imperial decree from 1837 (Cevdet Adliye n° 4933) mentioned by Barnes, 1986, p. 103.

17 Redhouse, 1987, p. 1905.

18 Deguilhem, 2002, pp. 220–221.

19 Thompson, 1993.

20 Incidentally, the list shows that the notion of Friday as a day off from work was unknown in mid-nineteenth century Damascus. One observes, nonetheless, that fewer people worked on Friday than on the other three days of the week.

21 In the 'central lands', Ilyas is the Muslim version of this name and non-Muslims are often called Ilya.

22 Bowring, 1840, pp. 51, 124. For the sake of comparison, Bowring mentions that a wood-cutter could receive up to $2\frac{1}{2}$ piastres a day, a trimmer up to 3 a day and a man working in transport up to $3\frac{1}{2}$ piastres daily. But the latter also needed to feed his pack animal (p. 12).

23 Faroqhi, 2004, pp. 15–16.

24 As documented in numerous studies, among which: Râfiq, 1985; Rafeq, 1993, p. 44; Rafeq, 2002.

25 Qudsî, as translated by McChesney, 1988, p. 100. In relation to this point, the Dictionary of Damascene Professions that was written at the turn of the twentieth century notes that masons in Damascus at the end of the nineteenth century were almost all Christian and that the drainpipe layers were often Jews: al-Qâsimî, al-Qâsimî and al-'Azm, 1988, pp. 55, 366, 479. According to the names given in the 1844 document, this was indeed true for the masons, most of whom were Christian, if not all of them, but the names show that the drainpipe workers were also Christian and not Jewish.

26 The following information from the 1844 document is listed according to the order found in the document.

27 The term denoting mastership (*mu'allim*) follows the name of the four *mi'mârs* listed here, whereas, for the other personnel categories, the same title precedes the names.

28 As noted in the text of this chapter, the fact that there are two separate entries for labourers having worked on one and the same day leads one to assume that these workers were skilled labourers in a particular domain of masonry.

29 According to his name, this individual more than likely originated from the village of Yabrûd in the Qalamûn region north of Damascus, an area which continues to provide skilled and unskilled workers in the building trades to this day.

30 In the Majlis Shûrâ document itself, titles are given only when an individual is mentioned for the first time. It is impossible to say whether this was standard practice in nineteenth century Damascene record-keeping. An asterisk in my list indicates that the person in question is already on record for a previous day's work.

Bibliography

Primary Sources

Unpublished

Damascus, Markaz al-Wathâ'iq al-Târîkiyya
Awâmir sultâniyya series, register n° 5, 1844–1845

Published

al-Awâmir al-sultâniyya li-wilâyat Dimashq fî ta'yîn al-qudâh wa'l-wulâ wa'l-mu'azzafîn min khilâl tarjamat al-sijillât al-mahfûza fî markaz al-wathâ'iq al-târîkhiyya bi-Dimashq, dir. Hakîm, Da'd, Damascus, Ministry of Culture Publication, 2002.

Bowring, John, *Report on the Commercial Statistics of Syria*, London, William Clowes and Sons, 1840.

Qâsimî, Muhammad Sa'îd al-, Jamâl al-Dîn al-Qâsimî and Khalîl al-'Azm, *Qâmûs al-Sinâ'ât al-shâmiyya*, Zâfir al-Qâsimî, ed. Damascus, Tlasdar, 1988.

Secondary Sources

Akarlı, Engin, 'Gedik, Implements, Masterships, Shop Usufruct and Monopoly among Istanbul Artisans, 1750–1850', *Wissenschaftskolleg Jahrbuch*, 1985–1986, pp. 223–232.

Barnes, John Robert, *An Introduction to Religious Foundations in the Ottoman Empire*, E.J. Brill, Leiden, 1986.

Bilici, Faruk, 'Les waqfs monétaires à la fin de l'Empire ottoman et au début de l'époque républicaine en Turquie: des caisses de solidarité vers un système bancaire moderne', in Faruk Bilici, ed., *Le waqf dans le monde musulman contemporain (XIXe–XXe siècles). Fonctions sociales, économiques et politiques*, Istanbul, French Institute for Anatolian Studies, 1994, pp. 51–59.

Çizakça, Murat, 'Changing Values and the Contribution of the Cash Endowments (*Awqâf al-nuqûd*) to the Social Life in Ottoman Bursa, 1585–1823', in Faruk Bilici, ed., *Le waqf dans le monde musulman contemporain (XIXe–XXe siècles). Fonctions sociales, économiques et politiques*, Istanbul, French Institute for Anatolian Studies, 1994, pp. 61–70.

Colonna, Fanny, 'Le spectre de la dépossession. Du Déracinement à la misère du monde', *Annuaire de l'Afrique du Nord*, 2004.

Deguilhem, Randi, 'Wakf in the Ottoman Empire to 1914', *Encyclopedia of Islam*, fascicule 179–180, 2000, pp. 87–92.

Deguilhem, Randi, 'Centralised Authority and Local Decisional Power. Management of the Endowments in Late Ottoman Damascus', in Jans Hanssen, Thomas Philipp and Stefan Weber, ed., *The Empire in the City. Arab Provincial Capitals in the Late Ottoman Empire*, 2002, pp. 219–234.

Faroqhi, Suraiya, *Towns and Townsmen of Ottoman Anatolia. Trade, Crafts and Food Production in an Urban Setting, 1520–1650*, Cambridge, Cambridge University Press, 1984.

Faroqhi, Suraiya, 'The Fieldglass and the Magnifying Lens: Studies of Ottoman Crafts and Craftsmen', *The Journal of European Economic History*, 20, 1991, pp. 29–57.

Faroqhi, Suraiya, 'Ottoman Guilds in the Late Eighteenth Century: The Bursa Case', in Suraiya Faroqhi, *Making a Living in the Ottoman Lands 1480–1820*, Istanbul: Isis Publishers, 1995, pp. 93–112.

Faroqhi, Suraiya, Bruce McGowan, Donald Quataert and Şevket Pamuk, *An Economic and Social History of the Ottoman Empire 1600–1914*, v. 2, Cambridge, Cambridge University Press, 1994.

Ghazzal, Zouhair, *L'économie politique de Damas durant le XIXe siècle. Structures traditionnelles et capitalisme*, Damascus, French Institute of Arab Studies (IFEAD), 1993.

Kütükoglu, Mübahat, ed., *Osmanlılarda Narh Müessesesi ve 1640 Tarihli Narh Defteri*, Istanbul, Enderun Kitabevi, 1983.

Marcus, Abraham, *The Middle East on the Eve of Modernity, Aleppo in the Eighteenth Century*, New York, Columbia University Press, 1989.

McChesney, R.D., 'Ilyas Qudsi on the Craft Organizations of Damascus in the Late Nineteenth Century', in R.D. McChesney and Farhad Kazemi, ed., *A Way Prepared. Essays on Islamic Culture in Honor of Richard Bayly Winder*, New York, New York University Press, 1988, pp. 80–106.

Meier, Astrid, '*Waqf* Only in Name, Not in Essence. Early Tanzîmât Waqf Reforms in the Province of Damascus', in Jans Hanssen, Thomas Philipp and Stefan Weber, ed., *The Empire in the City. Arab Provincial Capitals in the Late Ottoman Empire*, 2002, pp. 201–218.

Rafeq, Abdul-Karim, 'Craft Organization, Work Ethics, and the Strains of Change in Ottoman Syria', *Journal of the American Oriental Society* 3/3, July–September 1991, pp. 495–511.

Rafeq, Abdul-Karim, 'Craft Organizations and Religious Communities in Ottoman Syria (XVI–XIX Centuries)', *La Shia Nell'Impero Ottomano*, Rome, Academia Nazionale Dei Lincei, 1993, pp. 25–56.

Rafeq, Abdul-Karim, 'Making a Living or Making a Fortune in Ottoman Syria', in Nelly Hanna, ed., *Money, Land and Trade. An Economic History of the Muslim Mediterranean*, London, I.B.Tauris, 2002, pp. 101–123.

Râfiq, 'Abd al-Karîm, 'Mazâhir min al-tanzîm al-hirafî fî bilâd al-Shâm al-'uthmânî', *Buhûth fî târîkh al-iqtisâdî wa'l-ijtimâ'î li-bilâd al-Shâm fî 'l-qarn al-hadîth*, Damascus, 1985, pp. 160–192.

Redhouse, Sir James W., *A Turkish and English Lexicon*, Beirut, Librairie du Liban, 1987 (first printed 1890).

Thompson, Elizabeth, 'Ottoman Political Reform in the Provinces: The Damascus Advisory Council in 1844–1845', *International Journal of Middle East Studies* 25, 1993, pp. 457–475.

Yıldırım, Onur, 'Ottoman Guilds as a Setting for Ethno-Religious Conflict: The Case of the Silk-thread Spinners' Guild in Istanbul', *International Review of Social History* 47, part 3, December 2002, pp. 407–419.

Part Three

THE END OF GUILDS

CHAPTER 10

Relations of Production and Social Conditions among Coppersmiths in Contemporary Cairo[1]

Claudia Kickinger

Among other traditional artisans, coppersmiths are still active in Cairo today. Throughout the centuries, their products have been highly esteemed, but competition from Western-style objects, beginning around the second half of the nineteenth century, has been strongly felt. This study looks at the organisation of crafts and trades in Cairo with the eye of a social anthropologist. Although my field research is primarily concerned with economic and social conditions among coppersmiths in contemporary Cairo, it also reflects, to a certain degree, aspects of the craft's history, especially the division of labour among coppersmiths (*nahhâsîn*).

The study of archival documents, particularly those emanating from the law-court registers, has shed new light on Ottoman guilds. However, there still seems to be a shortage of material regarding, in particular, the organisation of production within and between various guilds in Ottoman times. What I would like to convey above all in this study is information about the actual work of these craftsmen and the way that they organise production. There is a highly developed specialisation among craftsmen according to the technology that is used: this can be seen in their traditional way of organising production as well as in the process of technological development.

In contemporary Cairo, the *nahhâsîn* are united in a *niqâba*, which should represent their interests vis-à-vis the authorities and protect its members. The *niqâba* is headed by a *mandûb*, who

is elected by the members of the *niqâba*. Although the *niqâba* does fulfil some social tasks, such as supporting the craftsman in case of a serious accident or paying the equivalent of about five months' income when he is entitled to a full pension, the *niqâba* is a good instrument by which the authorities control craftsmen. There are many craftsmen in Cairo who do not wish to join a *niqâba*, not only because they must contribute 1 percent of their income, but also because the *niqâba* is obliged to report its membership lists to the authorities.

A craftsman must also be officially insured by social insurance (*al-ta'mîn al-iǧtimâ'î*), which means that about 10 percent of his income goes towards insurance. In return for this, the craftsman receives financial support in case of illness or an accident at work. Hospitals are free, but the craftsman cannot choose the hospital and he must sometimes wait a long time before being treated. Members of the *niqâbas* are united by the *gama'îya al-ta'âwunîya*, a co-operative society, which is headed by an administrative board, the *majlis al-idâra li'l-gam'îyat al-ta'âwunîya*, the double aim of which is control over production and blocking the black market. Once a year, prices for raw materials which the craftsmen can buy at the *gam'îya* are fixed, but many *nahhâsîn* are not really satisfied with the goods offered by the co-operative.

The organisation of the craftsmen differs greatly from what we generally know about guilds. Moreover, the following presentation of the way that production is organised does not, in any way, assume the existence of an uninterrupted tradition. To a certain degree, the present-day division of labour may reflect former practices within the coppersmith's guild, but due to the lack of historical sources, it is impossible to be sure.

Baer attributes the decline of the guilds in the second half of the nineteenth century to the influx of European goods and a developing Europeanised taste, as well as to the modernisation or centralisation of Egyptian administration. The result was that crafts were practised in increasingly individualistic forms. Unfortunately, it cannot be determined exactly when the coppersmiths' guild ceased to exist. It can be said, however, that in 1863 the *nahhâsîn* were already badly hit by European competition and by oppressive stamp duties. If the functions of the guild shaykh were still carried out at that time, this figure must have lost his power, especially in the 1880s and 1890s; in 1881, the shaykhs were

first relieved of tax collection and, in 1890, the Professional Permits Duty was introduced.[2]

The Professional Permits Duty, which announced the freedom of all trades, contributed to a large degree towards the decline of craftsmanship. Qualification played no role in the process of obtaining a work permit. If the *nahhâsîn* are skilled in a large variety of different techniques today, this must be attributed to the efforts made by the workmen themselves, as well as to the early activities of the diverse trade unions. A trade union aiming to raise the quality of Egyptian handicrafts was founded as early as 1911. Annual exhibitions were organised by the coppersmiths, presenting craft objects, mainly embellished with Islamic and Pharaonic designs; this contributed substantially towards improving standards. The trade union also helped craftsmen open workshops.

The coppersmiths' market, the Sûq al-nahhâsîn, is today near the mosque and *mâristân* of Sultan Qalâwûn; more specifically, it is between these buildings and the Sûq al-Sâgha. This was already mentioned by the French at the time of Napoleon's expedition to Egypt. Raymond states that in the seventeenth and eighteenth centuries, as in the time of al-Maqrîzî, almost all the *nahhâsîn* were based in the street called Bayn al-Qasrayn, which was then referred to as the street of the *nahhâsîn*, in the same location as today's market.[3] Raymond also mentions the street called 'Asfa al-nahhâsîn, where a certain number of *wakâlas* (khans) specialised in the production and selling of copperware, as well as noting the Khân al-Khalîlî area as a sales centre for local and imported copperware, mainly coming from Istanbul.[4] The most prosperous time for the coppersmiths, according to Raymond, must have been the seventeenth century. According to late seventeenth century court documents, this was when there were as many *nahhâsîn* located in the Khân al-Khalîlî as in Bayn al-Qasrayn: their economic superiority over other artisans was clearly visible. In the eighteenth century, the importance of the *nahhâsîn* in the Khân al-Khalîlî diminished and the coppersmiths were increasingly concentrated in the Sûq al-nahhâsîn.[5] Today, some remain in the Khân al-Khalîlî. This is also the place where engravers (*naqqâsh*) and inlayers (*munazzil*) do their work, although many are also scattered throughout the market area while others work at home.

Relations of production within the production chain

There is a strong tendency to specialise among the *nahhâsîn*, especially according to technology and technological knowledge, with obvious repercussion upon the process of technological improvement. Co-operation is therefore required between groups of craftsmen or workshops within the production chain. A typical production chain is described below which uses the example of the production of trays (*saniya*), from raising and chasing as well as the technically advanced method of spinning on the lathe and punching to engraving, inlaying and polishing. The following workshops are involved:

Workshop A (al-Balbasî I): Three artisans are employed in raising and chasing as well as in spinning on the lathe.
Workshop B (al-Balbasî II): Six artisans are active in spinning on the lathe and in stamping.
Workshop and Shop C (Hasan and Muhammad Unsî): Engraving is performed in this workshop. Two brothers, Hasan and Muhammad, own both the workshop and the shop. Two other artisans are employed.
Workshop D (Nagîb[6] Barwâ): Engraving and inlaying are performed here by three artisans.
Workshop E (Mahmûd Sphinx): The owner is the only craftsman.

Workshop A

In this workshop, brass and aluminium objects are produced by raising and chasing as well as spinning on the lathe. Raising and chasing is the process of hammering trays or vessels from one piece of sheet metal without a join. Although raising and chasing have been abandoned to a large degree, these activities are still carried out on custom order. In addition to the traditional copperware, a tendency towards the production of aluminium objects can be observed in this workshop since aluminium is cheaper than brass or copper and serves as the material for utensils used by the poor.

The workshop is equipped with a large number of tools, such as an anvil, four different sorts of hammer, mallets, ten different

sorts of stake, four different sorts of punches, as well as metal rings to shape the object. To work the sheet brass which is the basic raw material for the coppersmiths, further utensils are necessary: a pencil, a pair of compasses, a steel ruler, plate shears, a cake of lead, as well as cloth and grease (see Annex 1).

The traditional way of raising and chasing a tray is described below using the example of a crescent-shaped tray (*saniya helâlât*).

Production of the saniya halâlât

A tray decorated with crescents made in workshop A passes through the following stages:

The craftsman takes his compass and makes a circle (diameter 80 cm) on the brass sheet (thickness 2 mm). With a pencil and a ruler, he divides the circle into 14 segments. He cuts out the circle from the sheet with his plate shears. He then puts the metal ring on to the anvil (*sindâl taglîs*). He takes the brass sheet and places it onto the metal ring so that the metal ring is positioned 10 cm inside the edge of the sheet. He commences the raising by striking sharp blows with the wooden mallet on the brass so that the brass sinks about 2 cm at an angle into the hollow of one half of the metal ring.

After the 14 crescents (*halâlât*) have been shaped by this process, the craftsman removes the metal ring from the anvil and starts planishing the brass within the crescents. Then, he turns the object around to flatten and planish the rim (*shiffa*) on the anvil, first with the mallet, then with the hammer (*shakûsh shînî*). He then turns the object around in order to remove any remaining unevenness.

The *saniya* is then taken to the lathe, where it is checked to verify whether the object is really circular. Wherever it is not circular, the outer edge has to be cut off with a chisel. After this, a line (*kâmak*) is drawn on to the rim. In former times, a spinning wheel set in motion by the feet was used for this procedure. The craftsman controls and corrects with his compasses the distances between the centre of the tray and the tips of the crescents. This is done from the back of the tray.

The craftsman then takes a punch called the *maqta' tadlî* and places it on the tip of the crescent, striking a sharp blow with the

hammer (*shakûsh murabba' murabba'*) in order to drive the metal into the cake of soft lead which is placed under the tray. He then draws a line to the middle of the crescent. This process is repeated in all 14 crescents.

Having done this, the craftsman shapes the area within the crescents (*khânât*) with the same type of hammer previously used. This is done on the anvil from the front of the tray. Afterwards, he planishes the walls of the crescents, using the stake (*watad kalâwî*). He turns the tray over it so that the wall of the crescent is placed on the curved side of the stake and hammers against it with the *shakûsh shînî*.

Finally, the craftsman shapes the rim of the tray so that it is slightly bulged. This is first done with the mallet and a round-headed stake and then with the hammer. At this stage, the tray can be carried to the decorator's workshop.

The craftsmen and their work

Workshops A and B are jointly owned by the brothers Darwîsh Mustafâ al-Balbasî and al-hâgg Muhammad Mustafâ al-Balbasî, who inherited the workshop from their father Mustafâ Muhammad al-Balbasî. At the age of thirty, the latter opened the workshop in Khân Abû Taqîya, as well as workshop B in 1949. Darwîsh Mustafâ al-Balbasî, the head and master of workshop A, had learned the craft at the early age of five in his father's workshop.

'Îd Hasan Darwîsh has worked in this same workshop since 1945. At the age of twelve years, he had started as an apprentice in another workshop where lamps (*fawânîs*) were produced but then changed over to workshop A.

'Atîya 'Abd al-Fatâh al-Balbasî, a nephew of Darwîsh, was introduced into the workshop when he was a small schoolboy. He had finished school with a technician's diploma. Nevertheless, his situation was rather difficult. He was obliged to work in the morning in an aluminium workshop and, in the afternoon, was employed in his uncle's workshop, where he operated the lathe and cut the metal sheet.

There were no trade-wide regulations concerning occupational careers or the process of movement from one status to the next.

An artisan's status within the workshop reflected his experience, expertise and age. Although not officially in the position of workshop head, 'Îd Hasan Darwîsh possessed all a master's qualities. Both he and Darwîsh did the raising and chasing as well as work on the lathe when necessary. This was especially true when 'Atîya had to work in the other workshop. Furthermore, Darwîsh, the head of the workshop, was responsible for the reception of orders and for the distribution of work.

Two types of arrangements were typically concluded between the shopkeepers and the head of the workshop: either the former provided the latter with the metal sheets and merely paid for the work or the head of the workshop bought the metal sheets, the price of which was then added to the production costs. Although orders were usually made by shopkeepers, they were also received from private persons, but that was rarely the case.

Concerning the financial situation of the artisans, Darwîsh, the head of the workshop, was by no means in a better position than 'Îd, who worked ten hours a day but who had the advantage of a regular daily wage, whereas Darwîsh's income was irregular. He had to save money in good times so that he could pay his workers even when there was little to do. Ever since the 1960s, he had not even thought of investing in the workshop because

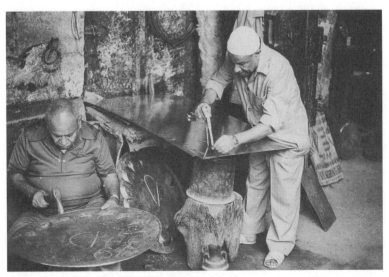

Raising a tray in al-Balbasî's workshop

there was no money left over after expenses. 'Atîya, who worked six hours per day, received a little bit less than half of the amount of 'Îd's wage. However, the workers' identification with the workshop was strong, so a possible delay in payment was understood. They knew that they all had to live from the same craft and everybody tried to do his best.

Workshop B

Raising and chasing has been abandoned in this workshop in favour of spinning and stamping. Spinning is a method by which the metal sheet is shaped on a lathe (*mikhrata*). Stamping is carried out on the press (*makbas*). The press is as old as the workshop, which was founded in 1949 and headed by al-hâgg Muhammad Mustafâ al-Balbasî.

The lathe has an interesting history. It was constructed in 1968 by al-hâgg Muhammad himself. He could not buy a new lathe for financial reasons, so he studied the functioning of this tool in another workshop and constructed two such items on his own. This had considerable consequences. About twenty workers were in the workshop until 1968, but then the number of workers began to decrease dramatically until there are now only six of them left. Although the machines are by no means modern, it has to be considered that the production of an object on a lathe takes between 5 and 10 minutes. The production of an object on a press is even completed in only a few seconds.

Preparation for production

The craftsman needs a pencil, a steel ruler, a pair of compasses, plate shears, a vice and sheets of metal measuring 1, 1.5 and 2 mm in thickness in order to prepare the sheet brass. He is either assisted by a helper when cutting out the sheet or he uses the vice.

The lathe

The implements used for the lathe are form-giving tools such as the *rûl* (*rûl kabîr, rûl mutawassat, rûl saghîr*) and the *mas'âla fûla*, both of which are used to press against the object, a chisel

(*rãndã solb hãwâ*) a centring tool (*mas'âla isti'dâl*). Other necessities are cloth, grease, oil and soap. In addition, a large number of moulds is necessary (*qawâlib al-makhrata*). They are kept hanging on the wall of the workshop. There are 13 different types of moulds, all of them in several sizes (see Annex 1). In former times, most of those objects now produced on the lathe were raised and chased.

Production on the lathe

In today's Cairene workshops, the lathe is worked in the following manner. First of all, the craftsman must screw on the mould or disk (*qâlib*). He then places the sheet of metal between the mould and a disk (*qudba*) and fixes it slightly with the hand wheel. Then he positions the tool carriage (*rakîza*).

The motor must then be turned on or, if already on, the lever (*dirâ' al-'ammâl*) must be operated so that the belt (*qishât*) moves to the active wheel. Subsequently, the other lever must be operated to obtain the lowest speed. Then, the object must be centred with the centring tool (*mas'âla isti'dâl*) and tightened.

To get a higher speed, the speed lever (*dirâ' al-suru'ât*) must be operated so that the belt shifts to the other speed wheel (*mudarrag al-suru'ât*). Having done so, the craftsman can start with the process of form-shaping. To do this, he presses against the rotating object with a tool (*rûl* or *mas'âla fûla*) so that the sheet of metal slowly takes on the desired shape. If the rim is shaped freely, this is done by stretching and compressing. An assistant is needed to press against the object, especially in the case of large items. From time to time, the tool must be dipped into oil or soap.

Before cutting and smoothing the edge with the chisel, the object must be turned around. Then, a line can be drawn on the rim (0.5–1 cm inside the edge) with the chisel which the decorator uses as guiding line. If the object is not to be decorated in another workshop, the rim is then rubbed off and polished with emery. After this, the lever *dirâ' al-battâl* is operated in order to shift the belt to the passive wheel so that the machine is out of motion. The next object can then be fixed.

The press (**makbas**)

The rectangular, oval and also some of the round trays are shaped with the press, which is operated by three persons. The craftsman, who places the dies and the sheet brass between the dies, sits in a hollow in front of the press. Two assistants turn the wheel so that the positive die (*dakkar al-istamba*) is pressed

Tools for the lathe

on to the sheet brass into the negative die (*nitâyat al-istamba*). Co-operation is very important in this case because all three workers must follow the same rhythm. Up to 50–100 trays are

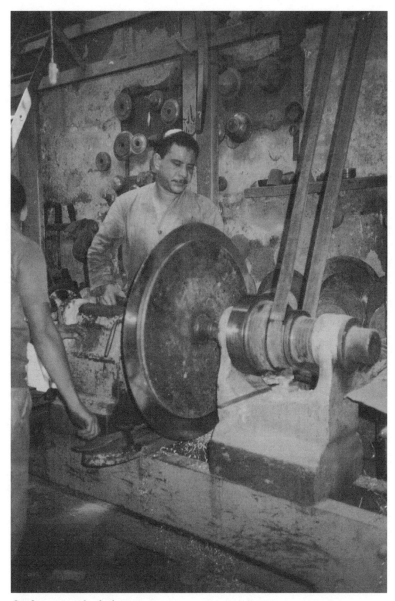

Craftsmen at the lathe

sometimes produced at the same time. A second of inattention and the craftsman is badly hurt! After the work is done, the trays are either carried to the workshop of the decorators or, if they are not to be decorated, to the *sanfarî*, who rubs the rims with emery and polishes the whole tray, if necessary.

The dies have been produced in Khân al-Khalîlî to the order of al-hâgg al-Balbasî. They were partly designed according to the models of old raised and chased trays and partly following the hâgg's ideas. At the time of my research, the workshop possessed 29 different sorts of die (see Annex 2).

Planishing of the decorated trays

This process is necessary if any unevenness appears after engraving or inlaying. The tools used are the anvil (*sindâl taglîs*, with three straight sides and one curved side), the wooden mallet (*doqmâqa 'âda*) and the hammer with a square face (*shakûsh murabba' murabba'*). Planishing is done from the back of the tray. If the craftsman needs to correct some parts from the front, he must be very careful as he could damage the decorator's work.

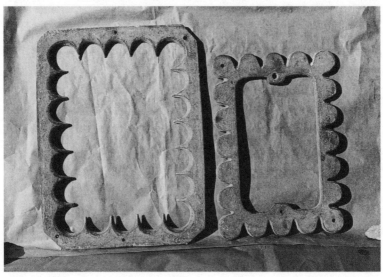

Dies for the press

The craftsmen and their work

Although workshop A and workshop B were jointly owned by the brothers Darwîsh Mustafâ al-Balbasî and al-hâgg Muhammad Mustafâ al-Balbasî, the latter was the actual head of workshop B. As we have noted, he had learned the craft of raising and chasing in his father's workshop when he was five years old. Now, he is responsible for taking orders and distribution of work. He can no longer practise the craft actively because of old age. Only occasionally, when he feels strong enough, he takes a brass sheet and does the raising and chasing, which otherwise has been abandoned in this workshop in favour of spinning on the lathe and stamping.

His nephew, Muhammad Darwîsh Mustafâ al-Balbasî, who will be the successor, assists him in decision-making. Muhammad Darwîsh started to work in workshops A and B at the age of six and also attended elementary school. As a master, he is skilled in every domain covered by the workshop. He mainly operates the press, but also works the lathe. Hasan Yûsif al-Hifnâwî, who began to work in this same workshop in 1962 at the age of eight years, attended school for eight years as well. He is now in the position of a journeyman, mainly operating the lathe, but also trained for the press. Mustafâ Bâsit al-Balbasî, a grandson of al-hâgg Muhammad Mustafâ, is also employed in the workshop. He has completed his education with a business diploma (*diblûm tuggâra*) and bides his time in this workshop until he can find a job commensurate with his education. He mainly assists al-Hifnâwî and Muhammad Darwîsh on the lathe and the press.

Muhammad Sa'd al-Dîn began to work in 1962 at the age of nine and attended school for an additional five years. Because he was drafted into the army for some time, he only worked half-days. His tasks are mainly assistance on the lathe and press and the cutting of brass sheets. Târiq Ahmad Kabsha, who began to work in al-Balbasî's workshop at the age of fourteen, after having completed eight years of school, is employed half-days in the military administration in Cairo. In the afternoon, he assists on the press and lathe or cuts the brass sheets.

As mentioned, at the time of my research, there were no trade-wide regulations concerning promotion; this was in the hands of the master and head of the workshop, who accorded

the titles to their employees and increased their wages as he saw fit.

As in workshop A, the status within the workshop reflected experience, expertise and age. Arrangements between shop-keepers and the head of the workshop also resembled those of workshop A. Again, the head of this workshop had to save money in order to pay his workers in times when market conditions were bad. Muhammad Sa'd al-Dîn, Mustafâ Bâsit al-Balbasî and Târiq Ahmad Kabsha all earned about half as much as the journeyman. Given his position of responsibility, the wage to the master, Muhammad Darwîsh, was not fixed. As a member of the family and successor to the master, he took his uncle's financial situation into consideration regarding his own pay and I had the impression that good and bad times were shared alike between nephew and uncle.

Working conditions were rather bad for everybody. There was a lot of very loud noise and brass shavings polluted the air. There were no windows and the only source of light, in addition to the lamps, came through the roof. In wintertime, it was icy cold.

Workshop C

All sorts of trays and vessels are engraved in this workshop: 80 percent of the engraving is done on trays. The craftsmen are called *naqqâsh* (in colloquial Egyptian: *na"âsh*). The workshop is located in *Shâri' Rab'a al-Silhidâr* in the area of *Khân al-Khalîlî*. The workshop is really only a niche opposite the shop which the craftsman and his brother have inherited from their father. Although both are co-owners, Hasan Unsî is in charge of the workshop, while his brother deals with the shop. The products of many other *nahhâsîn* are sold here as well and, conversely, the master Hasan Unsî works to order for other traders or clients. The tools used by the craftsmen are two sorts of hammers (*shakûsh al-naqsh* and *shakûsh tashtîb*), which are used together with punches, chisels and gravers (*qalam al-naqsh*), punches (*qalam gûharsa, qalam zumba*), compasses, a wooden vice and a file. Further utensils are pitch (*zift, bayât*), a Bunsen burner (*wâbûr gâz*), a sharpening stone for the chisels (*misann*), emery paper (*sanfara*), steel wool (*sanfara silk*), oil and grease (*zayt*), cloth (*qutn*), pencils

and a ruler. The trays that they decorate are 1 mm, 1.5 mm and 2 mm in thickness.

Production

As for production itself, the craftsman fixes the tray on the pitch by heating the latter's surface. He waits until the pitch hardens and then draws the design with a pencil, ruler and compasses or, in some cases, with the aid of tracing paper. Having done so, he draws the basic design, the *naqsh zahîrî*, by using the hammer (*shakûsh al-naqsh*) and a chisel. The chisel must be led at an angle of about 45° in order to properly remove the metal waste produced by engraving. It must be oiled and sharpened repeatedly. Having engraved the basic design, the craftsman produces hatching by filling it up with small parallel lines and/or punches. The latter process is called *tashtîb*.

When the craftsman has finished his work, he takes the tray off the pitch by heating its surface so that the pitch softens. The back of the tray is then rubbed with steel wool. At this stage, the item may be carried to the workshop of the *sanfarî* to be polished. Hollow vessels are engraved by the same process, the pitch being poured into the vessels, which are held in a wooden vice. Furthermore, Hasan Unsî makes rather modern-looking door-plates to custom order. Sheet brass is cut to the desired shape in al-Balbasî's workshop B, while Hasan Unsî does engraving in his own workshop.

The craftsmen and their work

The engraver Hasan Unsî, master and head of the workshop, began to work in his father's workshop when he was ten years old. This was also the time when he left school. In 1974, together with his brother Muhammad, he inherited both the workshop and the shop. Muhammad had received a better education and worked in a bank before he took over full responsibility for the shop, acquiring an adequate stock for a wide variety of customer tastes. Although selling was his major occupation in the shop, he also found orders for his brother, who, when necessary, replaced Muhammad in the shop. It was difficult to ascertain how profits were shared between the two brothers, but it was obvious that

Hasan was in the better financial situation and that his social status within the market was high. His brother, on the other hand, although he had jointly inherited the shop and workshop, was a simple but highly qualified *naqqâsh*.

Hasan's son, Ahmad Unsî, had learned the craft (*naqsh*) from his father. At the time of my research, he was still practising, but he was also on the lookout for business in Cairo and Alexandria and supplied some shops in both cities with engraved brass trays.

Sâbir Muhammad Maslûb came from Luxor, where he attended elementary school and learned the craft in his father's workshop beginning at the age of ten. When his father died, he moved to Cairo with his uncle. Sâbir served in the military, where, every day, he remained until two o'clock in the afternoon. A hard-working person, he then took the bus and rushed to the workshop, where he engraved trays until about nine or ten o'clock in the evening. He had just one day off and this was the only time when he could relax a little. He was considered a good worker and, therefore, his daily wage was almost as high as the weekly pay of a young apprentice and equivalent to what was earned by the journeyman in workshop B.

Workshop D

Nagîb Barwâ's workshop is located in the Wakâlat al-Makwâ in the area of Khân al-Khalîlî. He is an engraver as well as an inlayer (*munazzil*). The practice of inlaying parts of a metal object with patterns formed from wires is called *tanzîl*. Artisans' tools in this type of work are different sorts of hammers (*shakûsh al-naqsh, shakûsh tanzîl*), chisels (*qalam al-naqsh, qalam al-tanzîl, qalam fard* and *qalam gûz*), punches (*qalam raml, qalam gûharsa, qalam zumba*) and compasses (*bargal*). Further utensils are pitch, a Bunsen burner, a sharpening stone for the chisels, emery paper, steel wool, oil, grease, cloth, tracing paper (*rasm*), a pen, ink (*rîsha, hibr*), a ruler and copper and silver wires (*silk*). The thickness of the trays to be inlaid are 1 mm, 1.5 mm and 2 mm.

Production

The craftsman fixes the tray on the pitch. Then, he draws the design, in most cases by using tracing paper. He starts with the basic design, the *naqsh zahîrî*, by using the *shakûsh al-naqsh* and the *qalam al-tanzîl*. He does not yet engrave the parts to be inlaid, but he only indicates the borders of the design. The design to be inlaid is then engraved and all the waste metal carefully removed. He begins with the *qalam fard* and leads it by giving quick blows with the hammer. Then, he uses the *qalam gûz* at a different angle and leads it in the same direction. This procedure completed, he places it so that he can lead the chisel in the opposite direction.

If the craftsman wants to inlay larger patterns, he must divide the design into lines. These lines must be placed side by side so that the brass does not appear when he has driven the wire into the recess. After this, the wire is held in position and the craftsman gives it quick taps with the hammer (*shakûsh tanzîl*). The blow drives the wire down to the roughened metal which grips the wire firmly. This process is called *tashbîk*. Patterns must sometimes be tapped down additionally so that the metal spreads out on the sides and makes a complete overlay, which is called *tagmî*. After this, punches are driven in the empty areas of the metal, which is called *tashtîb*.

The next phase is called *malw wa-tash'îr*, which means further special decoration of the empty areas with small irregular parallel lines. Once this is done, the craftsman can remove the tray from the pitch by heating it. The inlaid item can then be taken to the workshop of the *sanfarî* to be polished.

The craftsmen and their work

Naǧîb Barwâ attended elementary school and began to work at the age of ten years in the workshop of an engraver and an inlayer. In 1976, he opened his own workshop. He is assisted by two craftsmen. One of them, 'Abd al-Mugayyid Muhammad Sa'îd, who was introduced into the craft in another workshop at the age of twelve, does good work and earns as much as the journeyman in workshop B. Ahmed Zayd learned the craft at the age of sixteen after he had finished elementary school. His

experience and expertise were not of as high a standard as that of 'Abd al-Mugayyid, a fact expressed in a slightly lower wage. There was no division of labour within the workshop. Everyone worked on his own piece from start to finish, but better qualified craftsmen executed the more complicated designs.

Nagîb Barwâ was only a little better off than the other craftsmen. He complained about the shopkeepers who were late in paying since he, himself, needed to defray the wages of the craftsmen, provide them with good tools and buy the sheet brass and wires. If the objects were defective, they could not be sold at the previously agreed price, an occasion for losses which might prove to be serious. Therefore, Nagîb Barwâ had to try and save money in good times. He had nothing left over for investment in the equipment of the workshop.

All the craftsmen involved form part of the *nahhâsîn* group, although they also have other names, as seen above, related to their specialised craft. The only craftsman in the chain of production who does not belong to the *nahhâsîn* is the polisher (*sanfarî*) located in Shâri' Abû Taqîya.

Inlaying in Nagîb Barwâ's workshop

Conclusion: living conditions observed
outside the workshops

As a conclusion, we will refer to social conditions among the various *nahhâsîn* whom we have encountered. These are not only reflected in the social relations of production and in the conditions prevailing in the workshops, but also in the artisans' living standards at home and in the community. With the exception of the shopkeeper, Muhammad Unsî, I had the impression that no one was satisfied with his social situation, even though the artisans' aspirations were rather modest. Financial problems dominated their thoughts and they found it difficult to improve their condition. Throughout, they felt dependent on the current state of the market. Even in the case of workshop B, technological improvement or mechanisation did not ensure upward social mobility. Artisans 'made do' by renting inexpensive flats, either in the market district or in other cheap quarters of Cairo, by riding bicycles, motor-cycles or buses and by leading a tradition-bound, simple life within a modest household. These craftsmen were convinced that their craft had no future and were interested in a better education for their children or, at the very least, vocational training in trades or occupations with a greater demand.

Annex 1 : Tools, utensils and other objects found in the
above workshops and shops[7]

Sheet brass: *lûh* (in 0.5 mm, 1 mm, 1.5 mm, 2 mm thickness)
Pencil: *qalam*
Pair of compasses: *bargal*
Steel ruler: *mastara*
Plate shears: *maqass*
Chisel: *randa sulb hawâ'*
Cake of lead: *qurs al-rasâs*
Cloth: *qutn*
Grease: *zayt*
Lathe: *mikhrata*

Moulds: *qâlib*
- *qâlib sanîya bâgha*: 25, 30 and 100 cm; depth: 1–4 cm
- *qâlib taqtûqa* (for ashtrays): 11, 12, 13, 14 and 15 cm; depth: 0.5 cm
- *qâlib birwâz mirâya* (for mirror frames, although also used for trays): 30, 35 and 70 cm; depth: 3–5 cm
- *qâlib angar bi-shiffa 'adla* (a traditional water basin used with a jug): 25, 28, 35 and 55 cm; depth: 3.5–8.5 cm
- *qâlib angar faddîya shiffatu bi-dawwarân* (a typical *baladî* tray for holding poultry or fruit. The term *faddîya* does not always imply that the material is silver, but rather refers to everything that looks like silver. The tray must be tinned because copper and brass are toxic. Therefore, *faddîya* refers to tinning.): 25, 28, 35, 40, 45 and 70 cm; depth: 1–4 cm
- *qâlib sanîya miskûfi* (right-angled): 20–100 cm; depth: 1.5–6 cm
- *qâlib sanîya faddîya bi-shiffa malfûfa li'-l-dâkhil* (a *sanîya* with a concave rim): dimension: 25, 25, 30 and 50 cm, height: 1.5–3 cm
- *qâlib sanîya faddîya bi-shiffa 'adla wa-bi-kharazâna* (with an even rim. This tray was once made of silver; today, it is made of brass): 20, 25, 30 and 50 cm; depth: 1.5–3 cm
- *qâlib sanîya shiffa bi-kilwatân* (two convex bulges): 20, 25, 30 and 50 cm; depth: 1.5–3 cm
- *qâlib sanîya faddîya bi-shiffa 'adla* (an even rim): 20, 25, 30 and 50 cm; depth: 1–2 cm
- *qâlib garas* (a gong): 17, 20, 25 and 30 cm; depth: 1.5 cm
- *qâlib sanîya bâgha mahkûmat al-shiffa bi-shakl al-qâlib*: 20, 25, 30 and 50 cm; depth: 1–2 cm
- *qâlib atbâq al-naqsh* (in this case, decoration is not an optional addition but is obligatory): 15, 20, 25 and 50 cm; depth: 2.5–6 cm

Mallets: *duqmâqa 'âda*

Hammers: *shakûsh*
- *shakûsh murabba' murabba'*: hammer with a square face
- *shakûsh murabba' midawwar*
- *shakûsh shînî*
- *shakûsh murabba' bi-kilwa*
- *shakûsh al-naqsh and shakûsh tashtîb*: used together with punches

Anvil: *sindâl taglîs*
Metal ring: *gilba*
Vice: *milzama*
mangala (wooden vice)
File: *mibrad*
Press: *makbas*
Gravers: *qalam al-naqsh*
Stakes: *watad*
- *watad midawwar*: circular for curves and pinnacles
- *sindâl saghîr*: small stake with three straight sides and one curved side to form the bulge between the bottom and the rim
- *watad mikrâsh baydâwî*: two straight sides and a curved one
- *watad kalâwî*: for shaping the area between the bottom and the rim, for special bulging of the outer rim and for decoration
- *watad sawwâ sûka*: for right-angled corners
- *watad sûbâ*': 'finger': one side is sharply pointed, the other curved
- *watad zufr*: 'claw' for right-angled shapes and bulges
- *watad tadlî*': to make notches on the rim, used with the *maqtâ' tadlî*'
- *watad tadlî*' with two notches (it is used with the *maqtâ' shiffa*)
Punches: *maqtâ*'
- *maqtâ' zufr*: to shape pinnacles along the rim
- *maqtâ' zufr al-zâwiya*: to shape pinnacles in the corners
- *maqtâ' shiffa*: to shape two notches on the rim simultaneously
- *maqtâ' tadlî*': to make notches on a rim

Annex 2 : Dies (in workshop B)

2 types of *halâlât* (crescent): one 35 by 35 cm and the other 40 cm
2 dies with no particular name: one 40 by 40 cm and the other 35 cm
yâsîr: 30 by 40 cm
2 types of *gamîla*: diameter 30 cm and the other 30 by 40 cm

'*azîza:* diameter 30 cm
'*abîr:* diameter 35 cm
sunnî : diameter 40 cm
bazza: 30 by 40 cm
sukkara: 30 by 40 cm
kantûr : 30 by 40 cm
mârkîz: 35 by 46 cm
lûsha: 30 by 40 cm
fu'âda: diameter 40 cm
baydawî miskûfî (oval and right-angled): 35 or 46 cm
samîha: diameter 35 cm
alif wa-thulthumîya: 38 by 50 cm
bi-sinna: 35 by 46 cm
rashâ: 35 by 46 cm
bi-sinna baydawî: 35 by 46 cm
alif wa-khumsumîya: 40 by 50 cm
halâlât lûh sitta (thus called because the available sheet of metal is divided into 6 pieces): 35 by 46 cm
khartûsha: 15 by 25 cm or 18 by 28 cm
khartûsha bi-kharazâna: 15 by 26 cm or 19 by 30 cm
miskûkfî lûh sitta: 35 by 46 cm
nûra: 15 by 26 cm
maqlama lûh thamaniyya (pen-case which involves 1/8 of a sheet): 26 by 42 cm.

Notes

1 The transcriptions used in this chapter conform to Egyptian colloquial usage in Cairo.
2 Baer, 1964, pp. 138, 144–149.
3 Raymond, 1973, p. 359.
4 Raymond, 1973, p. 359.
5 al-Maqrîzî (1306, v. XI, p. 374) mentions a market of inlayers which, according to him, was beginning to disappear by the beginning of the fifteenth century. It is not mentioned in later sources.
6 Transliteration is according to local pronunciation, hence the 'g' instead of the 'j'.
7 Transliteration is according to local pronunciation.

Bibliography

Baer, Gabriel, *Egyptian Guilds in Modern Times*, Jerusalem, Israel Oriental Society, 1964.

Maqrîzî, Taqî al-Dîn Ahmad 'Alî b. 'Abd al-Qâdir b. Muhammad al-, *Kitâb al-mawâ'iz wa'l-i'tibâr fî dhikr al-khitat wa'l-âthâr*, Bulaq, 1306.

Raymond, André, *Artisans et commerçants au Caire au XVIIIe siècle*, Damascus, French Institute of Damascus, 1973–1974.

CHAPTER 11

Histories and Economics of a Small Anatolian Town: Safranbolu and its Leather Handicrafts

Heidemarie Doğanalp-Votzi

The economic and social history of the Ottoman Empire is still largely a scientific desideratum. This is even more true for the economic and social history of local regions such as, for example, small Anatolian towns, simply because the availability of scarce archival and other written sources is so often a matter of chance.

On the other hand, studying the local and regional economic history of Asia Minor always means, to some extent, dealing with multi-cultural, multi-ethnic and multi-religious conditions, a fact all too easily and often even willingly neglected by many scholars in Turkey and elsewhere. This study attempts to trace aspects of the history of the small town of Safranbolu, regarding several aspects related to its different cultures, ethnic composition and religions. At the same time and in relation to the town's historical diversity, the study focuses on economic activities in Safranbolu with particular emphasis on the town's leather handicrafts.[1]

Safranbolu – rather remote, not easily accessible and off the important routes of traffic and commerce in former times – was certainly not a very prominent centre of the Anatolian leather industry. Nevertheless, it undoubtedly had some importance on a regional scale: after agriculture and timber, leather handicrafts constituted the third main branch of production for the town and its environs.

Safranbolu is located in the western part of the Pontic ranges, 65 km inland from the Black Sea and 105 km west of Kastamonu. Whereas in Ottoman times, for the most part, Safranbolu was

administratively connected to Kastamonu, nowadays it belongs to the province of Zonguldak, the large coal-mining district on the western Black Sea. About 10 km to the west of Safranbolu is Karabük, with its Demir ve Çelik Fabrikası: Turkey's first integrated iron and steel works, which began operation in 1939 and was privatised some years ago. Since Karabük then became the centre of attraction, Safranbolu could stay the way that it was and not be affected by the modern urbanisation that took place in Anatolia in the 1950s. Because of this, its old architectural traditions were preserved, especially the half-timbered, three-storied houses in the Pontian Greek style constructed to be earthquake-proof. As a result, several years ago, Safranbolu was included in UNESCO's World Heritage programme.

Historical aspects

Tumuli mounds dating back to the third and fourth millennium BC suggest that the region around Safranbolu has a long history of human settlement. The oldest known civilisation in this area seems to be that of the Gasgas and the Zalpas, neighbours of the Hittites. In the first millennium BC, the region was known as Paphlagonia. Persian, Hellenic, Roman and, of course, many Byzantine remains from the following centuries are found in and around Safranbolu.[2]

Different interpretations identify Safranbolu with the ancient towns of Flaviopolis, Theodoropolis, Hadrianopolis, Germia and Dadybra.[3]

In any case, the town's name was said to have been Dadybra when it was temporarily conquered by the Seljuks. At that time, Melik Muhibittin Mesut, the son of Kılıç Arslan, had promised the Greek-Byzantine population of the town that their lives would be protected if they surrendered without a fight. It is recorded that the town was taken by force but it is not known what happened to the Christian inhabitants after the conquest.[4] But, in those days, there were Greek communities already living *extra muros* within the confines of present-day Kıranköy, situated outside the then fortified city. This was where Safranbolu's main Greek quarter was later to be located and where the exchange of populations took place in 1923.

Following the Seljuks, the town's name was changed to Zalifre and the region Sinop-Kastamonu-Safranbolu-Gerede-Söğüt was declared a frontier zone (*uç*).[5] In the subsequent years, the regions around Safranbolu switched hands several times between Turcomans and Byzantines. From 1213 to about 1280, the town belonged to the *beylik* of the Çobanoğulları, who had established themselves in Kastamonu and Sinop, and who were appointed by the Rumseljuks as frontier guards: 'The political role of the Turcomans during this period is a matter of conjecture; one possibility is a *de facto* division of authority between the provincial authorities of the Saldjuks, controlling the town itself, and the Turcoman amirs, in virtual control of much of the hinterland of the province', as Heywood states.[6] The majority of the Greek-Byzantine population continued to live there, although this very region then served as a source for Greek slaves, obtained in *razzias* on the frontier zone and destined for the Seljuk army. Later on, the Çobanoğulları became tributary to the Mongol Ilkhanids.

In 1326, Candaroğlu Süleyman Paşa took Safranbolu. Six years afterwards, Ibn Battuta came to the town and, on his way to Kastamonu, paid a short visit to its governor, Ali Bey, son of the pasha of Kastamonu. According to Ibn Battuta, a *medrese* teaching the Hanafi doctrine already existed there.[7] From the period of the reign of the Candaroğulları, the Gazi Süleyman Paşa mosque functioned in Safranbolu; there was also a former Byzantine church, two bathhouses and several fountains. Aside from the church, these structures seem to date from the initial phase of Islamic architectural history in Safranbolu. A second and comparable period of Islamic construction occurred only much later, in the seventeenth century.

In the mid-fourteenth century, Safranbolu came under Ottoman supremacy for the first time. From this point up to the final Ottoman conquest in 1416, Safranbolu became a frontier town between the Candaroğulları and Ottoman territories. In this region, the Ottomans tried to settle Turcoman nomads (known as Yörükan-i Taraklı) on a large scale.[8] From the middle of the fourteenth century onwards, the town was called Taraklı Borglu and was also known simply as Borglu and Borlu. In the mid-eighteenth century, the name Zağfıran Borlu appeared and then changed to Zağfıran Bolu in the nineteenth century. Finally, at

the beginning of the Republican era, the town was known as Zafranbolu and then in the 1940s as Safranbolu.[9]

Not much is known about its history during Ottoman rule. In the fifteenth century, the town seems to have experienced a relatively quiet time. In the sixteenth and seventeenth centuries, it grew and expanded downhill due to waves of migration from surrounding villages into the town. Reasons for these migrations, which took place in all of Anatolia, included high taxation rates, in addition to a huge burden on farmers in connection with revolts and insurrections in most of Asia Minor, as well as insecurity outside the towns. As a result of these events and of immigration, there seems to have been a large-scale Turkification of Safranbolu.

During the seventeenth century, a new period of construction activities began and continued up to the nineteenth century. The first impulse for this construction was due to Cinci Hoca, a man from Safranbolu who had gained much influence in Istanbul palace politics during the time of Sultan Deli Ibrahim (1640–1648). Cinci Hoca had a khan built in the centre of Safranbolu's market area. It is a huge double-storied building made of squared stone; there are sleeping quarters on the upper floor and depots and stables on the ground floor. A khan of that size had become necessary because from the seventeenth century onward – at the latest – a branch of the so-called *ortakol* (a trade route leading from Istanbul to Bolu, Gerede, Tosya, Amasya, Tokat and Sivas) bifurcated in Gerede and led via Safranbolu and Kastamonu up to Sinop. Safranbolu was one of the stops on this second-order route.[10] Yet, Safranbolu's nearest connection to the Black Sea was the small harbours of Bartın and Amasra.

Köprülü Mehmet Paşa, the well-known grand vizier, spent his enforced exile in Safranbolu and, shortly before his death in 1661, built a mosque there which was named after him. Subsequently, and since the end of the eighteenth century, certain persons originating from Safranbolu and its environs gained political influence in the Empire, such as Izzet Mehmed Paşa, who was Sultan Selim III's grand vizier from 1794 to 1798. He built a mosque, a *medrese* and a library in Safranbolu's market area. Before being exiled to the island of Sakız, he also established a pious foundation (İzzet Mehmed Paşa Vakfı), whose

properties came from many estates around Safranbolu as well as within the town's market, mainly within the blacksmiths' quarter.[11]

Perhaps the influence of personalities from Safranbolu within Istanbul palace circles can explain the documented emigration from Safranbolu and Gerede to the capital which started in the eighteenth century, continued during the reigns of Sultans Selim III and Mahmud II, and increased after 1850.[12] In Istanbul, these Safranbolu emigrants worked as seamen or as bakers. According to de Planhol, from the 1860s onwards, persons from Safranbolu held quite a monopoly in the bakery business so that almost three-fifths of all Istanbul bakers were recruited from among immigrants from the Safranbolu region.[13] It is conceivable that notables and dignitaries originating from Safranbolu brought their relatives, friends or simply their clientele with them to the capital.[14] That a proportion of these immigrants were Greeks, as de Planhol indicates, is probable, especially in the case of the seamen.

In the nineteenth century, despite some changes due to Ottoman administrative reforms, Safranbolu remained, for the most part, the centre of the Safranbolu 'district' (*kaza*) and was attached to the province of Kastamonu. In the latter years of this century, a modern government building was built on the slopes of the hill where the fortress had been located in former times. Towards the end of the nineteenth century, Safranbolu had about 7,500 inhabitants. Twenty-eight mosques were located there, as well as two Greek Orthodox churches, 13 *tekkes* (attached either to the Nakşbendiye or the Halvetiye), two libraries, 191 schools with 2,937 pupils, 12 *medreses*, eight Greek (millet) schools, one telegraph station, 24 khans, 11 bathhouses, 940 shops and a hospital for the poor and syphilitic patients (who were mostly former soldiers and their relatives).[15]

In 1923, the town's Greek Orthodox population was forced to emigrate. In the aftermath of this exodus, Safranbolu's population sank to about 5,000 persons and stagnated on this level until about 1940. In 1937, in the nearby village of Karabük, a steel works, the Demir ve Çelik Fabrikası was established. The desire for regulated working hours, higher wages, social security and early retirement, together with a guaranteed old age pension scheme, led to the departure of many artisans and farmers from Safranbolu, thus depriving the – in any case – quite unattractive

handicrafts industry of its recruits. Not only has the population of Karabük risen to more than 100,000 persons, the population of Safranbolu nevertheless increased after the 1940s to about 20,000 inhabitants. The town's social structure has, since then, changed fundamentally: while the handicrafts industry and trade were dominant until then, now more than 50 percent of the population are workers, employees or clerks. Safranbolu has been turned into a somewhat remote and picturesque suburb of the steel city of Karabük. In recent years, it is tourism that has turned out to be the possible future profession for Safranbolu. To this end, a college for tourism, hotel management and restoration has been opened in the town.

Today, Safranbolu is composed of three main quarters:
– The old city with its famous, mostly three-storied half-timbered buildings and with the market-area (*çarşı*). Many of these half-timbered houses are under preservation; they have been partly turned into museums.
– Kıranköy (although officially named Misakı Milli): despite the population exchange of 1923, it is still called Granköy by the local people.[16] This is the quarter where the main part of the Greek Orthodox population formerly lived.
– Bağlar, an area established in the nineteenth century which was only used during the summer months by well-off families. Vineyards and orchards are still to be found there. Muslims and Greeks were living in proximity in Bağlar up to 1923. Since then, a majority of the 'old' Safranbolu population has established itself in Bağlar and lives there year round.

The question of the former Greek inhabitants

The Turkification of Anatolia occurred in distinct phases and strongly differed from region to region.[17] As stated earlier, Safranbolu was first conquered by the Seljuks at the end of the twelfth century. While it is not known what happened to its Christian communities at that time, from the point of view of its architectural history, a Turco- (Sunni) Islamic style can be perceived only from the fourteenth century onwards, when the first mosques were established under the rule of the Candaroğulları, though they showed little interest in this project.

Furthermore, it is documented that the lands in and around Kıranköy, as well as those of another nearby Greek village, Yazıköy, were not turned into state land (*miri*) after the Seljuk conquest so the lands remained in the hands of the Greeks; this privilege was not changed under Ottoman rule.[18] It should be stressed that, up until the nineteenth century, written sources for this sort of information are extremely scarce.

After the Turkish conquest of Anatolia, the Greek exodus from Asia Minor was pronounced until the fifteenth century. Separation from the centre of the Orthodox world in Constantinople, together with more or less strong pressure towards Islamisation, resulted in a noticeable decline in the Anatolian Greek Orthodox community. The Ottoman unification of Anatolia and Sultan Mehmed the Conqueror's regularisation of the church's status after the destruction of the Byzantine Empire brought better conditions for the remaining Christian communities in Anatolia.

Greek-speaking Christians who lived in Anatolia prior to the exchange of populations in 1923 were either descendants of the Byzantine population resident in Asia Minor prior to the Turkish conquest or were Greek speakers who had come to Anatolia after the Ottoman conquest, the main centre being Izmir (Smyrna).[19] Because of the fact that a large number of Anatolian Orthodox Christians spoke Turkish rather than Greek in the nineteenth century, many scholars declared these Orthodox Christians (the so-called Karamanlıs) to be of Turkish rather than of Greek origin. These Christians very often knew no Greek except for those who had learned it in the new Greek schools founded in many parts of Asia Minor, but wrote Turkish with the Greek alphabet. They were to be found in the regions of Adana, Ankara, Aydın, Kayseri, Hüdavendigar, Konya, Sivas and also – a fact which is of interest to this study – in the regions of Kastamonu and Safranbolu.[20]

When Mordtmann came to Safranbolu in the middle of the nineteenth century, he noticed that the Greek community of Kıranköy where he was invited as a guest of the Greek Orthodox monastery – accommodation that he gladly preferred to the khan – was turcophone and did not know the Greek language. The only person whom he met who knew Greek was a monk and teacher at the Greek school. Mordtmann was impressed by the monk's knowledge of classical Greek: 'He read Demosthenes,

Plutarch, Plato and so on just like me and my countrymen read the *Allgemeine Zeitung*.[21]

Mordtmann mentions some 2,000 Muslim households in Safranbolu proper and 250 Greek families in Kıranköy.[22] According to Ainsworth, who had come to the town about ten years earlier, there were 3,000 Muslims and also about 250 Greek *hanes* to be found in the town.[23] At the end of the nineteenth century, Sami Bey Frascheri gives 8,000 as the total population, of which 3,351 were Christians.[24] According to Cuinet, the demographic structure was as follows: 4,705 Muslims (2,810 men and 1,895 women) and 2,795 Greek Orthodox (1,435 men and 1,360 women). The total population was thus 7,500 persons.[25]

Already in the middle of the nineteenth century, Mordtmann speaks of a certain feeling of insecurity among Safranbolu's Greek community. This feeling had certainly increased during the years of the First World War. After the declaration of war by the Ottoman side, Greeks as well as Muslims were drafted; the former – like all other drafted non-Muslims – were not allowed to carry weapons and had to work under very severe conditions in work columns, mainly in road building. Hunger and sickness struck many of them. Numerous Greeks fled into the mountains and all who gave any sort of help or support to these deserters were sentenced to capital punishment. Thus, a resistance movement developed in the Pontic regions to the east, which was brutally crushed after the Russian troops' retreat in the years 1916–1917.[26] Being in the near vicinity, the Greeks of Safranbolu must have heard about these events.[27]

Developments in the Greek-Turkish war finally added a further element to the rising intimidation of the Greeks in the area. This uncertainty of Safranbolu's Greek community is perceptible in a telegram published in the newspaper *Ikdam* on 13th March 1921 in Istanbul.[28] In this telegram, 12 Greek Orthodox signatories – mainly heads of Greek communities in and around Safranbolu who claimed to speak on behalf of Safranbolu's entire Greek population, which numbered, according to them, 2,749 persons – urged others to see them as Turks in regard to origin, customs, traditions and language. They said that they had not been able to show this formerly because they had been under the 'pressure and influence of the Greek Orthodox patriarchy in Istanbul, which had been involved in pan-Hellenistic

aspirations'. The signatories, however, wanted to live in peace together with the Turks, just like many other *Rum* in Anatolia, so they stated. These are the reasons for which they had broken off all relations with the Istanbul patriarchate. Their aim, they continued, was the establishment of a Turkish Orthodox patriarchate in a suitable place in Anatolia.[29]

Nevertheless, together with the peace treaty signed in Lausanne at the end of January 1923, a separate convention was signed between Venizelos, the representative of Greece, and Ismet (Inonü), the Turkish representative, for a compulsory exchange of populations. Turkish nationals of the Greek Orthodox religion living in Turkish territory and Greek nationals of the Muslim religion living in Greek territory were to be exchanged. Thus, all the Greeks of Safranbolu left the town in that very year.

Kıranköy was left abandoned for quite a long time until immigrants, mostly workers from the steel factory in Karabük, settled there from the 1940s onwards. Before this time, the former inhabitants of Safranbolu had not shown too great an interest in settling in Kıranköy.[30] Meanwhile, the former church of Hagios Stephanos in Kıranköy has been turned into a mosque and from the 1950s the character of this quarter has changed along the lines of Turkish Anatolian style urbanisation (in contradiction to the other quarters of Safranbolu, where immigrants were not that numerous in those years).

The most important heritage of Safranbolu's Greek community is, without doubt, the half-timbered dwelling houses that give the town its characteristic shape and charm, over the last twenty years attracting the attention of national and international organisations devoted to preservation, and of tourists as well.

The market

Safranbolu's permanent market (*çarşı*) still exhibits, to some extent, the formerly strict separation of professions. With its shops, workshops, mosques, bathhouses, khan and weekly-held cattle, cereal and vegetable markets (*pazar*), it is the economic and social centre of the town. Yet, with the considerable decline of the traditional handicrafts, the market has lost one of its most important functions – that of production – and has changed to

some sort of *çarşı* supermarket in 'a flashlight museum town'.[31] In 1985, the market area was declared to be an urban historical site by UNESCO and many civil architectural and monumental buildings were taken under protection.

The permanent market is located on an interesting geo-logical formation in the southern part of the old city. The Gümüş, Akçasu and Bulak rivers pass through the city, forming three separate canyons. These rivers unite with the Araç river in the area of the so-called 'Lower Tannery' (Aşağı Tabakhane). The existence of two tannery quarters, a leather market, a shoe-market (*arasta*) and a cobblers' street (Kunduracılar Sokağı), as well as a saddlers' street (Saraçlar Sokağı) and a pack-saddlers' street (Semerciler İçi) continue to underline the former im-portance of the leather handicrafts. Out of all the other artisans in the town only the iron-smiths (*demirci*) have at any time possessed a separate market of their own.

At the time of my field-work, the former strict separation of professions in the streets and quarters was only evidenced by the numerous old street and market names. More than half of the former workshops were empty. The old shoe market had been given up almost totally some years before. Only one of the saddlers still had his workshop in the saddlers' street. Whereas retail trade and services were dominant in the upper part of the market, the artisans proper had retreated to the lower and quieter part of the market that was only filled on Friday after-noons after mosque prayers, and on Saturdays when people, mostly coming from the surrounding villages, went to the weekly market. This market day gave farmers the opportunity to sell their agricultural products and to provide themselves with urban goods. In this lower part of the market, about a dozen black-smiths were concentrated, some coppersmiths (*bakırcı*), a couple of carpenters (*marangoz*), two of the three saddlers of the town (*saraç*) and, lower down in the market area some pack-saddlers (*semerci*) and farriers (*nalbant*) were found. The most vital sector was the shoe-makers, who had been reinforced with several new masters, whereas there were almost no apprentices to be found in any of the other handicrafts.

The former tannery quarters were located in the canyon-like valley downhill from the market area. In the early 1980s, only the so called 'Upper Tannery' (Yukarı Tabakhane) on the banks

of the Akçasu was preserved. Most of the workshops were empty or had been turned into dwellings. The former meeting-place (*lonca*) of the Yukarı Tabakhane guild collapsed in the mid-1980s and had to be pulled down to its foundations. As for the other tannery quarter, the 'Lower Tannery' (Aşağı Tabakhane), which was probably Safranbolu's oldest leather production area, there remained only ruins of some workshops and remnants of the leather factory founded in 1924, but never set in operation.

It is not known when and how the Ottoman patterns of guild organisation were established in Safranbolu's market. It can be assumed that this happened in the seventeenth or eighteenth century when the town grew and the market area took on the shape partly preserved until today.[32] Neither is there evidence concerning a specific structure or other details about the Safranbolu guilds. In respect of the *ahi* fraternities and their traditions – of great importance in many of Asia Minor's towns and especially in leather handicrafts – nothing is known for Safranbolu.[33]

According to Safranbolu's twentieth century oral traditions, the guilds seem to have fulfilled the same economic, social, political, administrative, fiscal, legal and military functions common to Ottoman guilds in general. They also seem to have possessed the same hierarchical structures in that they safe-guarded the interests of their members vis-à-vis the local authorities and the representatives of the central government. They looked after the collection and delivery of taxes, they ensured the regular supply of members with raw materials and their distribution to each of the masters, and so on. The guilds possessed a limited autonomy in legal matters and created a sort of social security network among their members. According to the information given by the last (traditional) tanner in Safranbolu, the guilds also determined prices and ensured quality control. Each guild had at least one meeting place, mostly a guild-owned coffee house or, in the case of bigger guilds such as the tanners, members met in their own guild house open to all guild members.[34]

It is known that Muslims, Jews and Christians were, to a certain extent, separated in the Ottoman artisans' organisations. For Safranbolu, it is known from the oral tradition that, after a certain time Christian shoe-makers (*yemenici*) were not allowed

into the guild, but that they could work and sell under its supervision. In the oral tradition, it is reported that in the later days of the *arasta* (or *arasna*, as the former shoe market in Safranbolu is called in the local vernacular),[35] Christians who did not produce shoes in the market workshops, but rather in their own houses, and who brought their shoes with them to the shoe market were guaranteed a precedent selling right (*şatışta öncelik hakkı*). As long as the Christians' shoes were not sold, Muslim artisans of the *arasta* did not begin selling their own products.[36]

A separation of Greek Christians and Muslims did exist in the market of Saframbolu and, consequently, in the guilds.[37] That this was not limited to the shoe-makers is indicated at by architectural specificities: the structure of Greek Christian houses differed from Muslim ones mainly in that the former had work-shops on the ground floor, whereas either parlours or stables were found on the ground floors in Muslim homes. It can be assumed, therefore, that Greek artisans mostly worked in their homes and only sold their wares in the market.[38] Since women were generally not very welcome in the *çarşı*,[39] the separation of Greek artisans from the market enforced a certain tendency in the composition of the market as an area of production (workshops) and reproduction (coffee houses, restaurants and guild houses) of Muslim Turkish male society, which largely kept to itself.

Officially, the guilds were abolished in 1908 after the as-sumption of power by the Committee of Union and Progress, at which time the artisans' unions (*esnaf birlikleri*) were founded. Some of the old guild traditions continued in Safranbolu up to the 1950s, however, such as, for instance, the joint picnics organised by the artisans of the town, which were held every 7–14 days during the summer months. In the local idiom, they were called *erfane*.[40]

Safranbolu's leather handicrafts

It is unclear how far back in time one can trace large-scale leather production in Safranbolu. Barlas mentions, without ever quoting any of his sources, that the town's tannery already included 102 workshops in the fourteenth century. He also states

that Safranbolu developed into a centre of commerce situated on a trade route from the Mediterranean via Gerede and Safranbolu to Sinop.[41] According to the same author, there existed a division of labour between some of the region's towns. Thus, Kastamonu would have been the centre of weaving and Safranbolu of tanning and leather handicrafts. All the hides from the region of Kastamonu-Gerede-Eflani should have been processed in Safranbolu.

Branch specialisation of that sort between Ottoman towns was not uncommon. However, Safranbolu's prominent inter-regional position with regard to its leather production was not unchallenged since tanneries also existed in the other cities cited above. So it does not seem probable that Safranbolu imported rawhides from neighbouring towns on any major scale. To give one example: in the eighteenth century, a tax tenure (*mukataa*) on leather did exist in Gerede, but not in Safranbolu.[42] In Gerede, a relatively prosperous leather industry is still functioning nowadays.

For these reasons, Kuzucular's notion that leather production and processing on a larger scale developed only in the seventeenth century as a sequel of the 'great flight' to the town and the increase of Safranbolu's population seems more probable.[43] Of course, it can be assumed that leather production of some importance had already existed before this time but it is not to be presumed that it had had any greater inter-regional significance. The question of the economic importance of Safranbolu in the leather trade remains open. Barlas mentions that the town's leather production not only served local and regional needs, but that the town's leather was also exported to Istanbul and even to Europe, especially from the seventeenth century onwards.[44]

Around the middle of the nineteenth century, the first European travellers visiting the town noted the prominent position of leather handicrafts. Thus, Mordtmann stated that Safranbolu's population gained the major part of its living from viniculture and from leather industries.[45] He mentioned tanneries, morocco leather factories and many shoe-makers.

Tannery

About the end of the nineteenth century, Cuinet also stressed the importance of Safranbolu's leather-producing and leather-processing handicrafts.[46] Besides agriculture (especially the cultivation of saffron and mulberry around Ulus and Eflani), forestry and milling, the tanning of leather played an important role in the town's economy. According to Cuinet, there were 84 tanneries. Sami Bey Frascheri cited the same number of tanners' workshops and mentioned the production and the export of the varieties called *kösele* and *sahtiyan*.[47]

In the early 1920s, there were attempts to establish a leather factory within the confines of the 'Lower Tannery'. However, this experiment failed, mainly due to a lack of will and qualified manpower. The people of Safranbolu simply were not yet disposed at that time to work outside a guild structure. Gradually, partly because of its better situation on the Ankara-Istanbul route, Gerede gained greater importance as a production centre for leather. However, in 1923, according to the statistics of the Chamber of Commerce in Safranbolu, there were still 415 persons engaged in the leather industry who were active in about one hundred tanneries.[48]

The introduction of modern production technologies, such as the use of chrome or aniline dyes, the change to mechanised and faster production methods, the forced emigration of Safranbolu's Greek community and the ambitious industrial-isation projects under the new Turkish Republic – in this case, the foundation of the steel works in Karabük – led to a final decline in leather handicrafts in Safranbolu.

A 1924 report by Safranbolu's Chamber of Commerce describing the previous year's industry and trade in the town mentions varieties of leather that were brought in from outside and those which were produced and exported.[49] According to import statistics for 1923, European glacé leather (*Avrupa glasiyesi*) and European patent leather (*Avrupa rugani*) are quoted with a value of 18,900 Ottoman Liras (OL). The report also states that black cow-hide leather (*siyah vakete*) worth 15,000 OL, white cow-hide leather (*beyaz vakete*) at 9,000 OL, sole leather (*kösele*) at 3,600 OL and buffalo skin (*manda gönü*) at 25,000 OL were imported into Safranbolu. These varieties were re-exported to

neighbouring districts and provinces. In addition, morocco leather as well as *corduan* (*sahtiyan*) worth 30,000 OL was not only exported to neighbouring regions but also to Istanbul.

In this connection, it should be noted that the term *vakete* does not generally appear in earlier Ottoman sources. In all probability, it can be identified with the Ottoman leather variety known as *gön*, a sturdy cow-hide leather, yet thinner and softer than *kösele*.[50] In the cited statistics, the term *gön* only appears with reference to buffalo *gön*. The considerable quantity of exported buffalo hides is astonishing in so far as the Safranbolu region was not a prominent centre for buffalo raising.[51] The quoted statistics, on the other hand, note an import of 5,600 cattle and buffaloes into Safranbolu; the number of buffaloes, however, is not specified. Concerning rawhide import, only goat and sheep skins in modest quantities are mentioned (20,000 pieces).

The *sahtiyan* quoted can surely not be identified with the real 'Levantine' morocco leather, so highly appreciated, even in Europe, from the sixteenth century onwards[52] and produced by lengthy and complicated combined tanning procedures in the Kurdish-Armenian regions of the Ottoman Empire. Without a doubt, the *sahtiyan* produced in Safranbolu was, strictly speaking, not morocco leather but *corduan*. Nevertheless, in many parts of western Asia Minor and also in Safranbolu, sheep, goat or calf leather produced by simple bark tanning was called *sahtiyan* as well. The technologies documented for Safranbolu, referring to the traditional simple bark tanning, prove once more that this region should be situated within the 'western Anatolian circle of technology', as I have called it. In Asia Minor, there were three socio-culturally, geographically and historically defined 'circles of technology' with regard to leather manufacturing, namely, the 'western Anatolian', the 'Armenian' in the northeast (salt bath, wheat-bran, tanning with gall-nut, *sumak* or similar agents) and the 'southeastern Armenian-Kurdish circle of technology' characterised by its combined tanning methods.[53]

Mehmet Erayten, born in 1928 the son of a farrier, in the 1980s was probably one of the last traditional tanners working in Safranbolu.[54] After leaving primary school, he took up the profession of his maternal grandfather and, between the ages of twelve and eighteen, was a tanner's apprentice in the 'Upper

Tannery'. Thereafter, he did his military service. Returning to his home town in 1951, he did not go back to his profession as a tanner, but became a worker in the steel works in Karabük, a destiny that he shared with many other inhabitants of Safranbolu. In 1968, he purchased one of the abandoned workshops in the 'Upper Tannery'. After having been pensioned off, he worked there again as a tanner. His home was not far from his workshop, located in the very house in which his grandfather's workshop had been situated.

Erayten produced only two sorts of leather, *sahtiyan* (*sekyen* in the local idiom of the tanners and *setyen* according to the saddlers) and alum leather (*şaplı*). Alum leather is a relatively thick and soft leather used mainly for lining or as a stuffing material. It was the least appreciated and cheapest sort of leather in Ottoman times and of almost no importance in the leather trade. It is not cited in the 1923 statistics of Safranbolu's Chamber of Commerce.

The methods applied by Mehmet Erayten can be summarised as follows. Concerning the preparatory procedures, the rawhides delivered by the local butchers are cured with salt in order to conserve them (*salamura*). The hides are folded, salted again and stored. The long woolly hairs must be removed before treatment. In Safranbolu, this is women's work which is done in the home and not in the workshop. Then follows three to four days when the hides soak in water. After that, the insides are cleaned with an iron scraper. The hides are then put into a lime bath (*kireç suyu*, called *hayden* in the local idiom), where they remain for about twenty days in summer and up to one and a half months in winter. The hides are then cleaned, soaked and wrung in order to free them of lime remnants. This last part of the work was formerly very exhausting but it is now done in cylinders acquired from the never-opened leather factory. There then follows a bate process: in former times, this was done with dog excrement (*soma*), but nowadays industrially produced bating agents are used. The hides are then thoroughly cleaned one more time.

Then, comes the tanning of the *sahtiyan* leather. For the first tanning (*ilk harç*) process, about 100 kg of pounded pine-bark is mixed with a sufficient amount of water. About one hundred hides are put into this mixture. During the first few days, they

must be turned over five times a day (*işleme*) and afterwards once every eight days (*bederste*). This first tanning takes about one month. The hides are then scraped once more. Acron powder is used for the second and the third tanning. The procedures themselves are similar to those of the first tanning. The hides must rest for one night between the second and the third tanning. The preparation of alum leather is done in a solution of salt, alum and water. By cutting the edges of the leather, the tanner determines whether it is ready (*kirdinen kesme*, in the local idiom).

Finally come the finishing procedures. The raw leather is cleaned again and hung up to dry. It is then greased, formerly with train or mutton grease, but nowadays with sunflower or olive oil. The oil is heated to boiling point and coated in a cooled, viscous condition with a brush on the inner side (*mağı*). After the oil has been absorbed, the leather can be moistened and dyed. Finally, the outer side is smoothed and polished.

Mehmet Erayten also manufactured drum skins and seat leather. For the latter, the rawhides were mostly delivered by local families, especially after *kurban bayramı*. He produced drum skins from time to time for the schools or the local military. This tanner, however, did not sell a lot of his leather to the leather-processing handicrafts of the town. He did not, for personal reasons, have any relations with most of the Safranbolu artisans working with leather. The saddlers, for example, purchased their leather from tanneries or factories in other towns and not from this tanner in Safranbolu. An expanding enterprise also existed in the 'Upper Tannery' which worked on a small factory scale using mechanical and industrial tanning agents (such as sulphuric arsenic, Oropon, Valex, sulphuric acid and others). This firm produced cheap chrome leather (*kromlu deri*), all of which was delivered to Istanbul. The owner of this factory at the time of my interview was forty-year-old Ahmet Sarıtunç who had never been trained as a tanner.

Thus, the only local leather manufacturing workshop, as well as the leather factory, sold almost no leather to local leather-processing handicrafts still found in the town. It should be mentioned that a depot for the conservation of rawhides was located in the 'Upper Tannery' close to the former leather market. It was managed by two men from Safranbolu who bought hides

from farmers and butchers of the region, conserved the hides with salt, stored them and finally sold them wholesale to tanning enterprises in Gerede or Istanbul.

In the 1980s, that was all that remained of the once considerable leather production of Safranbolu: altogether, one small factory producing cheap chrome leather and one ageing, part-time tanner working according to traditional methods. In this decade, a committee of ten people from Safranbolu, all sons of tanners, initiated a plan for establishing a tanning company in the town. They turned to Ankara for support. Their project was rejected, however, by the state's planning board with the argument that the raw material was deficient.

The shoe-makers

Once again, written sources are only available from the nineteenth and twentieth centuries. Nevertheless, the *arasta* and the shoe-makers' street alone point to the former importance of this handicraft in Safranbolu. The shoe market was an artisans' quarter of its own. Surrounded by walls, it had small workshops made of timber, its own coffee house and its own prayer corner.[55] The trees planted there made the whole place appear somewhat like a garden. As mentioned above, there were only Muslim shoe-maker masters working there before 1923 since the Greek artisans had to work in their homes. At the time of my field-work in 1982, the *arasta* was almost abandoned. Only two shops were opened from time to time by aged shoe-makers. All the other workshops were closed and some of them served as iron-ware depots. The plans to architecturally restore the *arasta* were realised in 1986.

In the years of the Greek-Turkish war (called the War of Independence [Kurtuluş Savaşı]) from 1920 to 1922, the shoe-makers of Safranbolu supplied the 'National Army' (Kuvva-yı Milliye) with a great part of its demand for shoes and boots after the rapidly achieved pacification of the town on the part of the Kuvva-yı Milliye.[56]

Up until this pacification certain incidents like disturbances and fights had occurred in Safranbolu that are not at all clearly understood. In this region, some 'irregular troops' were active

who partly worked together with the Caliphate's army and partly operated independently against the policies of Mustafa Kemal (Atatürk). Thus, in 1920, insurrections against the nationalists arose around Düzce and Bolu which, subsequently, extended to Safranbolu.[57] After the conquest of Safranbolu by the National Army, attempts to integrate these former irregular troops and partisan formations into the *Kuvva-yı Milliye* were more or less successful.

The bellicose conflicts of those years had an influence on Safranbolu's leather handicrafts, especially on its shoe-makers. According to the existing sources, it appears very probable that the Greek shoe-makers of the town also produced shoes for the Kuvva-yı Milliye.

How large the scale of shoe production in Safranbolu must have been, at least in the first two decades of the twentieth century, is documented in the statistics of the Chamber of Commerce that we have already quoted.[58] Even after the exchange of population, there were still 430 persons active in this sector as *yemenici*, *kunduracı* and *dikici*. In 1940, 101 persons continued to be active and, around the year 1970, some 80 persons still worked in the profession. But in the 1980s, only 21 were active in this branch of work.[59] This last number, however, still seems considerable for a small town like Safranbolu.

Saddlery

The numbers of artisans in twenty types of handicrafts active in 1923 are cited in the Chamber of Commerce's statistics. Thus, for instance, the pack-saddle makers numbered one hundred and twenty *semerci*, but no numbers were cited for the saddlers properly speaking. The *semercis* produced pack-saddles typical for these parts of Anatolia, which were used mainly on asses or mules. Pack-saddle makers have always been considered as the 'humble brothers' of the *saraç*, the saddlers proper.[60] The question to be posed is whether the saddlers were simply forgotten in the statistics or whether there were no saddlers to be found in Safranbolu at that time.

It does not seem plausible that the saddlers were included under the pack-saddle makers since these handicrafts have always

been strictly separated not only terminologically but also in regard to their products, both in the Ottoman period as well as in Republican times. This distinction is also displayed in the different street names in Safranbolu, i.e., Saraçlar Sokağı and Semerciler İçi. But, of course, as from the first half of the twentieth century, saddlery had already lost much of its former importance due to the rising use of motorised vehicles. In 1940, there were nine saddlers in Safranbolu, the number fell to six around 1970 and, at the time of my field study in 1982, there remained three of them.

So why were the saddlers missing in 1923? One could suppose that, at least, a great number of the pre-Republican saddlers were Greek and had to leave the town. Another possibility is that the saddlers had been conscripted into the army during the long years of war. Or were they simply forgotten in the statistics?[61] If there really had not been any saddlers in Safranbolu, a great problem would have ensued because saddlery, due to the conditions and means of travel during that time, occupied an important place in the transport of people and goods.

In the 1980s, all three saddlers in Safranbolu were well aware of the decline of their profession. Only one of them, the saddler still active in the old saddlers' street, hired an apprentice (çırak) and a journeyman (kalfa). The oldest saddler of the town, Mehmet Alış, born in 1928, had personally witnessed the decline of his handicraft. In his youth, every family had at least one ass, mule or horse, but in the later years of his life, only some 50 percent of the families in the town possessed such animals, so he told me.[62] That was why he did not see any future for saddlery in Safranbolu. Only very seldom were entire saddles sold in the early 1980s, so the repair of saddles was one of the main activities of the saddlers. The youngest master, Hüseyin Yıldırım, attempted to produce 'modern' goods, for example, saddle-bags for motorcycles, belts, girdles, watch bands and purses, by copying industrially made models. However, he did not envision a future as a saddler for any of his three sons.

In Ottoman times, a great variety of products were made by saddlers or sold under the auspices of their guilds. In their markets, one could find everything needed for travelling, such as complete riding equipment, cases, trunks and many other articles. Saddlery mainly dealt with equipment for transport and

riding. In this regard, strong ties were maintained with other handcrafts. Just to give some examples: the saddlers received their leather from the tanners; snaffles, curb-bits, stirrups and other products were obtained from the smiths and casters; saddle-trees, collar-woods and transport chests were bought from the joiners and carpenters, and materials for saddles, caparisons and horse-rugs from the felt and cloth makers.

Of the variety of saddlers' products still being produced in Safranbolu at the time of my visit there in 1982, the following are the most important:[63]

Saddles (*eyer*): Only one type, the *çerkez eyeri*, was still produced, although the older master saddler still had models of the English or Hispanic type (*ispanyol eyeri*) in his depot. The Ottoman type, which had just one front pommel, had already totally disappeared.[64] The *çerkez* saddle is characterised by a four-leaved cover formed on the saddle-pad and a saddle-tree with two-forked pommels in the front and at the back. As a whole, it consists of five parts: the caparison (*belleme*) composed of several felt layers, a cotton lining on its inner side and canvas with leather application or just with leather on its upper side; the saddle-tree support made of leather with side bulges to support the saddle-tree; the wooden saddle-tree; the saddle-pad made from *sahtiyan* and filled with fine feathers; and, finally, the saddle-cloth (*eyer keçesi*) one-half of which serves as an intermediate layer between the saddle-tree and the saddle-pad, while the other half, rolled up when riding, can serve as a horse rug. It is made of felt and has leather applied on its upper side and a cotton lining on its inner side.

Bridles (*dizgin*) twisted from thin leather strips are called *çerkez* bridles, but the head-gear made from plain leather strips does not have a special name. Both types are decorated with rivets, colourful woollen tassels or blue glass beads. Collars (*hamut*) are composed of a bipartite wooden trestle, two shoulder-pads made of leather, a neck-pad made of felt with a canvas covering, two leather keepers for the side-girths and one strap for the back tether-girth. Harness belts (*aşırtma*) are composed of the back belt (*tin-tin-tipi*) and the tail belt (*paldım*). Back belts are made of felt, carpet pieces with leather embroideries or just of leather; tail belts are always made of strong cow-hide leather. Saddle-bags (*heybe*) are used for riding as well as on pack saddles.

They are made of carpet pieces, leather and cotton cloth, and have a cotton lining on the inside. There are types with and without leather side-parts.

In addition to this, the saddlers also produced horse whips (*kamçı*), dog collars (*halta*) made of strong cow-hide leather with or without iron spikes intended to protect the shepherd's dogs from wolves and, finally, amulets (*nazarlık*) for animals, stables and dwellings, which are believed to shield the owner or wearer from the evil eye. They are made of blue glass beads or colourful synthetic beads, woollen tassels, small bells and rattles. Tiny leather bags are sometimes attached to them into which verses of the Koran can be put.

In addition, saddlers sold saddle-bags, fodder-bags and girths made of goat wool (*keçi kılı*) produced in the winter by farmers around Kastamonu, Denizli and Nazilli. The stirrups, snaffles, curb-bits, chains and spurs that the saddlers sold were all manufactured by the blacksmiths in Safranbolu.

This short summary shows not only the variety of products, but also the different kinds of materials and technologies used in saddlery. There were no considerable differences between workshops in relation to the range of products and technologies applied. The difference was in the raw materials that they processed: each situation was distinct. This concerned not only the variety of leather and felt types with which the saddlers worked, but the fact that they all purchased most of their raw materials from different sources of supply. Just to give one example: the old saddler Alış processed only traditional sorts of leather, namely, *sahtiyan*, *vakete* and alum leather all of which were purchased from a tannery in near-by Gerede. His former pupil, Hüseyin Yıldırım, still young and more 'market-oriented', tried, with success, to buy his leather for a lower price than did his former teacher. He bought *sahtiyan* from Çankırı, *vakete* and white kid-leather (he was the only one to use this sort, called *keçi beyazı*) from Balıkesir and alum leather from Bursa. He also processed 'industrial' leather such as chrome leather, which he bought from a factory in Bursa.

As mentioned above, the relationship between the last tanners of Safranbolu and the town's leather-processing artisans was not very good. Moreover, an extensive lack of co-operation and solidarity among the saddlers themselves was all too obvious. This was not true just with regard to purchasing their raw

materials. When purchasing and transporting in bulk, they surely could have acquired their raw materials at a lower price if they had co-operated with one another. But, to the contrary, they shunned any contact as far as possible. This lack of organisation and collaboration, and the almost grotesque fragmentation in this marginalised handicraft, struck me as somehow curious, especially when thinking of the former corporative structures defined by the guilds, whose traditions were still vivid in Safranbolu up to the late 1940s, as stated above.

Of course, an explanation for this rather stunning pheno-menon can, presumably, be found in personal, religious and political considerations, especially at the time of the military junta in 1982, when mutual mistrust prevailed, a fact that also hampered my field-work to some extent. Nevertheless, similar phenomena have been witnessed by social anthropologists in other parts of the world and under other circumstances as well. They called it 'com-petitive individualism' or 'amoral familialism', explaining this state of disorganisation among petty commodity producers and artisans by a weakening of traditional groups in times of crisis.[65]

Conclusion

This research has analysed the various historical formations and changes in the demographic, socio-political, ethnic, religio-ideological, ecological, economic and technological aspects of life in the small town of Safranbolu. The list of adjectives in the preceding sentence is very long because one must work with a complicated structure, incorporating different circumstances. One of the problems in studying Ottoman history from this point of view relates to sources, as often referred to in this study. Many archives in Turkey, especially local ones, are in very bad condition and all too often documents get lost, destroyed or used as waste paper. I had no access to local archives in Safranbolu and do not even know their condition.

A history of the regions, areas and towns in present-day Turkey – which also incorporates a view of history from the bottom up or from the periphery to the centre – is just in its beginnings. In recent years, some promising steps have been taken. The present study may form a small contribution in this regard.

Notes

1 Some of the material presented in this study was gathered during my research stay in Safranbolu for several weeks in the summer of 1982. For an indirect result of my stay in the town, see Doğanalp-Votzi, 1997.

2 On the early history of Safranbolu, see Umar, 1985; Tuğlacı, 1985, pp. 307f.; Sözen, 1976, p. 8.

3 For references for the above towns, see respectively Ainsworth, 1842, p. 59; Mordtmann, 1972, p. 253; Ramsay, 1962, p. 320; *Tübinger Atlas*, 1988, map B VIII 1.

4 Yücel, 1980, p. 34. Claude Cahen (1968, p. 117), on the other hand, identifies Dadybra with the present-day town of Devrek.

5 Yazıcıoğlu and Al, 1982, p. 15.

6 Heywood, 1978.

7 Defrémery and Sanguinetti, 1853, p. 340.

8 Yazıcıoğlu and Al, 1982, p. 25.

9 Kuzucular, 1976, p. 31.

10 Tuğlacı, 1985, p. 307 and Heywood, 1978.

11 Sözen, 1976, p.10. İzzet Mehmed Paşa was dismissed by Sultan Selim III and sent into exile ostensibly because he had not taken the necessary precautions against the French occupation of Egypt.

12 de Planhol, 1975, p. 286.

13 The question of whether the profession of a baker in Istanbul was attractive remains unanswered since every baker who sold too light a loaf was nailed by the ear to the door of his shop. Thus, most of the bakers engaged a well-paid journeyman who let himself be nailed instead of his master: see Schurtz, 1903, p. 703.

14 In the time of Sultan Mahmud II, Bostancıbaşı Deli Abdullah Paşa from Safranbolu was grand vizier in 1822–1823. From 1872 to 1874, Turşçuzade Hacı Efendi, also originating from Safranbolu, held the post of *şeyhülislam*.

15 The figures are mainly drawn from the works of Cuinet, 1895; Frascheri, 1884 and the *sâlnâme* of Safranbolu from the year 1306 (1889), published in Yazıcıoğlu and Al, 1982, pp. 84ff. On the frequency of syphilis in the region of Kastamonu-Safranbolu, compare von der Nahmer, 1904, pp. 297ff.

16 The 'National Pact', Misakı Milli (or, less commonly, Ahd-i Milli), had been discussed by the nationalistic movement built around Mustafa Kemal at the congresses of Erzurum and Sivas and was accepted by the Ottoman Assembly of Representatives in Istanbul in 1920. After the dissolution of this parliament, the National Pact

was approved and an oath was again taken at the opening session of the National Assembly in Ankara on 23rd April 1923. The National Pact renounces claims to the former Arabic provinces. At the same time, it states that the remaining territories in which lived an 'Ottoman-Islamic' majority should form an inseparable unity and that a sovereign state should be established within these territories. Consequently, claims were laid on mainly Kurdish and former Armenian regions, on Eastern Thrace, on the whole of Anatolia and the provinces of Kars, Ardahan and Batumi, as based on an 'Ottoman-Islamic' (and not a Turkish) argument. Minority rights should be guaranteed to non-Muslims. The borders, however, were not defined in this pact. The entire text of the National Pact is published in Tunçay, 1976.

17 On these issues, see Vryonis,1986; Cahen, 1968.

18 Yücel, 1980, p. 34.

19 Of the regions where a Greek-speaking population had lived since Byzantine times and survived into the twentieth century, the area of Pontus was the most important (towns and villages located between Rize, Trabzon, Samsun and Gümüşhane). A second area of Greek speakers was the region south of Pontus and north of Cappadocia, centred on Şebinkarahisar. The third important Hellenophone region comprised the Cappadocian villages situated around Niğde and Kayseri. See Vryonis, 1986, pp. 446ff.

20 The Turkish-speaking Greek Christians appear for the first time, as Vryonis states, in a Latin report presented to the council of Basle in 1437 on the state of the Eastern church. The author of this report remarks that, in many parts of Anatolia, some of the clergy, including bishops and archbishops, not only wear the garments of the 'Turkish infidels', but also speak their languages: see Vryonis, 1986, p. 453.

21 Mordtmann, 1972, pp. 258f.

22 Mordtmann, 1972, p. 253.

23 Ainsworth, 1842, p. 65.

24 Frascheri, 1884.

25 Cuinet, 1895, p. 475. No other ethnic-confessional communities are referred to in the written sources of the nineteenth century. Only Boré, who visited the vicinity of Safranbolu, but not the town itself, heard – during his stay in Bartın – of some hundred Greek and Armenian families who were said to live in Safranbolu: Boré, 1840, p. 248.

26 For an interesting, though partly biased, study about the oral traditions of Pontian Greeks who fled to the US, see Papadopoulos,

1983. Many of Papadopoulos's informants felt that the Turks had turned against them after the slaughtering of the Armenians. Great numbers of Pontian Greeks fled from the reprisals with which they were confronted: some 160,000 to 250,000 were deported to Inner Anatolia by the army. According to estimations by the army, only 25–30 percent survived. As early as November 1922, the Turkish authorities registered all Pontian Greeks and their properties. They were told to come to Trabzon in order to officially confirm their 'will' to emigrate.

27 I would like to point out here a study in Greek which I could not include in the present study because of time and language constraints: Kiryakopoulos, 1995.

28 Republished in Kazgan, 1980.

29 On the Turkish Orthodox church and its founder, Papa Eftim, see Jaeschke, 1964; Vryonis, 1986, pp. 453f.; Bornträger, 1994.

30 Barlas, 1982, p. 12.

31 In the words of Barlas, 1982, p. 9.

32 In general, the characteristic multifunctional patterns of the Ottoman guild system as a politico-religious relationship of production in urban Ottoman civilisation were not formed before the end of the fifteenth and the early sixteenth centuries. In the seventeenth and eighteenth centuries, these guilds finally developed into general societal organisations of public order in the towns of the Ottoman heartlands: Doğanalp-Votzi, 1997, pp. 33ff.

33 The only suggestion that I could find about *ahis* in Safranbolu was the existence of a pious foundation called Ahi Süreyya Vakfı: Yazıcıoğlu and Al, 1982, p. 76. For the specific importance of the *ahi* traditions in leather handicrafts, see Doğanalp-Votzi, 1997, pp. 201ff.

34 For these oral traditions, see Kuzucular, 1976, pp. 32f.; Bauer, 1987.

35 Originally *arasta/araste* meant 'a camp fair, a sutler's camp in the suite of an army' (Redhouse, 1890, p. 57), but the term also denotes that part of the market where artisans or traders of the same branch are collectively located.

36 Kuzucular, 1976, p. 34.

37 In the Ottoman Empire, the guildsmen both produced and sold their goods in the market. One exception were the tanners, who always had their workshops outside the market centre.

38 It should be noted that in contrast to the textile sector, leather handicrafts were generally dominated by men.

39 This is not true for the *pazar*, where women acted not just as buyers, but also as sellers.

40 *Arifane*, a joint picnic.
41 Barlas, 1982, p. 31.
42 Ergenç, 1988.
43 Kuzucular, 1976, p.31.
44 Barlas, 1982, pp. 32f.
45 Mordtmann, 1972, p. 253.
46 Cuinet, 1895, pp. 473ff.
47 Frascheri, 1884.
48 This report of the Safranbolu Chamber of Commerce has been republished in Yazıcıoğlu and Al, 1982, pp. 59ff.
49 Yazıcıoğlu and Al, 1982, p. 71.
50 On the Ottoman leather varieties and the problem of their definition and the translation of the relevant terminology, see Doğanalp-Votzi, 1997, pp. 71ff.
51 Cuinet (1895, p. 475) gives the following numbers for the end of the nineteenth century: bovines – 7,500 oxen, 2,300 cows, but only 700 buffaloes; ovines – 14,000 sheep, 11,546 goats and 17,997 mohair goats. One should, of course, allow for a certain flexibility regarding these numbers in relation to the region's animal-breeding.
52 See Desmet-Grégoire, 1994, pp. 61ff.
53 On these 'circles of technology', see Doğanalp-Votzi, 1997, pp. 107ff. In my studies, three different regions came to the fore (not only in regard to leather production) concerning relations concentrated around ergological, technological, ethno-religious, historical, ecological, economic and cultural conditions, which I have called 'circles of technology'. It is very interesting that Quataert, studying the developments and changes within Ottoman textile handicrafts in the nineteenth century, suggests comparable and similar zones of industrial activities and technologies: Quataert, 1993, pp. 2ff, pp. 49ff.
54 For the following, see Bauer, 1987, pp. 59ff.
55 This was not a *zaviye:* but merely a small room where people prayed.
56 Barlas, 1982, p. 33.
57 The Republican historiography of Safranbolu tries to refute these events and states that there was no real, noticeable resistance against the National Army and the latter's sympathisers in the town. This historiography states that the town had instead been occupied by the Caliphate's troops and, because of communication problems, this occupation had been reported to Ankara as a rebellion: Yazıcıoğlu and Al, 1982, p. 129. In any case, Safranbolu has its own 'Kemalist saint' in the person of Dr. Ali Yaver Ataman, who fought for the nationalists. After his death, a memorial to Dr. Ataman was

built on a hill in the town at the place of the former tomb of a Sufi saint.

58 Yazıcıoğlu and Al, 1982, p. 71.
59 Bauer, 1987, p. 72.
60 This is the term given to them by Wulff, 1966, p. 97.
61 It could, of course, also be a combination of all three possibilities. In Yazıcıoğlu and Al, (1982, p.111), there is a photograph showing a certain Kör Zühtü, a saddler, in his pre-Republican clothes.
62 Interview, August 1982.
63 For a detailed description of the production procedures and the materials, tools and technologies: see Doğanalp-Votzi, 1995, pp. 393ff.
64 The use of the Ottoman saddle had already declined earlier on. In its place, the English saddle became the more widely used type in the more western parts of Anatolia whereas, in the eastern parts, it was the *çerkez* saddle.
65 Kahn, 1984.

Bibliography

Interviews

Safranbolu, summer 1982.

Publications

Ainsworth, W. F., *Travels in Asia Minor, Mesopotamia, Chaldea and Armenia* I, London, John W. Parker, 1842.
Barlas, Uğurol, *Safranbolu Halk Bilgisi*, Karabük, Safranbolu'yu Koruma Derneği, 1982.
Bauer, Werner, 'Die Gerberei in Safranbolu', *Archiv für Völkerkunde* XLI, 1987, pp. 53–76.
Boré, Eugène, *Correspondances et mémoires d'un voyageur en Orient*, v. I, Paris, Olivier Fulgence, 1840.
Bornträger, E., 'Die Konstantinopelgriechen in der türkischen Republik. Vom Mittelpunkt neuhellenischen Wirtschafts- und Geisteslebens zur peripheren Restgruppe', *Europa Ethnica* LI/1, 1994, pp. 1–15.
Cahen, Claude, *Pre-Ottoman Turkey*, London, Sidgwick and Jackson, 1968.
Cuinet, Vidal, *Géographie administrative, statistique, descriptive et raisonnée de chaque province de l'Asie Mineure* IV, Paris, Ernest Leroux, 1895.

Defrémery, C. and B. R. Sanguinetti, *Voyages d'Ibn Batoutah*, v. II, Paris, Imprimerie Impériale, 1853.

Desmet-Grégoire, Hélène, *Le Divan Magique. L'Orient turc en France au XVIIIe siècle*, Paris, L'Harmattan, 1994.

Doğanalp-Votzi, Heidemarie, 'Lederproduzierende und lederverarbeitende Handwerke im Raum Vorderasiens. Wirtschaftsethnologische Studien zur traditionellen urbanen Güterproduktion des Raumes', Vienna, unpublished PhD thesis, University of Vienna, 1995.

Doğanalp-Votzi, Heidemarie, *Der Gerber, der Kulturbringer. Politik, Ökonomie, Zivilisation im osmanischen Vorderasien*, Frankfurt, Peter Lang, 1997.

Ergenç, Ömer, 'XVIII. Yüzyılda Osmanlı Sanayi ve Ticaret Hayatına ilişkin bazı Bilgiler', *Belleten* LII, 203, 1988, pp. 501–533.

Frascheri, Sami Bey, 'Zağfranbolu', *Qamûs ul-Alâm*, Constantinople, Mihran, 1311/1884, v. IV, p. 2415.

Heywood, C.J., 'Kastamonu', *Encyclopedia of Islam*, 2nd ed., v. IV, 1978, pp. 737–739.

Jaeschke, G., 'Die Türkisch-Orthodoxe Kirche', *Der Islam* XXXIX, 1964, pp. 95–129.

Kahn, Joel, 'Economic Scale and the Cycle of Petty Commodity Production in West Sumatra', in Maurice Bloch, ed., *Marxist Analyses and Social Anthropology*, London, Tavistock Publications, 1984, pp. 137–158.

Kazgan, H., 'Milli Mücadele'de Zafranbolu Rumları', *MTRE*, ITÜ (Istanbul Teknik Üniversitesi), Mimarlik Tarihi ve Restorasyon Enstitüsü, Bülteni XI/XII, 1980, pp. 33–36.

Kiryakopoulos, Hristos, *Safranpoli*, Thessaloniki, published by the author, 1995.

Kuzucular, Kani, 'Safranbolu Çarşısı', *Türkiye Turing Otomobil Kurumu Belleteni* LIV, 333, 1976, pp. 29–39.

Mordtmann, A.D., *Anatolien. Skizzen und Reisebriefe aus Kleinasien 1850–1859*, ed. by F. Babinger, Osnabrück, Biblio Verlag, 1972.

Nahmer, E. von der, *Vom Mittelmeer zum Pontus*, Berlin, Allgemeiner Verein für Deutsche Literatur, 1904.

Papadopoulos, A., 'Events and Cultural Characteristics Regarding the Pontian-Greeks and their Descendants', unpublished PhD thesis, New York University, New York, 1983.

Planhol, Xavier de, *Kulturgeographische Grundlagen der islamischen Geschichte*, Zürich, Munich, Artemis Verlag (Die Bibiothek des Morgenlandes), 1975.

Quataert, Donald, *Ottoman Manufacturing in the Age of the Industrial Revolution*, Cambridge, Cambridge University Press, 1993.

Ramsay, W.M., *The Historical Geography of Asia Minor*, Amsterdam, Adolf M. Hakkert, 1962.

Redhouse, James W., *A Turkish and English Lexicon*, Constantinople, A.H. Boyajian, 1890.

Schurtz, Heinrich, 'Türkische Bazare und Zünfte'', *Zeitschrift für Socialwissenschaften* VI, 1903, pp. 683–706.

Sözen, Metin, 'Safranbolu Anıtları', *Türkiye Otomobil Kurumu Belleteni* LIV, 333, 1976, pp. 7–15.

Tübinger Atlas des Vorderen Orients 11, Lieferung, Wiesbaden, Reichert, 1988.

Tuğlacı, Pars, *Osmanlı Şehirleri*, Istanbul, Milliyet Yayınları, 1985.

Tunçay, Mete, 'Misak-i Milli'nin Birinci Maddesi Üstüne', *Birikim* XVIII/XIX, 1976, pp. 12–16.

Umar, Bilge, *Paphlagonia*, Istanbul, Ak Yayınları, 1985.

Vryonis, Speros, *The Decline of Medieval Hellenism in Asia Minor and the Process of Islamization from the Eleventh to the Fifteenth Century*, London, University of California Press, 1986.

Wulff, H.E., *The Traditional Crafts of Persia, their Development, Technology, and their Influence on Eastern and Western Civilization*, Cambridge (Mass.), MIT Press, 1966.

Yazıcıoğlu, Hulusi and Mustafa Al, *Safranbolu*, Karabük, Özer Matbaası, 1982.

Yücel, Yaşar, *Çobanoğulları, Candaroğulları Beylikleri*, Ankara, Türk Tarih Kurumu, 1980.

CHAPTER 12

The End of Guilds in Egypt: Restructuring Textiles in the Long Nineteenth Century

John Chalcraft

Guilds were one of the fundamental urban institutions of the Ottoman Empire. They organised the majority of the economically active urban population from the Balkans to North Africa from at least the sixteenth to the nineteenth century. Most urban merchants, retailers, artisans and service-workers (broadly defined) had their guilds, which, although highly heterogeneous by trade, location and time, linked urban trades to the government, regulated relations of production and exchange, and provided a community of some kind for those practising a particular trade.

However, during the nineteenth century, the Ottoman guilds largely disappeared. Whereas Gabriel Baer identified and documented a 'ramified system' of guilds in Egypt until as late as the 1880s, he gave a useful (if problematic) outline of their demise over the following three decades.[1] In spite of Baer and other research, the course and causes of this important transformation remain little understood and under-researched. Very few case studies have been undertaken. By and large, historians have had to resort to generalities on the basis of fragmentary evidence, usually culled from colonial reports or occasional references in the accounts of elite groups.

Standard views assert that when Egypt or Ottoman traditional handicrafts and trades encountered the full blast of European manufacturing competition in the nineteenth century (especially after 1830) and as modern banking and commercial systems

338

came to be established through the remainder of the century, in addition to the effect of direct European investment after the 1880s, which created scores of new large-scale companies (in municipal infrastructure, transportation, agro-processing and the like), the traditional guilds – largely unable or unwilling to resist or adapt – were displaced and destroyed.[2]

This study argues that the guilds were not simply destroyed 'from above' by the elite and the European. Through an examination of Egypt's textile trades (which, one should note, encountered European manufactures – in the shape of Manchester cotton – more directly than any other artisanal trade), I suggest that economic adaptation and restructuring on the part of the textile trades themselves made an important contribution to the end of their guilds. Textile production (spinning, weaving and dyeing) was not destroyed during these years, but was transformed. Textile merchants, masters and workers found new ways to adapt and often expand their activities under the constraints imposed by opportunities which flowed from world economic integration and political change. Increasing rural production, growth of putting-out systems, greater participation of women, larger workshops and the protests of journeymen all worked in various ways to undermine the old-established, predominantly male and city-based guild system.[3] Subaltern adaptation and protest, therefore, was just as much a part of the end of the guilds in Egypt as the impact of Europe and its imports.[4]

The guilds

The argument can hardly begin without addressing some of the important problems associated with the Ottoman 'guilds'. First, there is a major issue of terminology. As is often pointed out, there is no Arabic or Ottoman Turkish word directly translatable into English as guild. The term *ta'ifa* (pl. *tawâ'if*), which was most commonly used in later nineteenth century Egypt, meant little more than 'group' or even 'community' and did not specifically designate a craft guild, however defined. The term could be used to refer to ethnic, religious or national communities in Egypt or even other social groups such as gypsies (*tâ'ifa al-*

ghafar). Nonetheless, alternative terms such as 'craft association', 'occupational grouping' or 'community' raise difficulties of their own and to leave the term *tâ'ifa* or *esnaf* untranslated is to avoid the problem, not to solve it. Nor can one wish the issue away altogether and simply speak of crafts and trades because there was a distinctive and, in my view, pre-modern institution (although highly heterogeneous, changing and not simply 'traditional') which organised crafts and trades in the Ottoman Empire. To continue tentatively to use the term 'guild' remains the best available option as long as direct analogies to European, Chinese or other guilds are treated with great caution and the work of definition in the Ottoman context tackled head on.

As for such a definition, most justifiably accept that proposed by Baer as at least a useful point of departure: 'a group of town people engaged in the same occupation and headed by a shaykh'.[5] The guild certainly was a group of some kind and it was invariably to be found in an urban setting. Guilds tended very much to include only those practising the same occupation or related occupations (although there were exceptions). Furthermore, guilds tended to be headed by a shaykh (in the Arab provinces) and more typically by a *kethüda* in Ottoman Anatolia, although this was by no means an inflexible rule. Beyond this, however, general-isations about guilds are extremely difficult to make. As Quataert rightly remarked: 'we do not really understand...the nature and functions of most Ottoman guilds...[they] varied quite consider-ably not only over time but also contemporaneously by place. In some areas they may have been monopolistic; in others they were only loose associations of persons engaged in the same activity.'[6]

Indeed, the very basis of the guilds remains in doubt. Although Baer – by stressing economic and professional functions – de-bunked the excesses of the Massignonite view of the guilds as primarily a brotherly pact of honour linking crafts workers to a wider Islamic community,[7] the role of what Raymond later called their 'para-religieuse' functions remains decidedly unclear today and cannot simply be dismissed as epiphomenal. Further-more, although it is plausible to speak of guilds as based on the division of labour and craft specialisation, it is not clear how this principle squares with the cultural and political aspects of guild practice or whether it should take precedence as a somehow more fundamental aspect of guild activity.

Finally, and perhaps most importantly, while recent re-visionism has successfully moderated Baer's exaggerated view of the guild as a 'tool in the hand of the government' and shown that guilds were far more autonomous from the state than Baer had believed,[8] it is not clear that a new 'civil society' approach to the guilds will take one any further than this useful revisionist task, positing as it sometimes does a too radical state/society dichotomy where the pre-modern Ottoman order (especially that of the seventeenth and eighteenth century) is concerned.[9] In part, therefore, cultural, economic and political views concerning the basis of the guilds compete and are not yet resolved.[10]

The guilds were arguably, above all, a set of heterogeneous intermediary institutions linking urban crafts and trades to the government. In this respect, they were neither part of a repressive state apparatus nor bastions of civil society. Here, they were a technology of decentralised rule, a way of connecting government to urban crafts where fiscal and regulative functions were not centralised in a salaried bureaucracy, where regulations (in spite of the importance of sultanic decrees, treatises and Islamic law) were not largely codified and written down, but embodied substantially in constantly reinterpreted customary law which, partly by definition, was local and could only function effectively if interpreted locally.[11]

In this regard, guilds were a way for the expanding and conquering Ottoman rulers to connect to the urban population without disturbing too drastically the fabric of urban life in a vast, polyglot and 'multi-ethnic' empire.[12] On the most plausible account, they emerged in Egypt in a distinctive form after the Ottoman conquest of 1517.[13] They kept justice and order in the crafts and trades (not just on behalf of the authorities, but also of other crafts workers), and ensured the upward flow of taxation and requisitioned goods and services to the authorities. Through links to the guilds, the Ottoman authorities did not have to directly regulate the minutiae of trade life, which could instead be ceded to the jurisdiction of guild leaders, who were nominated or elected by members or senior members and who governed according to the supposedly old-established and het-erogeneous customs of the trade with an eye on relevant sultanic decrees and Islamic law.

Justice and order very often demanded that guilds regulate the number of 'slots' or 'licences' in a particular trade.[14] In eighteenth century Cairo, it was fairly well-established that those practising weaving or dyeing or associated trades had to hold a 'licence' or *gedik*. These 'licences' could be purchased, but were very often inherited and were regulated by the guild. The 'licence' was, in theory, about ensuring a just and orderly system: one in which enough textiles workers, for example, were present to satisfy markets and supply the cities and government, but not one where too many weavers appeared and thus ruined each other in competition (in a situation of long-run demand fluctuation rather than expansion). The institution of *gedik* worked to prevent would-be rural weavers, 'outsiders' or those not qualified to practise the trade from entering textile production.[15]

The guild was often entrusted, from 'above' and 'below', with the task of certifying in one way or another the competence of those who became masters in a trade. This meant quite elaborate initiation ceremonies, in some cases, which particularly seemed to have emphasised the ethical components of mastership. Masters were called both *possessors* of crafts and trades (*ashâb al-hiraf*, or *arbâb al-hiraf*) and if one was to translate literally, they were teachers (*mu'allimîn*) of that knowledge. Guild leaders also held guarantees of the probity and good faith of their members and were answerable to purchasers, employers and government officials to whom they contracted labour. In a broader sense, guild leaders were responsible for the reputation of the guild in the city.

In parts of Anatolia and Syria (but, as far as is known, not in Egypt), guild leaderships distributed raw materials, in theory, equitably between members, a practice which was meant to ensure that where supply was limited, some members would not face ruination through inability to obtain raw materials.[16]

Intimately bound up with the foregoing was the fact that the guild simultaneously constituted, in a highly variable way, a kind of community for all those practising a particular trade in a particular city quarter. Certain festivals were celebrated by particular guilds, which carried the symbols of their trade in procession on the eve of Ramadan, for example. Some guilds were exclusive and marked their boundaries with elaborate initiation ceremonies. Other guilds, as Quataert remarked, were merely

loose associations of traders. Shared local, regional, 'ethnic', kinship, gender, Janissary, 'national', status-related, Sufi and/or confessional backgrounds were all important in different ways in different times and places and in different trades, and worked to constitute the character of the guild and the nature of the community which partly made up that guild. Specific trades and the guilds related to them were identified with particular localities. Moreover, a manner of dress, a certain kind of song, a distinctive technique or skill could identify different professions. Some guilds practised mutual help of various kinds.[17]

Community and face-to-face ties were closely connected to power relations within the guild and the way that it articulated crafts and government. The personal authority of the guild shaykh was a particularly effective intermediary regulative technology where those practising a trade formed a relatively small group based on craft specialisation in a particular urban quarter or street. Here, as elsewhere, intimate knowledge was bound up with power and authority. In the guilds, it was not so much the census, the map, the investigation or the examination which constituted this power, but the knowledge of person and locale circulating through face-to-face ties. A mark of the status of the shaykh was that he collected customary dues from members for his own pocket. He could also punish errant members through fines or expulsion.[18]

In the nineteenth century, in a process wrought at least partly 'from below', the guilds largely disappeared. By 1914, they no longer operated as an intermediary institution linking crafts and government, ensuring order in relations of production and exchange and providing a community for those practising a particular trade. A fundamental remaking (not to say the actual modern construction) of state, society and economy saw the attrition of the guilds and the disarticulation of their practices and activities, which now came to reside in the centralised government apparatus, the emerging market and new social institutions: putting-out systems, syndicates, unions, larger workshops, contracting and informal networks, chambers of commerce and some factory-based industry. This fragmentation and reordering was an important part of the making of modern Egypt. Here, I can only pick up on a piece of this wider picture: the contribution made to it by adaptation by those in the textile

trades under conditions of state-building and world economic integration.

Rural manufacturing

One of the things which can be more or less firmly established with respect to Egypt's textile trades was that production and employment shifted from town to country in a fairly dramatic fashion during the long nineteenth century (1805–1914). In the early nineteenth century, in Egypt as elsewhere in the Ottoman Empire, textiles (spinning, weaving and dyeing) comprised the most important group of urban manufacturing guilds in terms of output or numbers employed. Raymond estimated, for example, that between a quarter and a third of Cairo's artisans worked in cotton, silk, wool or linen textiles in the late eighteenth century, serving the demands of local elites as well as the less well-to-do, and exporting some yarn and cloth to Syria.[19] Weavers left the most substantial legacies in the artisanal sector and some of the largest manufactories in Cairo were one or two important dye works near the Citadel.[20] A measure of the importance of the textile sector can be glimpsed from the fact that it was here that Muhammad 'Alî (ruler of Egypt 1805–1848) concentrated his pioneering but ultimately doomed projects of import substitution. Clothes were a necessity which consumed a large proportion of the purchasing power of the mass of the population and they were an important luxury through which elites displayed their wealth and status. Although French imports of woollen goods had increased during the eighteenth century, English textile imports had actually decreased. With the advent of the Napoleonic wars, French trade with the Eastern Mediterranean was even further cut off, reducing imported competition which was still relatively minor in any case.

Although scattered references to rural production and even putting-out systems exist,[21] textile production was largely an urban and guild-based affair in the eighteenth century and probably before. The *gedik* system worked to maintain this state of affairs. A steady stream of references to quarrels over 'outsiders' and others attempting to muscle in on production show that non-guild producers attempted to enter the market, but they do

not (although the evidence is not conclusive) show that rural or outsider production for the market came anywhere close to that of the cities. The limits on rural/urban transport infrastructure were part of the background to this, as was political instability, particularly in Egypt between 1780 and 1801.

But during the nineteenth century, this pattern changed. Textile manufacturing was increasingly carried on outside the urban guilds, in rural and household settings, and in putting-out networks of various kinds. The figures are quite telling in this regard. On one hand, the censuses of 1868, 1897, 1907 and 1917 make clear that textile production was not being destroyed as world economic integration went ahead.[22] Numbers employed fluctuate or increase slightly rather than either radically diminishing or rapidly increasing. This finding even appears to hold in respect to cotton-weaving, which bore the brunt of increased importation from Manchester. It also compares favourably to the bulk of recent research for other parts of the Ottoman Empire.[23]

But, more important for the purposes of my argument here was the changing balance between town and country. According to a tax return, around one-half of Mansura's manufacturers were involved in textiles in 1863, whereas, by 1917, this proportion had shrunk to just a few percent. A marked transformation took place in Cairo and Alexandria. In Cairo, numbers in textiles merely held their own in absolute terms, whereas, in Alexandria, they actually declined. Moreover, Egypt's new towns – Suez, Port Sa'id, Isma'iliya and Zaqaziq, for example – did not become home to substantial textile manufacturing. (The same could not be said, for instance, for industries of clothing and dress or construction trades.)

However, in rural areas, numbers employed in spinning, weaving, dyeing and mat-making appear to have been growing and accounted for an increasing proportion of all those employed in textiles. Judith Tucker has brought to light evidence of country-side and female production reaching back to the first half of the nineteenth century[24] and other evidence tends to indicate its growth as the century wore on. Certainly, the statistics given in the *Statistique de l'Égypte* of 1871 argue for a substantial rural–urban textile trade. According to this source, 33,066 locally woven linen pieces and 21,219 silk veils for women were imported into Cairo in 1871. Furthermore, 3,780 silk and cotton veils for women

and 14,400 cotton pieces arrived in Alexandria from the surrounding hinterland in the same year. Minufiya apparently bought up 124,352 pieces of cotton cloth woven locally. Damietta purchased 21,623 pieces of butter-muslin and 6,269 female veils. Hundreds of thousands of mats, baskets and items of straw and palm-leaf work also arrived in Egypt's cities and towns in 1871. These figures include, for example, 179,747 mats of red reed imported into Cairo, over 400,000 locally made mats imported into Minuf and 211,800 baskets into Alexandria.[25]

Rural production probably benefited from the dismantling of Muhammad 'Alî's monopoly system, which bought villagers' products at below market price. Greatly enhanced political security (thanks to the dynasty-building projects of Muhammad 'Alî and his successors) and constantly developing transport infrastructure, particularly after the arrival of the railway in 1856, also facilitated rural–urban linkages. Finally, rural producers went unmolested by the urban guilds, inasmuch as there is no evidence that town-based guilds attempted to shut down such rural producers. More and more, the institution of *gedik* was not enforced and the term *gedik* practically disappears from the available sources. Those establishing themselves in these new settings did not try to set up guilds for themselves, partly because this institution was completely foreign to the rural environment, but primarily because to do so would have attracted unwelcome taxation.

Particularly under Ismâ'îl (1863–1879), countryside production made sense as a way to avoid increasingly onerous taxation in the urban guilds. After coming to power in 1863, Ismâ'îl set in motion an 'active search for every possible subject of taxation'[26] initially in order to fund his modernising Europeanising schemes and, eventually, in order to stave off bankruptcy and ensure the very survival of his regime. By 1872, the overall tax burden in Egypt was nearly twice what it had been in 1852.[27] The income-related professional tax (*wirkû*) levied on all guild-organised local subject merchants, shopkeepers, manufacturers, service-workers and labourers was significantly raised. In 1863, the Provincial Governor of Daqahliyya received an order which instructed that, in view of the recent gains made by the people of Mansura in industry and trade, the 'professional tax (*wirkû*) should be raised until it corresponded to this increase in their

wealth'.[28] Such *ad hoc* directives gave way to more systematic legislation raising the lowest tax bracket to 50 piastres per year and the highest to 750 piastres.[29] This probably meant a significant rise in tax in view of the fact that, in the early 1860s, the *average* tax paid by members of the trades (*arbâb al-kârât*) in Mansura was 40 piastres per annum.[30] The new legislation meant that the lowest tax bracket was higher than this at 50 piastres per annum. It is no exaggeration to say that the petitions of these years were dominated by battles over taxation.[31] The complaints of Muhammad Mahmûd Mawsî of Fayoum, a merchant in grains and other goods who petitioned against the recent doubling in his *wirkû* to the Provincial Offices in 1872, comprised one example of many.[32] In this context, arrears in the professional tax mounted fast. It does not seem too far-fetched to posit, in this context, the growth of non-guild countryside production as fugitive from heavy urban guild taxation.

After the advent of the British (1882) and as taxation on urban textiles (as on other crafts and trades) started to fall, rural production became more of a way to cut costs than to avoid taxes: female labour was extremely cheap, rents and overheads often non-existent where looms were installed in domestic settings. By 1914, even fewer textile workers (in relative terms) were working in Egypt's cities and even more in the countryside. In 1910, for example, we hear that almost all of the 6,000 weavers in al-Mahalla al-Kubrâ, Egypt's principal textiles region, worked in their own homes 'scattered all over the town and surrounding district'.[33] The same was true of the numerous weavers of Qalyubiya, where there was usually not more than one loom per house.[34] As the surveys of 1910 and 1925 make clear, in a significant transformation from a hundred years before, the picture was not entirely dissimilar up and down the Nile.[35]

Putting-out systems

It is likely that various kinds of putting-out arrangements organised a substantial portion of this rural production. One suspects that merchant-organisers were present where finished textiles were marketed in large quantities or over long distances, that is, between provinces or into larger towns and cities. It seems

unlikely that household and female workers could have mar-shalled the credit, contacts or resources to work independently where long-range distribution was involved. If such merchants were drawn from the ranks of urban textile guilds or from merchants who had authority in the urban setting, then perhaps it is not surprising that putting-out networks were not opposed by those self-same urban textile guilds.[36]

Long-distance distribution was by no means a rarity. For example, Mansura and other smaller towns in Daqahliyya such as Kum al-Nur and Mit Abu Khalid sent a certain amount of their flax and cotton weaves to neighbouring provinces and even to Cairo. The silk fabrics of Damietta, besides being bought locally, also went to big towns and cities like Cairo, Tanta, Alexandria and Mansura.[37] It was said that the industries of Asyut were 'chiefly for supplying the wants of the large surrounding population engaged in agricultural pursuits', but there was also a con-siderable export to Cairo and elsewhere.[38] As seen, the *Statistique de l'Égypte* for 1871 makes clear that Cairo, Alexandria and other towns imported considerable quantities of cloth from their hinterlands. Such figures are isolated snapshots of a trade about which historians know practically nothing, but which indicate at least the likelihood of putting-out systems operating between Egypt's towns and countryside in the second half of the nine-teenth century.

The survey of 1910 tells us that the spinners of Manzala bought their raw silk from merchants based in the major cities, who, in turn, imported it from China.[39] It is unclear whether these purchases involved spinners in a larger putting-out network, but it is hard to imagine otherwise how household workers could have obtained the credit and access to the market that such a long-range trade implied. The balance of probabilities suggests that merchants or entrepreneurs either organised these spinners in Manzala or, at least, to some extent controlled their production from Cairo. Similarly, when we hear that the weavers of Asyut imported raw silk from Lyons, France,[40] that weavers of al-Mahalla al-Kubrâ brought raw silk from China or that raw flax was bought into Daqahliyya by big merchants in the centres who imported it from Europe,[41] one suspects the presence of merchants or intermediaries. The dyers of Asyut also imported cotton yarn for dyeing from abroad via Alexandria.[42] Asyut weavers

obtained their cotton thread spun and dyed partly by locals and partly by European factories.[43] In al-Mahalla al-Kubrâ, most of the cotton threads came from Manchester.[44] Qalyubiya weavers used a lot of American cotton, bought from dealers in Cairo. In Daqahliyya, cotton threads were also bought from big city merchants who imported threads from India and England.[45]

It would appear that rising imports of European and other foreign yarns and raw materials facilitated the penetration of putting-out merchants into household countryside production since town-based merchants had easy access to imported raw materials (and so did not have to get involved with home-based and distant spinners) and, more importantly, these merchants then held the keys to a standardised product which weavers sought, but may not have had the liquid cash to pay for on the spot. Once merchants had lent on the raw materials, it was but a short step to using weavers' debts on this front to secure weavers' produce cheaply and thus develop a more thoroughgoing putting-out system.

More detailed references to the activities of town-based merchants exist. In Asyut, merchants reportedly sent produce to more distant markets further south or to Cairo. As we hear: 'some of the merchants [in Asyut] have orders from Cairo and other towns in Egypt [for weaves]'.[46] This formulation suggests that local putting-out merchants in Asyut were linked in some way to bigger Cairo-based merchants. Sidney Wells also wrote that cloth from Qalyub itself was sold wholesale to Cairene merchants, who came up from Cairo in search of inexpensive products made possible by cheaper provincial labour.[47] In the carpet manufacture of Beni Adi, some kind of putting-out system appears to have been in place. Women were at work in various households in the vicinity for moderate wages (5–7 piastres a day) on account of intermediaries (*wusatâ'*) who bought up the produce, although it is not clear whether these 'intermediaries' supplied the raw wool, which came from local *badu*. The intermediaries then sold either in the open market or to those who had placed an order.[48]

Beyond this were more systematic putting-out networks. In 1910, we hear that cotton thread was imported ready for weaving from Manchester by Cairo merchants who sent it on order to the provinces to be woven.[49] The weaving survey of the same

year reported that 'big Cairo merchants' imported raw silk from Syria, cleaned and dyed it by machines in special workshops and sent it on order ready to be woven to provincial weavers.[50] There is little indication of the origin of such activities in this account, but this fragment of information does suggest a certain scale to operations where 'special workshops' using machines cleaned and dyed the thread, which was then sent on to weavers in the provinces.

Female labour

Female participation in textiles, particularly of the paid variety and in putting-out arrangements, almost certainly increased during these years. The presence of women and girls is a recurring feature of the survey of 1910 and it is clear that female labour was highly desirable to the industry: above all, it was cheap. Female wages ranged from far lower than those of men to zero, namely, where women contributed labour to a house-hold. Cheap labour was particularly in demand in the silk industry, where preparation of the threads required so much more labour time than the same activities in wool, cotton or flax production. More than half of the one thousand silk spinners in al-Manzala were women.[51] Silk cocoons in Daqahliyya were washed by women, being paid at a rate of 5 piastres per kilogram, which turned out to mean a tiny wage of 1 piastre per day. The male weavers were hardly affluent, but still earned six to ten times more.[52] The 1907 census somewhat exceptionally mentioned 2,083 women in the textile trades for the Fayoum province out of a total of only 4,882 persons employed.[53] The numerous women who spun wool in Daqahliyya were apparently paid one-half of a piastre per *ratl*, which also meant a wage of about 1 piastre a day.[54]

The relatively small but well-known and expanding carpet-weaving industry in Beni Adi was unusual in that the *weavers* were women. Such women could weave a carpet of 1 1/2 by 1/4 metres in ten hours (one day), which then sold at the quite high price of over 2 Egyptian *lira*. Such carpets were mostly made on order and were sent to Asyut, Beni Suef, Minya and Girgah but also as far afield as Lower Egypt.[55] Women made fishing nets 'in their homes' in al-Matariya and Rosetta in Lower Egypt, the former

town being apparently well-known for this manufacture according to the survey of 1925. Such nets were used by the fishermen on the nearby lakes.[56]

Apparently, in the early 1900s, the expanding and somewhat famous[57] industry of shawl-making based in Asyut was 'entirely carried on by women and girls working in their own homes'. These workers combined a certain kind of metal strip with mosquito netting in a distinctive way to create a product that was much in demand as a veil or shawl in Egypt's towns. It was also in demand among tourists, being mentioned by the Report on Commerce and Industry as one of the trades which suffered when tourist demand fell off during the war.[58] Merchants imported the raw materials from Austria and elsewhere, provided them to women working in their houses, not only to those in Asyut itself, but also to women 'of the *fellahîn*' in the surrounding villages such as Bajur in *markaz* Asyut and Nakhila in *markaz* Abu Tig. It would appear that the women paid for these raw materials at the point of delivery and then sold on the finished product – whether to the same merchants or not is unclear. Such a system would appear to have allowed a certain measure of independence to the producer, who may have been able to choose, to some extent, between both raw material providers and merchant-purchasers. Sidney Wells's team recorded that the price obtained from the Cairene merchants for Asyut shawls was apparently only a 'very little more' than the price that the women had paid for the raw materials.[59] In other words, these women worked for very low profits, surely a factor which kept them in business and their products cheap and desirable.

In the early 1920s, a putting-out system organised the mostly female production in Asyut for the embroidery of tulle, a delicate net-like fabric for use principally in veils. The industrial survey of the early 1920s mentioned 12 cloth and tulle veil merchants in Asyut. Such merchants distributed white tulle and tulle thread (via intermediaries) to workers in the surrounding villages. Three metres of white tulle (costing 10 piastres) was needed for each veil, which required up to about a kilo and a half of thread (costing about 70 piastres) which the merchants imported from France or Germany. When the work was completed, the producers themselves transported the finished garments to the merchants and took payment for what they had done. The women sold

their veils to the merchants according to weight: 1 *dirham* (3.12 grams) cost 3–3.5 *millimes*. The merchants also apparently paid 2 piastres to their intermediaries for heavy veils and 1 piastre for light veils. According to the industrial survey, output was greatest between 1908 and 1912.[60] Overall, women (and sometimes girls), often working at home, came to participate in Egyptian textile manufacturing on a considerable scale through various kinds of putting-out as well as through more independent production.

In order to escape taxation and cut costs, there occurred important shifts in the textile sector. By the early twentieth century, most textile workers were villagers and/or female, often employed by putting-out traders. The prevalence of this labour force, with no connection to the guilds, undermined the predominantly male city-based guild system. Where textile workers, often women, were scattered all over the countryside and in domestic settings, often specifically to avoid guild-based taxes, textile guilds could no longer discharge their key long-standing intermediary functions in taxation and regulation of crafts. Such a development in what continued to be one of Egypt's most important industries was probably a major consideration in inducing the government's decision by 1890 to abandon guilds as units of taxation and regulation, at least as far as textiles were concerned. Far-reaching delocalisation, rapid sociological change and the emergence of new 'informal' networks and allocatory mechanisms associated with putting-out systems rendered the guild unable (and probably unwilling) to regulate the textile economy. As a corollary, the guild became increasingly irrelevant as a social community for textile workers.

Larger workshops

As workshops in the textile trades expanded either in terms of looms or numbers of people employed, the structure of Egyptian textile manufacturing was further transformed. The timing, distribution and organisation of this restructuring is barely known, but fragmentary descriptions and references do exist. Certain local entrepreneurs appear to have established larger 'sheds' or factories, in which up to a hundred looms were at work. An Egyptian government report of 1919 suggested that

in all the major centres of textile production such as in Mahalla Kubrâ in the Delta, Akhmim, Damietta, Qalyub and Cairo, 'workshops containing as many as 100 looms' were worked by hand and foot.[61] Such workshops had been largely unknown in eighteenth century Egypt.[62]

In 1910, the largest workshops in Damietta belonged to 'Abd al-Fattah Bey al-Lûzî, who apparently owned 37 looms (of the 200 present in the town) which produced about 170,000 metres of silk fabric per annum.[63] It seems likely that as a 'bey', al-Lûzî made or had made his principal wealth either in land or as a merchant. Enterprises such as his, even if relatively prosperous, were set up, it was said, not in the covered and contained work-shops known to the authors of the *Description de l'Égypte* in the heart of the old commercial centres but, as Germain Martin, a French-trained lawyer and resident of Cairo, wrote: 'in the quarters where most of the buildings are ramshackle, at the back of courtyards, in sheds deprived of their roofs' and in 'long, narrow and badly lit spaces'. Such conditions must have lowered overheads, rents and maintenance costs. Martin wrote that one found there 'weaving workshops, coppersmiths, copper-beating, dyeing, mat-making'. Up to thirty workers under the orders of a few overseers were active here: 'this is Cairo's big industry'.[64] Some such workshops, according to Martin, 'cluster all the tasks necessary for the production of finished cloth ready for sale in one place' such as spinning, dyeing, drying of the skeins, weaving, mangling the woven cloth and then hammering the silk or wool cloth for lustre. All such operations took place 'in a sombre, dark room'.[65]

The Commission on Commerce and Industry offered a similar description of larger weaving establishments, which it said were to be found in tumbledown quarters occupying 'shanties' half in ruins, open to the winds, with dirty walls and dusty floors. Others were cramped and had no ventilation. According to the Commission, the 'preoccupation of locals with very great economy displaces all other considerations'. Such practices constituted a danger to the health of the workers 'who pass there the biggest part of their existence'. The Commission went on: 'in another more prosperous workshop for the production of braiding and trimmings, a manufactory in which the mechanism is moved by cattle, the locals are so pressed that men and beasts

work in some way, side by side, and in the very worst conditions of hygiene and lack of space'.[66] Underlining the harsh conditions of these larger workshops, Clerget noted that an official enquiry before the war in Kirdasa (a suburb of Cairo in Imbaba, Giza Governorate, on the west bank of the Nile) revealed that nearly all the weavers had eye diseases because the workshops were so unhealthy.[67]

Martin reported that hours in these establishments were long and work was more 'regular' than in the smaller workshops. He mentioned that weavers and spinners in Cairo were among those who took night work during one-third of the year which lasted until midnight or one o'clock in the morning.[68] Indeed, he reported that adults and numerous children working in Cairo's larger workshops were 'tireless'. Their activities, he reported, were kept up sometimes by a rhythmic chant and sometimes by the extremely regular cadence of the wood mallets which lustred the cloth.[69]

Martin compared the masters-cum-entrepreneurs of such larger workshops to the smaller masters of the more common workshops. The small master, according to Martin, 'eats off the same plate' as his journeyman and nothing in his external manner or occupational activities 'allows the visitor to distinguish between master and journeyman'. The 'big master' was quite different. He oversaw the work of his underlings: 'he has a certain solemnity. Dressed in a gallabiya in lustred cotton or even of silk; proud of his large sash in different colours, one would take him most likely for a religious man, for a priest who surveys his faithful. He abstains from all manual work and the greater part of his time is devoted to receiving his friends or his clients. A bench allows him to invite [them] to take coffee.'[70]

Whether such workshops were headed by ex-members of the guild hierarchy or by newly established entrepreneurs using capital from land or commerce, they undermined the older textile guilds in various ways: they subverted the intermediary bargain struck between guild and state, diminished the ability of the guild to regulate relations of production and exchange, and strained the older form of guild community. They rapidly attracted new cadres, particularly rural migrants in search of work. They were often established in new, 'suburban', cheap-rent locations, distant from the covered markets in the centre of

the old Ottoman city. The allocatory and extractive networks commanded by entrepreneurs worked to submerge and displace those commanded by old guild leaders and new kinds of pressures and fault lines appeared, especially where workers could find allies among elite nationalist groups.

Martin's impression was that despite the 'distant attitude' and superior 'external bearing' of the larger masters, relations between journeymen and masters were still 'excellent'. But, as in Damascus,[71] employers and employed did come into conflict in such establishments. Martin himself reported that Cairo's silk-spinners had attempted to form a syndicate in 1905, 'but without success'.[72] One might suggest that their failure, in this regard, was partly related to lack of support from elite nationalist constituencies which, at this point under Mustafa Kamal, leader of the Nationalist Party until February 1908, were not systematically looking towards establishing a base among the urban masses.[73] Nonetheless, new kinds of institutions were, for the first time, becoming a possibility among the urban crafts.

Economic exploitation, worker protest and nationalist support drove this forward. On 20 April 1907, inspired by the success of the mass strike of the cab drivers just two days before and by the success of the carters on the previous day, several hundred Cairene silk-weavers went on strike. *Al-Jarîda* reported that 'the spirit of the strike has spread from the coachmen to the silk-weavers and a group of them met yesterday afternoon [20 April], rounded up their colleagues (*zumalâ'*) and roused them to stop work'. The *Gazette* reported that: 'After the agitation of the cabmen and carters, the weavers have begun to move and on Sunday, about 300 of them went on strike. They did not, however, commit any outrages...These men demand an increase in wages.'[74] The weavers soon confronted a police detachment sent from Bâb Sha'riyya police station. According to *al-Jarîda*, it was likely that the owners (*ashâb al-mâl*) would answer their demands.[75] Whatever the outcome, the authorities did not shrink from punishing the strikers: 14 silk-weavers each paid a fine of 12 Egyptian *lira* and were sentenced to 10 days in prison.[76]

Within the week, another strike had broken out, this time amongst Cairo's mat-makers. *Al-Jarîda* reported a 'New Strike' (*i'tisâb jadîd*) on 27 April 1907: 'This morning, many of the workers (*'ummâl*) of the mat-makers (*tâ'ifat al-husriyya*) went on strike

and met in Manshiyya Square.' It soon became known that the workers were planning to attack the owners of some of the mat-making workshops, who must have taken such a possibility seriously as they then 'sent a petition to his honour the *hikmadâr* today, demanding that he take the necessary precautionary measures to prevent the strikers from attacking them tomorrow'.[77] Unfortunately, it is unclear how the issue was resolved.

Another strike attempt among weavers about a month later in the same year was nipped in the bud by police coercion. Al-Ahrâm reported on 22 May that '14 weavers met and went to the workshop of Hasan 'Alî al-Sawwâf in Bulaq. They assaulted him and his workers with the intention of forcing them to agree with them on a strike. So, policemen arrested them and sent them for a summary hearing for sentencing.'[78]

As elite nationalist groups increasingly looked toward an urban constituency which they could represent in their struggle against the British[79] and as weavers and others were encouraged by sympathetic portrayal of their strikes and protests in the nationalist press, syndicates and unions, with support and funding from nationalists, started to be established. The Manual Trades Workers' Union, founded in 1909 in Cairo (Bulaq) by the Nationalist Party, had 193 weavers as members by 1912.[80] Although one can hardly claim any in-depth understanding of these processes, it does seem clear that here was a 'route' different from that taken by the guilds where restructuring, protest, and rising nationalism combined to forge and lend support to new social institutions representing the interests of textile workers. Here again, protest and adaptation 'from below' was crucial in the unmaking of guilds and the development of new social networks and institutions.

Conclusion

Arguably, at least as far as the textile trades were concerned, the end of the guilds was somewhat more complicated and interesting than standard views allow. Instead of the simple destruction of the 'traditional' handicrafts at the hands of imports 'from above', in the textile trades one sees how adaptation and protest by crafts workers themselves worked to undermine the

guilds and build new networks and institutions. The demise of this important institution of Egyptian craft guilds was not simply about the incorporation of a passive periphery into a world economy based on Europe, but was also related to the adaptation and protest of crafts workers themselves in a context of state-building and rising nationalism. Where textile production was rapidly delocalised and sociologically transformed, where women often working in domestic settings scattered throughout the countryside came to comprise a significant proportion of the textile workforce, where merchants and newcomer entrepreneurs started to organise both putting-out networks and larger work-shops and where journeymen started to protest against their masters and join new kinds of organisation, the political, economic and social functions of the guilds were radically undermined.

The guild could hardly provide a meaningful social com-munity based on face-to-face ties under these circumstances. Nor could it either regulate economic activities in the textile trades or provide an effective fiscal or regulative link to the government. The government's decision to progressively abandon, between 1881 and 1892, the fiscal and regulative functions of the guilds surely makes considerable sense in this context. It was not that the guilds had been destroyed by imports nor was their abolition the draconian and top-down intervention of a colonial state. In the case of the textile trades, this demise was, at least, in part a response to adaptation 'from below': a surprisingly far-reaching restructuring which left little untouched, created new fault lines, brought in new cadres, new spatial arrangements, new links between employer and employee, and new kinds of informal activity. All these novelties helped overwhelm and sub-merge older patterns of guild activity and contributed to the making of new informal networks and social institutions. No wonder that as many of the crafts and trades were already staffed by new cadres, Martin encountered a certain vagueness in 1909 among artisans in Cairo about the old guild regime, already part of an increasingly distant past.

In sum, subaltern adaptation and protest had contributed to the dissolution of one of the fundamental institutions of the Ottoman Empire. To begin to document this process is to make a small contribution to the recovery of colonial history from below.

Notes

1 Baer, 1964, pp. 130ff.

2 Issawi, 1963, p. 19. Issawi also argued that the development of the transport sector and the consequent import of European manufactures in the second half of the nineteenth century 'eliminated most handicrafts': Issawi, 1968, p. 397. Also see Issawi, 1993, p. 177: 'we hear that [h]andicrafts, exposed to the competition of European machine-made goods, were for the most part eliminated'. A host of others expressed similar views: Baer argued that crafts and guilds were largely eliminated by the impact of foreign competition in the later nineteenth century: Baer, 1964; Raymond likewise: Raymond, 1999; he also explained how foreign investment in Egypt eliminated traditional trades as in the case of the water-carriers: Raymond, 1958. This historiography was partly based on models of industrialisation and development dominant in the 1950s and 1960s which greatly emphasised capital-intensive and factory-based production: Deane and Cole, 1962; Landes, 1969; Gerschenkron, 1962. Post-Second World War development theory, partly influenced by successful large-scale Soviet industrialisation in the 1930s, saw little utility in non-factory industry for solving the problems of underdevelopment: see, for example, Rostow, 1953. Much broadly Marxist literature, 'dependency' and 'world systems' theory, also envisaged the destruction of peripheral handicrafts at the hands of the industries of the 'core', valorised the 'nationalist bourgeoisie' and stigmatised 'compradors' seen as collaborating with core capitalism. A major volume along these lines was Islamoğlu-Inan, 1987; also see Kasaba, 1988; Gran, 1980.

3 The notion of simple and undifferentiated handicraft decline was challenged as early as the 1960s. Dominique Chevallier led the way in 1962. Roger Owen then argued that Egypt's building industry (much of it small-scale) was a 'major recipient of the great increase in agricultural incomes which took place between 1897 and 1907': Owen, 1969, p. 347; also see Owen, 1984. Marxist articulation of 'modes of production' analysis also started to envisage more complex economic change in the periphery. For example: Koptiuch, 1999; *ibid.*, 1994. Other Marxist-inspired work found 'proto-capitalism' rather than simple decline in Syrian textile industries: Reilly, 1993; see also *ibid.*, 1992; *ibid.*, 1987. Donald Quataert's pioneering research, focusing on rural and household industry (inspired by work on proto-industrialisation) has convincingly argued against the simple 'decline' thesis, finding busy, complex and changing

forms of rural industry in the Ottoman Empire in the nineteenth century. Among many other works, Quataert, 1993, pp. 1–2; *ibid.*, 1992; *ibid.*, 1986, p. 128. See also Chalcraft, 2001.

4 Chandavarkar's emphasis on the great diversity of emerging working classes in a South Asian context provides a suggestive comparison for the complex forms of work and capital accumulation emerging in Egypt in the later nineteenth century in a context of state-building, emerging capitalism and colonial rule: Chandavarkar, 1998, p. 7.

5 Baer, p. 18. Raymond agreed that: '"une corporation" was a group of individuals in a town practising the same professional activity under the authority of a shaykh': Raymond, 1973–1974, v. 2, p. 507.

6 Quataert, 1996, p. 29.

7 For Massignon, the 'Islamic' guild was primarily a pact of honour, a pledge of chivalry rooted in mysticism: Massignon, 1963; see also *ibid.*, 1934. Bernard Lewis' position was similar: Lewis, 1937–1938. An example of Baer's challenge to this view comes in Baer, 1964, pp. 1–10.

8 This view has arisen more recently in revision of Baer's work: Gerber, 1976; Gerber, 1988; Inalcik, 1993, pp. 194–197 and regarding Egypt: Cole, 1993, pp. 164–189; Toledano, 1990, pp. 226ff; Ghazaleh, 1995.

9 Both Baer's work and that of those who revised him deploy a too sharp state/society dichotomy which mistakes the complexities of guild/state relations where neither entity was monolithic in its relation to the other. It is highly problematic to pit state and society against each other with the guild as a litmus test of 'Oriental despotism'. The guild cannot be identified unproblematically with something called 'civil society' or even 'society' because guild activity was closely bound up with state-*like* functions: jurisdiction and taxation. As Toledano pointed out, guilds were not voluntary associations and the language of members' '*interests*' in this context is highly problematic and anachronistic or, at best, has to be very carefully defined: Toledano, 1990, pp. 226ff. On the other hand, guilds were simultaneously embedded in the social and economic life of crafts and trades and were never identified unproblematically with a radically distinct and distant government in the way argued by Baer.

10 This question goes to the basis of divisions between the disciplines, rhetorics and practices of economics, politics and culture as well as raising related questions respecting the problematic representation of the pre-modern. These questions can hardly be satisfactorily resolved here.

11　As Stanford Shaw wrote almost three decades ago: 'In theory...the sultan had almost absolute powers...In practice, however...[t]he nature of the Ottoman system in fact left the sultan with very limited power...significant aspects of Ottoman life were left to be dealt with autonomously, not only by the millets but also by the guilds, the corporations, the religious societies, and the other groups forming the corporative substructure of Ottoman society.': Shaw, 1976, v. 1, p. 165.

12　This did not mean that Ottoman intervention in the crafts was always welcomed. Baer's 'Gotha' manuscript (from the later sixteenth century) was bitterly critical of the newly imposed Ottoman system.

13　This is a long debate: the evidence and findings are certainly inconclusive and only point to a fairly plausible account. Furthermore, this 'distinctive form' had great internal diversity by region, trade and over time.

14　For a useful discussion, see Akarlı, 1985–1986; also see Ghazaleh, 1999.

15　Raymond, 1973–1974, v. 2, pp. 549–550.

16　See, for example, Marcus, 1989, pp. 170–175.

17　See, for example, Ghazaleh, 1999, pp. 63–66; Cole, 1993, p. 72.

18　Ghazaleh has shown that at least in the case of eighteenth century Egypt, these powers were contested and negotiated within a larger set of relationships between kadi courts, tax farmers, government officials and groups within the guild: Ghazaleh, 1999, pp. 35–40.

19　Raymond, 1973–1974. Other important research substantiates this claim. See, for example, Quataert, 1993; Faroqhi, 1984; Todorov, 1983; Establet and Pascual, 1998, pp. 86–89, 151–159; Hanna, 1998, especially, pp. 89–90.

20　Raymond, 1973–1974, p. 223.

21　Salzmann, 1995, p. 320.

22　The seventy-volume Cairo census of 1868, the *Sijillât Muhâfizât Misr Ta'dad nufûs* 1285 84/1/lam is found at DWQ, Cairo. NB: Up until the present time, no study has been devoted to this census, which is based on the 1846 census studied by various researchers such as Reimer, 1987; Cuno, 1992; Alleaume and Fargues, 1998; and research in progress by Muhammad Hakim.

23　See note 3.

24　Tucker, 1982.

25　*Statistique de l'Égypte*, 1873, pp. 213–215.

26　PRO: Memorandum by Baring enclosed in Malet/Granville, 5 May 1880, PRO FO633/96: 281.

27 Consul West, 'Commercial Report 1872' in *House of Commons Accounts and Papers*, v. CXIV, 60 (consulted in University Library, Cambridge, Official Publications Room).

28 DWQ MA 118 *Amwâl* Khedivial Order/*Mudîr* of Daqhaliyya (15 *Rabî'a al-thânî* 1280).

29 QM 1876–1880 (Part I 1879): 124–125. NB: The date of this legislation is not clear. It seems to have been in force during the 1870s. It was to be amended in 1880.

30 This is my calculation based on a tax return from Mansura: see note 28.

31 See Cole, 1993, pp. 91–96.

32 Muhammad Mahmûd Mawsî to Fayoum Province, Rabî'a al-Ahkir 1289: DWQ MW ND MA M9 (no number).

33 Gordon, 1910, p. 335.

34 Wilson, 1911, p. 53.

35 Quataert has argued convincingly for the relative vibrancy of countryside production in nineteenth century Anatolia: Quataert, 1993.

36 Compare how Plovdiv's guild of *aba*-makers reinterpreted its customs in order to allow countryside production organised by prominent guild members: Todorov, 1983, pp. 223–225.

37 Wells, 1911.

38 Ablett, 1910, p. 328.

39 Gordon, 1910; Wells, 1911.

40 Ablett, 1910, p. 329

41 Wells, 1911.

42 Ablett, 1910, p. 329.

43 Ablett, 1910, p. 329.

44 Gordon, 1910.

45 Wells, 1911.

46 Shearer, 1910, p. 185; also Ablett, 1910, p. 330.

47 Wells, 1911.

48 '*Nubdha Sinâ'iyya*' [no author] in *Sahîfat al-Tijâra*, July 1925, 4, pp. 41–42. Each loom produced 3 square metres of rug in a day and thirty kilim rugs of different sizes per month. One square metre required 3–5 *ratl* of wool. One *ratl* cost 8 piastres. The selling price was 13–15 piastres for one *ratl*. In other words, rugs sold at 70–80 piastres for 1 square metre.

49 Chenouda, 1910, p. 187.

50 Chenouda, 1910, p. 187.

51 Wells, 1911, p. 63.

52 Wells, 1911, p. 67.

53 One should note that Wells expressed doubt about the large size of this figure: Wells, 1911, p. 59.
54 Male wages in wool weaving (quite close to the bottom of the barrel for any male wage anywhere in Egypt at that time) were 4–6 piastres per day: Wells, 1911, p. 68.
55 Wells, 1911, p. 70.
56 'Nubdha Sinâ'iyya' [no author] in Sahîfat al-Tijâra, April 1925, 3, pp. 5, 9.
57 See, for example, the comments in the Egyptian Government Almanac 1917, Cairo, Government Press, 1919, p. 185. FO848/16 PRO.
58 DWQ MW NM 19, Lajnat al-Tijâra wa'l-Sinâ'a, part II, pp. 4–5.
59 Ablett, 1910, p. 330.
60 'Nubdha Sinâ'iyya', Sahîfa al-Tijâra, April 1925, 3, p. 64.
61 FO848/16, Egyptian Government Almanac 1917, Cairo, Government Press, 1919: 184–5.
62 Somewhat exceptionally, a dye works near the Citadel at the time of the French occupation (1798–1801) employed several scores of workers: Raymond, 1973–1974, p. 223.
63 Wells, 1911, p. 63.
64 Martin, 1910, pp. 52–53.
65 Martin, 1910, pp. 52–53.
66 DWQ MW NM 19, Lajnat al-Tijâra wa'l-Sinâ'a, part III, p. 14.
67 According to the survey of 1925, Kirdasa was quite a centre for weaving, apparently having 920 looms at work: 'Nubdha Sinâ'iyya', in Sahîfa al-Tijâra, July 1925, 4, p. 2.
68 Martin, 1910, p. 83.
69 Martin, 1910, p. 61–62.
70 Martin, 1910, p. 75. As James Reilly has noted of late nineteenth century Damascus, such entrepreneurs were no longer the 'possessors' or 'teachers' of a craft and its skills: Reilly, 1993.
71 Vatter, 1994.
72 Martin, 1910, p. 86.
73 This is, of course, to follow Lockman's powerful analysis of the importance of the nationalist movement in the making of labour protest in the early twentieth century: Lockman, 1994; see also Beinin and Lockman, 1987, pp. 66–69.
74 'The Situation in Cairo, Quiet Restored', Egyptian Gazette, 23 April 1907, p. 4.
75 Al-Jarîda 21 April 1907, p. 4. Notice here how the phrase ashâb al-mâl has replaced ashâb al-hiraf: restructuring generated divisions within the crafts and the idea of 'ownership' of a craft has here given way to ownership of capital. These personages are now

directly contrasted with the workers (*'ummâl*), a term which now
refers to those who work under the direction of the owners of capital.

76 *Al-Jarîda*, 1 May 1907, p. 4.
77 *Al-Jarîda*, 27 April 1907, p. 4.
78 *Al-Ahrâm*, 22 May 1907, p. 4.
79 See Lockman for a compelling account of this: Lockman, 1994.
80 Beinin and Lockman, 1987, p. 69.

Bibliography

Primary Sources

Egyptian National Archives: Dâr al-Wathâ'iq al-Qawmiyya (DWQ)

Interior Ministry, Arabic Correspondence: *Nizâra al-Dâkhiliyya, Mukâtiba 'Arabî* (ND MA)
Research Files: *Muhâfiz al-Abhâth* (MA)
Council of Ministers, Finance Ministry: *Majlis al-Wuzarâ', Nizâra al-Mâliyya* (MW NM)
Census of Cairo Governorate, 1868: *Sijillât Muhâfizât Misr, Ta'dad nufûs* 1285 84/1/lam.

Public Record Office, London (PRO)

FO633/96 (Cromer Papers)
FO848/16 (Documents presented to the Milner Mission)

Journals and Newspapers, Dâr al-Kutub, Cairo

al-Jarîda (April–May 1907)
al-Ahrâm (April–May 1907)
Egyptian Gazette (April 1907)
Sahîfat al-Tijâra (April–July 1925)

Official Publications

al-Qarârât wa'l-Manshûrât al-Sâdira min al-Nizâra (QM), Bulaq, Government Press, 1876–1914.
Statistique de l'Égypte, Cairo, Ministry of Interior, 1873.

Books and Articles

Ablett, N. L., 'Asyut Industries', *Égypte Contemporaine*, 1910, pp. 328–333.

Akarlı, Engin Deniz, 'Gedik: Implements, Mastership, Shop Usufruct, and Monopoly among Istanbul Artisans, 1750–1850', *Wissenschaftskolleg Jahrbuch*, 1985–1986, pp. 223–231.

Alleaume, Ghislaine and Philippe Fargues, 'Voisinage et frontière: résider au Caire en 1846', in Jocelyne Dakhlia, ed., *Urbanité arabe. Hommage à Bernard Lepetit*, Sindbad/Actes Sud, Paris, 1998, pp. 77–112.

Baer, Gabriel, *Egyptian Guilds in Modern Times*, Jerusalem, Hebrew University Press, 1964.

Beinin, Joel and Zachary Lockman, *Workers on the Nile: Nationalism, Communism, Islam, and the Egyptian Working Class, 1882–1954*, Princeton, Princeton University Press, 1987.

Chalcraft, John T., 'The Striking Cabbies of Cairo and other stories: crafts and guilds in Egypt, 1863–1914', New York University, unpublished PhD dissertation, 2001.

Chandavarkar, Rajnarayan, *Imperial Power and popular politics: Class, resistance and the state in India, c. 1850–1950*, Cambridge, Cambridge University Press, 1998.

Chenouda, Attya, 'Notes on the Weaving Industry', *Égypte Contemporaine*, 1910, pp. 187–193.

Chevallier, Dominique, 'Un exemple de résistance technique de l'artisanat syrien aux XIXe et XXe siècles : les tissus ikates d'Alep et de Damas', *Syria: Révue d'Art Oriental et d'Archeologie* 39, 1962, pp. 300–324.

Cole, Juan R. I., *Colonialism and Revolution in the Middle East: Social and Cultural Origins of Egypt's 'Urabi Movement*, Princeton, Princeton University Press, 1993.

Cuno, Kenneth, *The Pasha's Peasants*, Cambridge, Cambridge University Press, 1992.

Deane, P. and W. A. Cole, *British Economic Growth, 1688–1959: Trends and Structure*, Cambridge, Cambridge University Press, 1962.

Establet, Colette and Jean-Paul Pascual, *Ultime Voyage pour la Mecque. Les inventaires après décès des pèlerins morts à Damas vers 1700*, Damascus, IFEAD (French Institute of Arab Studies), 1998.

Faroqhi, Suraiya, *Towns and Townsmen of Ottoman Anatolia: Trade, Crafts and Food Production in an Urban Setting, 1520–1650*, Cambridge, Cambridge University Press, 1984.

Gerber, Haim, 'Guilds in Seventeenth century Anatolian Bursa', *Asian and African Studies* 11, Summer 1976, pp. 59–86.

Gerber, Haim, *Economy and Society in an Ottoman City: Bursa, 1600–1700*, Jerusalem, Hebrew University, 1988.

Gerschenkron, Alexander, *Economic Backwardness in Historical Perspective*, Cambridge, Harvard University Press, 1962.

Ghazaleh, Pascale, 'The Guilds between Tradition and Modernity', in Nelly Hanna, ed., *The State and its Servants: Administration in Egypt from Ottoman Times to the Present*, Cairo, American University in Cairo Press, 1995, pp. 60–75.

Ghazaleh, Pascale, *Masters of the Trade: Crafts and Craftspeople in Cairo, 1750–1850*, Cairo, American University in Cairo Press, 1999.

Gordon, F. Moore, 'Notes on the Weaving Industry at Mehalla-Kebir', *Égypte Contemporaine*, 1910, pp. 334–339.

Gran, Peter, 'Political Economy as a Paradigm for the Study of Islamic History', *International Journal of Middle East Studies* 11, 1980, pp. 511–526.

Hanna, Nelly, *Making Big Money in 1600. The Life and Times of Isma'il Abu Taqiyya, Egyptian Merchant*, Cairo, The American University in Cairo / Syracuse University Press, 1998.

Inalcik, Halil, 'The Appointment Procedure of a Guild Warden', in Halil Inalcik, ed., *The Middle East and the Balkans under the Ottoman Empire: Essays on Economy and Society*, Bloomington, Indiana University Press, 1993, pp. 194–198.

Islamoğlu-Inan, Huri, ed., *The Ottoman Empire and the World-Economy*, Cambridge, Cambridge University Press, 1987.

Issawi, Charles, *Egypt in Revolution: An Economic Analysis*, London, Oxford University Press, 1963.

Issawi, Charles, 'Asymmetrical Development and Transport in Egypt, 1800–1914', in William R. Polk and Richard L. Chambers, ed., *Beginnings of Modernisation in the Middle East: The Nineteenth Century*, Chicago, Chicago University Press, 1968, pp. 383–401.

Issawi, Charles, 'Middle East Economic Development, 1815–1914', in Albert Hourani, Philip S. Khoury and Mary C. Wilson, ed., *The Modern Middle East: A Reader*, Berkeley, University of California Press, 1993 pp. 177–194.

Kasaba, Reşat, *The Ottoman Empire and the World Economy: The Nineteenth Century*, Albany, State University of New York Press, 1988.

Koptiuch, Kristin, 'Other Workers: A Critical Reading of Representations of Egyptian Petty Commodity Production at the Turn of the Twentieth Century', in Zachary Lockman, ed., *Workers and Working Classes in the Middle East: Struggles, Histories, Historiographies*, Albany, State University of New York Press, 1994, pp. 41–71.

Koptiuch, Kristin, *A Poetics of Political Economy in Egypt*, Minneapolis, University of Minnesota Press, 1999.

Landes, David S., *The Unbound Prometheus: Technological Change and Industrial Development in Western Europe from 1750 to the present*, London, Cambridge University Press, 1969.

Lewis, Bernard, 'The Islamic Guilds', *The Economic History Review* 8, 1937–1938, pp. 20–37.

Lockman, Zachary, 'Imagining the Working-Class: Culture, Nationalism, and Class Formation in Egypt, 1899–1914', *Poetics Today* 15/2, Summer 1994, pp. 157–190.

Marcus, Abraham, *The Middle East on the Eve of Modernity: Aleppo in the Eighteenth Century*, New York, Columbia University Press, 1989.

Martin, Germain, *Les Bazars du Caire et les petits metiers Arabes*, Le Caire, 1910.

Massignon, Louis, 'Sinf', *The Encyclopaedia of Islam*, 1st ed., 1934, pp. 436–437.

Massignon, Louis, 'La '*Futuwwa*', ou 'Pacte d'Honneur Artisanal' entre les travailleurs musulmans au Moyen Age', *Opera Minora* 1, Beirut, 1963, pp. 396–421.

Owen, Roger, 'The Cairo Building Industry and the Building Boom of 1897–1907', *Colloque International sur l'Histoire du Caire*, DDR (Deutsche Demokratische Republik), Ministry of Culture of Arab Republic of Egypt, 1969, pp. 337–350.

Owen, Roger, 'The Study of Middle Eastern Industrial History: Notes on the interrelationship between factories and small-scale manufacturing with special references to Lebanese silk and Egyptian sugar, 1900–1930', *International Journal of Middle Eastern Studies* 16, 1984, pp. 475–487.

Quataert, Donald, 'Ottoman Handicrafts and Industry, 1800–1914: A Reappraisal', in Hans Georg Majer, ed., *Osmanistische Studien zur Wirtschafts- und Sozialgeschichte*, Wiesbaden, Otto Harrassowitz, 1986, pp. 128–135.

Quataert, Donald, *Manufacturing and Technology Transfer in the Ottoman Empire 1800–1914*, Istanbul, Isis Press, 1992.

Quataert, Donald, *Ottoman Manufacturing in the Age of the Industrial Revolution*, Cambridge, Cambridge University Press, 1993.

Quataert, Donald, 'The Social History of Labor in the Ottoman Empire', in Ellis Goldberg, ed., *The Social History of Labor in the Middle East*, Boulder (Colorado), Westview Press, 1996, pp. 19–36.

Raymond, André, 'Les Porteurs d'eau du Caire', *Bulletin de l'Institut Français d'Archéologie Orientale* 57, 1958, pp. 183–203.

Raymond, André, *Artisans et Commerçants au Caire au XVIIIe siècle*, 2 v., Damascus, Institut Français de Damas, 1973–1974, reprint 1999,

Institut Français d'Etudes Arabes de Damas/Institut Français d'Archéologie Orientale.

Raymond, André, 'Les Transformations des corporations de métiers au Caire du XVIIIe au XIXe siècle', in Hervé Bleuchot, ed., *Les institutions traditionelles dans le monde arabe*, Paris, Karthala, 1999, pp. 29–40.

Reilly, James A., 'Origins of Peripheral Capitalism in the Damascus Region, 1830–1914', unpublished PhD dissertation, Georgetown University, 1987.

Reilly, James A., 'Damascus Merchants and Trade in the Transition to Capitalism', *Canadian Journal of History* XXVII/1 April 1992, pp. 1–27.

Reilly, James A., 'From Workshops to Sweatshops: Damascus Textiles and the World-Economy in the last Ottoman century', *Review* XVI/2, Spring 1993, pp. 199–213.

Reimer, Michael J., 'Les fondements de la ville moderne: un tableau socio-démographique entre 1820 et 1850', *Revue de l'Occident Musulman et de la Méditerranée* 46, 1987.

Rostow, W.W., *The Process of Economic Growth*, Oxford, Oxford University Press, 1953.

Salzmann, Ariel, 'Measures of Empire: Tax Farmers and the Ottoman Ancient Régime', *1695–1807*, Columbia University, unpublished PhD dissertation, 1995.

Shaw, Stanford, *History of the Ottoman Empire and Modern Turkey*, Cambridge, Cambridge University Press, 1976.

Shearer, W.V., 'Report on the Weaving Industry in Assiout', *Egypte Contemporaine*, 1910, pp. 184–186.

Todorov, Nikolai, *The Balkan City, 1400–1800*, Seattle, University of Washington Press, 1983.

Toledano, Ehud, *State and Society in Mid-Nineteenth Century Egypt*, Cambridge, Cambridge University Press, 1990.

Tucker, Judith, *Women in 19th century Egypt*, Cambridge, Cambridge University Press, 1982.

Vatter, Sherry, 'Militant Journeymen in Nineteenth-Century Damascus: Implications for the Middle Eastern Labor History Agenda', in Zachary Lockman, ed., *Workers and Working Classes in the Middle East: Struggles, Histories, Historiographies*, Albany, State University of New York Press, 1994, pp. 1–21.

Wells, Sidney H., 'The Weaving Industry in Egypt', *Égypte Contemporaine*, 1911, pp. 52–73.

Wilson, J.J.V., 'Textile Industry in Kalioubieh', *Égypte Contemporaine*, 1911, pp. 53–73.

Index